TREASURES OF VENICE

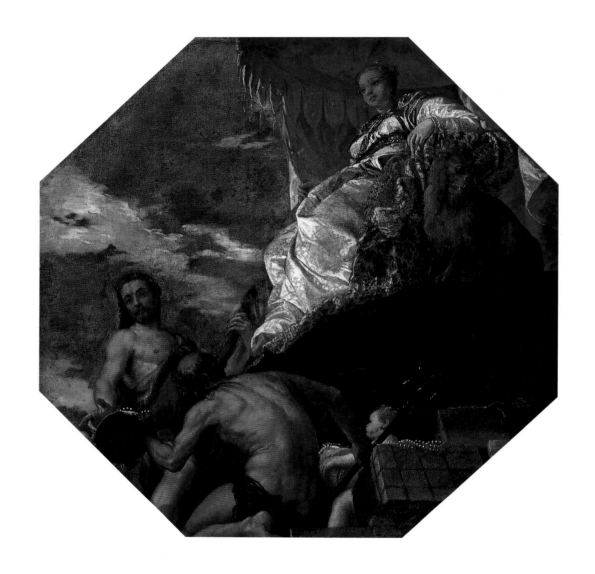

Treasures

PAINTINGS FROM
THE MUSEUM OF FINE ARTS
BUDAPEST

EDITED BY

George Keyes,
István Barkóczi, Jane Satkowski

WITH ESSAYS BY

Klára Garas, George Keyes, and Philip Sohm

AND CONTRIBUTIONS FROM

István Barkóczi, Zsuzsanna Dobos
Vilmos Tátrai

of Venice

THE MINNEAPOLIS INSTITUTE OF ARTS

This book has been published in conjunction with the exhibition *Treasures of Venice: Paintings from the Museum of Fine Arts, Budapest,* organized by the Minneapolis Institute of Arts.

High Museum of Art, Atlanta, Ga.
February 28–May 21, 1995

Seattle Art Museum
June 22–September 17, 1995

The Minneapolis Institute of Arts
October 22, 1995–January 14, 1996

This exhibition has been made possible, in part, by a grant from
the National Endowment for the Arts, a federal agency.

Translated from the Hungarian by Victor Mészáros and István Barkóczi
Color photography by András Rázsó and Dénes Józsa
Black-and-white photography by Mária Szenczi and Györgyi Fodor
Text edited by Fronia Simpson
Designed by Bret Granato
Produced by Marquand Books, Seattle
Printed and bound by C & C Offset Printing Co., Hong Kong

Front cover/jacket: Bernardo Strozzi, *The Annunciation* (cat. no. 13)
Frontispiece: Paolo Veronese, *Allegory of Venice* (cat. no. 51)
Page 66: detail, Sebastiano Ricci, *Bathsheba at the Bath* (cat. no. 4)
Page 82: detail, Paolo Veronese, *Christ on the Cross* (cat. no. 10)
Page 114: detail, Giovanni Battista Tiepolo, *Saint James Conquering the Moors* (cat. no. 25)
Page 144: detail, Marco Liberi, *Jupiter and Asteria* (cat. no. 35)
Page 170: detail, Titian, *Portrait of Doge Marcantonio Trevisani* (cat. no. 45)
Page 198: detail, Canaletto, *The Locks at Dolo* (cat. no. 53)

Library of Congress Cataloging-in-Publication Data

Treasures of Venice: paintings from the Museum of Fine Arts, Budapest / with essays by Klára Garas, George Keyes, and Philip Sohm ; and contributions [catalog entries] from István Barkóczi, Zsuzsanna Dobos, Vilmos Tátrai.
p. cm.
Published in conjunction with an exhibition held at the Minneapolis Institute of Arts.
Includes bibliographical references.
ISBN 0-8109-3880-4 (Abrams: cloth). — ISBN 0-912964-56-1 (Museum: pbk.)
1. Painting, Italian — Italy — Venice — Exhibitions. 2. Painting, Modern — 17th–18th centuries —Italy — Venice — Exhibitions. 3. Painting — Hungary — Budapest — Exhibitions. 4. Szépművészeti Múzeum (Hungary) — Exhibitions. I. Garas, Klára. II. Keyes, George S. III. Sohm, Philip L. (Philip Lindsay), 1951- . IV. Barkóczi, István. V. Dobos, Zsuzsanna. VI. Tátrai, Vilmos. VII. Minneapolis Institute of Arts.
ND621.V5T74 1995
759.5'31'074776579—dc20 94-29185

Contents

Preface

THE MINNEAPOLIS INSTITUTE OF ARTS is proud to have worked with the Szépművészeti Múzeum in Budapest, Hungary, which has been extremely generous in lending highlights from their world-famous collection of Venetian paintings for this exhibition, which will bring them to new, appreciative audiences across the United States. Our cities and museums have much in common. Both Budapest and Minneapolis/St. Paul are "twin cities" divided by great rivers. Our institutions were both founded in the last two decades of the nineteenth century, and our beaux-arts, neoclassical buildings were erected early in the twentieth century. The Szépművészeti Múzeum is well known for the depth and range of its collection of paintings by Venetian masters of the sixteenth through the eighteenth centuries, and Minneapolis has also developed its Venetian collection over the years to represent this great tradition, admittedly on a more modest scale.

The artistic importance of this exhibition is mirrored in the historical opportunities it represents. This new era of cultural collaboration will serve as an effective bridge between our countries. Our new freedom of communications has made this opportunity possible, and we can only hope that it represents the beginning of a bright future of cultural collaboration and exchange projects in the arts.

I would like to express our most grateful thanks to Miklos Mójzer, director of the Szépművészeti Múzeum, and his colleagues for their constant support and work to make this project a reality. Thanks are also due to our other authors, Dr. Klára Garas, former director of the museum in Budapest, and Dr. Philip Sohm, for their catalogue essays. I would also like to thank my museum colleagues and friends, Ned Rifkin, director of the High Museum in Atlanta; Jay Gates, former director, and Mimi Neill, director of the Seattle Art Museum, for their helpful and constant support.

The logistics of crating and transporting the pictures for this exhibition, especially those requiring microclimates, are complex. I wish to thank Cathy Ricciardelli, the registrar of the Minneapolis Institute of Arts, for so capably coordinating this aspect of the project. A very special thanks to Dr. George Keyes, Patrick and Aimee Butler Curator of Paintings at the Minneapolis Institute of Arts, for his excellent work in co-organizing the project with Dr. István Barkóczi and for his scholarly contributions as an author and editor of the catalogue. Warm thanks also go to Dr. Jane Satkowski, of the department of paintings, who edited the catalogue along with Dr. Keyes and Dr. Barkóczi.

This vital project was supported by a generous grant from the National Endowment for the Arts, a federal agency, which also is underwriting the critically important international insurance indemnification.

Evan M. Maurer, *Director*
Minneapolis Institute of Arts

Foreword

WHEN THE ESTERHÁZY COLLECTION was transferred from Vienna to Pest in 1865 and subsequently purchased by the Hungarian government in 1870, those in charge of domestic Hungarian cultural policy, already strongly determined by a sense of bourgeois independence, had every reason to feel satisfaction. Due to the absence of a royal collection as the foundation of a great picture gallery in the rapidly developing capital, the acquisition of one of Europe's largest private aristocratic collections filled an enormous gap in Budapest.

The National Museum, which contained a gallery of paintings, had already been in existence since 1802. This collection was notably enhanced when Archbishop Pyrker, a former Patriarch of Venice (1820–27), donated his picture collection in 1836. However, the purchase of the Esterházy Collection guaranteed for the first time in Hungarian history that an outstanding European picture gallery, along with a celebrated collection of drawings and prints, could be exhibited on the second floor of the newly built Hungarian Academy of Sciences. Although the primary focus of this "National Picture Gallery" was the recently purchased Esterházy Collection, in 1872 it was further enriched by the donation of Arnold Ipolyi. To this day these three great nineteenth-century collections—Pyrker, Esterházy, and Ipolyi—form the core of the picture gallery of the Museum of Fine Arts in Budapest.

It was during the later nineteenth century that virtually all the museums of the nation of Hungary (which at the time comprised considerably larger territories than present-day Hungary) were founded. The Museum of Fine Arts was the last of these, established by legislative fiat in 1896. From an architectural point of view the new buildings erected to house these national art collections reflect a strong sense of historicism. The present building of the Museum of Fine Arts was born out of this historicizing attitude. Finished in 1906, this neoclassical structure was virtually the last example built in this style on the European continent (fig. 1). Behind its classical facade, it contains great halls in the Doric, Ionic, Romanesque,

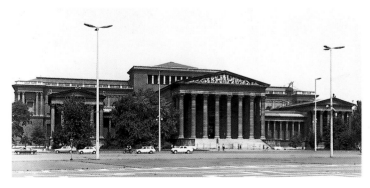

FIG. 1. Museum of Fine Arts, Budapest, exterior, erected 1906.

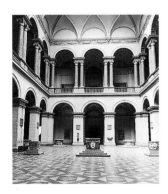

FIG. 2. Interior; the Renaissance Hall.

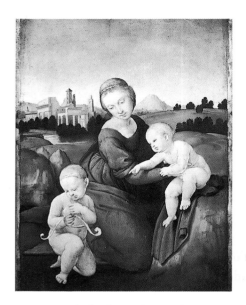

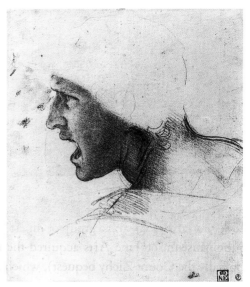

FIG. 3. Raphael, *The Esterházy Madonna.* Budapest, Museum of Fine Arts.

FIG. 4. Leonardo da Vinci, *Head of a Warrior,* study for the lost fresco of *The Battle of Anghiari.* Budapest, Museum of Fine Arts.

Renaissance, and Baroque styles (fig. 2). By deliberately incorporating such stylistic variety, the architects of the Museum of Fine Arts sought to create a monument recalling the ideal past which would reflect the continuity and integrity of European culture.

This spirit of historicism coincided with a new attempt to assess the historical past systematically and also had bearing on the architecture and applied arts of this era. These precepts also constituted the basis for the organization of museums and largely shaped a more modern policy toward acquisitions determined by careful planning and scholarly research.

Parenthetically, the Hungarian name of the Museum of Fine Arts—Szépművészeti Múzeum—is the equivalent of the French *Musée des Beaux-Arts* or the German *Museum der bildenden Künste.* Our museum is one of the preeminent national galleries of the world, even though the idea of its national character is not expressed by the museum's name. Instead, its name conforms in spirit to the archaizing tendencies of the age when our institution was founded. Paradoxically, Hungarian art was separated from our institution in 1957, when a separate Hungarian National Gallery was founded. It opened in 1973 in its current location, the former royal palace of Buda Castle.

The Museum of Fine Arts initiated the policy of acquiring significant paintings in conformity with the dictates of these deeply held historicizing precepts. In actuality this attention to the past dated back to the period following the Enlightenment of the eighteenth century as manifested by the collecting habits of the Esterházy princes, who wished to secure for their collection at least one representative work from each of the most important schools of painting. The 637 paintings and the thousands of prints and drawings acquired by the Hungarian state from the Esterházy Collection include many of the masterpieces for which Budapest is celebrated. Among these highlights are major pictures by Bronzino, Claude, Correggio, Cranach, Crivelli, Cuyp, Goya, Murillo, Raphael (*The Esterházy Madonna,* fig. 3), Ribera, Ruysdael, and Saenredam. Moreover, the drawings in the Esterházy Collection are of equal repute, containing major sheets by Rembrandt plus a magnificent array of the Italian school capped by the two celebrated chalk studies for *The Battle of Anghiari* (fig. 4) by Leonardo da Vinci.

The succeeding directors of the Museum of Fine Arts implemented this aspect of collecting in an even wider historical sense. They aimed at forming a picture gallery that had an encyclopedic representation of those European schools of painting then deemed the most important. Conversely, these directors' judgment of the nineteenth century was rather conservative and traditional, with the result that, more often than not, they were apprehensive of the Impressionists and their avant-garde contemporaries and immediate successors. This explains why there are relatively few works in the museum's collection from this period. Moreover, most of those that found their way into the collection came primarily as donations.

During the twentieth century the Museum of Fine Arts has continued to secure notable collections. The most important of these is the bequest of Count János Pálffy in 1912, whose collection contained many important old-master paintings (including works by Petrus Christus, Guercino, Michael Sittow, and Jan Steen), and a group of nineteenth-century pictures as well. Since World War II the Museum of Fine Arts acquired the Fővárosi (Municipal) Picture Gallery in 1953 (originally the Count Zichy bequest), which added significant treasures to the collection.

During this same period the Museum of Fine Arts has continued to make a series of judiciously selected individual purchases. Collecting high-quality, typical works of important masters or from significant art centers has always been the policy of the Museum of Fine Arts. The possibility of acquiring the greatest names or works by the most famous artists was confined to a few, lucky instances in the history of Hungarian collecting. The overriding goal remained that of securing paintings of either very high or representative quality regardless of the artists' actual names. These efforts resulted in groupings of paintings determined by the traditional art-historical approach that placed the highest priority on definable schools of painting. This policy, which now results in a surprisingly complete representation of national and regional artistic traditions, remains in effect to the present day.

On this occasion we are proud to present a selection of our paintings of the Venetian school. These works are but a microcosm of the greatness of our collections and reflect the many important collectors—Pyrker, Esterházy, and Pálffy—that so enriched the Museum of Fine Arts.

I would like to express my gratitude to Dr. Evan Maurer, director of the Minneapolis Institute of Arts, and Dr. George Keyes, Patrick and Aimee Butler Curator of Paintings at the Minneapolis Institute of Arts, for making this exhibition possible and for enabling the Museum of Fine Arts to clean and conserve many of the paintings in the exhibition. I am also much obliged to Dr. István Barkóczi, Curator of Later Italian and Spanish Painting; Dr. Vilmos Tátrai, Curator of Italian Renaissance Painting; and Zsuzsanna Dobos, Assistant Curator, for preparing the catalogue entries. Their many scholarly insights and discoveries greatly enrich our knowledge about this important segment of our picture collection. I also wish to acknowledge Dr. Philip Sohm for his erudite essay examining Venetian art theory as it pertains to the broad assessment of Venetian seicento painting, so richly represented in our collection. Finally, I wish to thank my eminent predecessor, Dr. Klára Garas, for her essay discussing the history of collecting Venetian paintings in Central Europe, a subject particularly close to her heart and to all of us for whom Budapest is such a magical city.

Miklos Mójzer, *Director*
Museum of Fine Arts, Budapest

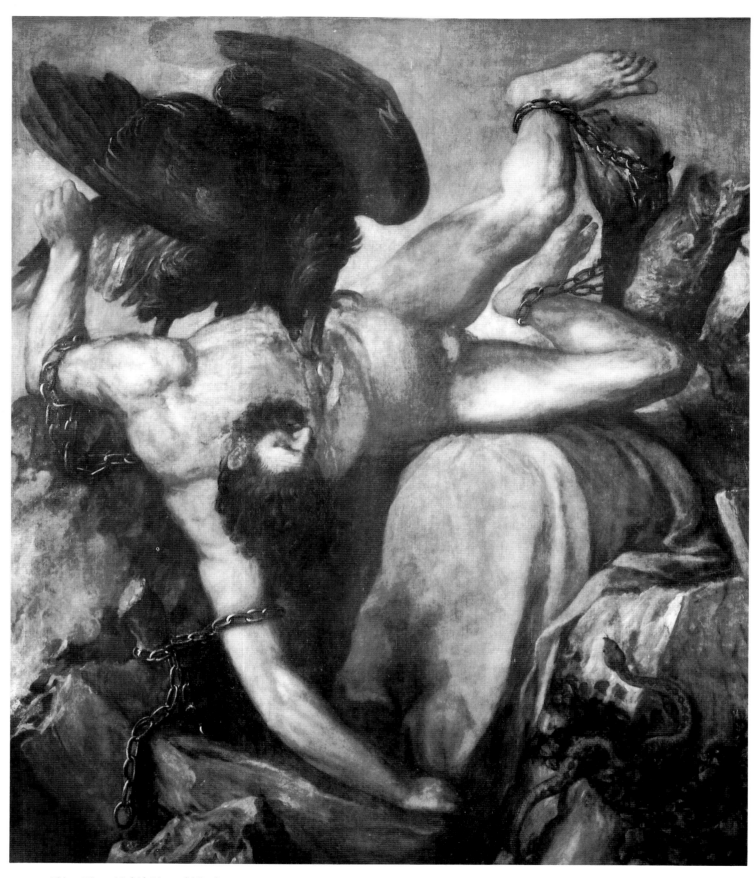

FIG. 1. Titian, *Tityus.* Madrid, Museo del Prado.

The Early Impact of
the Venetian Golden Age

GEORGE KEYES

THIS ESSAY EXPLORES certain of the means by which sixteenth-century Venetian painting became a potent and recognized force throughout much of Europe during the later sixteenth and early seventeenth centuries. The process by which the Venetian coloristic tradition became a vital and integral component of a wider painterly tradition of the Baroque followed many routes. The most direct of these involved paintings by the greatest Venetian masters of the cinquecento painted on commission for non-Italian clients or acquired by them for their distinguished collections. Of equal force, reproductive prints after the inventions of the most celebrated Venetian masters assured the diaspora of this artistic tradition throughout Europe during this time. Finally, many foreign artists traveled to Italy in the sixteenth century and sojourned in Venice.

By the seventeenth century, however, artists no longer had to restrict their visits to Venice itself; they also had access to celebrated collections containing important Venetian paintings in such far-flung cities as Brussels, London, Madrid, Prague, Rome, and Vienna. This wider access enabled the greatest painters of the Baroque to respond powerfully to the earlier Venetian colorists. Painters such as Rubens, Van Dyck, Poussin, and Velázquez assimilated the magnificent tradition through their travels to Italy and elsewhere. Although Rembrandt's access to Venetian paintings was far more restricted, he, too, was deeply influenced by the colorism of Titian, most notably in his portraits. Rembrandt's late paintings are executed in a personal technique that offers a remarkable parallel to Titian's own late style.

Yet no ambassador could speak so eloquently as original paintings by the leading Venetian masters that were commissioned by or acquired by collectors outside Italy, and no Venetian artist was better positioned to promote himself than Titian. His first great foreign patron was Charles V, whom Titian first met in Parma in 1529 through Federico Gonzaga, duke of Mantua. The following year Charles was crowned Holy Roman Emperor in Bologna by Pope Clement VII. In 1533 Titian painted Charles V's portrait in Bologna. His connection with Charles V assumed renewed importance shortly before midcentury when, at Charles's behest, Titian traveled to Augsburg in 1548 in the company of his son, Orazio, his nephew, and his assistant, Lambert Sustris, to be present at the *Reichstag,* or Imperial Diet. There, surrounded by kings, dukes, electors, and princes, Titian painted many portraits including three of Charles V, of which only *Charles V on Horseback,* now in the Prado, survives.

Titian produced not only portrait likenesses but also major religious and mythological subjects, which left his studio for distant destinations. Although King Philip II of Spain's subsequent commissions for *poesie* and religious works were the most celebrated of these projects, it was, in fact, Charles V's sister, Mary of Hungary, regent of the Netherlands, who first commissioned a series of mythological pictures from Titian. Like Titian, she was also in

FIG. 2. Cornelis Cort after Titian, *Paradise* (*Adoration of the Holy Trinity*). Rotterdam, Museum Boymans-van Beuningen.

FIG. 3. Cornelis Cort after Titian, *The Martyrdom of Saint Lawrence*. Rotterdam, Museum Boymans-van Beuningen.

Augsburg in 1548 and ordered a series of four paintings, *The Damned* (also known as *The Furies*) to decorate the main hall of her palace at Binche, near Brussels.[1] Although removed from Mary of Hungary's residence within twenty years after Titian delivered the two canvases depicting the stories of Tityus (fig. 1) and Sisyphus in 1549, this cycle was influential in introducing Titian's advanced painterly style into the Low Countries.

In 1550 Charles V's son Philip invited Titian to return to Augsburg, where the emperor reconvened the Diet to announce his imminent retirement. He abdicated six years later, designating his son King Philip II of Spain and also granting to him Spain's colonial possessions and the Low Countries. By 1552 Titian and Philip II commenced correspondence pertaining to the many commissions that were to occupy much of the painter's time and energies up until his death.[2]

As the head of a large studio, Titian also became an effective entrepreneur, marketing his inventions through the process of reproductive printmaking. Initially he concentrated on woodcut illustrations based on his own designs. Titian produced preparatory pen drawings for professional wood engravers who translated them into large woodcuts, impressive for their size and quality.[3]

By 1565 Titian had secured the services of one of the most gifted reproductive engravers of his age, the Netherlandish printmaker Cornelis Cort (1533–1578).[4] As Rosand and Muraro indicate,[5] by this time Titian had lost interest in woodcuts because he was more anxious to

promulgate reproductive images after his paintings rather than his line drawings. Cort pro-
duced fifteen engravings after major Titian compositions, and most of these were created
under the painter's direct supervision. His involvement became so intense that in January
1566 Titian successfully secured a fifteen-year copyright privilege from the Council of Ten.
Following this first period of activity, from 1565 to 1566, Cort left Venice for Rome but re-
turned again in 1571–72, when he engraved his last three prints after Titian, working directly
with the aged painter. Many of the subjects engraved by Cort were related to or copied from
paintings by Titian that were sent to foreign clients. By means of Cort's engravings, Titian
was able to assure his inventions wider publicity. Bierens de Haan cites correspondence be-
tween Titian and certain of his patrons[6] indicating that the painter sent impressions of Cort's
engravings as presents, which provide useful documentation as to the dissemination of his
celebrated inventions. Such gifts included impressions after *Paradise* (or *Adoration of the
Holy Trinity*, now in the Prado; fig. 2) commissioned by Charles V in 1551 and delivered in
1554 to Margaret of Parma, regent of the Netherlands, or two impressions of Cort's engraving
The Martyrdom of Saint Lawrence (fig. 3) that Titian sent to King Philip II.[7]

Cornelis Cort was by no means the first Netherlandish artist to work under Titian's
employ and tutelage. Lambert Sustris (ca. 1515/20–ca. 1568), who had already settled in
Venice in about 1534, was Titian's assistant during the period 1548–52 when Titian traveled
to Augsburg. Sustris appears to have principally functioned as a portraitist. For about two
years, from 1555 onward, Dirck Barendsz. lived in Titian's house almost like the artist's son.
Barendsz. was indelibly influenced by Titian and other Venetian masters including Tintoretto,
Veronese, and Schiavone. In particular, his brush drawings on dark-tinted paper betray this
Venetian experience. Barendsz.'s broad, liquid brushwork also owed much to his assimila-
tion of Venetian painterly technique. In one notable instance Barendsz. produced a large and
highly finished drawing, *The Venetian Ball* (*Wedding of Antenor*),[8] which conveys the ele-
gance and pomp of the type of ceremonial display that he would have witnessed firsthand in
Venice. Barendsz. also produced two designs, *Sinful Mankind before the Great Flood* and
Sinful Mankind before the Last Judgment, that are powerfully reminiscent of his Venetian
experience. Both were engraved by Jan Sadeler I[9] and enjoyed widespread popularity.

The Sadeler family of engravers, and particularly Aegidius Sadeler (ca. 1570–1629),
Johannes Sadeler I (1550–ca. 1600?), and Raphael Sadeler I (1560–1628 or 1632?), were
important reproductive engravers who disseminated much creative imagery of the later six-
teenth century, melding ideas generated in the Low Countries, Italy (and especially Venice),
Bavaria, and Rudolphine Prague. In contrast to Cornelis Cort, who almost exclusively re-
stricted his activity in Venice to reproducing the inventions of Titian, the Sadelers reproduced
important imagery after Jacopo Bassano,[10] Tintoretto, Palma Giovane, Hans Rottenhammer
(see below), Pauwels Franck, and Lodewijk Toeput. Their publishing activity in cities like
Munich and Prague provided the Sadelers with access to Mannerist artists such as Pieter de
Witte, known as "Candide," Frederick Sustris, and Christof Schwartz, plus an even greater
abundance of material in Prague after Hans van Aachen, Joseph Heintz, Roelandt Savery,
Bartholomaeus Spranger, and Peter Stevens. Added to this, they produced many engravings
after the leading Netherlandish Mannerists of the period, above all, Maerten de Vos.[11] The
fact that Venetian painters were popularized by various members of the Sadeler clan con-
firmed the close link between Venice and late-sixteenth-century international Mannerism.

During the second half of the sixteenth century further artists from the Low Countries and Germany were active in Venice. Pauwels Franck and Lodewijk Toeput ("Pozzoserrato") spent many productive years in Venice. Toeput (ca. 1550–1603/5) was attracted to the landscape idiom of Tintoretto and Paolo Veronese and developed his own distinctive strain of imaginary landscape (fig. 4) that had considerable impact.[12]

The German-born artist Hans Rottenhammer (1564–1625) settled in Venice from about 1596 until 1606. There he developed an exquisite *maniera* style best expressed through his refined drawings and his jewellike works painted on copper. Many of these recapitulate subjects treated earlier by Titian and include representations of Christian celestial visions or pagan mythological themes.[13] In Venice Rottenhammer served as an agent for the emperor Rudolph II and also restored pictures for him.[14] While in Venice Rottenhammer came into contact with Raphael Sadeler I and Lucas Kilian, who produced reproductive engravings after his compositions.[15]

Holland came late to the stage of international Mannerism; the style there was largely shaped by artists who immigrated north. In particular, the city of Haarlem played a central role through the presence of Hendrick Goltzius, Cornelis Cornelisz. van Haarlem, and Karel van Mander. Van Mander's *Het Schilder-Boeck* of 1604 contains many references to the celebrated painters of Venice. He was first exposed to Venetian art through his second teacher, Pieter Vlerick, a now obscure artist who had traveled to Italy, where he resided in Venice with the painter Jacopo Tintoretto and was active in his studio. Van Mander studied with Vlerick in 1568–69 shortly after Vlerick's return from Italy.[16] Vlerick instilled in Van Mander an abiding admiration for Venetian painting and a desire to visit Italy. Ironically, when Van Mander did travel to Italy in 1573 he was forced to bypass Venice on his way to Rome, where he remained until 1577. There he met and befriended Bartholomaeus Spranger. Through this connection Van Mander was later able to introduce Hendrick Goltzius (1558–1616) to Spranger's *maniera* style, which Goltzius immortalized in his virtuoso reproductive engravings of the 1580s.[17]

Unlike Van Mander, Goltzius did visit Venice during his trip to Italy. Late in 1590 Goltzius arrived in Venice, where he resided with Dirck de Vries, whom he portrayed in his magnificent black and sanguine chalk drawing now in the Teylers Museum in Haarlem.[18] On his return journey from Rome to Holland in 1591, Goltzius once again stopped in Venice, enjoying the further hospitality of his friend De Vries. There he drew the portrait of the Venetian painter Jacopo Palma Giovane[19] now in Berlin. During the mid-1590s, following his return from Italy, Goltzius became progressively more interested in the Venetian concept of landscape as embodied by the woodcuts after Titian.[20] At this time Goltzius produced several landscape drawings in pen and ink that demonstrate a shift from a Bruegelian-inspired concept to one more deeply Venetian in inspiration.

During the late 1580s Goltzius began to produce woodcuts, culminating in his celebrated chiaroscuro images (fig. 5) that reforge what had predominantly been an Italian tradition into one indelibly his own. This interest in bold colorism spilled over into his drawings, including three remarkable representations of trees that count among his most advanced and subtle renderings of landscape subjects.[21] With Goltzius, the highway transmitting the basic tenets of Venetian art of the sixteenth century was transformed from the black-and-white process of reproductive engraving into a medium that, in itself, was coloristically splendid.

This graphic tradition transmitting the visual language of Venetian painters intermingled in a truly international marketplace and became a vital component of late-sixteenth-century Mannerism, equally at home in Italy, central Europe, and the Low Countries. It would perpetuate itself into the new century but would ultimately be subsumed by the pictorial investigations of younger artists, whose assimilation of this tradition was realized primarily through the process of painting. In their work the pictorial language of cinquecento Venice

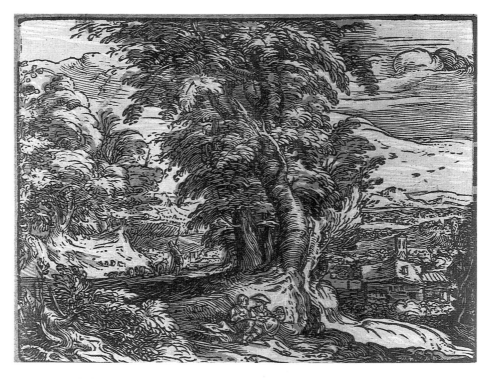

FIG. 5. Hendrick Goltzius, *Landscape with Trees and a Peasant Couple.* The Minneapolis Institute of Arts.

15

and its brilliant colorism effectively coalesced back into one and the same phenomenon, albeit now interpreted through new, non-Italian eyes.

Five of the most celebrated non-Italian painters of the earlier seventeenth century—the Flemings Peter Paul Rubens and Anthony van Dyck, the Frenchman Nicolas Poussin, the Spaniard Diego Velázquez, and the Dutchman Rembrandt Harmensz. van Rijn—had unique access to major Venetian paintings, and each assimilated the painterly tradition of Venice into his own style, thereby transmitting it into the mainstream of Baroque art. What first evolved as a regional Italian tradition of seminal importance became part of the broader pictorial tradition of seventeenth-century European painting, universally accessible and intrinsic to painterly tendencies that would recur during the ensuing centuries. This tradition would leave its stamp on the Rococo, the romantic epoch, and find a most enduring afterglow in the world of Impressionism.

Peter Paul Rubens (1577–1640), the earliest of the five painters of the Baroque, first came into contact with Venice during his long sojourn as a court painter to Vincenzo Gonzaga, duke of Mantua. Not only did Rubens have immediate access to the princely collections of this family but, as a member of its retinue, traveled to Florence, Rome, and Spain. While in Spain during 1603 Rubens first saw the celebrated Titian paintings acquired by the emperor Charles V and his son Philip II. While in Italy Rubens availed himself of every opportunity to study antiquity and the artists of the sixteenth century—Raphael, Michelangelo, Correggio, and the leading Venetians, Titian, Veronese, and Tintoretto. Upon his return to Flanders in 1608, Rubens established himself as the foremost painter of Antwerp, receiving important ecclesiastical commissions. One of these, *The Raising of the Cross,* datable to about 1610–11, painted for the Church of Saint Walpurgus and now in Antwerp Cathedral, displays Rubens's profound admiration for Michelangelo and Jacopo Tintoretto.[22] Once established in Antwerp, Rubens assembled a vast art collection containing antiquities, the graphic arts, and paintings.[23] In terms of paintings, the Venetian school, dominated by Titian, was particularly strongly represented and was a source of inspiration to Rubens and his pupils. Rubens's admiration for Titian was rekindled when he traveled to Madrid in 1628–29 as ambassador for his sovereign, Isabella, regent of the Spanish Netherlands. During the many months of frustrating diplomatic inactivity Rubens was able to reexamine the Titian paintings in the Spanish royal collection, which he had first seen more than twenty-five years earlier. He copied many of these paintings. Subsequently, during the 1630s, Rubens produced his two remarkable variants now in Stockholm of Titian's *Andreans* and *The Worship of Venus.*[24]

In his many smaller devotional images representing subjects such as holy families and half-length depictions of Christ, for example, Rubens made constant reference to Titian, whereas in his larger altarpieces he recalls not only certain of Titian's most celebrated ecclesiastical commissions but also the splendor of Paolo Veronese's great public commissions for altarpieces and allegorical compositions that so perfectly mirrored the pomp and ostentation of later sixteenth-century Venice.

The subtle painterly effects of Rubens's late style owed much to the example of Titian, whose own late style is so magnificently represented in the Spanish royal collection. Rubens's portraits of his second wife, Helena Fourment, and contemporaneous religious and mythological paintings, such as his *Bathsheba* in Dresden (fig. 6) or his *Andromeda* in Berlin, reveal the degree to which Rubens reembodied the spiritual breadth and pictorial subtlety

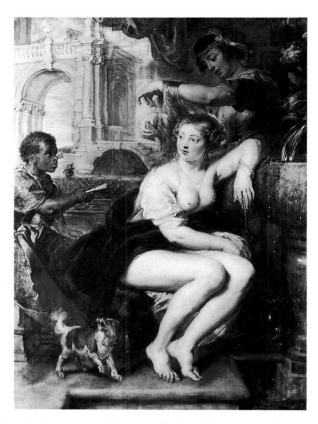

FIG. 6. Peter Paul Rubens, *Bathsheba*. Dresden, Staatliche Kunstsammlungen.

of Titian's smoldering colorism, indelibly associated with his late work. At the same time Rubens charted new territory as his ever more profound vision of human beauty and spiritual grace evolved.

Anthony van Dyck (1599–1641) entered Rubens's studio by about 1617 and soon became his most gifted collaborator while independently pursuing his own career.[25] No artist became more enthralled by Titian than Van Dyck, who in the eyes of his contemporaries was considered a reincarnation of the Italian painter. Van Dyck's earliest contacts with Titian's art occurred in Antwerp, where he had access to a few original paintings, plus copies and reproductive prints. Most of this material would have been in Rubens's remarkable collection to which Van Dyck would have had immediate access.[26] During his first visit to England, from late 1620 until early 1621, Van Dyck saw important Venetian paintings including works by Titian in the collections of the earl of Arundel and the duke of Buckingham.[27]

Only a few months after his return to Antwerp Van Dyck set off for Italy, where he remained until 1627. During these years he traveled extensively and recorded those art works that especially interested him in his *Italian Sketchbook*, now in the British Museum.[28] Van Dyck single-mindedly recorded many paintings by Titian that he saw in Venice, Rome, and elsewhere and even maintained a log of those cities where major works by Titian attracted his interest. For example, certain rapid pen sketches in the *Italian Sketchbook* record Titian's two great paintings in the Borghese Gallery in Rome, as well as those paintings by Titian commissioned by Pope Paul III Farnese on view in the Palazzo Farnese in Rome. Van Dyck also copied Titian's two great *poesie* painted for Alfonso d'Este, which had been transferred

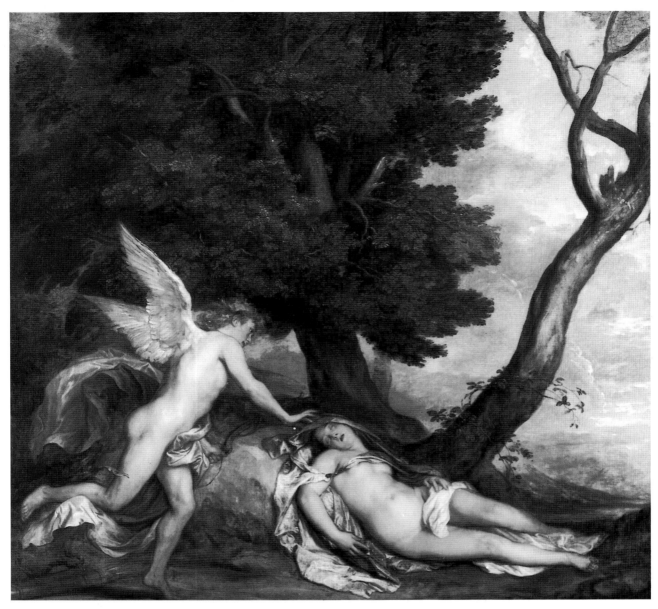

FIG. 7. Anthony van Dyck, *Cupid and Psyche*. London, Kensington Palace, Her Majesty Queen Elizabeth II.

from Ferrara to Rome in 1598. In 1621 *The Andreans* and *The Worship of Venus* were given by the Aldobrandini to Cardinal Ludovisi and hung in the Villa Ludovisi in Rome until 1637, when Niccolò Ludovisi, prince of Piombino, presented them to Philip IV of Spain.[29]

By the time he returned to Antwerp in 1627, Van Dyck had amassed a notable art collection that included many paintings by Titian. In fact, when Marie de Médicis visited Antwerp in 1631, Van Dyck's collection was referred to as his "cabinet de Titien."[30]

In December 1629 Van Dyck completed his *Rinaldo and Armida*, now in Baltimore, for King Charles I of England. The extraordinary evocation of Titian's colorism in a subject that matched the grandeur and evocative poetry of Titian's great *poesie* deeply impressed the English king, who invited Van Dyck to England. In 1632 Van Dyck moved to London, where he soon established himself as the king's favorite court painter. In England he had the unique opportunity to immerse himself in the magnificent art collection of Charles I,

recently augmented by the purchase en bloc of much of the Gonzaga Collection, acquired through negotiations that began in 1623. As with Rubens's return to Madrid in 1628, Van Dyck was able to study the Gonzaga Collection for a second time following its transfer to London. Charles I perceived in Van Dyck a reincarnation of Titian and saw his own patronage of this prodigiously talented painter as a modern parallel to Charles V's or Philip II's support of Titian.[31]

Van Dyck was deeply influenced by Titian's portraits, many of which he copied in his *Italian Sketchbook*. His own refined concept of portraiture proved ideally suited to the demands of the Caroline court. There, Van Dyck established conventions of aristocratic portraiture that would continue to stamp British likenesses until the Edwardian epoch. Van Dyck had little time to paint religious or mythological subjects for Charles I, but the one surviving mythological subject, *Cupid and Psyche* (fig. 7), of about 1639–40[32] indicates how successfully Van Dyck re-created the brilliant coloristic harmony of Titian's *poesie* in a work that most perfectly justifies the claim that Van Dyck was Titian's undisputed heir.

Nicolas Poussin (1594?–1665) became involved with Venetian painting early in his career following his departure for Italy in 1622–23. Prior to his arrival in Rome in March 1624, Poussin probably spent several months in Venice. His earliest surviving paintings betray a tonality and deep, sonorous palette that reflects his interest in Venetian art.

However, Poussin's greatest interest in Venetian painting, and specifically in Titian, occurred in the years following his arrival in Rome. As Van Dyck had done only slightly earlier, Poussin was able to study the celebrated bacchanals that Titian painted for Alfonso d'Este, which had been transferred from Ferrara to Rome in 1598. By 1621 *The Andreans* and *The Worship of Venus* had been given by the Aldobrandini to Cardinal Ludovisi and

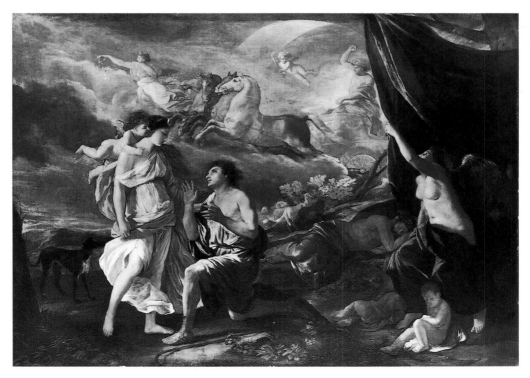

FIG. 8. Nicolas Poussin, *Selene and Endymion.* The Detroit Institute of Arts.

hung in the Villa Ludovisi, where Poussin would have seen them. By contrast, Titian's *Bacchus and Ariadne,* now in the National Gallery in London, remained with the Aldobrandinis.[33] Joachim von Sandrart, in his *Teutsche Academie,* relates that in 1629, in the company of Poussin, Claude, Duqesnoy, and Pietro da Cortona, he saw one of Titian's bacchanals in the Palazzo Aldobrandini in Rome.[34] During the later 1620s Poussin consulted these Titian paintings regularly. As a result, his own art became imbued with Titian's colorism and pictorial rhythms. As Friedlander indicates, Poussin's interest in Titian during the late 1620s was filtered by his equally profound debt to Roman antiquity and to the classicizing tradition of the Carracci.[35] Moreover, Titian's influence on Poussin was largely restricted to his pagan mythologies (fig. 8) rather than the religious subjects. This is not to say that Poussin did not admire Titian's great altarpieces in the Frari Church or Paolo Veronese's many religious and allegorical subjects that he would have seen in Venice, but that his own religious art, such as *The Martyrdom of Saint Erasmus,* from the end of the 1620s, reveals the degree to which this impulse had been tempered by Poussin's own classicizing strain.

At the end of his career Poussin developed a style that, although far removed from Titian's late, mysteriously expressive painting technique, emits a comparable breadth of vision and a strong stoical sense of the inevitable undercurrent of tragic potential that inexorably alters human affairs. The profundity of his vision echoed that of Titian and, like the aged Venetian master's works, Poussin's late paintings are executed in a broad, evocative manner.

Diego Velázquez (1599–1660), after his move from Seville to Madrid in 1623 to become court painter to King Philip IV, abandoned his crisp, Caravaggesque *tenebroso* style for one which, as it evolved, would embody the very essence of painterly virtuosity. El Greco, one sustained source of inspiration for Velázquez, had trained in Venice, and his dynamic, expressive brushwork derived from such Venetian painters as Titian, Jacopo Bassano, and Tintoretto.[36] Velázquez's quantum stylistic shift was due in large measure to his response to the celebrated Venetian paintings and, above all, to Titian's works in the Spanish royal collection. Today, after so much of the collection has been lost in fires, scattered and partly dispersed, and suffering damage owing to the course of time, it is hard to imagine the incomparable range of Venetian masterpieces available to the young Velázquez. His interest in such paintings would have been reinforced by Rubens. While in Madrid in 1628–29 Rubens befriended Velázquez, and the two artists had ample opportunity to discuss the world of painting in front of renowned works in the royal collection. Rubens would have imparted his own deeply held response to the great works of Titian in Madrid, many of which he copied during his visit.

Velázquez's strict sense of discipline enabled him to assimilate the painterly fluency of his Venetian antecedents and transform this experience into a painting technique that truly rivaled the virtuosity and evocative visual perception of Titian. Like Titian in his later work, Velázquez explored in his paintings the realm stretching far beyond the descriptive to the suggestive. The vast majority of his commissions were for portraits, and the formality of these paintings conveys a proper sense of dignity. Despite conforming to the conventions of aristocratic portraiture, Velázquez's likenesses also manifest the painter's probing investigation into the elusive nature of visual appearance. His means of recording the play of light on fabrics and its role in defining the ambiance enveloping his sitters become the ultimate mediation between subject and viewer and vest his sitters with an uncanny presence. Velázquez's allegorical subjects are few, but the greatest of these, *The Spinners* (fig. 9) of about 1657 in the

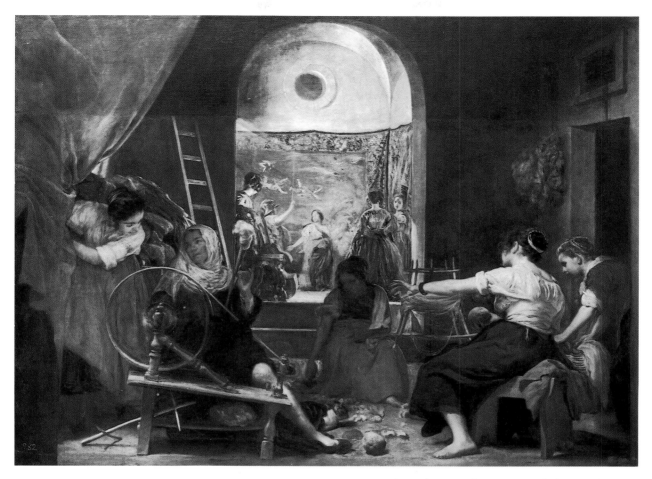

FIG. 9. Diego Velázquez, *The Spinners*. Madrid, Museo del Prado.

Prado, contains an eloquent reference to his primary source of inspiration: the tapestry that Velázquez represents in the background of this painting is a copy of Titian's *Rape of Europa,* one of the celebrated *poesie* that Titian painted for Philip II.

Rembrandt (1606–1669) had the least access to Titian. Nonetheless, celebrated Italian Renaissance paintings passed through the art trade in Amsterdam. In the late 1630s, at a critical moment in his career, Rembrandt had the opportunity to see two such works, Raphael's *Portrait of Balthassare Castiglione,* now in the Louvre, and Titian's so-called *Ariosto,* now in London.[37] His response to these two portraits is found in his etched *Self-Portrait* (B. 21) of 1639 and his painted *Self-Portrait at the Age of 34* in London.[38]

Rembrandt's style in his final years evolved into one of extraordinary painterly complexity (fig. 10) that expressed an inexhaustible depth of meaning. In its mysterious sfumato and broken brushwork Rembrandt's late style parallels that of Titian. In a remarkable confluence of two great painterly traditions, the world of the aged Titian and Rembrandt almost seem to join together across time. This union of styles served to perpetuate the expressive potential of colorism while articulating deeply profound ideas through the very process of painting at its most mysterious and personal.

The five Baroque painters discussed above and their sources of contact with the Venetian painters of the cinquecento—namely the great royal and princely collections assembled

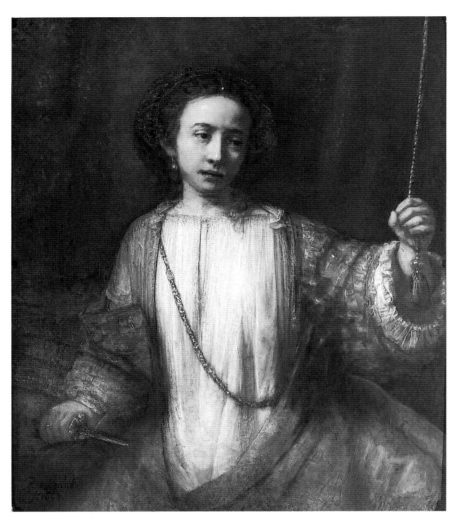

FIG. 10. Rembrandt, *The Suicide of Lucretia.* The Minneapolis Institute of Arts.

outside Italy—lead in two directions. The first brings us to Klára Garas's discussion of the history of collecting Venetian paintings in central Europe, which explains the relationship of this phenomenon to the wider collecting activities of monarchs, princes, and prelates through-out Europe in the course of the later sixteenth and seventeenth centuries. The second direc-tion involves the manner by which Venetian colorism was incorporated into the art-historical theories that would shape the academic perception of artistic tradition. Philip Sohm discusses how theorists wrestled with the phenomenon of Venetian colorism as it was first formulated, adopting the cinquecento as a paradigm. In its wake, stylistic changes in seventeenth-century Venetian painting required vision and revisionism on the part of theorists in order to assimi-late the Venetian seicento into a larger theoretical framework. This process was hastened by the determination of so many great painters of the seventeenth century to familiarize them-selves with Venetian colorism and incorporate it into a style that would become their own.

NOTES

1. Titian executed only three of the four pictures for Mary of Hungary, and the entire series was transferred to Madrid before 1566. For further discussion of this cycle see Venice, Palazzo Ducale–Washington, National Gallery of Art, *Titian: Prince of Painters*, 1990–91, p. 284, cat. no. 44.

2. For further discussion of this relationship see C. Hope, in Venice–Washington 1990–91, pp. 81–82, 84.

3. For a full discussion of this corpus see Washington, National Gallery of Art, *Titian and the Venetian Woodcut*, 1976–77, cat. by D. Rosand and M. Muraro.

4. C. Bierens de Haan, *Cornelis Cort: Graveur hollandais* (The Hague, 1948).

5. Washington 1976–77, pp. 22–23.

6. Bierens de Haan 1948, pp. 9, 229–230.

7. Ibid., p. 9.

8. Now in the Rijksprentenkabinet, Amsterdam; see K. G. Boon, *Netherlandish Drawings of the Fifteenth and Sixteenth Centuries in the Rijksmuseum*, 2 vols. (The Hague, 1978), cat. no. 26, repr.; J. R. Judson, *Dirck Barendsz.* (Amsterdam, 1970), cat. no. 61, fig. 29. Hendrick Goltzius produced an engraving after this drawing in 1584 (Hollstein, Goltzius, no. 292).

9. Hollstein, J. Sadeler I, cat. nos. 264–265; Judson 1970, cat. nos. 72, 71, figs. 41, 42. Barendsz.'s original drawing for *Sinful Mankind before the Last Judgment*, dated 1581, is in the Victoria and Albert Museum, London; see Judson 1970, cat. no. 57, fig. 27.

10. P. Marini, in Fort Worth, Kimbell Art Museum, *Jacopo Bassano*, 1993, pp. 32–33, 36–38, stresses the importance of the Sadeler family's reproductive engravings after the inventions of Jacopo Bassano and further notes that Karel van Mander, in his *Schilder-Boeck*, published in 1604 but with the Italian sections compiled about 1576, also underscored the importance of these Sadeler prints after Jacopo Bassano and perceived this phenomenon as symptomatic of the dynamics of the art market during the later sixteenth century. Reproductive prints after Jacopo Bassano were recently the subject of an exhibition organized by E. Pan, Bassano del Grappa, Museo Civico, *Jacopo Bassano e l'incisione: La fortuna dell'arte bassanesca nella grafica di riproduzione dal XVI al XIX secolo*, 1992.

11. This group also included Jodocus van Winghe, Crispijn van den Broeck, Hans Speckaert, Gillis Mostaert, Marcus Geeraerts, Dirck Barendsz., Hans Bol, Paul Bril, and Jan Bruegel the Elder.

12. T. Gerszi, "The Draughtsmanship of Lodewijk Toeput," *Master Drawings* 30 (1992): 367–395. A particularly fine, unpublished drawing in the Baltimore Museum of Art, *A Panoramic Landscape*, inv. L39.459, in pen, brown ink, and wash, typifies Toeput's concept of landscape. This drawing was first correctly identified by Joaneath Spicer.

13. I. Jost, "Drei unerkannte Rottenhammerzeichnungen in den Uffizien," *Album Discipulorum Professor Dr. J. G. van Gelder* (Utrecht, 1963), pp. 67–78.

14. T. DaCosta Kaufmann in Washington, National Gallery of Art–Princeton, Princeton Art Museum, *Drawings from the Holy Roman Empire, 1540–1680*, 1982, p. 98.

15. Ibid.

16. M. Leesberg, "Karel van Mander as a Painter," *Simiolus* 22 (1993–94): 14–15.

17. In particular his engraving *The Wedding Feast of Cupid and Psyche* of 1587 (Hollstein 322), repr. in Amsterdam, Rijksmuseum, *Dawn of the Golden Age*, 1993, pp. 330–331, cat. no. 2.

18. E. K. J. Reznicek, *Die Zeichnungen von Hendrick Goltzius* (Utrecht, 1961), pp. 6, 83, 369, cat. no. 287, pl. 140. As N. Bialler notes in Amsterdam, Rijksmuseum–The Cleveland Museum of Art, *Chiaroscuro Woodcuts: Hendrick Goltzius and His Time*, 1992–93,

p. 155, Dirck de Vries possessed a distinguished collection of Venetian woodcuts.

19. Reznicek 1961, p. 365, cat. no. 281, pl. 202.

20. Reznicek 1961, p. 109; Bialler, in Amsterdam–Cleveland 1992–93, p. 173. Moreover, Bialler stresses the degree to which Goltzius's *Four Small Landscapes* (B. 242–245) are inspired by Venetian antecedents deriving from Titian.

21. Reznicek 1961, cat. nos. 397, 402, 410.

22. P. Sutton in Boston, Museum of Fine Arts–The Toledo Museum of Art, *The Age of Rubens*, 1993–94, p. 25.

23. For discussion of Rubens as a collector, see J. M. Muller, *Rubens: The Artist as Collector* (Princeton, 1989).

24. Sutton, in Boston–Toledo 1993–94 pp. 27, 40; Stockholm, Nationalmuseum, *Bacchanales by Titian and Rubens*, 1987, ed. G. Cavalli-Bjorkman.

25. For recent discussion of the young Van Dyck's relationship to Rubens see S. J. Barnes in Washington, National Gallery of Art, *Anthony van Dyck*, 1990–91, p. 19.

26. The nature of this material may be reflected in certain folios of the so-called *Antwerp Sketchbook*, which records certain now lost compositions of Titian. This sketchbook was reproduced in facsimile by M. Jaffé, *Van Dyck's Antwerp Sketchbook*, 2 vols. (London, 1966). For the most recent discussion of the attribution of this sketchbook see C. Brown in New York, The Pierpont Morgan Library–Fort Worth, Kimbell Art Museum, *The Drawings of Anthony van Dyck*, 1991, pp. 38–47, cat. no. 1. For the impact of Rubens's collection on Van Dyck see Barnes, in Washington 1990–91, p. 22.

27. C. Brown, *Van Dyck* (Ithaca, 1983), pp. 52–53, 56–57; C. Brown, in Washington 1990–91, p. 40.

28. For discussion of the *Italian Sketchbook* see Brown 1983, pp. 62–70, 76–77; and idem in New York–Fort Worth 1991, pp. 29–32, 170.

29. For discussion of the Roman history of these Ferrarese *poesie* see H. E. Wethey, *The Paintings of Titian*, vol. 3, *The Mythological and Historical Paintings* (London, 1975), p. 147.

30. Brown 1983, p. 131; and J. Wood, "Van Dyck's *Cabinet de Titien*: The Contents and Dispersal of His Collection," *Burlington Magazine* 132 (1990): 680–695.

31. Brown 1983, p. 137.

32. Washington 1990–91, cat. no. 85; Brown 1983, pp. 186–187, pl. 187, dates the picture to about 1638.

33. For the whereabouts of these paintings during the seventeenth century see Wethey 1975, vol. 3, pp. 143–150.

34. W. Friedlander, *Nicolas Poussin: A New Approach* (New York, 1975), p. 25; K. Oberhuber in Fort Worth, Kimbell Art Museum, *Poussin: The Early Years in Rome*, 1988, p. 37.

35. Friedlander 1975, pp. 26–27.

36. J. Lassaigne, *Spanish Painting from Velazquez to Picasso* (Lausanne, 1952), pp. 53–54.

37. These portraits by Raphael and Titian were in the collection of the Amsterdam merchant Alfonso López. Rembrandt produced his remarkable pen sketch, now in the Albertina in Vienna, after the Raphael portrait when it was auctioned in Amsterdam in 1639; see P. van Thiel in Berlin, Altes Museum–Amsterdam, Rijksmuseum–London, National Gallery, *Rembrandt: The Master and His Workshop*, 1991–92, pp. 218–221.

38. Van Thiel in Berlin–Amsterdam–London 1991–92, pp. 218–221, cat. no. 32. The connection with Raphael has been repeatedly stressed in the literature on Rembrandt. E. de Jongh, "The Spur of Wit: Rembrandt's Response to an Italian Challenge," *Delta: A Review of Arts, Life and Thought in the Netherlands* 12 (1969): 49–67, calls much closer attention to Rembrandt's response to Titian's so-called *Ariosto*.

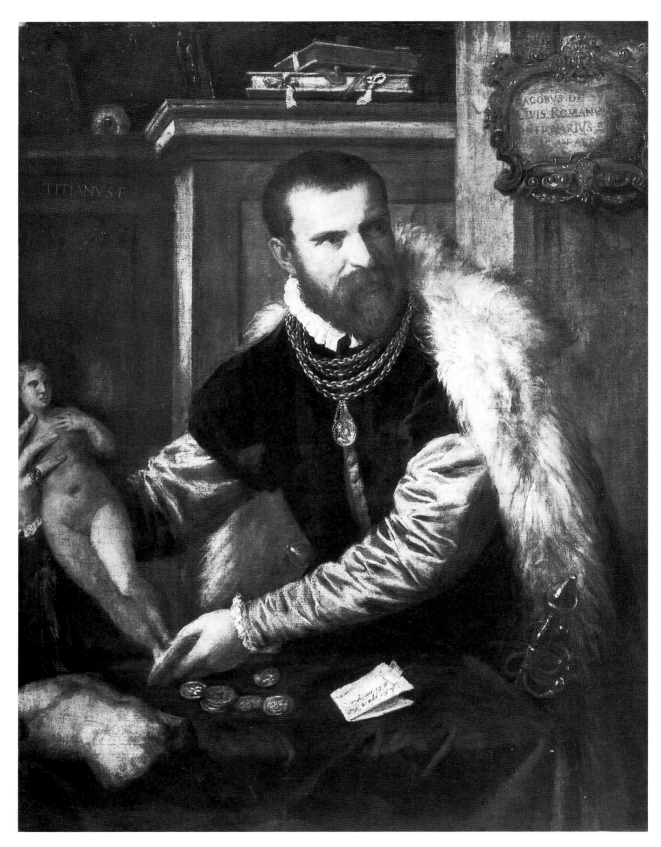

FIG. 1. Titian, *Portrait of Jacopo Strada*. Vienna, Kunsthistorisches Museum.

Collecting Venetian Painting
in Central Europe

KLÁRA GARAS

THE PRESENT SHORT SURVEY can provide only a glimpse into the role that Venetian painting played in Central Europe and the story of its being collected there. I shall concentrate on the decisive general factors as well as the origins and distinctive characteristics of some important collections, especially that of the Museum of Fine Arts in Budapest. This subject is extremely complex and multifaceted; the dynastic activities centered in specific territories in this part of Europe and the activities of other collectors are closely interlinked. Collecting often emerged hand in glove with commissioning and patronizing the arts. In the past the interest in Venetian painting was hardly distinguished from the more general appreciation of Italian painting; the choice of and preference for individual styles and schools were rare. Exact surveys are all the more difficult to make as the sources at our disposal are usually incomplete and random. Certain documentation has only recently come to light,[1] and indeed, a comprehensive study of the collecting of Italian art in Central Europe has yet to be undertaken.

The early sixteenth century marks the first time that Venetian paintings appear in the north. They were the result of clearly defined commissions, generated through direct contact between artist and patron. The Habsburg emperors of Central Europe were among the most important patrons of the Venetian masters, exemplified by the link between Charles V and Titian or the commissions given by Maximilian II. The most celebrated painters of the Venetian school—Titian, Tintoretto, Veronese, and Paris Bordone—worked for both the Habsburgs and the Bavarian ruling family, the Wittelsbachs. As a consequence, several Venetian painters actually made the trip across the Alps when invited by one prince or another. Individual taste was an important factor in forging the connection between artist and patron. The commissioner ordered definite works, determining the subject and the nature and scope of the painter's task. Such a pattern of patronage had a decisive influence on both the genesis of specific works and the development of collections.

Besides providing personal commissions and direct employment for painters, there are also quite early examples of real collecting, the conscious, occasional purchasing of paintings, a practice that later became widespread. The act of acquiring pictures, through either commission or purchase, was motivated by three primary considerations: the enhancement of prestige, power, and wealth; the accumulation of objects of value; and, last but not least, the cultivation and love of the arts.[2]

These factors soon coalesced into a well-established pattern. Because the personal experience and knowledge of the potentially interested patrons and collectors were usually rather limited, their purchases and commissions were generally left in the hands of suitable agents and middlemen, whose participation has been documented as early as the sixteenth century.

Diplomats and ambassadors were often assigned to act on certain occasions, or qualified, invited representatives, themselves collectors, dealers, or even artists, acted as agents and experts. The activity of ambassadors and consuls obviously represented specific dynastic interests, while professional agents maintained contacts with various patrons. During the final third of the sixteenth century, Niccolò Stoppio and the even more famous antiquarian Jacopo Strada (fig. 1), active in Venice, acquired works of art or made purchase offers on behalf of royal and princely patrons. These included the Habsburg emperors, such as Maximilian II and Rudolph II, the Wittelsbachs of Bavaria, such as Albrecht V or the great bankers of Augsburg, the Fuggers.[3] Political and commercial considerations played an important role in establishing and shaping collections in Central Europe. The export of art from Italy most often led from Venice through the usual trade routes across the Alps, north to Bavaria, Augsburg, and Austria. Bavarian princes such as Albrecht V and the elector, Maximilian I, maintained close ties to Venice, importing artists and objects, pictures and antiquities to the newly established Residenz, the palace of the Wittelsbachs in Munich, and inviting Venetian artists to their court.[4] Mainly through the ambitions of the Fuggers and other banking and merchant families like the Pellers, the Stainingers, and others, the city of Augsburg in southern Bavaria became one of the earliest and most significant centers of collecting Venetian art.[5]

Every characteristic feature of patronage and collecting is embodied in one of the most outstanding collectors of the period and perhaps of all time, Habsburg emperor Rudolph II. On the basis of surviving documents and inventories, we know a great deal about this ruler's insatiable collecting activity and his famous *Kunst- und Wunderkammer* located in the castle at Prague.[6] We can only briefly mention the role that Venetian painting played in this collection and the emperor's personal contacts with Venetian artists and that city's art trade. As we know, Emperor Rudolph II collected everything valuable, famous, or exotic; in painting he paid special attention to such German and Netherlandish masters as Albrecht Dürer, Pieter Bruegel the Elder, and Hieronymus Bosch. He was attracted by erotic subjects, representations of nude figures, and mythological and allegorical themes. His ideas and preferences were well met by Venetian masters of the cinquecento; Rudolph's gallery boasted numerous paintings by Titian, Veronese, Tintoretto, Palma, and others. These pictures were inherited from his predecessors or commissioned directly from the painters. Rudolph II received many fine works from Italian princes as presents but also had his agents scour Europe to acquire what was available.[7]

Of the more than three thousand paintings accumulated by Rudolph II, about seventy in his posthumous inventory of 1621 can be identified by name as Venetian. There were a number of masterpieces among them, but the collection also included many replicas and copies. Following his death in 1612, certain parts of Rudolph II's collection were distributed among his heirs and found their way to Vienna and Brussels. However, the majority remained in Prague Castle until 1648 when, at the very end of the Thirty Years War, the Swedish army captured the city. They plundered Prague of its rich collections and carried them off to Stockholm as war booty. As property of the Swedish crown, this booty subsequently became the personal property of Queen Christina, daughter of Gustavus Adolphus. When she converted to Roman Catholicism and abdicated, Christina moved to Rome and took many of these art treasures with her. Following her death, much of the queen's collection was dispersed. Certain of the most famous pictures once in her collection, including notable Venetian works, were subsequently acquired by the duke of Orleans. The pictures were housed in

his celebrated gallery in his Paris residence, where they remained until the late eighteenth century. His collection was dispersed at a series of auctions held in England during the French Revolution.

Despite suffering the loss of Rudolph II's collection, the Habsburgs' collections continued to grow throughout the seventeenth century. A spectacular number of Venetian paintings were added to the imperial holdings, despite a decline in direct patronage. Venetian painting of the seventeenth century failed to match the artistic importance of the masters of the Venetian Golden Age; contemporary commissions fulfilled mainly practical tasks, such as history paintings or portraits. For example, Pietro Liberi visited Vienna and Hungary in 1658–59 on the occasion of Emperor Leopold I's coronation, and Sebastiano Bombelli of Friuli painted a wide range of court portraits in Vienna.

The bulk of the Venetian masterpieces came into Habsburg possession as part of an exceptionally valuable collection, that of Archduke Leopold Wilhelm (1614–1660). Although the archduke occasionally employed contemporary artists or bought pictures from them, his chief interest lay in acquiring old-master paintings, which he collected with the flair of a connoisseur, involving expertise, passion, and refined taste. Archduke Leopold Wilhelm benefited from particularly favorable circumstances as a collector while he lived in Brussels when serving as governor of the Spanish Netherlands (1647–56).

During this period unique historical circumstances resulted in the liquidation of many of Europe's most distinguished art collections. At this time the splendid collection of the recently executed king, Charles I of England, and those of the dukes of Hamilton and Buckingham and that of the earl of Arundel were auctioned and dispersed in England and the Low Countries. Leopold Wilhelm took the opportunity to buy up Hamilton's collection en bloc. The Hamilton Collection was especially rich in Venetian pictures. Moreover, the circumstances of its formation are well documented.[8] As was often the case, critical middlemen helped shape the Hamilton Collection. Sir Basil Feilding, the duke's brother-in-law, served as England's ambassador to Venice. In 1637, acting on behalf of his brother-in-law, Feilding managed to buy one of the most outstanding galleries in Venice, Bartolommeo della Nave's collection of mostly Venetian masterpieces, as well as the Priuli-Venier bequest containing authentic works by Titian and Giorgione.

As a collector, the duke of Hamilton emulated Charles I, who had also expressed interest in acquiring della Nave's gallery. The Venetian paintings of the king's incomparably rich collection had come in part from the collections of the dukes of Gonzaga in Mantua, which Charles purchased in 1627. Like Hamilton, the king did not long enjoy his treasures. Following his defeat, Charles I was condemned to death by Parliament and was beheaded in 1649. In the following years his collections were auctioned, and Archduke Leopold Wilhelm bought many of the paintings, among them a number of Venetian masterpieces, for both his own collection and that of the Habsburg emperor.

Once again Archduke Leopold Wilhelm proved to be the most important buyer at the sale of the collection of George Villiers, first duke of Buckingham, the favorite of King Charles I. Buckingham's collection was smuggled out of England in 1648 and dispersed at auction in Antwerp. Through the untiring efforts of his agent, Balthasar Gerbier, and various ambassadors in Venice, Buckingham had acquired a large number of notable Italian pictures before his assassination in 1628. The Buckingham inventory, drawn up in 1648, includes nineteen paintings by Titian, thirteen by Veronese, seventeen by Tintoretto, and

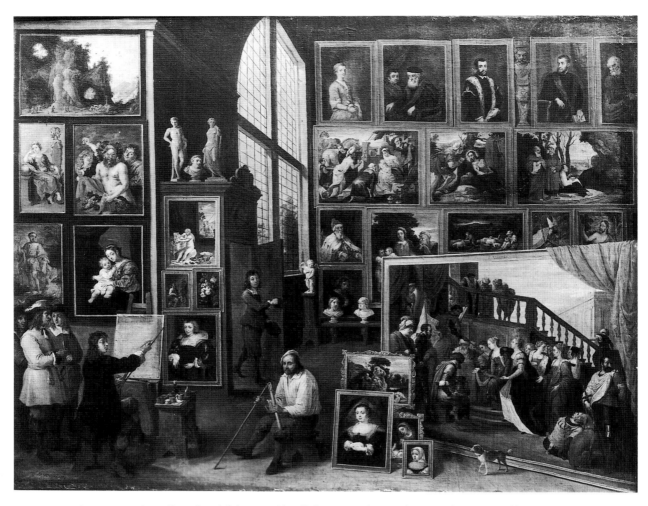

FIG. 2. David Teniers II, *The Gallery of Archduke Leopold Wilhelm in Brussels.* Munich, Bayerische Staatsgemäldesammlungen, Alte Pinakothek.

eight by Palma Vecchio. A considerable number of these pictures, consisting of about sixty items, were bought by Archduke Leopold Wilhelm for his brother, the Habsburg emperor, Ferdinand III, to make up for the losses sustained by the imperial collection in Prague following its plunder by the Swedes from the imperial residence in 1648.[9]

Finally, the Habsburgs displayed considerable interest in another world-famous English collection, that of Thomas Howard, earl of Arundel, who died in 1642. His collection was put up at auction around 1653. A large number of the paintings auctioned in the Netherlands were acquired by the brothers Imstenraed of Cologne, who offered them to Emperor Leopold I in Vienna, in 1660. After the negotiations failed, the pictures came into the possession of Karl von Liechtenstein, archbishop of Olmütz, and have remained in Central Europe, now partly in the National Gallery in Prague and in the galleries of Olomouc and Kroměříž.[10]

These historic English collections included perhaps the most beautiful and valuable Venetian paintings of all time; their royal and princely owners did not hesitate to exert considerable political influence or to spend large sums of money to secure the best works, and they paid special attention to those of the famous Venetian masters. Choice segments of these dispersed collections were acquired by the Habsburgs by the mid-seventeenth century. Their

acquisitions comprised a spectacular group of Venetian paintings of such extraordinary importance that it became the cornerstone of a great imperial art collection in Central Europe. To this day these pictures represent a comprehensive survey of the Golden Age of Venetian painting in superlative examples by the greatest masters of the Venetian school. The bulk of this material derived from Archduke Leopold Wilhelm's gallery in Brussels, which housed his paintings, including the many acquisitions from the dispersed English collections. After he retired as governor of the Spanish Netherlands in 1656, Leopold Wilhelm moved back to Vienna with his collection, which was housed in the Stallburg.

In accordance with his last will and testament, following his death, Leopold Wilhelm's art collection became the property of Emperor Leopold I and thereby became part of the imperial Habsburg collection. The Flemish genre painter David Teniers II served as Archduke Leopold Wilhelm's curator and painted several views of the archduke's gallery in Brussels (fig. 2), which provide unique documentation about this collection. Teniers also produced a series of engravings after selected pictures owned by Leopold Wilhelm, published under the title *Theatrum pictorium,* in 1659. Together with the Vienna inventory, also drawn up in 1659, these engravings show the gallery's range of material and the hundreds of Venetian paintings there.

The Venetians themselves were also aware of the importance and value of Leopold Wilhelm's collection. In his famous work *Carta del navegar pitoresco* of 1660, the Venetian painter and critic Marco Boschini eulogized the gallery. Boschini based his information on the account written by the Venetian painter Pietro Liberi during his sojourn in Vienna.[11] After its merger with the imperial collection, it was first housed at the Stallburg in Vienna and subsequently, in 1772, in the Belvedere. Part of it was transferred to imperial residences in Hungary, at Pozsony (now Bratislava in Slovakia), and in Buda, and many works from this collection were scattered and lost over time. Yet the core of this wonderful collection is still preserved in the Kunsthistorisches Museum in Vienna and includes among other celebrated paintings Giovanni Bellini's *Young Woman Holding a Mirror* (fig. 3); Antonello da Messina's fragmentary *San Cassiano Altarpiece;* Giorgione's *Laura, The Three Philosophers* (fig. 4),

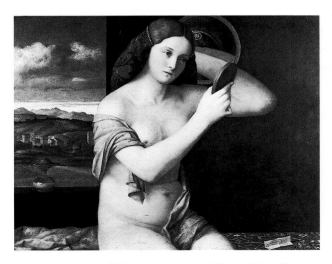

FIG. 3. Giovanni Bellini, *Young Woman Holding a Mirror.* Vienna, Kunsthistorisches Museum.

FIG. 4. Giorgione, *The Three Philosophers.* Vienna, Kunsthistorisches Museum.

FIG. 5. Titian, *The Bravo*. Vienna, Kunsthistorisches Museum.

and *Adoration of the Shepherds;* Titian's celebrated representations of the Madonna, his portraits of Benedetto Varchi and Jacopo Strada (see fig. 1), and *The Bravo* (fig. 5); Palma Vecchio's female half-lengths; Paris Bordone's *Allegories;* and splendid examples by Tintoretto, Veronese, and the Bassanos, to mention only the most significant masters.

A number of the Venetian paintings now in the collection of the Museum of Fine Arts in Budapest were once in the imperial collection and went to Budapest in the course of time from the castles of Pozsony and Buda. Certain of these, including Palma Vecchio's *Betrothed Couple,* Lorenzo Lotto's *Sleeping Apollo and the Muses* (cat. no. 29), Giorgione's small *Self-Portrait* (fig. 6), and others were also once in Leopold Wilhelm's collection. The pictures that Archduke Leopold Wilhelm acquired from the Buckingham auction

in 1648 to enrich the depleted imperial gallery in Prague Castle are now scattered among Budapest, Dresden, Prague, and Vienna. Following a series of sales that took place in Prague in 1742/43 and 1749, the dukes of Saxony acquired certain pictures including Jacopo Bassano's *Samson and the Philistines* (fig. 7) and Domenico Fetti's series of biblical parables (fig. 8) for the Dresden gallery. Other identifiable works from Leopold Wilhelm's purchases for Prague include Jacopo Tintoretto's cassone paintings and Veronese's biblical series now in Vienna (fig. 9), and Tintoretto's *Hercules Expelling the Faun from Omphale's Bed* (cat. no. 31), now in Budapest, whereas certain important pictures by Veronese and Jacopo Tintoretto are in the National Gallery in Prague. Remnants of the Arundel Collection include Titian's late masterpiece *Apollo and Marsyas,* Veronese's *Assumption of the Virgin* (fig. 10), and Sebastiano del Piombo's *Madonna,* now found in the galleries in Kremsier (Kroměříž) and Prague.

The examples of princely collecting and the formation of large, imperial and royal collections influenced a growing circle of aspiring collectors. As a result, demand for art increased significantly. "Everyone wishes to procure paintings and drawings in the style of our distinguished painters. . . . Everyone wishes to form a collection of paintings," stated the aforementioned Marco Boschini, indicating that many foreigners were flocking to Venice to acquire pictures. Boschini himself participated in the booming Venetian art business as a middleman.[12] Procedures and rules were established in an attempt to regulate turnover.[13] There was no difficulty in buying or commissioning pictures from living artists, and indeed many foreigners, among them Central Europeans, took this opportunity. For example, Count Humprecht Jan Czernin of Bohemia employed several contemporary artists while serving as imperial ambassador to Venice from 1660 until 1663. In addition, he acquired works for himself and Leopold Wilhelm from Pietro della Vecchia, Bernardo Strozzi (referred to in Venice as Prete Genovese), G. B. Langetti, and others.[14] A fellow Bohemian imperial ambassador, Count Franz Anton Berka, was likewise an active collector of pictures;

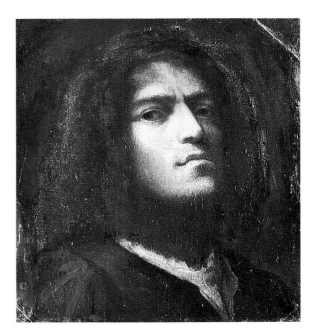

FIG. 6. Giorgione, *Self-Portrait.* Budapest, Museum of Fine Arts.

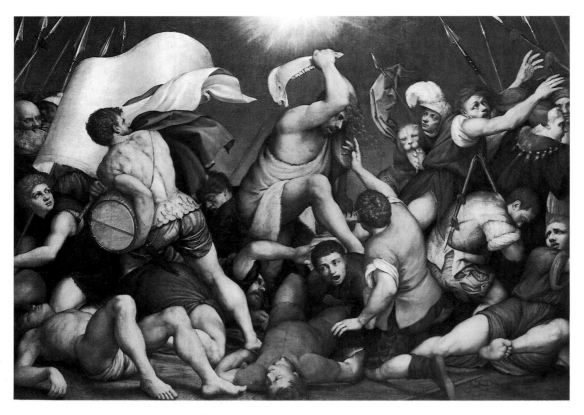

FIG. 7. Jacopo Bassano, *Samson and the Philistines*. Dresden, Staatliche Kunstsammlungen.

his acquisitions subsequently entered Prague's Nostitz Gallery. We may also mention the Hungarian count János Listy in this context, whose collection, including pictures by the Tintorettos and Bassanos, passed to the emperor after Listy's death in Venice in 1679 as payment for his debts.

However, during the second half of the seventeenth century, acquiring old-master paintings in Venice was already a difficult and complicated undertaking. Although the export of famous works preserved in churches, monasteries, and confraternities was prohibited, this law was often circumvented, occasionally involving criminal acts including theft.[15] The incredibly rich stock of paintings in the large family collections housed in the palaces of Venetian patricians remained closed and inaccessible until the city's economic decline. Many masterpieces of Venetian painting belonging to the Grimanis, the Contarinis, the Pisanis, the Vendramins, and the Vidmans were partially dispersed, sold to other Italian or foreign collectors. Carlo Ridolfi was still able to cite 160 picture collections in 1648, whereas by 1660 Marco Boschini lists about 75.[16] By 1663, in their volume on Venice, Sansovino and Martinioni only account for about 25.[17] Correspondingly, prices rose sharply, actually skyrocketing in the case of world-famous masters. Important works by Veronese, for example, could easily fetch 10–15,000 scudi. "For several years now there have been no more good paintings or drawings here and clearly the city has been completely plundered," wrote the art lover Paolo del Sera, summing up the situation in 1664.[18]

Despite the unceasing complaints about the robbing of Venice through the constant export of its art, the exodus of paintings continued unbroken throughout the eighteenth century. The supply of goods was provided by participants of an already well-established art

market. Regular exhibitions, public auctions held at the celebration of the Sensa, the Assumption lotteries, provided a colorful background for the lively art trade in Venice. An army of brokers and registered experts, as well as guidebooks and other publications, offered help in orienting collectors. The passing of time necessarily reduced the supply in relation to the ever-rising demand. The resulting shortage of authentic material encouraged the production of fakes and copies and also led to the production of amateur paintings of little quality, which masqueraded under the names of great masters. Among the multitudinous works offered for sale, buyers arriving from afar could hardly distinguish between worthless material and the genuine article, nor could they fully trust so-called registered expert opinions or the written certifications accompanying pictures.[19]

The surviving documents amply demonstrate the different ways of manipulating the art market, resulting from the productions of forgers, the dissolution of Venetian collections, and the changes in taste. For transalpine collectors and buyers, the eighteenth century saw a shift in focus, with new participants partly replacing more traditional collectors. The predominance of rulers and dynasties in collecting art was decreasing.

The Habsburgs' collecting activities, for instance, assumed a considerably lower key owing to a change in political ties and alliances. The direction of interest displayed by the court in Vienna, as well as by the aristocracy in Austria, Bohemia, and Hungary, moved toward Lombardy and the viceroyalty of Naples, new territories under Austrian Habsburg influence. Prince Eugene of Savoy, as well as the Liechtenstein, Harrach, and Daun families, purchased most of their art in Bologna and Naples rather than in Venice. Simultaneously, their interest in French art was also growing. Their links with Venetian painting mostly

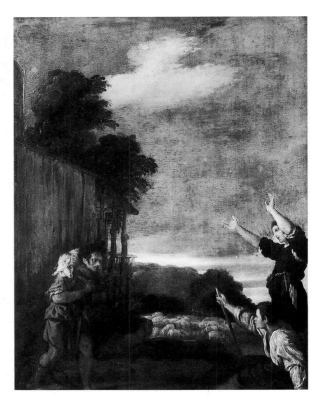

FIG. 8. Domenico Fetti, *The Parable of the Lost Sheep.* Dresden, Staatliche Kunstsammlungen.

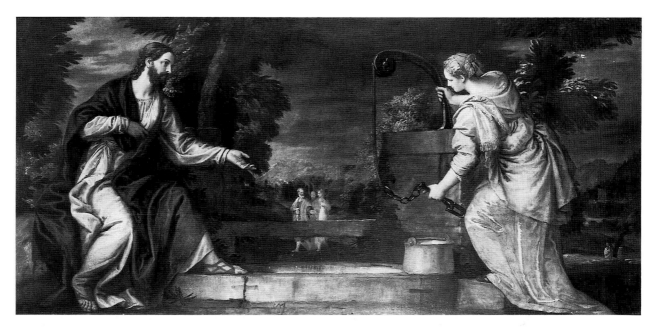

FIG. 9. Paolo Veronese, *Christ and the Woman of Samaria*. Vienna, Kunsthistorisches Museum.

involved the decoration of their palaces and castles. Such tasks occupied Antonio Bellucci who, from the turn of the century, worked for a long period in Vienna; Sebastiano Ricci, who undertook decorative work in the imperial palace at Schönbrunn; and Giovanni Antonio Pellegrini. These undisputed virtuosi of monumental painting were popular throughout Germany and elsewhere in Central Europe. A special branch of Venetian painting, namely fresco decoration, was represented by Jacopo Amigoni, Pellegrini, and Gaspare Diziani in Munich; Pellegrini, Diziani, and G. B. Grone in Dresden; and Giovanni Battista Tiepolo in Würzburg.[20] During the second half of the eighteenth century the northern market employed progressively fewer Italian fresco painters. By contrast, artists visiting from Venice such as Rosalba Carriera, who produced portrait likenesses, or Bernardo Bellotto, noted for his *veduta* paintings, were active in Vienna, Dresden, and Munich.

The success of globe-trotting Venetian fresco painters undoubtedly added to the fame of the Venetian school, yet they failed to become the primary focus of collectors' interest. The old and newly established galleries and the taste of decisive personalities mostly stayed with well-established conventional taste. The most significant new collection in the first half of the eighteenth century was created by the counts Schönborn in Vienna and southern Germany. A wide range of documents informs us about the huge architectural projects and picture purchases of Lothar Franz von Schönborn (1655–1729), bishop of Bamberg and elector of Mainz.[21] Letters and inventories supply us with an accurate picture of his connections with the art market and his pursuit of material for his collection. Despite his passion for art, Lothar Franz von Schönborn was careful and cautious. In his own words, he preferred to have pictures made by the modern painters: "As for purchasing works by the old masters, one becomes too deeply involved and is ordinarily duped." Of the contemporary Venetian masters, he preferred employing the history painters of the early eighteenth century: Gregorio Lazzarini, Antonio Bellucci, and Antonio Balestra. In securing works by the old masters, what principally interested him was "an original work from a famous and excellent master,

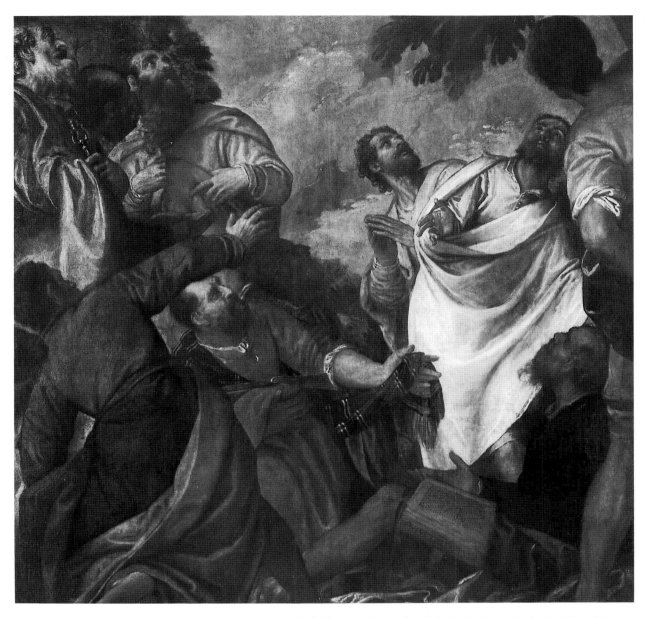

FIG. 10. Paolo Veronese, *Assumption of the Virgin*. Prague, National Gallery of Prague.

rare but worth the money." To certify authenticity, he sought and acquired expert opinion in Vienna through his brother, the vice chancellor Karl Friedrich von Schönborn, another ac⁄complished collector, or sent the picture in question directly to Venice to have it examined by the academy there. Lothar Franz von Schönborn had a new gallery built in his palace at Pommersfelden to house his treasures and had a catalogue of them printed in 1719.[22] This princely collection still exists in situ at Pommersfelden in galleries within the palace, recently refurbished to their original splendor.

The most significant new Venetian collection of the period was created in Dresden. Under the reign of Frederick Augustus, "the Strong" (1670–1733), and his successor, Augustus III, both electors of Saxony and kings of Poland, the relatively modest, traditional Saxon *Wunderkammer* was transformed into one of Europe's richest picture galleries, and

remains so to this day. By acquiring one hundred masterpieces from the ducal galleries of the d'Este family in Modena (fig. 11), by purchasing pictures from the castle in Prague, and by their generally untiring efforts, the dukes of Saxony managed to assemble an exquisite Italian picture collection. Their excellent advisors, especially the Venetian connoisseur and patron Count Francesco Algarotti (1712–1764), assured a special emphasis on the collecting and displaying of Venetian painting. Algarotti elaborated a detailed plan for establishing the gallery and, according to his program, submitted in writing, he commissioned the outstanding Venetian painters of the period—Amigoni, Piazzetta, Pittoni, Tiepolo, and Zuccarelli—to produce specific works for the Saxon collection. Algarotti selected themes best suited to the artists' individual talents and paid considerable fees in the name of the Saxon dukes for paintings of predetermined subject and size. Furthermore, Algarotti initiated grand purchasing campaigns and succeeded in acquiring twenty-one paintings for the Dresden gallery, including such famous works as *The Three Sisters* (fig. 12) by Palma Vecchio, *Europa* by Paolo Veronese, and the two *Sacrifices* by Sebastiano Ricci (fig. 13), from the famous Venetian collections of the Cornaro, Dolfin, and Giovanelli palaces.[23]

In forming the Dresden gallery, Algarotti was already practicing policies that anticipated the more modern, rational, and scholarly requirements subsequently employed in shaping great art collections. Not only did he emphasize that the great names were not to be admired exclusively and believed that it was not enough for a painting to be from the hand of a famous master, it had to be beautiful, from the master's best period, and in an excellent state

FIG. 11. Paolo Veronese, *The Madonna of the Cucina Family*. Dresden, Staatliche Kunstsammlungen.

of preservation. To assure the work's authenticity, its origin had to be identified and its prove-nance established. In one remarkable instance Algarotti documented the possibility of decep-tion by having a fake Veronese painted so that the king of Poland could see, in his advisor's own words, "that in Italy they pursue the art of imitating old paintings, in the same manner that porcelain is imitated in China."[24]

Algarotti played a decisive role in establishing a pattern for the modern collecting of paintings. He also personally possessed a well-selected ensemble and, to a great extent, popu-larized the collecting of Venetian painting during the eighteenth century. He tried to persuade another of his patrons, King Frederick the Great of Prussia, to collect Venetian masters, but Frederick preferred French painters and remained indifferent to the Venetians.[25] The lack of royal interest in Berlin was partially compensated for by the arrival in Prussia of two highly important Venetian collections. Marshall Johann Mathias Schulenberg's rich gallery, estab-lished in Venice, went to Prussia temporarily, and the collection of selected pictures assembled by the Venetian merchant Sigmund Streit was bequeathed by him to the Graues Kloster in Berlin, where it can still be seen.[26]

Alongside monarchs and nobles, the middle classes of society, including artists, writ-ers, and professionals, grew progressively more interested in collecting. The ways of transact-ing business in the art trade also changed, with new sources and opportunities opening up. Unlike the previous period when whole collections or large segments thereof often changed hands en bloc, a more fragmented wholesale trade evolved, involving a focus on retailing

with a steady turnover and with an increasing number of participants. Collecting also expanded through a phenomenon that we today could best describe as tourism. Young noblemen pursuing their studies went to Italy on the grand tours, and artists throughout Europe also visited Italy, compelled by their desire and need to study the great artistic heritage of antiquity and the Italian Renaissance. Interested lovers of art and wealthy burghers took home large numbers of art works acquired in Italy. Some of the paintings produced at that time, including low-priced small pictures such as *veduta* paintings, landscapes, and imaginary character studies, were made in large numbers, calculated to meet this general demand. These easily marketable, popular Venetian works were taken by intermediaries to the art markets in Austria and Germany. Auctions and exhibitions became more frequent and assumed a more important role in the art market.

A colorful and detailed picture of this booming market in Austria and Germany is left to us by Christian Ludwig von Hagedorn (1712–1780), an outstanding connoisseur and writer of the time. He traveled throughout Central Europe as a diplomat for the house of Saxony and summed up his experiences and opinions in a number of writings on art.[27] Himself a collector, Von Hagedorn developed a special interest in contemporary painters, commissioning works directly from Ádám Mányoki, Josef Orient, August Querfurt, Balthasar Denner, and others. As befitted a burgher's taste, he was fond of the realistic Netherlandish and German masters but was also interested in many trends and schools. He emphasized the importance of expert knowledge and, in connection with collecting old masters, Von Hagedorn indicated the considerable hazards resulting from widespread misrepresentation, cheating, and faking. As an example, he cited the booths of itinerant Italian merchants in German fairs "with paintings, mostly copies or rapidly executed battle subjects, and inconsequential Venetian *vedute* and a series of studies of heads that a certain Fedeli in Venice copied after Piazzetta and Nogari."[28]

FIG. 12. Palma Vecchio, *The Three Sisters*. Dresden, Staatliche Kunstsammlungen.

FIG. 13. Sebastiano Ricci, *Sacrifice at the Temple of Vesta*. Dresden, Staatliche Kunstsammlungen.

Beginning in the last quarter of the eighteenth century, a great historical and social transformation resulted in the victory of new intellectual and artistic trends, changing habits of patronage, sponsoring, and collecting, all clearly reflected in the evolution of taste.[29] Revolution and war destabilized and transformed the European art market. Many treasures of immeasurable value changed hands, having been forcibly removed from their previous owners. Galleries of worldwide fame were dissolved and dispersed through officially sanctioned war booty and widespread looting. Families stripped of power and wealth were forced to give up their art treasures accumulated over the centuries. Furthermore, as a result of the partial dissolution of monastic orders, churches and monasteries were divested of art objects that now appeared on the market in great quantities. The new participants in this market, by having access to an increased number of auction sales and middlemen, formed new collections, which led to the creation of new and significant galleries and museums. During this general upheaval a collecting boom started in Central Europe as well, with Vienna playing an increasingly important role as a center of distribution.[30]

It is against this historical background that we must place the general development of collecting art in Hungary in the eighteenth and nineteenth centuries and specifically as it pertains to Venetian painting. Although art collections existed in Hungary earlier, the difficult international situation during the previous centuries, precipitated by the Ottoman

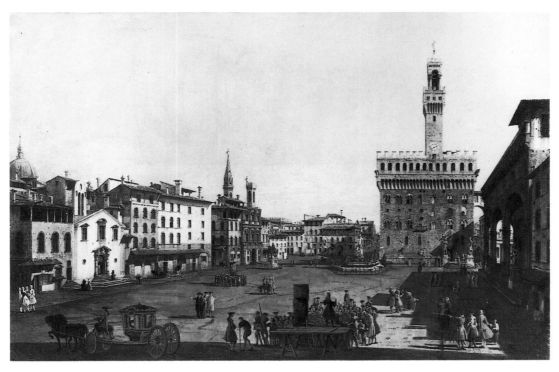

FIG. 14. Bernardo Bellotto, *The Piazza della Signoria in Florence*. Budapest, Museum of Fine Arts.

conquest of the country and its subsequent partitioning into three parts,[31] made the very existence and capacity for survival of art collections rather limited. However, from the late eighteenth century onward an ever-growing number of individuals were able to preserve and maintain, on a truly European level, the ensembles of art objects their families acquired and augmented systematically.[32] A decisive role in this respect was played by the country's richest and most powerful family, the princes Esterházy. The stock of art works accumulated in their palaces at Kismarton (Eisenstadt in Austria) and Eszterháza (Fertöd in Hungary) was transformed into a gallery of international fame by Prince Nicholas Esterházy (1756–1833) through his purchases in Italy, France, and Vienna, which made his collection a treasure trove of Italian, Netherlandish, and Spanish painting. Housed in the Austrian palaces of the Esterházy at Pottendorf and Laxenburg, then at the family's residence in Vienna (see cat. no. 55), the collection finally went to Pest in 1865.

Under pressure from the Hungarian public, the Esterházy Collection was bought by the Hungarian state in 1870.[33] The 637 paintings and immensely valuable store of prints and drawings from the Esterházys became part of the former National Picture Gallery, the predecessor of the Museum of Fine Arts. When this gallery merged with the newly established Museum of Fine Arts, which opened in 1906, the Esterházy Collection became the core of the Hungarian national collection. Within the rich ensemble of sixteenth- through eighteenth-century Italian painting are several famous works by Venetian masters, including Tintoretto's *Supper at Emmaus* (cat. no. 9) and *Christ on the Cross* (cat. no. 10) by Veronese, plus major pictures by Pietro Liberi and Giulio Carpioni (cat. nos. 32, 33), sketches for altarpieces by G. A. Pellegrini (cat. no. 14) and Sebastiano Ricci (cat. no. 23), Bernardo Bellotto's two views of Florence (fig. 14) and Giambattista Tiepolo's large altarpiece, *Saint James the Great Conquering the Moors* (cat. no. 25). We do not know whether Prince Esterházy ever purchased art directly in Venice. The Venetian pictures seem to have

entered the Esterházy gallery as part of the material acquired in other European cities—Naples, Rome, or Vienna.

Other important collections of the Hungarian nobility warrant mention. The galleries of the Apponyi, Viczay, Brunswick, Festetits, and other families contained Venetian paintings of lesser importance. Moreover, these collections were soon broken up and scattered. We must, however, examine in more depth a collection that was Venetian in origin and of outstanding importance as it related to the evolution and growth of Hungarian national collections: the gallery of János László Pyrker (1772–1847), patriarch of Venice and archbishop of Eger in Hungary.[34] In his case, fortunate historical circumstances provided Pyrker the opportunity to establish close Venetian contacts. Following the peace accord made at Campo Formio, Venice came under the authority of the Austrian emperor from 1797 until 1866. Thus the Cistercian abbot János László Pyrker, Hungarian born but an Austrian subject, became patriarch, archbishop of Venice, from 1821 until 1827. This provided him with ample opportunities to satisfy his love of the arts and to create a valuable collection of paintings.

Pyrker acquired certain famous Venetian art works from the dissolved monasteries and churches, from impoverished patrician families, from politician and artist friends like the Marquis Manfredini, a minister of Tuscany, or Antonio Canova, the sculptor. The most important of these were Gentile Bellini's celebrated portrait of Caterina Cornaro (cat. no. 38), G. A. Pordenone's busts of the evangelists (fig. 15), *Portrait of a Youth ("Antonio Broccardo")* (cat. no. 40) attributed to Giorgione, Paolo Veronese's *Allegory of Venice* (cat. no. 51) from an annex of the Palazzo Ducale, G. B. Tiepolo's *The Virgin Immaculata with Six Saints* (cat. no. 26) and *vedute* and landscapes by Giacomo Guardi, Michele Marieschi (cat. no. 54), and Francesco Zuccarelli. After his return to Hungary, Archbishop Pyrker donated his collection in 1836 to the National Museum, for which a new building was started that same year. The ensemble of 110 paintings, including the above-cited plus several more Venetian works, merged with the National Picture Gallery in 1875 and subsequently, along with the Esterházy paintings, became the property of the Museum of Fine Arts in 1906.

The special historical circumstances that led to the creation of Pyrker's gallery in the early nineteenth century determined the collecting of Venetian painting in other ways as well.[35] As part of the Habsburg monarchy, Venice became attached by close family ties to

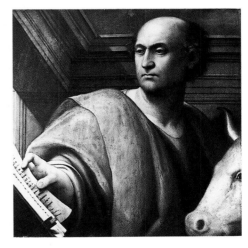

FIG. 15. Giovanni Antonio Pordenone, *Saint Luke the Evangelist*. Budapest, Museum of Fine Arts.

various Austrian and Hungarian noble families who often became proprietors of Venetian palaces and their contents. This is how the counts Szapáry of Hungary became owners of the Morosini-Loredano-Gatterburg bequest, which included a palace with ceiling decorations by Tiepolo, a portrait by Pietro Longhi, and some fine works by Tintoretto, Paolo Fiammingo (fig. 16), and others. In the same manner the Austrian counts Berchtold inherited part of the treasures of the Palazzo Contarini. The contents of the Palazzo Vendramin, including the paintings collection of the duchess of Berry, were transferred to the Austrian property of the Bourbons at Frohsdorf through the count of Chambord, and the list could be continued. The vast majority of these connections have been irretrievably broken through the course of time.[36] Alas, only a fragment of these former collections remains in Central Europe. Yet as these collections were formed, they contributed to the establishment and furthering of contacts while fostering and maintaining interest in Venetian art.

In the nineteenth century the contents of a number of Venetian palaces were auctioned and acquired by new owners, including bankers, merchants, and sometimes artists, resident in both Vienna and Budapest. It is in this context that the splendid series of Tiepolo's history paintings from the Palazzo Dolfin should be mentioned. They were acquired by Miller von Aichholz in Vienna in 1870 and are now divided between the Kunsthistorisches Museum in Vienna and the Hermitage in Saint Petersburg. Francesco Fontebasso's remarkable decorative ensemble of ceiling and wall paintings now in the collection of the Museum of Fine Arts left Venice in similar circumstances. These works were acquired by Count Károlyi and shipped to Hungary from the Palazzo Bernardi (or Bollani) at the end of the nineteenth century. The cycle includes *The Sacrifice of Iphigenia, The Continence of Scipio, Antiochus and Stratonice* (fig. 17), and several allegorical pictures in grisaille. The two masterpieces of otherwise unknown origin by Sebastiano Ricci, *Bathsheba at the Bath* (cat. no. 4) and *Moses Defending the Daughters of Jethro* (cat. no. 5), also now at the Museum of Fine Arts, may have been part of such a decorative ensemble as well. When in a private collection in Budapest they were considered to be by Tiepolo and were putatively accompanied by a ceiling painting which has, unfortunately, since been lost.

The examples provided here demonstrate the considerable broadening of interest in Venetian painting on the part of nineteenth-century collectors in Central Europe. Increasingly, attention all over Europe focused on typical examples of the Venetian settecento which had been purchased only sporadically by earlier collectors. Scholarly precepts and professionalism determined the direction of collecting more than ever before, and the national galleries and museums became decisive factors in this new shift in collecting. The growing number of publications, ranging from scholarly monographs to more popular educational treatises, as well as illustrated periodicals, together with the availability of photographs, created new conditions and methods in the study of art. The efforts made to enlarge and complete Hungarian public collections at the end of the nineteenth century are part of this already modern attitude toward collecting. Károly Pulszky, the ill-fated director of the National Picture Gallery in Budapest, strove consciously and consistently to make up for lacunae in the collection by buying old-master paintings for the museum during his trips to Italy between 1893 and 1895. In one of his memoranda drawn up in 1893, he emphasized that "the National Picture Gallery must strive to become a collection similar to galleries in Berlin and London, where not only every outstanding master is represented by at least a few characteristic works reflecting various aspects of their art, but also where those responsible for installing this material endeavor as much as possible to have the different schools of painting

represented in proportion to their relative importance."[37] With state support, Pulszky strove to fill gaps by purchasing important works by masters hitherto not represented in the collection or by further enriching certain northern Italian schools, including that of Venice. He augmented the existing Venetian material with early works including paintings by Michele Giambono, Marco Basaiti, and Paolo da Venezia, but Pulszky also managed to enrich the Renaissance material with some valuable works by Bonifazio Veronese, Lorenzo Lotto, Girolamo Savoldo, and Giovanni Cariani.

The single most important Venetian painting that Pulszky acquired for the gallery was the *Portrait of a Man* (fig. 18) by Sebastiano del Piombo. This example of Renaissance portraiture bore the traditional attribution to Raphael at the sale of the Scarpa Collection in Milan in 1895, and the sitter was identified as the poet Antonio Tebaldeo. The fact that both contemporary and later professional opinion attributed this painting to Sebastiano del Piombo, a native of Venice who later worked in Rome, had grave consequences on Pulszky's career. Despite the indisputable merits of this celebrated portrait, government officials and members of the public alike accused Pulszky of committing an error of judgment because he lacked sufficient expertise. These allegations and the ensuing attacks forced Pulszky to resign and later immigrate to Australia in 1899, where he subsequently took his own life.[38]

Among the collections involving Venetian painting coming to the National Picture Gallery (and subsequently transferred to the Museum of Fine Arts after its opening in 1906) we mention the gallery of the painter and art critic Zsigmond Ormós.[39] The paintings he purchased in Venice in the 1850s include works by Lorenzo Lotto, Giulio Carpioni, Francesco Fontebasso, G. B. Pittoni, and others. These were donated by their owner partly to the National Museum in Budapest and partly to the Museum Circle, the museum of his native town, Temesvár (Timisoara, then in Hungary, now part of Rumania).

The Venetian picture collection of our European national collection, the Museum of Fine Arts, was considerably enhanced in quality if not in quantity by the bequest in 1912 of 177 pictures belonging to Count János Pálffy. The collection came from the northern Hungarian palaces and castles of this powerful aristocratic family. Although part of the collection was inherited by Count János Pálffy, he acquired many of the paintings on his trips to Italy and Paris during the second half of the nineteenth century. The Venetian masterpieces in the Pálffy bequest to the museum include Marco Basaiti's *Dead Christ* (cat. no. 6), Vittorio Crivelli's *Madonna*, Antonio Vivarini's *Madonna Enthroned*, Tintoretto's *Portrait of Pietro Loredan*, Veronese's *Portrait of a Man* (cat. no. 48) and four *vedute* by Francesco Guardi (fig. 19). Other valuable old-master paintings from the Pálffy Collection, including Venetian works, are preserved in the National Gallery in Bratislava, Slovakia.[40]

Another collector important to the Museum of Fine Arts was György Ráth. The bulk of his collection consisted of antiquities and decorative art objects, yet this exceptional Budapest collector of the nineteenth century purchased valuable sixteenth- and seventeenth-century paintings as well, mostly in Vienna. Following his death in 1905, Ráth's collection became state property under the jurisdiction of the Museum of Applied Arts, of which he was a former director. After 1951 the paintings were permanently transferred to the Museum of Fine Arts. The Venetian school was represented in the former György Ráth Museum by the *Portrait of a Young Woman* (cat. no. 43), an exquisite early work by Sebastiano del Piombo, the *Agostino Nani Portrait* from the studio of Jacopo Tintoretto, *The Annunciation to the Shepherds* by Leandro Bassano, and some works by followers of Giovanni Bellini, among others.

FIG. 16. Paolo Fiammingo, *Jacob and Laban*. Budapest, Museum of Fine Arts.

Paralleling the collections of Pálffy and Ráth, the establishment of a third distin-guished Budapest collection, the Zichy gallery, was also characterized by the collector's wide-ranging interest and the contact that he maintained with the art markets in Vienna and Venice. Count Ödön Zichy created his collection in Vienna at the end of the last century.

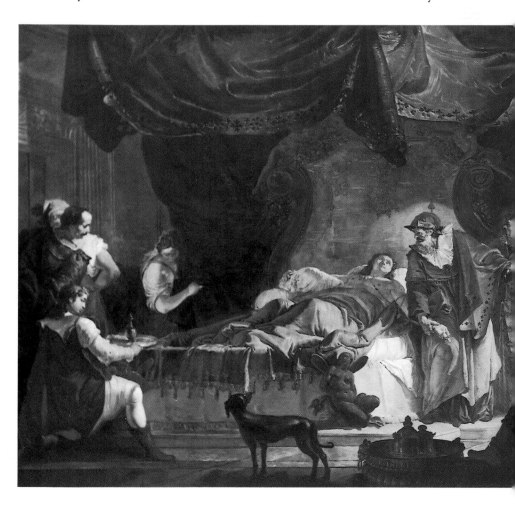

When his successor, Count Jenő Zichy, bequeathed it to the capital city of Budapest in 1906, this collection became the Zichy Municipal Gallery, under the jurisdiction of the city. In 1953 it was merged with that of the Museum of Fine Arts, augmenting the museum's holdings of the Venetian school with important works and filling gaps within the collection. The most significant paintings from this group are male portraits attributed to both Jacopo Bassano and Lorenzo Lotto, as well as some representative seventeenth- and eighteenth-century pictures including notable works by Bernardo Strozzi and Antonio Bellucci.

Supplementing the large collections and bequests that enriched the museum's permanent paintings holdings, museum purchases and the gift of individual works from private hands played an important role in the growth of the museum during the nineteenth and twentieth centuries. Some connoisseurs of exceptional talent, like Marcell von Nemes, a personality well known throughout Europe in his time, were exemplary in enhancing the value of Hungary's public and private collections, even when the economic situation made collecting on a wide scale rather difficult. Raised into the ranks of the nobility, Marcell von Nemes of Jánoshalma joined the international art trade during the first years of this century. Relying on recognized experts and his own discerning taste, he created incredibly rich collections in Budapest and Munich within a short time.[41] Nemes placed great emphasis on outstanding quality and focused his attention on less fashionable but nonetheless important schools and masters. He is well known as one of the pioneering rediscoverers of El Greco.

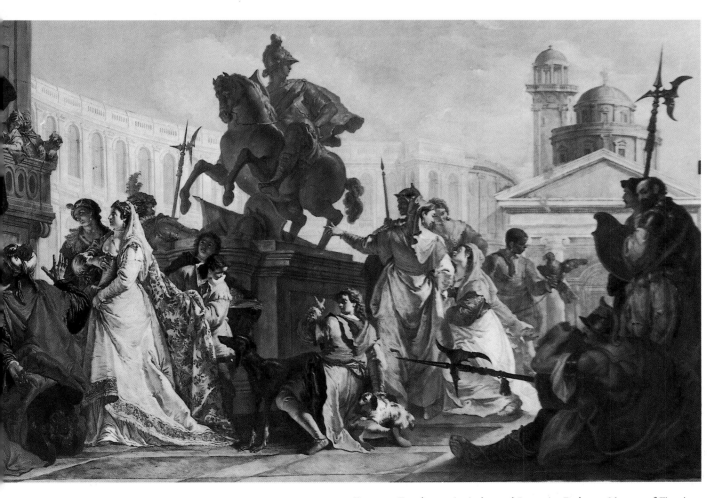

FIG. 17. Francesco Fontebasso, *Antiochus and Stratonice*. Budapest, Museum of Fine Arts.

45

FIG. 18. Sebastiano del Piombo, *Portrait of a Man*. Budapest, Museum of Fine Arts.

Besides the Renaissance masters, Veronese, Tintoretto, and others, Nemes also sought examples by the settecento painters of Venice for his collection, such as G. B. Tiepolo (fig. 20) and the *vedute* painters, Canaletto, Bellotto, and the Guardis. Marcell von Nemes's collection, or rather collections, were dispersed at auction in Paris, Amsterdam, Munich, and Budapest in 1913, 1928, 1931, and 1933. The works remaining in Hungary are those he donated to the Museum of Fine Arts or those which passed to his banker and fellow collector, Mór Lipót Herzog in Budapest. Giovanni Battista da Udine's *The Virgin with Saints*, Bernardino Licinio's *Portrait of a Woman*, Polidoro da Lanciano's *Christ and the Woman Taken in Adultery* (cat. no. 8), the supposed Venetian *Portrait of Goldoni*, and other pictures in the Museum of Fine Arts can be traced back to the collections of Marcell von Nemes and Herzog.

The political and economic turmoil of the twentieth century has been particularly disruptive in Central Europe. Unfortunately, most of the significant Hungarian private collections shared the fate of the Nemes collection, going under the hammer and scattered throughout the world. Of the Budapest galleries of Hugó Kilényi, Sándor Léderer, and others, of the rich collections of the family of Baron Hatvany and the counts Andrássy, only a few items could be secured for the national public collections. The Venetian works of outstanding value among these few exceptions are a *Christ Carrying the Cross*, a late masterpiece by Sebastiano del Piombo, a *Madonna* by Palma Vecchio, and *The Virgin Mary* by Girolamo da Treviso.

The scope of this essay does not allow for discussion of the recent growth of the collection of the Museum of Fine Arts or to assess developments in the collecting of Venetian paintings in Hungary. Summing up, however, we can conclude that, as a result of centuries of activity, an exceptionally rich picture collection, covering a wide range of national schools of many centuries, has been formed at the Museum of Fine Arts in Budapest. Rather than bearing the stamp of a great ruling house of Europe, its origins reflect the colorful collecting goals of aristocrats as well as those of clerics, wealthy burghers, and institutions. As a result, it differs markedly in character from the large European museums of imperial descent such as the Louvre in Paris or the Kunsthistorisches Museum in Vienna, whose collections were initially formed by royal or imperial fiat.[42]

FIG. 19. Francesco Guardi, *The Bridge at Dolo*. Budapest, Museum of Fine Arts.

FIG. 20. Giovanni Battista Tiepolo, *The Apotheosis of Aeneas*. Cambridge, Mass.,
Fogg Art Museum, Harvard University Art Museums.

Two of the distinguishing features of the Museum of Fine Arts are its distinctive charac-
ter and the scope of its collections, embracing a wide range of subject matter in considerable
depth, matched by the presence of important works by lesser-known masters and schools that
never found favor in the largest royal collections. For example, Gothic altarpiece fragments
and pioneering fifteenth-century masters can be found alongside the world-famous masters of
the cinquecento. Characteristic and important works representing Venice of the seventeenth
century join masters of the Venetian Golden Age, as well as a multitude of masters and char-
acteristic categories of Venetian painting representing the settecento. In addition to the perma-
nent installation of the museum, selected aspects of the collection are featured with increasing
frequency at large international exhibitions. Through scholarly research and publications,
our collection has become an important part of universal European art history.[43]

NOTES

1. Important comprehensive works include the following: N. Holst, "La pittura veneziana tra il Reno e la Neva," *Arte Veneta* 5 (1951): 131–138; H. Trevor-Roper, *The Plunder of the Arts in the Seventeenth Century* (London, 1970); F. Haskell, *Patrons and Painters: Art and Society in Baroque Italy* (New Haven–London, 1980); F. Zava Boccazzi, *Residenze e gallerie: Comittenza tedesca di pittura veneziana nel settecento. Venezia e la Germania* (Milan, 1986); K. Pomian, *Collezionisti, amatori e curiosi: Parigi-Venezia. XVI.–XVIII. secolo* (Milan, 1989); K. Garas, "Il collezionismo ungherese e la pittura veneziana," in Milan, Finarte, *Itinerario veneto: Dipinti e disegni del '600 e '700 veneziano del Museo di Belle Arti di Budapest,* 1991, pp. 3–15. See also L. Slaviček, *Artis pictoriae amatores* (Prague, 1993).

2. Balthasar Gerbier, buyer of paintings on behalf of the duke of Buckingham, candidly voices these justifications for collecting in a letter written in 1624: "Let enemies and people ignorant of paintings say what they will, they cannot deny that pictures are noble ornaments, a delightful amusement and histories that one may read without fatigue. I wish I could only live a century, if they were sold, to be able to laugh at those facetious folk, who says it is money cast away for baubles and shadows: I know they will be pictures still, when those ignorants will be less than shadows." Quoted in C. R. Cammel, *The Great Duke of Buckingham* (London, 1939), p. 362.

3. J. Stockbauer, *Die Kunstbestrebungen am Bayerischen Hofe unter Herzog Albrecht V. und Wilhelm V.* (Vienna, 1874), pp. 1–63; D. J. Jansen, "Jacopo Strada (1516–1588): Antiquario della Sacra Cesarea Maesta," *Leids Kunsthistorisch Jaarboek* 1 (1982): 57–69.

4. B. Volk-Knüttel, *Maximilian I. von Bayern als Sammler und Auftraggeber: Quellen und Studien zur Kunstpolitik der Wittelsbacher vom 16. bis zum 18. Jahrhundert* (Munich, 1980) pp. 83, 94.

5. *Des Augsburger Patriziers Philipp Hainhofers Beziehungen zu Herzog Philipp II. von Pommern Stettin* (Vienna, 1896), p. 106. J. Staininger's Venetian pictures, including works by Paris Bordone and others, later went to Archduke Leopold Wilhelm in Vienna. In Martin Peller's house (Peller died in 1629), where Palma Giovane was a guest, pictures by Tintoretto, Veronese, Titian, the Bassanos, and the Palmas are mentioned; see further K. Garas, "Die Fugger und die venezianische Kunst: Venedig und Oberdeutschland in der Renaissance," *Centro Tedesco di Studi Veneziani* (Sigmaringen, 1993), pp. 123–129.

6. K. Garas, "Zur Geschichte der Kunstsammlungen Rudolfs II," *Umeni* 18 (1970): 134.

7. Buyers of paintings in Venice on behalf of Emperor Rudolph II included the painter Hans Rottenhammer and the famous connoisseur and goldsmith Jacomo König. See further K. Garas, "Veronese e il collezionismo del nord nel XVI–XVII secolo," in *Nuovi studi su Paolo Veronese* (Venice, 1990), pp. 16–24.

8. At the end of the English Civil War, the duke of Hamilton, a staunch royalist, was tried by Parliament and executed for treason. His art collection was in the Netherlands shortly after 1649 and offered for sale to Archduke Leopold Wilhelm. By 1651 the Hamilton pictures were in Leopold Wilhelm's collection. E. K. Waterhouse, "Paintings from Venice for Seventeenth-Century England," *Italian Studies* 7 (1952): 1–23; K. Garas, "Die Entstehung der Galerie des Erzherzog Leopold Wilhelm," *Jahrbuch der kunsthistorischen Sammlungen in Wien* 63 (1967): 39–80; K. Garas, "Das Schicksal der Sammlung des Erzherzog Leopold Wilhelm," *Jahrbuch der kunsthistorischen Sammlungen in Wien* 64 (1968): 181–278.

9. J. Neumann, *La galerie de tableaux du Château de Prague* (Prague, 1967); K. Garas, "Die Sammlung Buckingham und die kaiserliche Galerie," *Wiener Jahrbuch für Kunstgeschichte* 40 (1987): 111–121.

10. A. Breitenbacher, *Dejiny arcibiskupské obrazarny v Kromérizi,* 2 vols. (Kroměříž, 1925, 1927); M. F. S. Hervey, *The Life, Correspondence, and Collections Formed by Thomas Howard, Earl of Arundel* (Cambridge, 1921); D. Howarth, *Lord Arundel and His Circle* (New Haven–London, 1985).

11. M. Boschini, *La carta del navegar pitoresco* (Venice, 1660). The oft-mentioned theory that Leopold Wilhelm's gallery stayed in Venice for some time is erroneous; see G. Savini Branca, *Il collezionismo veneziano nel '600* (Venice, 1964), p. 67.

12. Boschini 1660, p. 4: "Ognun procura haver quadri e disegni / De sti nostri Pitori singolari . . . Tuti vuol formar studio di pitura." For a comprehensive discussion of the Venetian art market in the mid-seventeenth century see J. Fletcher, "Marco Boschini and Paolo del Sera: Collectors and Connoisseurs of Venice," *Apollo* 110 (1979): 416–424.

13. See A. Emiliani, *Leggi, bandi e provvedimenti per la Tutela dei beni artistici e culturali negli antiche stati italiani, 1571–1860* (Bologna, 1978), p. 160. See further G. della Lena's manuscript report, "Esposizione istorica dello Spoglio, che di tempo in tempo si fece di pitture in Venezia."

14. Z. Kalista, "Humprecht Jan Černin jako mecenas a podporovatel vytvarnich umeni v dobe sve benatské ambasady (1660–1663)," *Pamatky archeologické* 36 (1928–29): 57; L. Slaviček, "Prispevky k dejinam Nostické obrazové sbirky," *Umeni* 31 (1983): 219–243.

15. Several sources report on Veronese's *Last Supper* being stolen from Verona; the court painter Peter Strudel allegedly acquired it for the Habsburg emperor in 1699. See further L. Olivato, *Provvedimenti della Repubblica Veneta per la salvaguardia del patrimonio artistico nei secoli XVII.–XVIII.* (Venice, 1974).

16. Ridolfi, *Le meraviglie dell'arte* (1648), ed. D. von Hadeln (Berlin, 1914); Boschini 1660, p. 16.

17. F. Sansovino and G. Martinioni, *Venetia città nobilissima* (Venice, 1663).

18. Quoted from del Sera's voluminous correspondence conserved in the Archivio del Stato in Florence, Carteggio d'Artisti, vols. V–VIII.

19. For details on this matter see P. Orlandi, *P. Guarienti: Abecedario pittorico* (Venice, 1753): "Una certa razza di gente poco onesta, e al guadagno anche illicito unicamente intesa, coll'onorato titolo di sensali un vergognoso commercio di quadri facendo, co'nomi più illustri, e famosi battezza quelli, che ha per le mani, e le supporte sue merci accredita con ideate relazioni, e menzogne" (A certain dishonest type, whose only aim is illicit gain, engages in a shameful transaction involving paintings, under the honorable title of broker. These people attribute the paintings that they have on hand to the most famous and illustrious names, and support their falsely accredited merchandise with lies and fabricated reports). In 1737 the Venetian art dealer Bodisson is identified as having sold many fakes to German buyers.

20. See note 1 and further Bonn, Rheinisches Landesmuseum, *Himmel, Ruhm und Herrlichkeit: Italienische Künstler an rheinischen Höfen des Barock,* 1989, ed. H. M. Schmidt et al., and *Venedigs Ruhm in Norden,* Hannover, Landesmuseum–Düsseldorf, Kunstmuseum, 1991–92.

21. H. Hantsch and A. Scharf, *Quellen zur Geschichte des Barocks in Franken unter dem Einfluss des Hauses Schönborn,* 2 vols. (Augsburg, 1931; Würzburg, 1955), pp. 546, 564, 1027, 1159, 1188; *Die Grafen von Schönborn: Kirchenfürsten, Sammler, Mäzene* (Nuremberg, 1989).

22. P. Byss, *Fürstlicher Gemähld- und Bilder Schatz* (Bamberg, 1719).

23. F. Algarotti, "Projetto per ridurre a compimento il regio Museo di Dresda," *Opere del Conte Algarotti,* vol. 8 (Venice, 1792), p. 355; F. Algarotti, *Saggio sopra la pittura* (Venice, 1762); H. Posse, "Die Briefe des Grafen Algarotti an den sächsischen Hof," *Jahrbuch der preussischen Kunstsammlungen* (1931): Beiblatt 40.

24. "[C]he in Italia possegon l'arte d'imitare i vecchi quadri, quanto alla Cina la vecchia porcellana." Quoted in F. Algarotti, *Opere,* vol. 6, p. 39. Anton Maria Zanetti, the elder and the younger, both art lovers and writers, played a role somewhat similar to that assumed by Algarotti. They mediated the sales of pictures for Prince Eugene of Savoy, Prince Liechtenstein in Vienna, Count Tessin in Stockholm, and the duke of Orleans in Paris, as well as providing artistic advice to these lofty patrons.

25. *Die Briefe Friedrichs des Grossen an seinen vormaligen Kammerdiener Fredersdorf* (Berlin, 1926), pp. 309, 353. Frederick the Great wrote in 1754 to his agent in Paris that he would be interested in securing works by Titian, Paolo Veronese, Luca Giordano, and Correggio: "Charming large gallery paintings, but no gruesome saints undergoing martyrdom, rather mythological or history subjects."

26. See Hannover-Düsseldorf 1991-92, pp. 16, 32.

27. C. L. von Hagedorn, *Lettre à un amateur de peinture* (Dresden, 1755); *Betrachtungen über die Malerei* (Leipzig, 1762); M. Stübel, *Christian Ludwig von Hagedorn: Ein Diplomat und Sammler des 18. Jahrhunderts* (Leipzig, 1912).

28. T. Baden, *Briefe über die Kunst von und an Christian Ludwig von Hagedorn* (Leipzig, 1797), p. 23.

29. From the mid-eighteenth century, critics and collectors alike complained about the growth in interest in Netherlandish painters. J.-P. Mariette expressed this sentiment in his letter to F. Temanza in Venice: "tandis qu'un tableau ou dessin d'un artiste italien n'est regardé qu'avec une sorte d'indifférence" (while currently a painting or drawing by an Italian artist is merely regarded with indifference). Quoted in *Archives des Arts* (1890). This finds an echo in the complaint of J. Strange from London in 1789: "E incredibile come sia decaduto qui il gusto de quadri antichi italiani" (It is incredible the degree to which taste in the Italian old-master paintings has become decadent). See F. Mauroner, "Collezionisti e vedutisti settecenteschi in Venezia," *Arte Veneta* 1 (1947): 48.

30. F. C. Scheyb describes the situation in Vienna in his theoretical work published in 1774, *Orestrio von den drey Künsten der Zeichnung,* vol. 1 (Vienna, 1774), p. 55: "Liebhabern der Kunst der schönen Künste, ich will sagen der Malerey will jetzo ein jeder nachahmen. Man lauft und ziert seine Wohnung mit Gemälden, man sammelt Kupferstiche, ohne von der Kunst einen gründlichen Begriff zu haben" (Lovers of art, particularly the fine art of painting, imitate each other. One purchases his house and decorates it with paintings, one collects prints without having any proper understanding of art). In 1798 the Polish dignitary Stanislas Kostka Potocki wrote from Vienna: "[I]l y a reflue ici des tableaux de tous les coins du monde, l'on ne s'y entende guères et avec un peu d'argent il y auroit moyen de fair de bons achats" (Pictures from all parts of the world are to be found here; one doesn't really know anything about them, yet with a little money there are opportunities to make good purchases). Quoted in B. Majewska-Maszkowska, *Mecenat Artystyczny Izabelli z Czartoryskich Lubomirskiej* (Wroclaw, 1976), p. 305.

31. As a result of the defeat of 1526, a great part of Hungary was occupied by the Turks until 1686, whereas another part was under the rule of the Habsburgs, and only Transylvania (part of present-day Rumania) remained an independent principality.

32. G. Entz, *A magyar mugyüjtés történetének vázlata 1850-ig* (An Outline of the History of Art Collecting in Hungary until 1850) (Budapest, 1937); K. Garas, "Il collezionismo ungherese e l'arte italiana al primo Ottocento," in *Popolo, nazione e storia nella cultura italiana e ungherese dal 1789 al 1850* (Florence, 1985), pp. 243-252; K. Garas in Milan 1991; see note 1.

33. S. Meller, *Az Esterházy Képtár Története* (The History of the Esterházy Gallery) (Budapest, 1915).

34. M. Harasztiné-Takacs, "A Pyrker Képtár a Szépművészeti Muzeumban" (The Pyrker Gallery in the Museum of Fine Arts), in *Pyrker emlékkönyv* (Budapest, 1987), pp. 207-277; P. Kiss, "A Pyrker képtár sorsa Egerben a 19-20 században és Pesten 1848-ig" (The Fate of the Pyrker Gallery in Eger in the Nineteenth and Twentieth Centuries and in Pest until 1848), in *Müvészettörténeti Értesitő* (Budapest, 1987), pp. 131-141.

35. It is worth mentioning the large-scale project in which a major consignment of the stored paintings of suppressed churches and monasteries in Venice was officially sent to Vienna between 1816 and 1838. The gallery of the Academy of Fine Arts received the emperor's gift of eighty-four important Venetian paintings which, following World War I, had to be returned in 1919, according to the intergovernmental treaty; see M. Poch Kalous, *Die Gemäldegalerie der Akademie der Bildenden Künste in Wien* (Vienna, 1968), pp. 19, 38.

36. Of the Szapáry Collection two beautiful biblical scenes by Paolo Fiammingo entered the Museum of Fine Arts; Domenico Tintoretto's *Woman of Samaria at the Well* was recently auctioned at Sotheby's, London, June 1, 1990, lot 63a, and G. B. Tiepolo's huge ceiling painting eulogizing the Morosini family was returned to Italy, to the Palazzo Isimbardi in Milan.

37. *Pulszky Károly emlékének* (Károly Pulszky in Memoriam), ed. L. Mrávik (Budapest, 1988).

38. The vitriolic tenor of this controversy embraced wider issues reflecting the desire of extreme conservatives to attack Pulszky's father who had been an important liberal leader during the revolution of 1848. For further discussion of this fascinating, but ill-fated, museum personality see T. Shapcott, *White Stag of Exile* (Harmondsworth, 1984).

39. Zs. Ormós, "Visszaemlékezések" (Reminiscences), vol. 3, *Gyüjteményeim* (My Collections) (Temesvár, 1888), which provides a detailed account of the origins and former Venetian or other owners of the pictures acquired by Ormós.

40. The detailed lists published in Budapest in 1909 of the Pálffy Collection contain little information on the provenance of the pictures. Only in exceptional cases are they sufficient to determine the origin: for example, the so-called *Portrait of Vittoria Farnese* (inv. 4213), earlier attributed to Titian, came from the Farnese Collection.

41. No comprehensive study on Marcell von Nemes (1866-1930) and his collections has been published to date. However, for an overview of his life and his collecting of the paintings by El Greco see I. Barkóczi, in Budapest, Museum of Fine Arts, *Hommage à El Greco,* 1991, pp. 69-84.

42. On the history and collections of the Museum of Fine Arts see the following recent publications: *The Budapest Museum of Fine Arts,* ed. K. Garas (Budapest, 1985), and I. Barkóczi in *Delights for the Senses* (Wausau, Wisc., 1989), pp. 10-17.

43. K. Garas, *A velencei settecento festészete* (Eighteenth-Century Venetian Painting) (Budapest, 1968, 1977); "Venezianische Malerei des 15. bis 18. Jahrhunderts," in Dresden, Gemäldegalerie Alter Meister, *Eine Gemeinschaftsausstellung des Nationalmuseum Warschau, der Nationalgalerie Prag, des Museums der Bildenden Künste Budapest und der Gemäldegalerie Alter Meister Dresden,* 1968; Venice, Palazzo Ducale, *Dal Ricci al Tiepolo,* 1969, ed. P. Zampetti; *El Settecento Veneciano Aspectos de la Pintura Veneciana del Siglo XVIII* (Zaragoza, 1990); Milan 1991; Hannover-Düsseldorf 1991-92.

Seicento Mannerism:
Eighteenth-Century Definitions
of a Venetian Style

PHILIP SOHM

WHEN IN 1771 ANTONIO MARIA ZANETTI (the Younger) labeled a group of seventeenth-century Venetian painters as Mannerists (*Manieristi*), he arrived at a nomenclature that had eluded him about forty years earlier when he first wrote about seicento painting.[1] In 1733 the still coalescent trend that he later named Mannerism had remained nameless. Between 1733 and 1771 Zanetti became librarian of the Biblioteca Marciana in Venice, compiled a catalogue of Greek and Roman manuscripts in its collection, and collaborated with his eponymous cousin and with Apostolo Zeno on a catalogue of Greek and Roman statues in the library's antechamber.[2] Also in the interim, Zanetti became well acquainted with the professional class of connoisseurs, critics, and academics, including Anton Francesco Gori, Innocenzo Frugoni, and Francesco Algarotti, who called Zanetti "my friend and famous Connoisseur." Possibly these experiences at classification led him to write a more systematic history of Venetian painting than he did in 1733, one that included discrete stylistic periods and categories such as that of the seicento *Manieristi*.

His final, mature statement on the subject, *Della pittura veneziana* (Venice, 1771), was pivotal to Venetian art historiography: it consolidated a pejorative view of seicento painting that writers had been grappling with since 1730 and presented it to posterity in the most complete and authoritative history of Venetian painting written during the eighteenth century. About one hundred years earlier, the Venetian art dealer, critic, and painter Marco Boschini had written an ad hominem against Giorgio Vasari whom he presented as having unfairly dismissed the Venetians as Mannerists (*pittori di maniera*).[3] Boschini invented this charge against Vasari in order to argue the opposite—that Venetians were stylish (*manieroso*) and worked "by style [*de maniera*], the true font of art"—and thereby to prove the excellence of seicento painters who perpetuated the styles of the cinquecento masters.[4]

This essay outlines how art writers transformed seicento style from the stylish style of Boschini in 1660 to the stylized Mannerism of Zanetti in 1771. Between 1731 and 1735 a group of Venetian and Veneto writers (Scipione Maffei, Antonio Maria Zanetti, Vincenzo da Canal, Antonio Balestra) deployed concepts of style and stylization to suppress a particular period of Venetian art. These authors explored the possibilities of a distinctive seicento style, and only later in 1771 did Zanetti first label and codify that style as "Mannerist." I propose a retrospective approach, starting at the end of the story, when the style of Venetian seicento painters was first reified as Mannerist by Zanetti in 1771, and ending with Vincenzo da Canal and the first, hesitant, attempts during the 1730s to isolate seventeenth-century painting as a coherent period separate from "modern" settecento art.

Until recently, Zanetti's judgment on seicento painting as the decadent nadir in a historical cycle of artistic progress, decline, and revival was accepted by modern art historians as

self-evident. That this view was inherited from eighteenth-century criticism held little interest in and of itself because it coincided with prevailing beliefs. Roberto Longhi accurately represented scholarly consensus in writing that seicento Venetian painting was "the least brilliant of all the centuries."[5] His criticism presents seicento painting as derivative from and destructive of a noble tradition. Pietro Liberi is accused of "falsifying" cinquecento models; Gerolamo Forabosco makes pastiches instead of originals; Francesco Maffei indulges in "a shameful remnants sale of Cinquecento paintings." Longhi seems unaware to what extent his views were themselves remnants of earlier opinion, especially with regard to seicento painting as an uncomprehending reiteration of cinquecento types. What Longhi called "falsariga manieristica" and Rudolf Wittkower called "academic eclecticism" are unintended retentions of Zanetti's *Manieristi*.[6] Longhi and Wittkower were not Venetians by birth or inclination; those who are have given serious and sympathetic attention to seicento painting, often entering the field from the side (Paola Rossi from the cinquecento, Antonio Morassi from the settecento, and Rodolfo Pallucchini from both sides). In some ways theirs are insular views that do not fully represent those of Italianists in general. For an important exhibition of Venetian seicento painting at the National Gallery (London), Homan Potterton explicitly subscribes to some earlier views—the "exhaustion" after the cinquecento; seicento painting as a precursor for the settecento[7]—but reveals deeper doubts by the choice of paintings included in the show: over half were done by artists born and trained outside of Venice whose reputations rest substantially on work done elsewhere in Italy. Hence, despite the determined efforts of Pallucchini and others to renew seicento studies, it would seem that even advocates of this period can still complicitly (and perhaps unwittingly) acknowledge the inferiority of native-grown painting. Since the weight of tradition still hangs heavily in the field, it might be useful to study its origins.

THE MANNERISTS OF ZANETTI

ZANETTI PRESENTS HIS SEICENTO MANNERISTS as tragic victims of historical circumstance. Despite their individual talents, they could not transcend the shifting fortunes of their time and the inexorable decline of art that started in the sixteenth century. *Della pittura veneziana* is divided into five books, each devoted to a coherent period style, and each bound to the others by an organic conception of artistic progress and decline. Book 1 opens with a truncated account of duecento and trecento painting before turning to the first mature phase of Venetian painting, that of the quattrocento.[8] Trecento and quattrocento painting, presented respectively as naive (*semplicissima semplicità*) and as calculated (*arteficiato*) renditions of nature, stand in relation to each other much as Giorgio Vasari first described them in 1550. Book 2, devoted to Giorgione, Titian, Tintoretto, Veronese, and Bassano, introduces those qualities that Zanetti had found missing in the quattrocento: an imagination that transcends the literal and sensible; a technique that translates the artist's ardent genius (*genio fervido*) into visible form. The historical fallacy that judged quattrocento painting to be an incomplete version of the cinquecento establishes these Golden-Age masters as the canon against which all later styles will be judged. Book 3 takes as its subject the "Disciples and Imitators of Giorgione and Titian" and presents Sebastiano del Piombo, Palma Vecchio, Lotto, Pordenone, Bonifacio Veneziano, Schiavone, and others as artists who initiated the

FIG. 1. From A. M. Zanetti, *Della pittura veneziana* (Venice, 1771). University of Toronto, Fischer Rare Book Library.

shift away from normative beauty. At their best, they followed "the style of the Masters as a good guide," but therein also lay the seeds of artistic decline. Nevertheless, Zanetti insisted that the followers of Giorgione and Titian "should *not* be called nephews but sons of nature" and hence do *not* deserve the Horatian epithet of servile imitators (*Imitatores servum pecus*). In so doing he was anticipating the perils of imitation that in his account would lead to the decline of painting in the seventeenth century.

Book 4 is devoted to the *Manieristi,* a group of early- and mid-seicento painters, starting with Palma Giovane (1544–1628) and ending with Pietro Bellotto (1627–1700).[9] The period is not defined exclusively by chronology. Among painters of the revived "modern" style, discussed in Book 5, are artists born in the 1630s: Sebastiano Bombelli, Andrea Celesti, and Antonio Zanchi. Instead of a strict chronological division of periods, Zanetti chose a period defined by a style, Mannerism, which consisted of an entelechtic set of qualities that revolve around the consequences of rejecting nature as the primary artistic model. I will return to the vexing problem of periodization in the last section of this essay.

The unifying theme of Mannerism was the displacement of rule and nature by imagination. This was represented emblematically by the image opening Book 4: paintbrushes and maulstick bound at the center and flanked by a pair of splayed wings (fig. 1). The wings stand for the speed and flight of pictorial imagination.[10] Nature, considered by the Mannerists to be an indirect route to truth, was replaced by more expeditious means of image making: 1) art becomes the model for art, not in the form of selective Ciceronian imitation but as servile, uncritical imitation; 2) the artists' "sterile imagination" (*la fantasia sterile*) or "abundant imagination" no longer consult nature and make "studious copies" (*le studiate repliche*) from her; 3) "practice" (*pratica*) instead of theory or principles (*principii*) guide the artist who accordingly works by routine and physical habit and "derives everything from the palette and brush."[11] This epistemology of Mannerism explains the forms that it produces: the variety of nature having been abandoned, forms become monotonous;[12] freed from the controls of reason, theory, and the careful imitation of nature and good art, imagination and practice run rampant allowing painters to work with excessive haste (*speditezza*).[13] Mannerism, like its root *maniera* (style), was not an absolute value but a matter of degree. Without style and imagination, painting would be incomplete as it had been in the quattrocento. Even in their pure application, style and imagination are necessary to depict subjects that cannot be directly observed in nature, at least not in stasis, such as "impetuous movements, figures in the air, and other similar things." The emblematic wings that open the chapter conflate the concept of imagination with the flying figures so often praised by the seicento critic Marco

Boschini and so popular with seicento painters; but these wings, like seicento Mannerists, were not grounded in nature.

The attributes of the *Manieristi* originated without exception in the concept of style itself (*maniera*). Zanetti explained the etymology of *Manieristi* with reference to a passage in *Dialogo della pittura intitolato l'Aretino* (Venice, 1557) by Lodovico Dolce, where *maniera* was identified with repetition and rote practice.[14] Zanetti cited Dolce not because he thought his concept of *maniera* encompassed the significant parts of style (it did not), but presumably because it first applied the term as derision to cinquecento Mannerists, particularly to Michelangelo. *Maniera* in its broader sense was given its standard definition by Filippo Baldinucci in the *Vocabolario toscano dell'arte del disegno* (Florence, 1681), the first dictionary of art terminology. Here style is presented as: 1) a regular way of working so that two works by the same artist will never be entirely different; and 2) as an indefinable distance from conventional truth and natural appearance. In the first definition, style is a stable element that remains untouched by the subject rendered, the size, medium, or any other variable; style in this sense is implicitly associated with rote practice or repetition but is primarily a connoisseur's clue. In the second definition, style is a type of distortion or variance from natural or constructed norms of pictorial quality. It is this latter sense, as will be shown in the following section, that becomes the basis for Mannerism.

Baldinucci made no reference to the concept that Zanetti placed at the center of his definition: imagination. Style and imagination had been connected in art literature at least since the early fifteenth century as necessary preconditions for inventing images that are individual to the artist and even expressive of the creator's character.[15] In the early seventeenth century, *maniera* and imagination became still more closely identified as negative connotations began to accrete to both. Sixteenth-century Mannerism provided an enduring lesson in the dangers of excess, where imagination becomes unmoored from reason, nature, and conventional models of beauty.[16] Both style and imagination capture an individual and subjective, rather than normative and objective, view of beauty. By losing contact with an external canon, whether natural or conventional, painting was thought to become a mechanical and empty repetition of forms.[17] Rote practice (*pratica*), which also produced a formulaic, repetitious art, was first identified with *maniera* and sixteenth-century Mannerism by Dolce in the passage cited by Zanetti.[18] For Zanetti, practice (*il tirar via di pratica*), imagination, and fluency or speed (*prontezza*) were historically relative: necessary in the early cinquecento when Giorgione and Titian were trying to escape quattrocento desiccation of color and rigidity of form, they became stultifying when applied in excess (*il continuo uso*) during the seventeenth century.

Zanetti presented Mannerism as a progressive degeneration and accentuation of qualities that in other historical circumstances were deemed to be positive. The cinquecento followers of Titian and Giorgione tilted toward servile imitation (Horace's *Imitatores servum pecus*), yet they did not descend so low as seicento painters.[19] If the cinquecento followers were still "sons of nature," seicento painters were more distant relations, "nephews," who exaggerated cinquecento tendencies toward subservience. By using "nephews," Zanetti adopts a metaphor proposed by Leonardo when he warned that "nobody should ever imitate another's style, because as far as art is concerned, he will be called a nephew rather than a son of nature."[20] "Nephew" was one of many negative metaphors for imitation used in sixteenth- and seventeenth-century art criticism. Others included "bastards of nature," "dirty canal water," and "shadows," terms that parodically juxtapose the purity and variety of

nature with the pollution of style.[21] The most enduring metaphor of slavish imitation was that of following in the footsteps or, as Michelangelo rephrased it, "no one who follows can ever get in front."[22] Quintilian, Michelangelo's probable source, used the footsteps metaphor for the same end that Zanetti adopted Leonardo's nephews: to explain the cause of artistic decline. If the original is always better than the imitation, then nature is better than its artificial reconstruction and the thing that casts a shadow is richer and more diverse than the shadow.[23]

The metaphor of nephews indicates how seicento painters operated within a continuous, albeit degraded, tradition of cinquecento painting. The seicento view of its art also emphasized continuity, like "rivers flowing into oceans" as Boschini put it,[24] without however implying a loss in quality. Consider how radically Boschini's familial metaphor differs from Zanetti's "nephews." In Boschini's formulation, seicento painters were closer to their cinquecento models than sons were to their fathers because they had become their fathers by metempsychosis: "I would say that the souls of Titian, Veronese, Giorgione, Bassano and others have transmigrated to these new painters."[25] Fourteen years later, in the prefatory *Breve instruzione* to the *Ricche minere della pittura veneziana,* one finds Boschini's acceptance of seicento parity with the cinquecento beginning to erode. The transmigrated souls are now called "epigones" and are seen in the ambivalent act of following in the "footsteps" of Titian, Tintoretto, and Veronese.[26]

The structure of *Della pittura veneziana* situates Mannerism as the last phase of a biological cycle in art: birth (duecento and trecento), growth (quattrocento), maturity (cinquecento), decay (seicento), and rebirth (settecento). Just as biology enforces an inevitable decline of art at the macrocosmic level, so too for individual artists. Excessive imagination and the formulaic repetition of *pratica* conventionally ascribed as characteristics of an artist's late style were adopted by Zanetti to define the late phase which is Mannerism. The Veronese painter Giambattista Cignaroli, writing in the 1760s, described the aging Bartolomeo Signorini as "fantasizing and dreaming mannered novelties, . . . he worked completely from the imagination."[27] A learned consensus held that Ventura Salimbeni studied nature carefully as a young artist but became somewhat mannered in old age; and that Giovanni Battista Vanni suffered the same fate by becoming self-complacent.[28] Filippo Baldinucci, who provided these reports, summarized the biological imperative by using a Venetian seicento painter, Pietro Ricchi, as his example of a universal tendency: "It happens even with most good masters that after many years of working they fall in love with their own way of painting and hence become mannered [*ammanierato*] and often abandon an obedience to nature."[29] For these reasons, it may be concluded that for Zanetti, seventeenth-century Mannerism was a late style as inevitable to the development of Venetian art as the onset of old age was to life itself.

EARLY DEFINITIONS
OF BAROQUE MANNERISTS

IN THE SEVENTEENTH CENTURY, as *maniera* came to be increasingly implicated by the failings of cinquecento Mannerism, and as that style became a more popular topic of discussion, a need arose for distinguishing the neutral sense of *maniera* (simply as any individual way of working) from its derogatory associations of a fanciful, formulaic, unnatural expression. Throughout the seventeenth century, most art historians had no stylis-

tic label to identify Mannerism as a movement or phase in art with its own discrete set of characteristics. The closest any writer came in this respect was Vincenzo Giustiniani, who in a once obscure but now famous letter written in the 1620s and posthumously published in 1675, defined three concurrent contemporary styles around the dichotomy of style and nature.[30] Those who painted "by style" (*di maniera*), such as Barocci, Romanelli, Passignano, and d'Arpino, worked by rote (*con lunga pratica*) and from their imagination. It was not until 1681 that the term *manierato* or *ammanierato* (mannered; stylized) appeared in print with reference to painting, and even then it was not attached to cinquecento Mannerism.[31] The utility of *ammanierato* as a term and its inclusion in Filippo Baldinucci's *Vocabolario* assured its popularity thereafter. Its definition is contained under the heading of *maniera* and derives its meaning directly from style. All artists must have style, and since style is a deviation from conventions of beauty and nature, all artists must inevitably depart from constructed ideas of beauty. Mannerism is there defined as simply too much style: "From the root *maniera* comes mannered [*ammanieriato*] which one says of those works where the artist, distancing himself a long way from the true, draws entirely upon his own style as much in making human figures as animals, plants, draperies and other things; these things could well appear to be made with ease and boldness. . . . And this vice is so universal that it embraces, more or less, most all artists."[32] In his life of Caravaggio, Baldinucci identified the inescapable tendency toward Mannerism with the "decadent" followers of Raphael.[33] In this passage Baldinucci named as *ammanierato* the attributes of sixteenth-century Mannerism that had been discussed previously by Giovanni Pietro Bellori in his life of Annibale Carracci and by Carlo Cesare Malvasia in his life of Guido Reni.[34] Most notably, the Mannerists (not yet designated by this name) indulged in an exaggerated form of style where the internal dialogue ("the artist . . . draws entirely upon his own style") replaces attempts to capture external reality.

Between the 1680s when Baldinucci began writing and the 1730s, the denotation of *ammanierato* remained stable, but the art that it designated shifted from sixteenth-century Mannerism to mid- and late-seventeenth-century Baroque. As the former receded in history, and as the Carracci "renaissance" became an accepted topos of art historiography, cinquecento Mannerism ceased to be viewed as a dangerous model and became instead an instructive reference point for critics of newer styles. During the 1730s a critical consensus emerged that held "modern" painting to be mannered (*ammanierato*). Giovanni Gaetano Bottari, Antonio Balestra, and Francesco Maria Niccolò Gabburri, who were in direct contact with each other between 1730 and 1732, used *ammanierato* to condemn "modern" painting as overly imaginative, unnatural, indulgent, and formulaic: "Today various modern painters go walking down a road diametrically opposed to the precepts of art, even though they have so many beautiful exemplars and so many masters to imitate, thereby introducing to painting that shameful plague of the Mannered (*AMMANIERATO*), never attending to the lessons of Leonardo da Vinci, the study of the best ancient statues, the imitation of nature with just, true and judicious rules."[35] The upper-case emphasis given to *ammanierato* by Gabburri might suggest its use as a period or school label, yet for Baldinucci and many eighteenth-century writers *ammanierato* was only one of many stylistic qualities that defined Mannerism.[36] Tempting as it may be to assume that *ammanierato* was given priority over other key terms such as *fantasia, capriccio,* and *pratica* as the dominant identifying label for Mannerism, any such assumption would be generally misleading.

Roland Fréart de Chambray coined the term *manieriste* in 1662 to describe a modern stylistic tendency, exemplified by d'Arpino and Lanfranco, that was sophistic (*le faux esclat*), spontaneous (*furie; franchise*), and ignorant.[37] His *Idée de la perfection de la peinture* came to the immediate attention of Italian critics, notably to that of Giovanni Pietro Bellori who adopted its title and some of its contents for "L'idea del pittore. . . ."[38] Possibly Bellori's interest in the *Idée* can help explain the earliest Italian usage of *Manieristi* (now upper case) by Pier Jacopo Martelli (1710) and Agostino Maria Taja (1712), where for the first time in Italy the Mannerists became reified as a coherent movement with the label *Manieristi*. Both Martelli and Taja had close contacts with Bellori's circle in late-seventeenth-century Rome and were members of the Accademia dell'Arcadia, a literary reform movement organized at the turn of the eighteenth century in order to purify Italian writing of the Baroque style. Martelli, a Bolognese poet and playwright, became friends with Carlo Maratta while in Rome; Taja gave a lecture to the pre-Arcadian academy founded by Queen Christina of Sweden, whose librarian was Bellori.[39] Neither writer is well known to art historians (they are absent from the bibliographic Bible compiled by Schlosser), which may explain why their discussions of Mannerism have escaped scholarly notice.

Martelli opens the *Commentario* by having Carlo Maratta ("celebrated imitator of Raphael") introduce him to Raphael's *Parnassus* (Vatican, Stanza della Segnatura). Martelli succumbs to the painting's enchantments and steps into Parnassus, where he is asked to adjudicate a debate then in progress between the Petrarchists and Marinists. The followers of the Baroque poet Giambattista Marino are charged with excessive artifice that undermines an accurate representation of natural, unaffected emotions. The Marinists' concern with art over nature, style over content, imagination over learning, rendered their poetry a sophism known for its "superficial frills" and "accidental ornament." Raphael, speaking as a Petrarchan painter, finds Marinist poetry to be the equivalent of paintings by certain "modern Mannerists" (*Manieristi moderni*), contemporaries of Maratta (1625–1713), whose agitated poses, charged contours, and flying drapery are derived more from style than nature.[40] These characteristics are hardly new, as we will see, but the term *Manieristi* and its application to mid- and late-seicento painting are.

Taja's *Descrizione del Palazzo Apostolico Vaticano* was written in 1712, according to the publishers Pagliarini, and issued posthumously in 1750.[41] The Mannerists, variously described as *manieristi* and *ammanierati,* started as a movement (*setta*) with the second- and third-generation followers of Raphael, Michelangelo, Correggio, and Titian, and continued through the seventeenth century.[42] Like Zanetti, Taja views Mannerism as a progressive disease that starts when artists imitate other artists instead of "the originating beauty of nature." With "the blind and servile imitation of their masters" comes a loss of the fundamental principles that helped form a stable canon of art and consequently a confusion and multiplicity of styles spilling out of their overheated imaginations. The formal results are described in terms of excess, luxury, and ostentatious display ("nello sfarzo eccessivo della moderna pomposità del colorito, e dell'aggruppata composizione; nello sfoggio del panneggiamento").[43]

The stylistic effects of seicento Mannerism that Martelli and Taja identified, often on the basis of earlier texts, developed into a standard morphology by the 1730s. Only one characteristic example need be mentioned at this time. Scipione Maffei emphasized distortions of poses ("what stretching of members, what bestial convulsions"), illegible compositions ("piles of confused figures stacked on top of each other"), and irrational drapery that is more

ornamental than naturalistic ("drapery that flies without wings").[44] His reading of late-seventeenth-century style, like Martelli's and Taja's, transferred to Baroque painting the qualities of exaggeration, confusion, fragmentation, and distortion that had originally been identified with cinquecento Mannerism. Giovanni Andrea Gilio, for example, commented in 1564 about the obsession of the "new anatomists" who furiously strove to create novel and unnatural figures ("figure, figurette, figuraccie e figuroni").[45] Tommaso Stigliani, a literary critic writing in the 1620s, drew attention to Mannerist painting as a means to illustrate the kinds of syntactic convolutions that he found in the poetry of Marino. The "heap of dismembered members" of Marino reminded him of modern painting "dismembered into tiny pieces and massed together into a confused heap."[46]

DEFINING A MODERN STYLE IN VENICE

CRITICS BETWEEN 1710 AND 1735 did not always agree about the temporal boundaries of the "Mannerists" or "mannered" styles. Chambray and Taja saw Baroque Mannerism as the later phase of a continuous tradition that started in the mid-sixteenth century and became increasingly debased as it devolved through the seventeenth. Their views were atypical. By the 1670s cinquecento painting ceased to be commonly denominated as "modern" (*moderni, à di nostri, oggidi, ne nostri tempi,* etc.) and became instead a completed phase in history separated from "modern" or seicento painting by the great revival instituted by the Carracci.[47] Painting after the Carracci was generally interpreted as an unbroken, albeit declining, tradition. Martelli, however, represents a very early maneuver to maintain the inviolable reputation of the Carracci by separating them from the perceived aberrations that followed. He does this by dividing the generation of Reni, Domenichino, and Albani from the succeeding generation of the "moderns" Cignani, Franceschini, and Quaini.[48] By the 1730s art critics and historians, including Lione Pascoli, Giovanni Pietro Zanotti, Giovanni Gaetano Bottari, Francesco Saverio Baldinucci, Antonio Ciocchi, Gerolamo Baruffaldi, and Francesco Maria Niccolò Gabburri, were prepared to view seicento painting either as a completed phase in history or one whose termination should be actively promoted.[49] This consensus arose largely in response to Arcadian literary criticism that identified seicento poetry as flawed by precisely those qualities that disturbed critics of seicento painting: slavish imitation, ignorance of rules and theory, uncontrolled imagination, convoluted syntax.[50]

As part of this pan-Italian revaluation of the recent past, Scipione Maffei, Antonio Maria Zanetti, and Vincenzo da Canal grappled with the question of artistic periods for Venetian painting. The question that preoccupied them between 1731 and 1735 was the relationship of seicento painting to contemporary painting: was a revival of art underway or was contemporary art merely a continuation of seicento styles? were they witnessing the end of one phase in art and the beginning of another? These were timely questions in 1730, since the turn of a century was traditionally thought to be a time of renascence, with Masaccio, Brunelleschi, and Donatello in the early quattrocento; Leonardo, Raphael, and Michelangelo in the cinquecento; and finally the Carracci in the seicento. This pattern of rebirth had received much attention and probably created similar expectations for settecento art.

In 1731 Maffei identified a "second Renaissance" during the early settecento after the "dark ages" of the mid- and late seicento.[51] His opinion was evidently shared by many.

Zanetti, in the *Descrizione di tutte le pubbliche pitture della città di Venezia* of 1733, and Canal, a Venetian nobleman writing between 1731 and 1735, reported an optimism widely held in Venetian society at that time. Zanetti concurred with this view; Canal did not: "It is the opinion of art professionals of good taste that contemporary painting (*al dì d'oggi*) has arrived at greater perfection than the preceding period. I do not know if I can admit this to be true. It is my impression that this opinion is an illusion."[52] Delusion or not, the popular view that Zanetti ascribed to and promoted helped form art historians' opinion today. As the most complete and influential histories of Venetian art published in the eighteenth century, Zanetti's *Descrizione* and the *Della pittura veneziana* shaped later views in ways that were unavailable to Canal, whose two books were not published until the nineteenth century at a time when his academicism and critical views of settecento art had a more receptive audience. Even then his books made no lasting impression. That Zanetti's position is accepted today as more accurate than Canal's speaks in part for its greater influence. Similarly, the complete absence of discussion on Canal's views of history—he is used today only as a mine of factual information—may derive from a belief that he is unreliable or marginal simply because his views do not coincide with our own.[53]

Before 1730 art critics rarely separated contemporary art from its degraded seicento predecessors and rarely hoped for future improvements. Maffei was a signal and influential exception. In an effort to make Veronese painting conform to a complex historical model popularized by Bellori (1672) and Malvasia (1678), Maffei defined a period of decline in the mid-cinquecento, a revival at the turn of the century, a second "dark ages" (*adombramento*) in the mid-seicento and a second "Renaissance" (*risorgimento*) at the turn of the century.[54] The *adombramento* of Baroque painting, a label that cleverly plays on its famed tenebrism, was marked by manual facility but little theory, by fluency in popular taste for color but little knowledge of antiquity, and by unfettered imagination detached from natural observation. These flaws were corrected by two artists—Santo Prunati (1656–1728) and Antonio Balestra (1666–1740)—who returned to antiquity and nature. Their examples have produced a recent flowering (*il fiorir*) that has equaled the Renaissance and, in his view, may someday surpass classical antiquity.

Maffei provided Zanetti with a structure to recent history that separated a decadent seicento from a reborn settecento. In 1733 Zanetti periodized seicento and settecento quite differently than he did in 1771 or as we do today. His division of painters between 1600 and 1733 into twenty-two dead painters and sixteen living seems arbitrary and lacking in historical judgment, and to some degree it was. Giovanni Segalla, one of the defunct, was born after Sebastiano Ricci, whose longevity assured him a place among the "living." The list of dead painters moves gradually, albeit sporadically, from the early to late seicento, but the sequence conforms neither to dates of birth or death nor to artistic merit or schools. The living painters are listed alphabetically, with one significant exception (Sebastiano Ricci), as if Zanetti really could not judge their relative merits as he professed.[55] Yet, as the entries on individual artists show, his judgment was keen; and as his identification of Ricci as a pivotal figure shows, he did perceive a stylistic shift at the turn of the century that he described as a turning away: "That unhappy century for all the arts having ended, it seems now that in our age we begin to abhor the stupidities of the other."[56] In the *Descrizione,* Zanetti attributed to seicento painting many of the same qualities that he would later in *Della pittura veneziana,* particularly servile imitation and facile practice, but he did not use *ammanierato* even though that term was in his vocabulary, at least by 1723.[57]

Zanetti's pivotal artist, Sebastiano Ricci (1659–1734), was born in the same years as Maffei's fulcrum, Prunati and Balestra, and served the same function as usher of a new era and restorer of cinquecento glory. Ricci is separated from the alphabetical list of living painters and placed at the

head with the explanation that "from the happy sixteenth century up until our own, no one emerged from the Venetian school who was better than this painter."[58] Scholars have deemed Zanetti's assessment to be historically accurate without, however, questioning how much the tradition initiated by him has formed their own values. According to Joachim von Derschau, Ricci invented "a new coloristic ideal, one of bright and rich beauty, which prepared the way for Tiepolo. . . . The evolution of the Rococo in Venetian painting would be incomprehensible without Ricci."[59] For Michael Levey, "almost everything that happened in Venetian history painting goes back to Ricci."[60]

Maffei's and Zanetti's belief in artistic revival represents the view of *professori* that Canal rejected in the *Vita di Gregorio Lazzarini*. Writing in 1730–31, Canal did not have access to Zanetti's *Descrizione* nor perhaps to Maffei's *Verona illustrata*, yet he too identified Ricci as the painter who broke from seicento tradition and initiated a new cinquecento style ("un misto di Tintoretto e Paolo").[61] In his later work of about 1732–35, *Della maniera del dipingere moderno*, Canal defined the "modern painting" of his title as a continuous tradition from 1580 to 1730 but made no suggestion of a new and better age arising. He adopted Zanetti's terminology of *moderni* (the recent dead) and *viventi*, without separating them stylistically.[62]

Canal interprets "modern" art in a more conflicted way than Zanetti or Maffei. Like Zanetti, he believed that art had decayed in the seicento because artists lost a theoretical foundation, yet as a writer his pedagogic method employs example instead of precept:

> Of the ancients, but not the fifteenth century, I would study the heads of Palma Vecchio, the late style of Titian and Pordenone, the nudes of Tintoretto with their movements, the drapery of Veronese and Giambattista Zelotti, the relief and strength of Bassano, the harmony and grandiose style of Palma Giovane. . . . Of the modern Venetians, the delicacy of Forabosco, the force of Zanchi, the drapery of Ruschi, the air, clouds and sky of Carpioni, the extravagant ideas of Pietro Vecchia, the characterizations of Negri and the true painterly style of Bellucci. Of the living, the outlines of Ricci with his noble style, the grace of Balestra, the correct design of Lazzarini, the sketchiness of Pellegrini and Pittoni, and the painterly boldness of Tiepolo.[63]

This impossible prescription, almost a parody of eclectic imitation if it were not sincerely intended, may represent the mentality criticized by Zanetti of understanding art only with reference to other art. Canal recognized significant progress in the area of "modern" coloring, which he describes as more graceful and lively, less cutting (*tagliente*), with more sfumato and with prettier (*vago*) and softer colors.[64] The attendant risks of locating creative advances exclusively in *colorito* are: 1) a tendency to enfeeble natural coloring with decorative or purely artificial displays of the brush, or with excessive delicacy; and 2) a loss of *disegno*, taken literally as a blurring or erasure of defining contours, or figuratively as a faded memory of theory and science (anatomy, proportion, perspective, and history). The tension between *colorito* and *disegno*, traditional in itself, is extended by identifying *colorito* with Venice and the "modern" style and *disegno* with Bologna and the "ancient" style. The qualities assigned to *disegno* over *colorito* establish their priority: intelligent, correct, exact, diligent, and studious, on the one hand; finely finished, soft, pretty, delicate, charming, sweet, stylish, and painterly, on the other.[65] Canal exploited a long tradition of feminizing Venetian coloring in order to diminish its achievements,[66] but instead of blaming the painters whom he admires individually but not collectively, he shifts much of the responsibility to the dilettantes: "And the

charmed dilettantes love to possess works with sweet, pretty, and delicate coloring even more than the bold, resolute, and strong coloring of the past century."[67]

Herein lies Canal's conflict. Clearly he valued Venetian *colorito,* but for his native school to flourish, it must become less like itself and incorporate foreign speech into its language. His dismay over the degraded state of "modern" Venetian painting was genuine, yet he consistently protected individual painters from criticism. What Canal loved in one artist's work—Balestra's "charm" or Celesti's "lovely coloring"—became reprehensible in the work of many artists. This necessitated a transformation of the objects that he loved. The conflict is most apparent in his application of *manierato* twice over to "modern" Venetian painting: 1) as the sole quality that Lodovico Carracci learned from the Venetians; and 2) as an encompassing quality aligned with "resolute" and "charming" (*vago*) and set in opposition to Bolognese painting, which is "finished with precision and more studious in its design."[68] *Manierato* simultaneously suggests the strength and limitation of Venetian painting. On the one hand, "mannered" Venetian painting was worthy of imitation by Lodovico Carracci who, for Canal, represents an epitome of art. On the other hand, the term itself and its traditional usage suggests a failure of some sort, which is confirmed by its opposition to the more desirable Bolognese qualities. Its meaning, not altogether clear from the passages cited, can be clarified in relation to *manieroso* (stylish) that Canal used interchangeably with *manierato.*[69] The Accademia della Crusca defined *manieroso* as "a beautiful way to act," and it was applied by art critics in this positive fashion most often in reference to a fluent and even sketchy application of paint.[70] Some writers applied *manieroso* to the cinquecento Mannerists, using it in the sense defined above for *ammanierato* as a disordered style (Passeri), as too capricious or too hasty (Malvasia), and as too artificial (Bellori and Scaramuccia).[71] Canal's use of *manieroso* as a virtue sui generis peculiar to Venetian painting, in particular the practice of painterly brushwork, derives directly from close readings of Boschini, Scannelli, and Malvasia.[72] The stylish artifices that Boschini celebrated with *manieroso* are consistent with its usage by Canal, but Canal is ambivalent about its value.

Zanetti wrote in 1771 with the benefit of a historical perspective unavailable to Canal. Between the 1730s and 1770s, the first Venetian art academy was founded, Venetian collections of ancient art were catalogued and published, and the influential histories of Winkelmann and Milizia appeared. These emergent forms of Neoclassicism defined its theoretical tenets and interpreted the historical evidence in opposition to the imaginative, painterly effects of seicento art. When Canal was writing in 1731, some "Mannerists" were still active and the passage of time had not effectively closed a phase in art. Because Canal was more deeply implicated in seicento art than Zanetti was, he had some difficulty in defining it as a coherent and independent style. In particular, he was unable to separate seicento from settecento painting, the latter becoming (by default) a continuation of the former. In other words, he was a transitional critic. This is evident in his usage of *manierato.* Whereas Zanetti defined the *Manieristi* with a consistent and unifying set of qualities, Canal's *manierato* had a semantic fluidity that both acknowledged and resisted conventional usage.

NOTES

1. The Social Sciences and Humanities Research Council of Canada and the Institute for Advanced Study have provided essential support for my project on style and stylistic terminology in Renaissance and Baroque art criticism, from which the present essay derives. Jack Greenstein discussed much of this material with me and gave this essay a careful reading that has greatly improved its content.

2. For a biography of Zanetti, see F. Borroni, "I due Anton Maria Zanetti," *Amor di Libro* 3 (1955): 195–208, and 4 (1956): 12–21; F. Firmiani, "Anton Maria Zanetti il Giovane tra illuminismo e neoclassicismo," *Arte Friuli Arte Trieste* 3 (1979): 73–76; L. Mattioli Rossi, "Collezionismo e mercato dei vedutisti nella Venezia del settecento," *Ricerche di Storia dell'Arte* 11 (1980): 79–92. For brief discussions of Zanetti's art history and criticism, see M. Pittaluga, "Eugène Fromentin e le origini della moderna critica d'arte," *L'Arte* 21 (1918): 6–23; N. Ivanoff, "Antonio Maria Zanetti critico d'arte," *Atti dell'Istituto Veneto di Scienze, Lettere ed Arti* 111 (1952–53): 30–31; F. Bernabei, "La letteratura artistica," in *Storia della cultura veneta: Il settecento* (Vicenza, 1985), pp. 504–505; and P. Sohm, *Pittoresco: Marco Boschini, His Critics, and Their Critiques of Painterly Brushwork in Seventeenth- and Eighteenth-Century Italy* (Cambridge, 1991), pp. 225–238.

3. M. Boschini, *La carta del navegar pitoresco* (1660), ed. A. Pallucchini (Rome-Venice, 1966), p. 134: "E dise che sti nostri Veneziani / I se chiama Pitori de maniera." For a discussion of Boschini, see Sohm 1991, chapter 3.

4. Boschini 1660, pp. 136 and 390. For a discussion of these passages, see Sohm 1991, p. 109.

5. R. Longhi, *Viatico per cinque secoli di pittura veneziana* (Florence, 1946), p. 32.

6. Ibid., p. 34; R. Wittkower, *Art and Architecture in Italy, 1600–1750*, 3d ed. (Harmondsworth-Baltimore, 1973), p. 226. Wittkower identified Padovanino's "academic eclecticism" as the source for "most" mid-seventeenth-century painters, who translated it into "a refined and often languid Seicentesque idiom."

7. London, National Gallery, *Venetian Seventeenth-Century Painting*, 1979, cat. by H. Potterton, p. 8.

8. The brief descriptions of Books 1, 2, and 3 are based on Zanetti's prefaces: A. M. Zanetti, *Della pittura veneziana e delle opere pubbliche de' veneziani maestri* (Venice, 1771), pp. 1–3, 6–7, 87–89, 201–202.

9. Ibid., pp. 300–373. The *Manieristi* include Antonio Aliense, Giulio Carpioni, Giovanni Contarini, Lionardo Corona, Pietro Damini, Francesco Maffei, Pietro Malombra, Palma Giovane, Santo Peranda, Paolo Piazza, Matteo Ponzone, Carlo Ridolfi, Dario Varotari, and Andrea Vicentino.

10. A winged hand stands for the flight of *ingenio* in A. Alciati, *Emblematum* (Milan, 1531), n.p. [A7b]. A winged hand stands for *celer itatem* in H. Junius, *Emblemata* (Antwerp, 1565), no. 32. Wings were a frequent figure of speech for inspiration and rapidity in Dante. For seventeenth-century examples, see F. Bracciolini, in *Marinisti*, ed. G. Getto (Turin, 1954), p. 263; C. Dati, "Editto dell'Accademia della Crusca" (1663), in *Scritti vari*, ed. L. Panciatichi (Florence, 1856), p. 384.

11. Zanetti 1771, pp. 300–302. For Vicentino, Peranda, and Aliense giving free rein to their imaginations, see ibid., pp. 330, 336, and 344. Zanetti excludes Carpioni, Varotari, and Damini from "the servile ideas and excessively free awkwardness of the Mannerists": ibid., p. 373. For the "mannered brushwork" (*incolpa . . . di maniera*) of Bellucci as exemplary of the Mannerists, see ibid., p. 413.

12. Ibid., pp. 323–324. Zanetti discusses here "la loro uniformità di stile . . . ch'è gran segno della decadenza d'un'arte." This refers to the collective uniformity of style of the Mannerists which frustrates even learned attempts to distinguish the style of one master from another.

13. Ibid., pp. 300–301, 330 (where Andrea Vicentino is described as "Abbondante era la fantasia. . . . facile era il suo pennello"). See pp. 344 and 351 for the *speditezza* of Mannerism.

14. Ibid., p. 301; Dolce, *Dialogo*, vol. 1 of *Trattati d'arte del cinquecento*, ed. P. Barocchi (Bari, 1961), p. 196.

15. M. Kemp, "From 'Mimesis' to 'Fantasia': The Quattrocento Vocabulary of Creation, Inspiration and Genius in the Visual Arts," *Viator: Medieval and Renaissance Studies* 8 (1977): 347–398.

16. V. Giustiniani, *Discorsi sulle arti e sui mestieri*, ed. A. Banti (Florence, 1981), p. 43; A. Bosse, *Sentiments sur la distinction des diverses manières de peinture, dessin et gravure, et des originaux d'avec leurs copies* (Paris, 1649), pp. 46–47 and 66–67; F. Scannelli, *Il microcosmo della pittura* (Cesena, 1657), p. 367; Giovanni Pietro Bellori, *Vite de' pittori, scultori et architetti moderni* (Rome, 1672), ed. E. Borea (Turin, 1976), pp. 31–32; C. C. Malvasia, *Felsina pittrice* (Bologna, 1678), ed. G. P. Zanotti (Bologna, 1841), 1:263–264.

17. G. Vasari, *Le vite de' più eccellenti pittori, scultori ed architetti*, ed. G. Milanesi (Florence, 1906), 3:585; Dolce 1961, p. 196; F. Baldinucci, *Notizie dei professori del disegno dal Cimabue in qua*, ed. F. Ranalli (Florence, 1847), 5:31; V. Monaldini, *Risposta alle riflessioni critiche sopra le differenti pitture del Sig. Marchese d'Argens* (Lucca, 1755), p. 62.

18. See, for example, Vasari 1906, 6:397 and 588; Giustiniani 1981, p. 43; C. Ridolfi, *Le meraviglie dell'arte* (Venice, 1648), 2:147; T. Stigliani, *Dello occhiale: Opera difensiva in risposta al Cavalier Gio. Battista Marini* (Venice, 1627), p. 29; and Bellori 1672, pp. 229, 266–267, 451.

19. Horace *Epistles* 19, lib. 1; Zanetti 1771, p. 373. The problem of servile imitation had been identified by Zanetti with seicento painters in the *Descrizione* of 1733. His immediate sources were mostly Arcadian literary criticism: Sohm 1991, pp. 232–236.

20. C. Pedretti, *Leonardo da Vinci on Painting: A Lost Book (Libro A)* (Berkeley–Los Angeles, 1964), p. 32.

21. For "not the sons, but the bastards of nature," see Bellori 1672, p. 21. For artists who mistakenly choose "the dirty canal water" of style over the "pure fountain water" of nature, see R. Borghini, *Il riposo* (Florence, 1584), pp. 139–140. Borghini's source might be Leonardo (C. Pedretti, *The Codex Atlanticus of Leonardo da Vinci: A Catalogue of Its Newly Restored Sheets* [New York, 1978], p. 199): "he who has access to the fountain does not go to the waterpot." For style following style as "shadows," see A. Caro, "Risentimento del predello," in *Opere*, ed. V. Turri (Bari, 1912), 1:77 (good painting is presented as a shadow of nature, but a painting imitating art is but a shadow of a shadow).

22. Vasari 1906, 7:280. Vasari might have been putting words into Michelangelo's mouth, since he applies a similar dictum to Mino da Fiesole ("rare volte passa innanzi chi camina sempre dietro"): 3:115. Michelangelo and Vasari had available a wide variety of *vestigia* in ancient sources, but the closest and best known would have been in Quintilian *Institutio oratoria* 10.2.9–10. For other sources and an excellent discussion, see G. W. Pigman III, "Versions of Imitation in the Renaissance," *Renaissance Quarterly* 33 (1980): 1–32, esp. 17–22.

23. For the relation of imitation and artistic decline in Quintilian, see E. Fantham, "Imitation and Decline: Rhetorical Theory and Practice in the First Century after Christ," *Classical Philology* 73 (1978): 102–116.

24. Boschini 1660, p. 407.

25. Ibid., p. 409. For a discussion, see Sohm 1991, p. 109.

26. Ibid., p. 740. On Boschini's views of seicento painting, see A. Palluchini's introduction to the *Carta* (pp. lviii–lxix).

27. Cignaroli's lives of Veronese painters were published by G. Biadego, "Di Giambattista Cignaroli pittore veronese: Notizie e documenti," *Miscellanea Pubblicata della R. Reputazione Veneta di Storia Patria* 6 (1890): 19–43 (see pp. 37–38 for Signorini). For repetition in old age, see, for example, Paolo Giovio criticizing Perugino for repeating himself in old age: published in A. Tiraboschi, *Storia della letteratura italiana* (Florence, 1712), 6:116.

28. Baldinucci 1847, 3:429 and 4:547.

29. Ibid., 5:105. A similar, but apparently unrelated, statement was made by Roger de Piles, who labeled the late style of artists as mannered (*manièré*) because in old age artists ceased to consult nature and relied instead on habit: *Abrégé de la vie des peintres* (Paris, 1699). Ricchi's life was written before Baldinucci's death in 1696, possibly edited by his son Francesco Saverio, and published only in 1728.

30. Giustiniani 1981, pp. 41–45; originally published in M. Giustiniani, *Lettere memorabili* (Rome, 1675), pt. 3, no. 85.

31. F. Baldinucci, *Vocabolario toscana dell'arte del disegno* (Florence, 1681), p. 88. The history of *manierato* has not yet been written; it will be included as one chapter of my forthcoming book, *Style and Stylistic Terminology in Italian Art Criticism, 1550–1750*. Studies of the reception of sixteenth-century Mannerism in seicento Italy have been few and generally fail to examine the semantic history of the term. Georg Weise and Mario Salmi, for example, mistakenly claim *manierismo* as a seventeenth-century term: Weise (citing Salmi in agreement), *Il manierismo: Bilancio critico del problema stilistico e culturale* (Florence, 1971), pp. 172–173.

32. Baldinucci 1681, p. 88.

33. Baldinucci 1847, 4:15–16.

34. Bellori 1672, pp. 31–33 (but see also p. 229); Malvasia 1678, 2:9 (but see also his life of the Carracci: 1:263–264). Sebastiano Resta did much the same as Baldinucci in his discussion of the "Scuola ideale e manierato" headed by Cesare d'Arpino: S. Resta, *La galleria portatile*, in *I disegni del Codice Resta*, ed. G. Bora (Bologna, 1976), p. 157.

35. Gabburri, *Abecedario pittorico*, manuscript in Florence, Biblioteca Nazionale; this passage quoted by U. Procacci, "Di uno scritto di Giovanni Bottari sulla conservazione e il restauro delle opere d'arte," *Rivista d'Arte* 30 (1955): 235–236. For additional sources applying *ammanierato* to modern painting and a discussion, see Sohm 1991, pp. 216–217 and 229–231. One additional source has come to my attention: J. V. Hugford, *Vita di Antonio Domenico Gabbiani pittore fiorentino* (Florence, 1762), pp. 10–11.

36. Nicolas Vleugels worried that early settecento painters would become confused yet again by following the mannered style of Pietro da Cortona, thereby reintroducing Mannerism to contemporary art: in the Nestenus and Moücke edition of L. Dolce, *Dialogo della pittura* (Florence, 1735), pp. 32–34 and 304. His source was Roger de Piles (1699, p. 248), who found Cortona to be *manièré par tout*. See also C. Ruta, *Guida ed esatta notizia à forastieri delle più pitture che sono in molte chiese della città di Parma* (Parma, 1739), p. 3. Ruta borrows Bellori's phrase "sia viziato con la maniera, o vogliamo dire con idea fantastica" and applies it to Baroque painting. See also G. G. Bottari's comments in his edition of Borghini, *Riposo* (Florence, 1730), pp. ix–x; and his comments in his edition of Vasari, *Vite* (Livorno, 1767), 2:121.

37. R. Fréart de Chambray, *Idée de la perfection de la peinture* (Paris, 1662), p. 120; trans. A. M. Salvini and published posthumously (Florence, 1809), p. 86.

38. E. Borea, in the introduction to her edition of Bellori 1672, pp. xxiv–xxv.

39. For Martelli, see the anonymous "Vita di Pier Jacopo Martello tra gli Arcadi Mirtolo Diandido," in P. J. Martelli, *Della tragedia antica e moderna* (Bologna, 1735), pp. i–liv. For Taja, see V. Leonio, "Vita di Monsig. Gio. Giustino Ciampini," in *Le vite degli arcadi illustri*, ed. G. M. Crescimbeni (Rome, 1710), 2:218; and G. Gigli, *Diario Sanese in cui si veggono alla giornata tutte le cose importanti* (Siena, 1722), p. 181.

40. P. J. Martelli, *Commentari* (Rome, 1710), in *Scritti critici e satrici*, ed. H. S. Noce (Bari, 1963), pp. 140–141. For further discussion of this passage in Martelli, see Sohm 1991, pp. 208–209.

41. A. Taja, *Descrizione del Palazzo Apostolico Vaticano* (Rome, 1750), p. 25. Although Gigli (p. 181) describes in 1722 the work as in press (*sta ora per metter fuora*), the Pagliarini did not receive it until 1748.

42. Taja 1750, pp. 13–15.

43. For sixteenth-century Mannerism as a proliferation of new styles far removed from "the true and natural" that appealed to the senses with charming colors and ornamented drapery ("la vaghezza de' colori . . . gli addobbi delle vestimenti"), Taja's source might have been Agucchi's widely circulated manuscript, published in its entirety by D. Mahon, *Studies in Seicento Art and Theory* (London, 1947), p. 247. The relevant passage had been published earlier by A. Masini in *Bologna perlustrata* (Bologna, 1650), p. 9; and by Malvasia in *Felsina pittrice*, 1:449–450, and in his *Le pitture di Bologna* (Bologna, 1686), pp. 24–25.

44. S. Maffei, *Verona illustrata* (1731; Milan, 1825), 4:260–261. Maffei identifies the "barbaric luxury" of clothing with Gothic architecture whose ornamental overload (a profusion of fringes, tassels, bows, locks, and other dangling ornaments) is taken as a distinguishing feature of Baroque architecture and painting alike: 4:156–157.

45. G. A. Gilio, *Dialogo nel quale si ragiona degli errori e degli abusi de' pittori circa l'istorie* (Camerino, 1564), in P. Barocchi, ed., *Trattati d'arte del cinquecento* (Bari, 1961), 2:3–4 and 49. Barocchi (2:590) suggests that the "notomisti del furioso" was suggested by Aretino's letter to Michelangelo, November 1545; and by Dolce 1961, 1:194ff. Giovanni Battista Armenini complained of contemporary artists as "strange masters of confusion" who amassed many figures and overloaded the composition: *De' veri precetti della pittura* (Ravenna, 1587), ed. M. Gorrer (Turin, 1988), p. 154.

46. Stigliani 1627, pp. 28–29. For further discussion on Stigliani and later criticisms of Mannerist and Baroque painting, see Sohm 1991, pp. 210–232.

47. L. Scaramuccia, *Le finezze de' pennelli italiani* (Pavia, 1674), pp. 22–23; Resta 1976, p. 283; Bellori 1672, pp. 7 and 31–32; Malvasia 1678, 1:263–266; G. B. Passeri, *Vite de' pittori, scultori et architetti che hanno lavorato in Roma*, published in *Die Künstlerbiographien*, ed. J. Hess (Leipzig-Vienna, 1934), pp. 6, 12–13, 21, and 241. Earlier in the century "modern" painting included the cinquecento: G. C. Gigli, *La pittura triofante* (Venice, 1615), p. 24; and Giustiniani 1981, pp. 43–44.

48. Martelli 1710, p. 140.

49. For these and other writers, see Sohm 1991, pp. 197–238.

50. Ibid., pp. 200–204, 207, 222, 232.

51. Maffei 1825, 4:254–255.

52. V. da Canal, *Vita di Gregorio Lazzarini*, ed. G. A. Moschini (Venice, 1804), p. 16; Zanetti 1733, p. 58.

53. The only article devoted to Canal is short and descriptive: N. Ivanoff, "Vincenzo da Canal critico della pittura Veneziana," *Arte Veneta* 7 (1953): 117–118.

54. Maffei 1825, 4:254–255.

55. Zanetti 1733, p. 58.

56. Ibid., p. 4.

57. Zanetti, in an undated letter to Gabburri (1723), used *ammanierato* to describe the distortion that an artist might inject into a copy of ancient statuary by charging it with excess grace: G. G. Bottari and S. Ticozzi, eds., *Raccolta di lettere sulla pittura, scultura ed architettura* (Milan, 1822), 3:137. It is possible that this letter was written by Zanetti's eponymous cousin, Antonio Maria Zanetti q. Gerolamo, who had started planning and making engravings for *Delle antiche statue* (Venice, 1740) as early as 1722; Zanetti q. Alessandro joined the enterprise in 1735.

58. Zanetti 1733, p. 59.

59. J. von Derschau, *Sebastiano Ricci: Ein Beitrag zu den Anfängen der venezianischen Rococomalerei* (Heidelberg, 1922), p. 40.

60. M. Levey, *Painting in Eighteenth-Century Venice* (London, 1959), p. 19. Levey removed this statement from the revised edition (New York, 1980) and wrote instead, "Ricci's importance as forerunner was colossal" (p. 44).

61. The most specific references for the date of the *Vita* are 1) "che va [Tiepolo] ora dipingendo in Milano"; and 2) "non conta desso [Tiepolo] che l'anno 35 di età" (p. 35). Tiepolo was born in March 1696. For a new documented dating of Tiepolo's work in Milan (August 1730), see P. Sohm, "Giambattista Tiepolo at the Palazzo Archinto in Milan," *Arte Lombarda* 68–69 (1984): 70–78. For the pivotal role of Ricci, see Canal 1804, p. 19.

62. V. da Canal, *Della maniera del dipingere moderno;* published in *Mercurio filosofico, letterario e poetico* (1732–35), March 1810, p. 20.

63. Canal 1810, pp. 19–20.

64. Canal 1804, pp. 17–19; Canal 1810, pp. 4 and 18.

65. For the attributes of coloring (*ameno, finito, morbido, vago, delicato, dolce, manieroso, pittoresco*), see Canal 1804, pp. 15, 17–19, 22, 27, 41, 70, 72; and 1810, pp. 4–7, 10, 12, 14, 18. For the attributes of design (*intelligenza, corretto, esatto, diligente, studioso*), see 1804, pp. 15, 17, 20, 23, 32, 44, 46–48, 70, 72; and 1810, pp. 4, 14, 16.

66. P. Sohm, "Gendered Style in Italian Art Criticism from Michelangelo to Malvezzi," *Renaissance Quarterly* (forthcoming).

67. Canal 1804, p. 19. For the taste that dilettantes have for coloring, see also Canal 1810, p. 11.

68. Canal 1804, pp. 15 and 19.

69. Canal 1804, pp. 19–20; 1810, p. 10. The description of Sebastiano Ricci as "risoluto e manieroso" repeats that of Venetian painting as "risoluto, manierato"; Balestra lacks "quel manieroso e di quel carattere pittoresco," which puts *manieroso* in relation to painterly (*pittoresco*) just as Canal had with "mannered" Venetian painting ("risoluta, manierata ed assai più vaga . . . un colore ed estro pittoresco").

70. *Vocabolario degli Accademici della Crusca* (Florence, 1612), p. 507; for a discussion of *manieroso* with many sources cited, see Sohm 1991, pp. 223–235.

71. Passeri 1934, pp. 12–13; Malvasia 1678, 1:212 and 263–264, and 2:7; Malvasia 1686, p. 149; Bellori 1672, p. 418; Scaramuccia 1674, p. 41.

72. Malvasia (1678, 1:220) used the same combination of *manieroso* and *risoluto* as Canal. Canal cited the *Felsina pittrice* as authoritative and seems to have used it as his primary source for Bolognese painting: 1810, p. 4. Scannelli (1657, pp. 109, 239, and 260) used *manieroso* as the unnatural appearance that seicento painters liked and as a specifically Venetian quality. Boschini used *manieroso* more often than any other writer, always in a positive sense as synonymous with beauty or an unnatural transcendent beauty, or as the painterly freedom of Venetians in particular: 1660, pp. 68, 136, 313, 326, 390, 735, 738.

CATALOGUE

AUTHORS

ISTVÁN BARKÓCZI (I.B.)

ZSUZSANNA DOBOS (Zs.D.)

GEORGE KEYES (G.K.)

VILMOS TÁTRAI (V.T.)

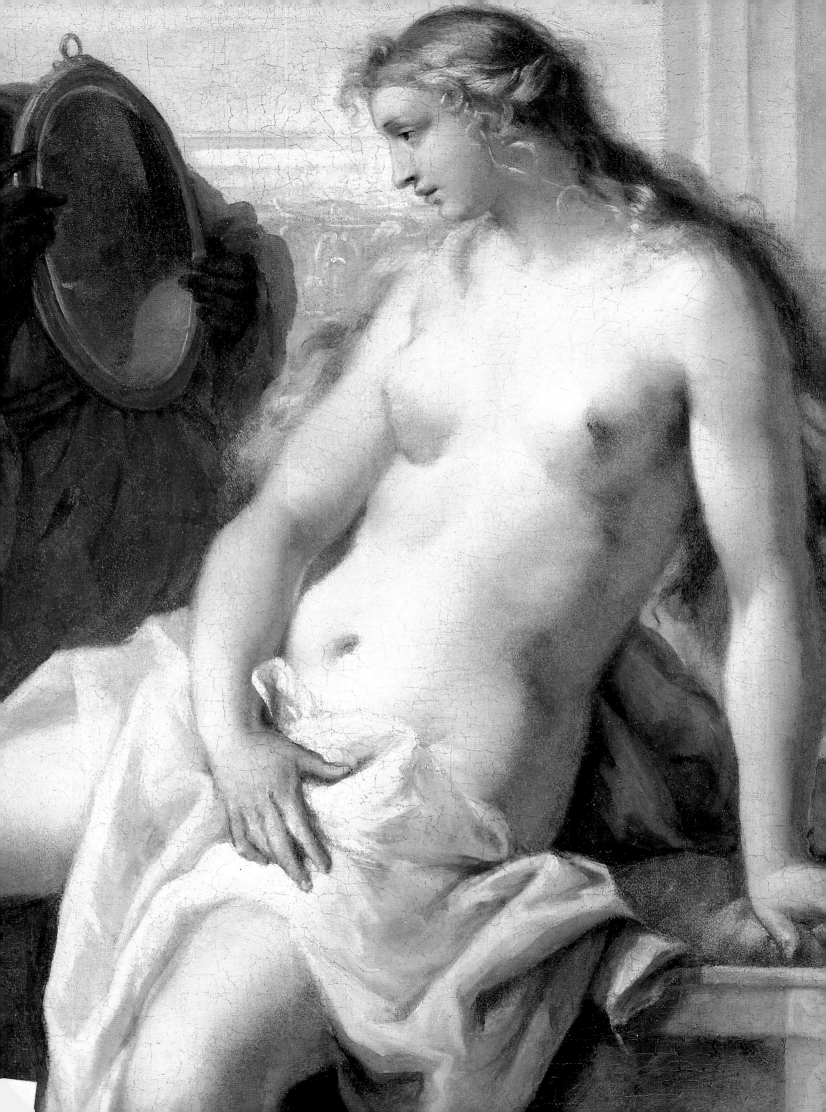

SCENES

FROM

THE OLD TESTAMENT

] *1* [

Judith with the Head of Holofernes

Oil on canvas, 129 × 104 cm
PROVENANCE: Venice, Vidiman Collection (?);[1] presented by
Ernő Kammerer to the museum, 1916,[2] inv. 4913

THIS SUBJECT, based on the apocryphal *Book of Judith* (13:8–10), became extremely popular during the early Baroque period, particularly in Venice,[3] where the story inspired numerous painters and musical composers from Giorgione to Vivaldi.

The Jewess Judith, accompanied by her maid, visited the Assyrian general Holofernes, who was besieging her city, Bethulia. She feasted alone with him in his tent, and after Holofernes succumbed to the influence of drink, she decapitated him. The Assyrian enemy, disoriented by the death of their leader, abandoned their siege and fled. Thus Judith became a heroine defending and securing the independence of her people. Her seductive role provided a perfect opportunity for painters to create sensuous representations of this biblical story.

Johann Liss, a native of the Holstein region in northern Germany, lived in the Netherlands between about 1615 and 1616. He resided in the cities of Haarlem, Amsterdam, and Antwerp before traveling to Paris and Venice, where he arrived by 1621. By 1622 Liss reached Rome, where he stayed for a few years, but toward the end of the decade he resettled in Venice.[4] During his journey from Holstein to Italy, Liss was exposed to many artistic influences, which he incorporated into his paintings. These included the genre painters of Haarlem, the exuberant Baroque art of Rubens, the realism of Caravaggio, and the colorism of Venice.

The composition of this *Judith* exists in several versions.[5] Showing the influence of several different painters, it was primarily inspired by Rubens. After Rubens returned to Antwerp from Italy in 1609, he painted many violently dramatic works such as *Prometheus Bound* of about 1611–12, now in the Philadelphia Museum of Art, and his now lost representation of *Judith*[6] of about 1609–10, which betrayed his debt to Caravaggio. Liss's visit to Antwerp seems to have coincided with this period of Rubens's activity in Flanders. The bold foreshortening of the figure of Judith in Liss's painting, the twisting bodies, the fluid brushwork, and the sensuous depiction of human flesh all emulate Rubens. This association with Rubens finds further confirmation through the theatrical lighting and strong modeling deriving from Caravaggio.

Nonetheless, other influences can be detected in this work. The compact grouping of the figures projecting into the foreground, the range of colors, and the generally buoyant spirit owe much to Roman

and Bolognese artists of the early Baroque. Conversely, the three-quarter-length format conforms to a well-established Venetian tradition, which continued well into the eighteenth century in the paintings of such artists as Sebastiano Ricci[7] and Piazzetta.

Compared to Liss's later, more mature and elaborate, works, such as *The Vision of Saint Jerome* in the Church of San Niccolò da Tolentino in Venice, *Judith with the Head of Holofernes* has a more balanced composition. Further, the dynamic movement of the figures in this *Judith* is characteristic of the early Baroque; therefore Levey's proposed dating of 1622–23 seems fully acceptable.[8]

The theatricality of this dramatic scene is underscored by the melodramatic light effects that illuminate the heroine's flowing dress and demonstrative gesture. Liss's Judith becomes a new, updated Venetian courtesan, notable for her provocative expression. She is self-consciously aware of her role, suffused with success and inner satisfaction.

After its recent cleaning in 1993, this painting revealed Liss's characteristic painterly touch, providing ample grounds to refute published assertions that the picture should be classified as a copy after Liss.[9] The dynamic rendering of the heroine's richly gathered blouse with its lace-trimmed neckline is painted subtly and with elaboration. The flesh tones of Judith's back and Holofernes's body are sensitively modeled and convincingly project Liss's spirited creative energy.[10] —I.B.

] 2 [

Lot and His Daughters

Oil on canvas, 177 × 208 cm
PROVENANCE: Budapest, Andrássy Collection; Budapest, private
collection; purchased for the museum, 1967, inv. 67.14

PIETRO LIBERI, after three years of apprenticeship in Padovanino's studio and several years of travel throughout the Mediterranean, spent three years in Rome before returning to Venice, where he became one of the most celebrated painters of the *Serenissima*. His art recalls the cinquecento tradition: his robust secular spirit and his representation of female nudes in selected allegorical subjects won the appreciation of the doge and that of the Habsburg emperor, Leopold I. The emperor invited him to his coronation in Vienna in 1658. From there Liberi visited Germany and Bohemia, and, alone among the leading Venetian painters of the seventeenth century, he visited Hungary. In 1659 he returned to Venice, where he remained active until his death.

Pietro Liberi's son, Marco, was also a painter whose style closely resembled that of his father, thereby leading to confusing issues of attribution. Only scant information survives concerning Marco, due principally to the fact that eighteenth-century biographers devoted only a few sentences to him, usually with pejorative overtones, invariably appended to the chapters on his father. Approximately twelve pictures have been attributed to him,[1] based on his one indisputable work, the signed *Jupiter and Asteria* (cat. no. 35) in Budapest. They prove that Marco was not only his father's pupil and assistant but also his most immediate artistic successor, faithful imitator, and propagator of his art. Marco's pictures display certain weaknesses, such as the lack of grandeur indicated by Zanetti[2] and the timorous draftsmanship cited by Nicodemus Tessin.[3] The more angular forms, drier execution, and, in some instances, the painfully clumsy proportions justify Zanetti's remark that some of Marco Liberi's female figures almost become caricatures of his father's heroines.[4]

Klára Garas[5] and later Á. Szigethi[6] published the Budapest version of *Lot and His Daughters* as Marco Liberi's work. According to the sources, both Pietro and Marco Liberi painted this Old Testament episode. None of Pietro's documented representations of Lot and His Daughters survive,[7] but we do know the composition that was once in the Palazzo Grimani in Venice from Pietro Monaco's engraving after it.[8] A half-length version by Marco was documented in the collection of Alessandro Savorgnan in 1699.

By comparing works indisputably attributed to both masters, we may conclude that the *Lot and His Daughters* in Budapest is by Pietro Liberi and is perhaps one of the above-cited versions. In this

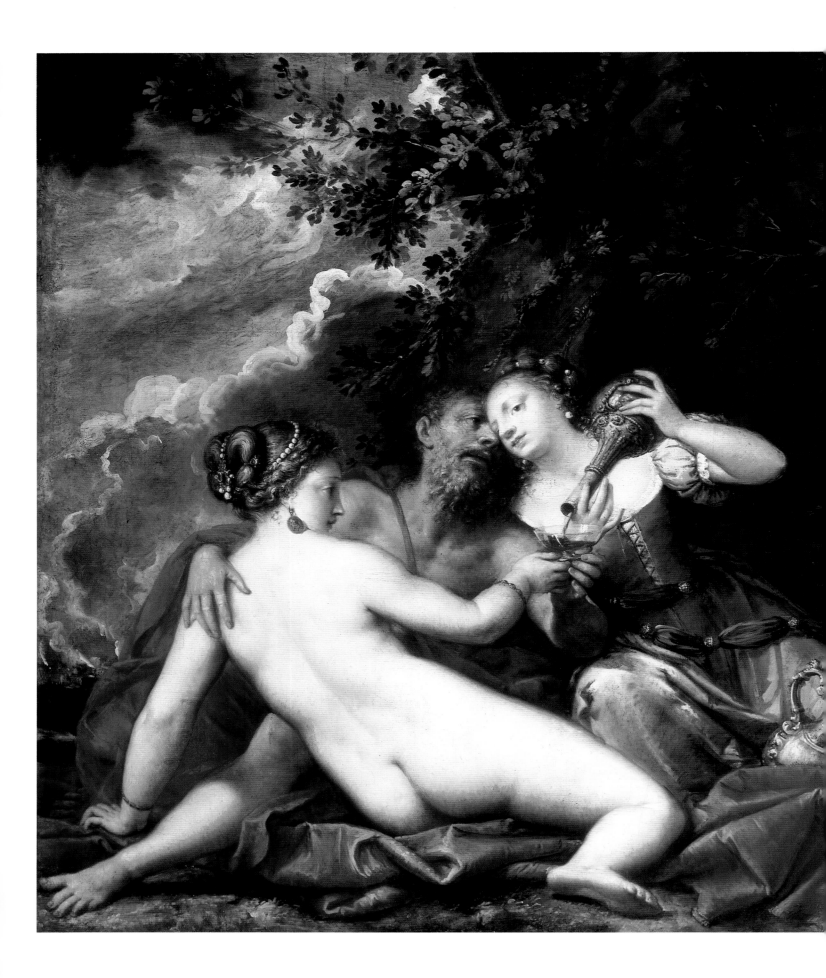

work, emphasis is placed on the intricate poses of the figures, conforming to late Mannerist taste. The nude seen from the back may be considered a "trademark," as it recurs almost verbatim in other paintings by Liberi.[9] Many analogous female figures in profile exist in Pietro Liberi's works. The closest parallel is found in *Medoro and Angelica* in the Alte Pinakothek in Munich, in which the face of the male hero, with his mouth open to speak, finds an almost exact match in the face of the daughter pouring wine. The two pictures are closely related in type and in the execution of the foreground vegetation, as well as in the use of chiaroscuro, which softens the forms. Light casts a delicate half shadow over the faces and sensitively delineates the locks of hair of each figure.[10] In contrast, even Marco's most successful works are more rigid in execution, more mechanical in representing the reflection of light playing on the figures' hair, and stiffer in modeling and coloring. When compared to the fiery red, ocher, and grayish blues found in *Lot and His Daughters,* Marco's palette seems dull and almost bloodless.

On the basis of this stylistic analysis the painting in Budapest may be dated to about 1660, close to *Diana and Actaeon* in Berlin, the *Bath of Diana* in the Hermitage in St. Petersburg, and the previously mentioned *Medoro and Angelica* in Munich.

In conclusion, a small but intriguing motif, truly a witty pictorial caprice, reinforces this cataloguer's assessment of the style and merits of *Lot and His Daughters.* Although this is only a conjecture, the daughter seen in profile wears an earring that appears to reflect the image of Cavaliere Pietro Liberi—a daring means of including a painter's self-portrait. —Zs.D.

] 3 [

Joseph Interpreting Dreams in Prison

Oil on canvas, 135 × 111 cm
PROVENANCE: Vienna, R. Herdler Collection; New York, Jenő Boross Collection;
by whom presented to the museum, 1930, inv. 6387

ALTHOUGH THE GENOESE Giovanni Battista Langetti began his career in the Roman work-
shop of Pietro da Cortona, he was ultimately not deeply influenced by Cortona's ceremonious, decora-
tive style. Already by 1660, five years after settling in Venice, Langetti was described by Boschini,
commenting on his *Apollo and Marsyas,* as painting with a "dark and shadowy genius."[1] Langetti's
expressive use of light and shadow, naturalism, rough and robust or sometimes demonstrably emphatic
forms find their roots in his Genoese origin and specifically in the influence of Orazio de Ferrari and
Gioacchino Assereto. Langetti was also inspired by Luca Giordano, who worked in Venice in the early
1650s and in the late 1660s and introduced Ribera's version of Neapolitan Caravaggism to that city.
Langetti's style finds parallels in the canvases of his Venetian contemporaries Antonio Zanchi, Pietro
Negri, and Johann Karl Loth.

Stefani Mantovanelli, the greatest Langetti authority, has recently compiled the master's oeuvre
totaling approximately 130 paintings, whose subjects are primarily drawn from the Old Testament, clas-
sical mythology, and ancient history.[2] Langetti's heroes (for he hardly ever depicted heroines), appear
most frequently in great moments of trial or in contemplative solitude, mental or physical anguish, or
dying. Typical Langetti subjects thus included suicidal Cato inflicting his fatal wound, Tantalus with
his face distorted in pain, Jonah tormented by his thoughts after having been disgorged by the whale, and
Archimedes recoiling from his murderer. Besides psychological characterization, Langetti was clearly
interested in anatomy, as evidenced by his representation of these half-length muscular, seminude male
figures, usually assuming complicated, twisting poses within bold compositions.

In several portrayals Langetti elaborated on the scene from Genesis in which Joseph explains
dreams while in prison, exploring the contradictory aspects of his prophecies. These variants differ in size
and format.[3] Compositionally, the Budapest painting relates most closely to a version at Nagyszeben
(Sibiu, Rumania). Though it is nearly impossible to arrive at a chronological sequence for Langetti's
paintings, *Joseph Interpreting Dreams in Prison* belongs, in all likelihood, to the painter's mature pe-
riod. This dating is supported by his effective use of light: in the Budapest painting, light penetrates the
small, dark cell from the left, illuminating the muscles and even the smallest details of the bodies, includ-
ing the joints of the fingers and the corners of the eyes. This raking light simultaneously casts deep shad-
ows across Joseph's face, torso, and the folds of his robe.

74

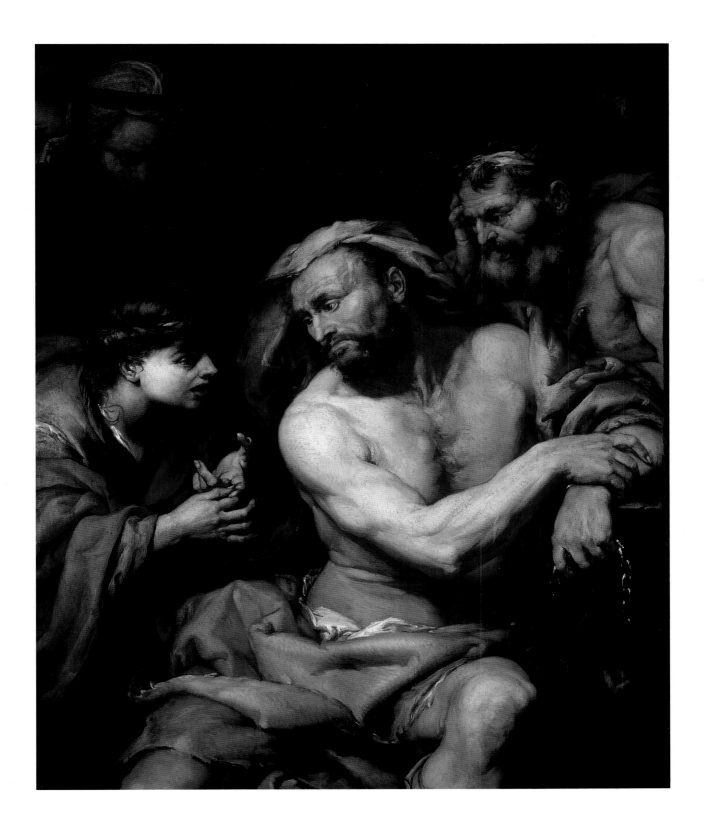

In addition to the bold chiaroscuro, the drama of the scene is enhanced by the figures' theatrical and pathetic gestures and expressive countenances. The three male figures who represent three different ages of man are standard characters of Langetti, recurring in various roles in his paintings. The thickly applied paint and the bright colors, such as the light blues and mauves contrasting with the gray hues of the body, reveal that Langetti remained indebted to his Genoese compatriot Bernardo Strozzi.　　—ZS.D.

] 4 [

Bathsheba at the Bath

Oil on canvas, 118.5 × 199 cm
PROVENANCE: Budapest, Csetényi Collection, by 1926;[1]
gift of Mrs. József Csetényi, 1957, inv. 57.9

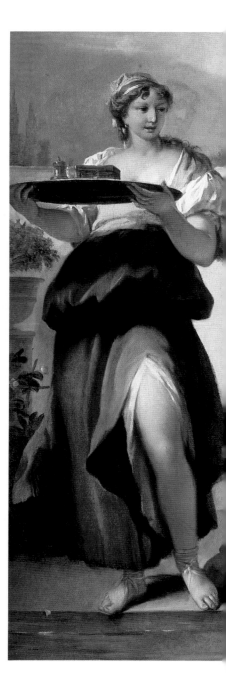

THE TWO OLD TESTAMENT SCENES by Sebastiano
Ricci in this exhibition, *Bathsheba at the Bath* and *Moses Defend-
ing the Daughters of Jethro* (cat. no. 5), are companion pieces. Al-
though nothing is known of their provenance, their size and format
suggest that they were wall decorations for a palace, probably in
Venice. The two paintings share a common iconographical theme,
the first amorous encounters of two Old Testament figures, Moses
and King David, with their future wives.[2] In *Bathsheba at the Bath*
King David gets his first glimpse of the beautiful Bathsheba (2 Sam.
11:2–3), whereas Moses first meets his future wife, Cippora, one of
Jethro's seven daughters, while he is guarding her father's sheep
(Exod. 2:16–17).

Both subjects were popular with painters active in Venice from
the beginning of the seventeenth century and especially with Ricci's
contemporaries, such painters as Liberi, Zanchi, Giordano, and
Celesti.[3] Despite the fact that both compositions appear in Ricci's
Venetian sketchbook,[4] no clue exists as to their original destination.
However, Ricci's drawings indisputably confirm the attribution of
these two paintings, despite the fact that they were earlier ascribed to
Giambattista Tiepolo. The drawings—and in the case of *Bath-
sheba at the Bath,*[5] surviving painted copies—prove that both com-
positions were originally somewhat bigger. *Bathsheba at the Bath*
has been cut along the top and its corners have been trimmed and
shaped as spandrels, whereas *Moses Defending the Daughters of
Jethro* has been trimmed along the top and right sides.

In *Bathsheba at the Bath* Ricci presents the erotically charged
subject in an opulent setting, into which the artist introduces an

76

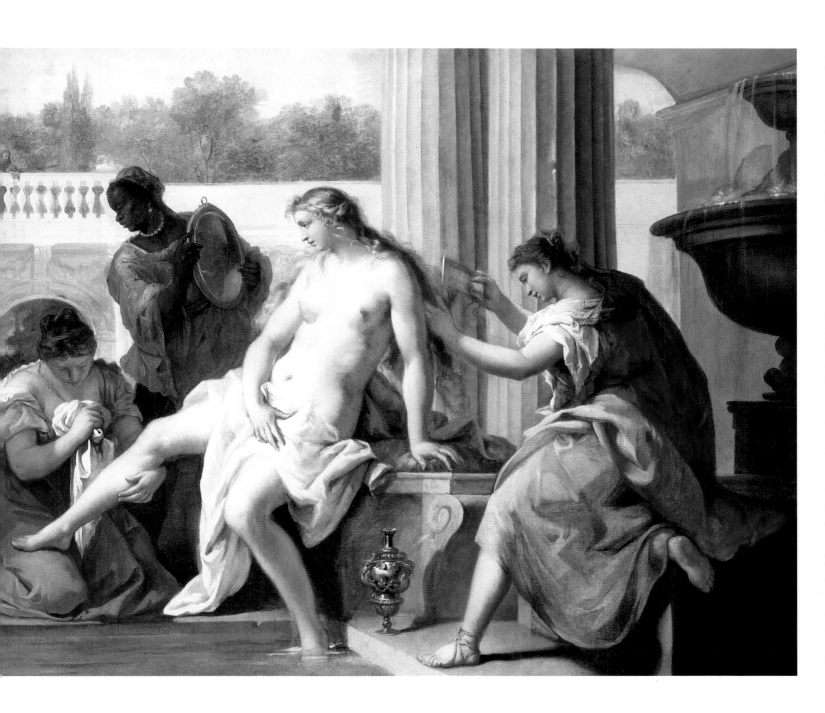

element of suspense. The festive, elevated mood is enhanced by the grand architecture, particularly the pair of fluted columns that emphasize Bathsheba's beauty and importance.

Although the composition is clearly inspired by Venetian Renaissance prototypes, Ricci's painterly technique, pastel coloring, and the almost silky, silvery luminosity may derive from Luca Giordano. The fact that the essential classical style of *Bathsheba at the Bath* betrays no influence from Magnasco, with whom Ricci became acquainted in 1711, may indicate a much earlier dating than hitherto proposed. It should be placed within the period 1708–11, at which time Ricci began to develop a style deeply inspired by the art of Paolo Veronese. This early dating is supported by compelling stylistic evidence, despite Pallucchini's proposed dating to just after 1717, Garas's and Daniels's dating to about 1724, and Martini's dating to the 1720s.[6]

The apparent relationship of this scene to the classicizing compositions Ricci painted in England in 1712–16 further supports this early dating, which underscores the true precociousness of this picture. Following Ricci's return from England his style became more agitated, reflecting the influence of Magnasco.[7] Ricci's compositions become more crowded and his representation of drapery becomes more detailed and broken.

Pictures offering the closest comparison include *Susanna and the Elders* of 1713, painted for Lord Burlington and now at Chatsworth, and *Angelica and Medoro*, probably of similar date, now in the Muzeul Brukenthal in Sibiu, Rumania. Analogies between these pictures and *Bathsheba at the Bath* are evident in the composition, in the scale of the figures relative to the picture space, and in the broad, yet angular representation of the drapery.　　　—I.B.

] 5 [

Moses Defending the Daughters of Jethro

Oil on canvas, 114 × 178 cm
PROVENANCE: Budapest, Csetényi Collection, by 1926;
gift of Mrs. József Csetényi, 1957, inv. 57.10

MOSES DEFENDING THE DAUGHTERS OF JETHRO is an important example of the eighteenth-century style known as *barocchetto*. This pictorial mode resulted in part from the amalgamation of certain classicizing features of Venetian Renaissance painting with elements of the Baroque. The contradictory aspects of this style can often be observed in a single painting, in which figures are represented in a Venetian Rococo mode, while the background architecture displays a pronounced classicism.[1] In Sebastiano Ricci's case the formal gardens, courtyards, and elegant buildings making up the setting for so many of his pictures are inspired by Paolo Veronese's mythological and history subjects. A prime example is *Bathsheba at the Bath* (cat. no. 4), the companion piece to *Moses Defending the Daughters of Jethro*. Ricci in fact played a major role in shaping this early-eighteenth-century Veronese renaissance. This revival of interest in Veronese can be interpreted as a form of escapism, a harking back to an earlier period perceived by artists as a kind of golden age in marked contrast to their own epoch, when the Venetian Republic was progressively diminishing in political and economic importance.

As opposed to the demonstrably Venetian inspiration of *Bathsheba at the Bath,*[2] in *Moses Defending the Daughters of Jethro* the tradition of Florentine Mannerism is manifest in such elements as the friezelike grouping of the figures. The delineation of drapery in broad, angular folds is another quality that relates this composition to Ricci's paintings executed in 1706–7 for the Marucelli and Pitti palaces in Florence. Nonetheless, the resonant, warm color scheme unmistakably derives from Paolo Veronese. This unique admixture of stylistic influences indicates that Ricci produced *Moses Defending the Daughters of Jethro* during his third sojourn in Venice, from 1708 to 1711. During this period Ricci fully formulated his own version of the Veronese revival, in which he expressed his complete understanding of the language of the Rococo with brilliant and scintillating clarity.[3] These contrasting qualities are evident in an idiosyncratic and potentially contradictory form in these two remarkable companion paintings in Budapest.

The original composition of *Moses Defending the Daughters of Jethro* was considerably larger, as demonstrated by Ricci's drawing from his Venetian sketchbook.[4] Moses appears as an Old Testament Hercules, protecting Jethro's seven daughters from the shepherds, although Ricci represented only three of the daughters in both this canvas and his preliminary compositional drawing.

Prior to the predominant influence of Veronese on his art, Sebastiano Ricci had been influenced by other painters such as Palma Giovane, Paris Bordone, and Annibale Carracci. Ricci's ability to emulate Veronese was sufficient to enable him to pass off some of his own work as by Veronese.[5] Independently, the well-known British resident in Venice, Consul Smith, had Ricci's *Finding of Moses,* now at Buckingham Palace in London, engraved in 1741 as a work by Veronese.[6] George Vertue bemusedly commented on Ricci's indisputable if morally dubious talent as "a great mimick of other former antient Italian Masters" and added, "by this means several of his pictures have been sold to Noblemen as the paintings of his predecessors when they were really his."[7]

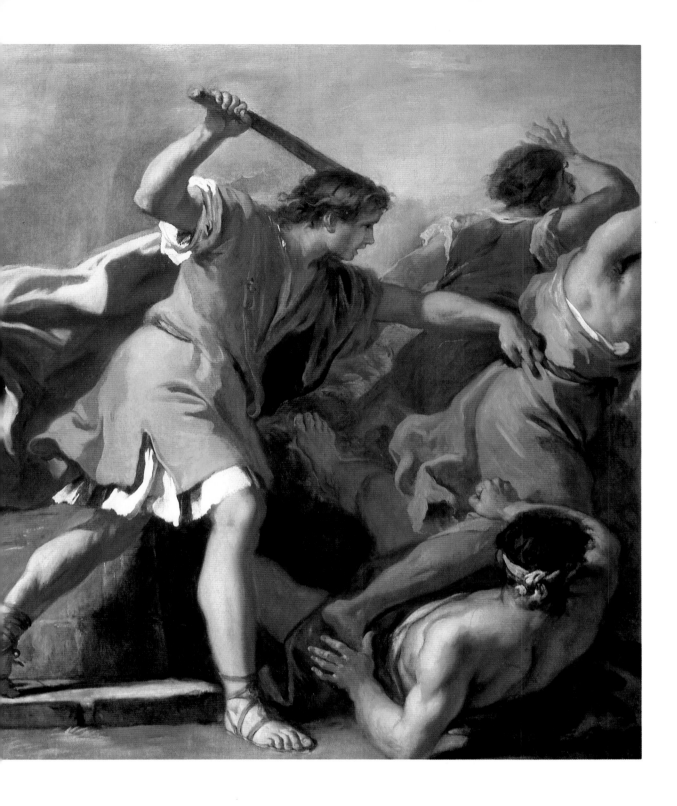

Ricci's importance as a forerunner of the full-blown Venetian Rococo of Tiepolo was inestimable. Yet the constant comparison of Ricci's art with that of Veronese and Giambattista Tiepolo has almost invariably resulted, until recently, in an unfavorable appraisal of Ricci's talent. Despite this deep-rooted negative assessment, one must recognize that Ricci was an innovator who first explored new subjects, including ones treated in contemporary Italian opera, and developed pioneering formal solutions which later painters successfully emulated. —I.B.

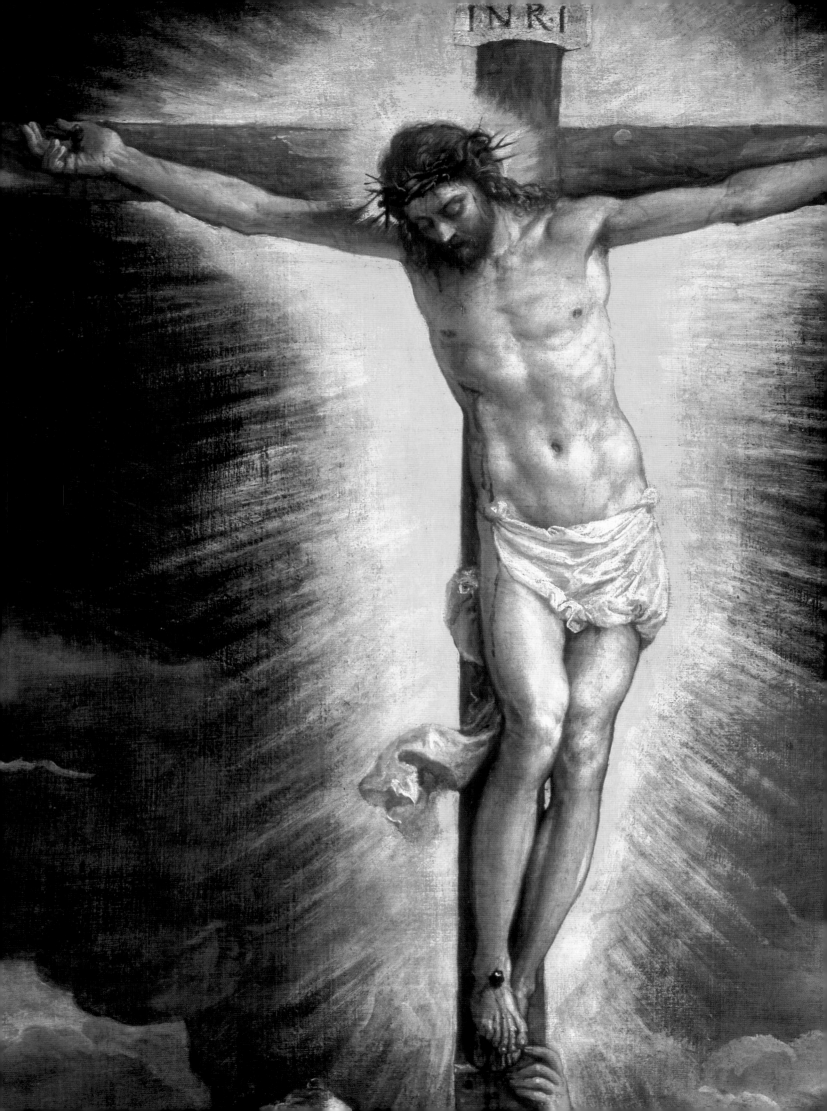

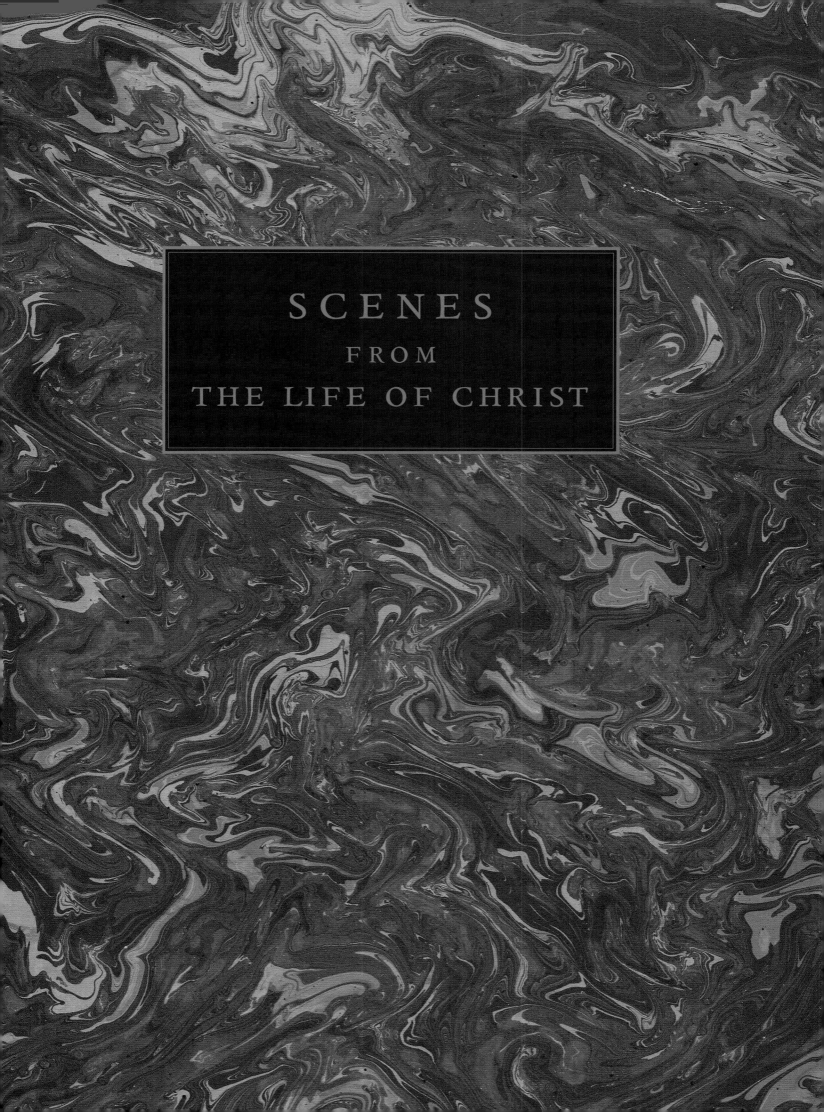

SCENES

FROM

THE LIFE OF CHRIST

] *6* [

The Dead Christ

Oil on panel, 87 × 69.8 cm
PROVENANCE: Pozsony (Bratislava), Count János Pálffy Collection;
by whom bequeathed to the museum, 1912, inv. 4206

LITTLE IS KNOWN about Marco Basaiti despite the fact that his sizable oeuvre includes signed and dated paintings ranging from 1496 until 1521.[1] Although he produced portraits, the majority of Basaiti's output consists of religious subjects that range from full-scale altarpieces to private devotional images. While reflecting the general influence of Giovanni Bellini, Basaiti's religious paintings also betray the impact of Alvise Vivarini and Cima da Conegliano.[2]

The Dead Christ in Budapest is one of Basaiti's finest pictures and demonstrates this artist's striving to synthesize the pathos expressed by Giovanni Bellini with Cima's penchant for detail. The picture is closely related to Basaiti's *Pietà*, formerly in Berlin, but destroyed during World War II.[3] This lost *Pietà* included an almost identical figure of Christ. In representing Christ alone, Basaiti altered the position of the Savior's left arm. It rests limply with the open hand displaying the nail wound, whereas in the Berlin *Pietà* Mary Magdalene holds Christ's left arm and raises his left hand to her face. One notable difference is Christ's hairstyle, which in the Budapest painting consists of curly locks. It probably derived from the figure of John the Evangelist in the *Pietà*, whose curly hair and general physiognomy are analogous to the head of Christ here.[4]

Basaiti's *Dead Christ* stems from earlier images of Christ as the Man of Sorrows. This subject evolved in the later Middle Ages, conflating representations of Christ on the cross with Christ in his tomb and containing many associations with the Passion cycle.[5] The image of the dead Christ seated or placed upright in his tomb is neither a historical subject nor an iconic cult image. Instead, it is lyrical and contemplative rather than epic or dramatic in intent, and as a devotional image it permits a meditative relationship between subject and viewer by association.[6]

Giovanni Bellini's representations of the Lamentation and of the Pietà were so compelling and conveyed such depth of feeling that they were widely emulated in Venice. Bellini transformed the traditional icon of the dead Christ, the *Imago pietatis,* into a modern devotional image which invokes a sense of historical actuality.[7] In certain images such as his damaged picture of about 1500 now in Stockholm, Bellini placed the three-quarter-length figure of the dead Christ seated in the tomb before a rock ledge.[8]

Basaiti's *Dead Christ* is closely related to Bellini's picture in Stockholm even down to such details as the many plants growing from the rocks. In both pictures, the dead Christ wears the crown of thorns

84

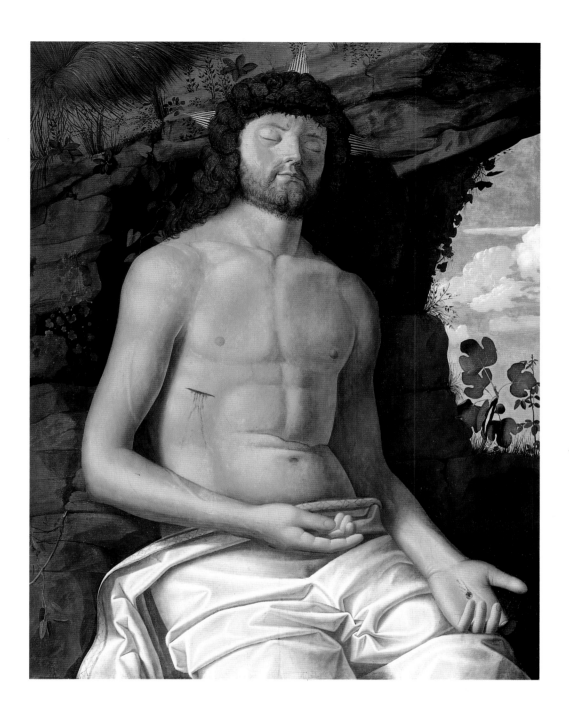

and has a halo consisting of three clusters of light beams radiating from the top and sides of his head. This image of Christ, nude except for the white shroud around his loins, is close to representations of the Man of Sorrows, but now his eyes are closed in death. This focuses meditation on the mystery of the Passion of Christ and his Resurrection. Christ is seated in a grotto, in reference to his tomb in Gethsemane, yet is miraculously resurrected from the tomb with its lid removed. Among the many plants the fig tree silhouetted against the sky at the right makes reference to the Fall of man. Other plants may allude to the herbs used to anoint Christ's body. The subtle play of light across Christ's muscular figure and his position before the rock ledge create a meditative image of great pathos and indicate to what degree painters like Basaiti responded to the daring innovations introduced into Venetian painting by Giovanni Bellini.

—G.K.

] 7 [

Christ Carrying the Cross

Oil on canvas, 94 × 114 cm
PROVENANCE: New York, Jenő Boross Collection;
by whom presented to the museum, 1922, inv. 5879

UNTIL RECENTLY Jacopo Bassano has failed to attain recognition, now long overdue, as an artist in the forefront of the Venetian school, close in rank to Titian, Tintoretto, and Veronese. This is due in large measure to the numerous inferior replicas and copies initially mass-produced in the Bassano family workshop and subsequently perpetuated by anonymous copyists who generated second- and thirdhand repetitions of the biblical subjects, genre scenes, and allegories of the seasons associated with Jacopo Bassano's late period.

During his long career, Bassano's style changed radically. Although he spent most of his life in his tiny native town of Bassano, at the foot of the Dolomites, his experimental spirit, open to a rich array of outside influences, was anything but provincial. Verci, in his *Opere de' pittori, scultori e intagliatori della città di Bassano* of 1775, divided Jacopo Bassano's oeuvre into four stylistic periods.[1]

Together with the *Beheading of Saint John the Baptist* in Copenhagen and the *Lazarus and Dives* at the Cleveland Museum of Art, *Christ Carrying the Cross* was painted in the early 1550s[2] and is one of the representative works from the third stylistic period, which encompasses Bassano's first fully mature Mannerist works inspired by Parmigianino and Schiavone. It came to the Museum of Fine Arts attributed to Andrea Schiavone. However, in 1929 Venturi not only recognized its true author but, in his discussion of Bassano in his *Storia dell'arte italiana*, praised the painting's exceptional beauty and dramatic power.[3] Indeed, this is one of Jacopo da Ponte's most sophisticated works, in which he portrayed the biblical episode in a visionary manner involving an extraordinarily complex interweaving of composition, light, and color. With regard to style and iconography, the innovative tenor of *Christ Carrying the Cross* in Budapest becomes readily apparent when juxtaposed with earlier versions of the same subject.[4]

In this sweeping drama, Christ and the other figures flash before us momentarily but remain indelibly fixed in our memory. Forced to his knees under the weight of the cross, harrowingly alone in the crowd surrounding him, Christ turns back to look at his mother, Mary, who clasps her hands in prayer. The two women accompanying her are embodiments of anguish. With their elongated proportions they seem spiritualized beings; their white shawls twist and turn like tongues of flame. Veronica, wearing a gleaming metallic dress, assumes a twisting pose as she proffers her veil. Her role in the drama transforms Veronica into a figure of noble beauty. Horses, helmeted soldiers in glittering armor, and muscular exe-

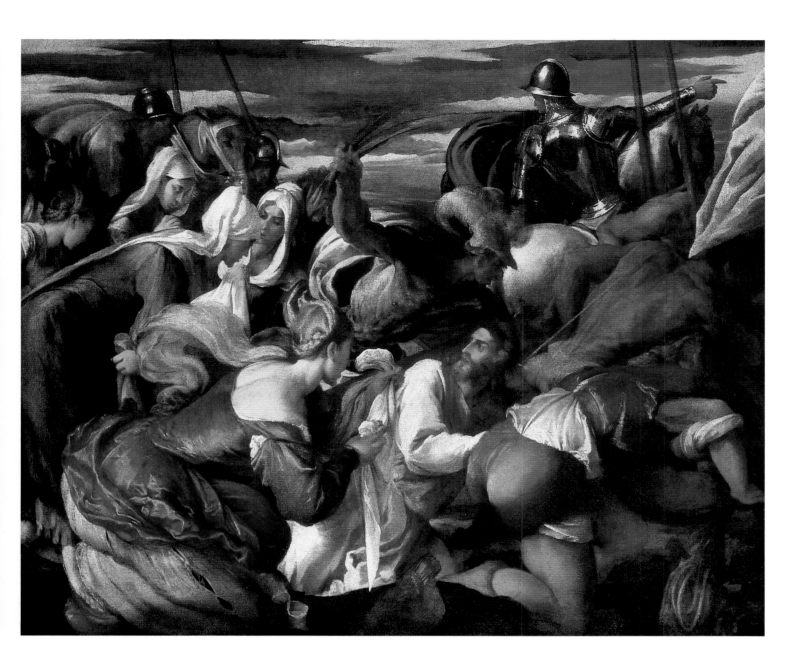

cutioners march across the scene. Seen as a mass, the figures all but screen out the sky across the top, which appears between the lances and the whip raised to strike Christ. The crowded yet subtly balanced composition, distorted proportions, and tense and febrile draftsmanship anticipate the work of El Greco. The simultaneous expression of love, bitterness, and brutality lends psychological poignancy to the subject, its expressive force enhanced by dramatic highlighting. These qualities make this masterpiece of Venetian Mannerism a consummate representation of tragic anguish, agony, and defenselessness.

—V.T.

] 8 [

Christ and the Woman Taken in Adultery

Oil on canvas, 163 × 202 cm
PROVENANCE: Rome, Palazzo Barberini (?); presumably taken
to Paris by an officer during the Napoleonic Wars (?); London, Grosvenor House, duke
of Westminster Collection, 19th century; Budapest, Marcell von Nemes Collection;
Munich, auction M. von Nemes (H. Helbing), June 16, 1931, lot 34;
Baron Lipót M. Herzog Collection; acquired, 1951, inv. 51.808

BURCKHARDT WAS THE FIRST to observe that this biblical episode in which forgiveness is pitted against hypocrisy and merciless judgment, described only in the Gospel of Saint John (8:1–11), was one of the most popular subjects in sixteenth-century Venetian painting.[1] Its popularity may in part reflect the antidogmatic attitude prevailing in Venice at the time, manifested in its religious and political tolerance. This New Testament subject also offered painters dramatic and narrative opportunities.

The Budapest picture is definitely Titianesque in character, despite the fact that it does not quote directly from any of Titian's known works. Two known variants of this composition survive. One, now in the Tosio Martinengo Gallery in Brescia but originally from the local church of Saint Afra,[2] served as the prototype for both the painting at the Minneapolis Institute of Arts[3] and a copy of poor quality in the Museo Civico in Padua.[4] The second variant, like the prime version under discussion, is in the Museum of Fine Arts in Budapest.[5]

During the eighteenth and nineteenth centuries the pictures in Brescia and Budapest were ascribed to Titian. Although this attribution is no longer tenable, the possibility remains that these may reflect a lost composition by the master. Much uncertainty exists concerning the attribution of the paintings in Brescia, Budapest, and Minneapolis, although certain of the more recent proposals can now be discarded. For example, Maxon's hypothesis ascribing the Minneapolis picture to the young Tintoretto is no longer plausible when compared with his early *Supper at Emmaus* (cat. no. 9).[6] Tintoretto's full-length representations of Christ and the Woman Taken in Adultery, datable to about 1546–47,[7] are imbued with a dynamism and psychological tension quite alien to the compositions in Brescia and Minneapolis.

Berenson's tentative attribution of the Saint Afra version of *Christ and the Woman Taken in Adultery* to Rocco Marconi was even wider of the mark.[8] Following Berenson's lead, Pallucchini and Rossi also attributed the picture in Minneapolis to Rocco Marconi.[9] Although Marconi painted several representations of this subject, Klára Garas's perceptive stylistic analysis of the paintings in question confirms that they must date at least fifteen years after Rocco Marconi's death in 1529.[10]

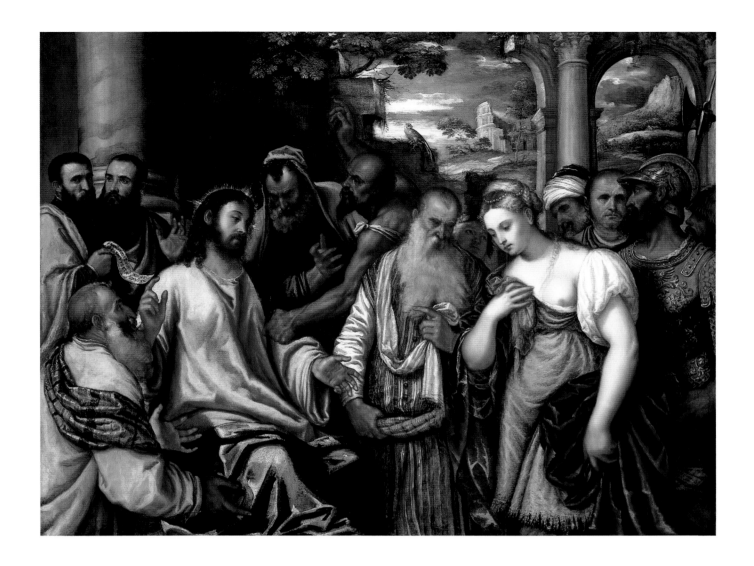

With justifiable caution, Garas left the Budapest painting anonymous, while in his catalogue Pigler[11] accepted Berenson's subsequent attribution of this work to Bonifazio de' Pitati.[12] However, Bonifazio's *Christ and the Woman Taken in Adultery* in the Brera in Milan, in its loose composition and anecdotal tenor, undermines Berenson's attribution.[13] In 1897 Berenson proposed yet another attribution of the painting in Budapest, this time to Polidoro da Lanciano, one of Titian's assistants.[14] This idea has recent supporters, including Ballarin[15] and Banzato.[16] Indeed, *Christ and the Woman Taken in Adultery* in Budapest displays several features in common with the *Pentecost* in the Accademia in Venice, painted by Lanciano in 1545 for the Church of Santo Spirito alle Zattere in Venice. These similarities support the attribution to Lanciano.[17]

Although the composition lacks the dramatic force characteristic of Titian, it is far more than a half-hearted emulation of a great prototype. The arrestingly characterized portraits of the two noblemen at the left who commissioned the painting, the Vitellius head[18] between the helmet and the turban at the right, and the fresh, original color scheme make this picture a significant example of cinquecento Venetian painting.

—V.T.

] 9 [

The Supper at Emmaus

Oil on canvas, 156 × 212 cm
PROVENANCE: Paris, Edmund Bourke Collection;
acquired by Prince Paul Esterházy from Bourke's widow in Paris, 1821;
Esterházy Collection; acquired, 1870, inv. 111

ACCORDING TO THE GOSPEL OF SAINT LUKE, two of Christ's disciples, while on their way to Emmaus, met the resurrected Christ and failed to recognize him. They sadly told him that Jesus' grave had been found empty. With a measure of tension, liveliness, and poignancy unprecedented in Venetian painting, Tintoretto's work illustrates the moment when the disciples first recognize their master. To quote from the Gospel account (24:30–31): "When he was at table with them, He [Jesus] took bread and blessed and brake and gave to them. And their eyes were opened and they recognized him; and he vanished out of their sight." Faithful to the Scripture, Jesus, while blessing the bread, is no longer corporeally present: he dissolves into an apparition. The pilgrim sitting with his back to us gesticulates wildly as if wanting to seize the disappearing vision, while his companion, shown facing the viewer, is turning toward the bearded old man, spreading out his arms in awe of the miracle. The other figures—the innkeeper offering fish to Christ on a dish and the servant girl proffering wine to a youth—remain unaware of the miracle, as their gestures indicate; although they are present, it eludes them.

The basic composition still conforms to the High Renaissance norm: the scene takes place in an enclosed space parallel to the picture plane, defined by a checkered stone floor across the foreground. Christ's place on the central axis is reiterated by the column over his head and the corner of the table. The two groups of three figures flanking Christ are regulated by the classical system of contrasting counter-balances. This compositional scheme, based on equal bilateral groupings is, however, shattered by the agitated movement of the figures to either side of Christ. The rough, broken brushstrokes, drawn with incredible vigor, emphasize the twisting postures of the disciples. Although the colors are typically Venetian, Tintoretto applies them to characterize figures that are Michelangelesque in energy and plasticity. Unlike Veronese, whose elegant style enthralls the viewer, Tintoretto utilized the theatrical nature of his compositions to command the viewer to witness the miraculous and supernatural. In his boldly conceived religious paintings, Tintoretto employed many Mannerist elements, including distortion, stylization, and dramatic, flickering light to represent transcendental experience.[1]

Detlev von Hadeln first identified Tintoretto as the author of *The Supper at Emmaus* in Budapest in 1922. Other scholars, including Bercken,[2] Pallucchini,[3] and Rossi,[4] concurred with Hadeln's

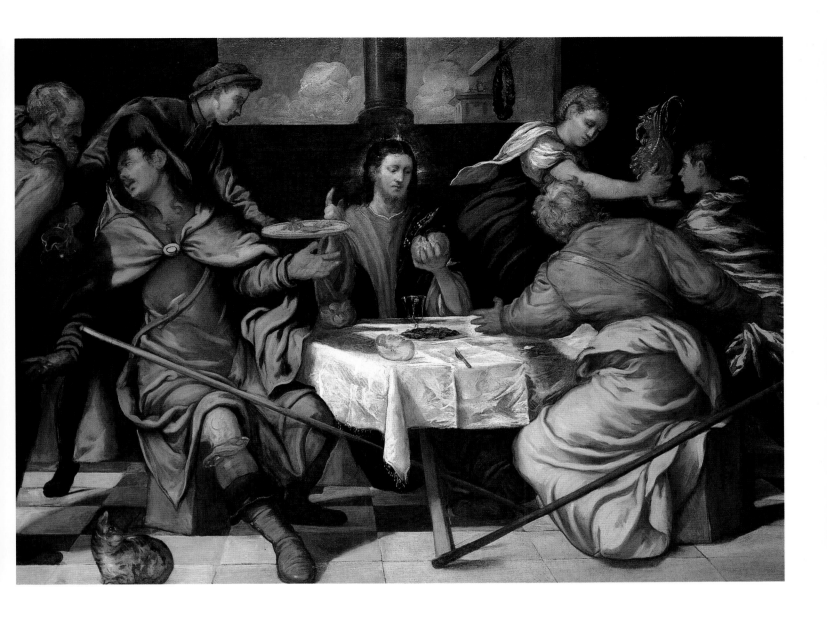

attribution. All consider the Budapest painting to predate Tintoretto's earliest documented painting, *The Last Supper* of 1547 in the Scuola di San Marcuola, suggesting a date around 1543, making the picture in Budapest one of the young Tintoretto's most important early works.

Until now *The Supper at Emmaus* has been obscured by an opaque yellowed varnish. Its cleaning and conservation undertaken in conjunction with the current exhibition provide American viewers the opportunity to appreciate the original coloring which Jacopo Robusti attained in the earliest phase of his career. —V.T.

] 10 [

Christ on the Cross

Oil on canvas, 149 × 90 cm
PROVENANCE: Esterházy Collection;
acquired, 1870, inv. 117

"QUANDOQUE BONUS DORMITAT HOMERUS":[1] Horace's quotation comes to mind as we contemplate Adolfo Venturi's extraordinary rejection of Veronese's authorship of *Christ on the Cross* in his study of the Italian paintings in the Museum of Fine Arts in Budapest, published in 1900. Despite his sensitive connoisseurship and his awareness of the unmistakable characteristics of artists' individual styles, Venturi denied the undeniable—Veronese's authorship of this picture.[2] We may conjecture that Venturi, upon his return from his visit to Hungary, mixed up his notes: he mentions the picture as a *Deposition* containing rather flattened, elongated figures of a type that do not appear in *Christ on the Cross.*

This confusing episode within the lifework of one of the giants in the field of Italian art history has had lasting impact on the ongoing critical assessment of the Budapest painting. As late as 1968 it caused one scholar to postulate that Benedetto Caliari, an assistant in Veronese's workshop, executed this picture,[3] despite the fact that the correct attribution to Paolo Veronese had already been cited in the 1823 inventory of the Esterházy Collection.[4] All doubts concerning Veronese's authorship were finally and conclusively laid to rest by Gombosi,[5] the first to draw attention to Veronese's preparatory sketch for the painting, a work in the Musée Bonnat in Bayonne. Ironically, this same drawing was first published with great enthusiasm by none other than Adolfo Venturi,[6] who failed to mention the painting in Budapest. Fiocco[7] and Berenson, in 1957,[8] ascribed *Christ on the Cross* to Veronese without any reservations. Moreover, Rodolfo Pallucchini,[9] recognized for his vast erudition on the subject of Venetian painting, considered this picture to be the high point of Veronese's interest in dramatic light effects, characteristic of his late period.

On closer examination, the handwriting of a painter of genius becomes evident in the confident brushwork seen here, as well as in the subtle modeling of Christ's perfectly proportioned body. The composition itself adheres to classical principles without seeming anachronistic; it anticipates the classicizing Baroque style of the Carracci while still embodying Raphael's High Renaissance principles. The ample forms of the figures, the gestures expressing grief with pathos, the harmonic grouping of figures represented at this culminating moment in the Passion of Christ, and the concept identifying moral goodness with aesthetic beauty have far more in common with Florentine and Roman painting of the

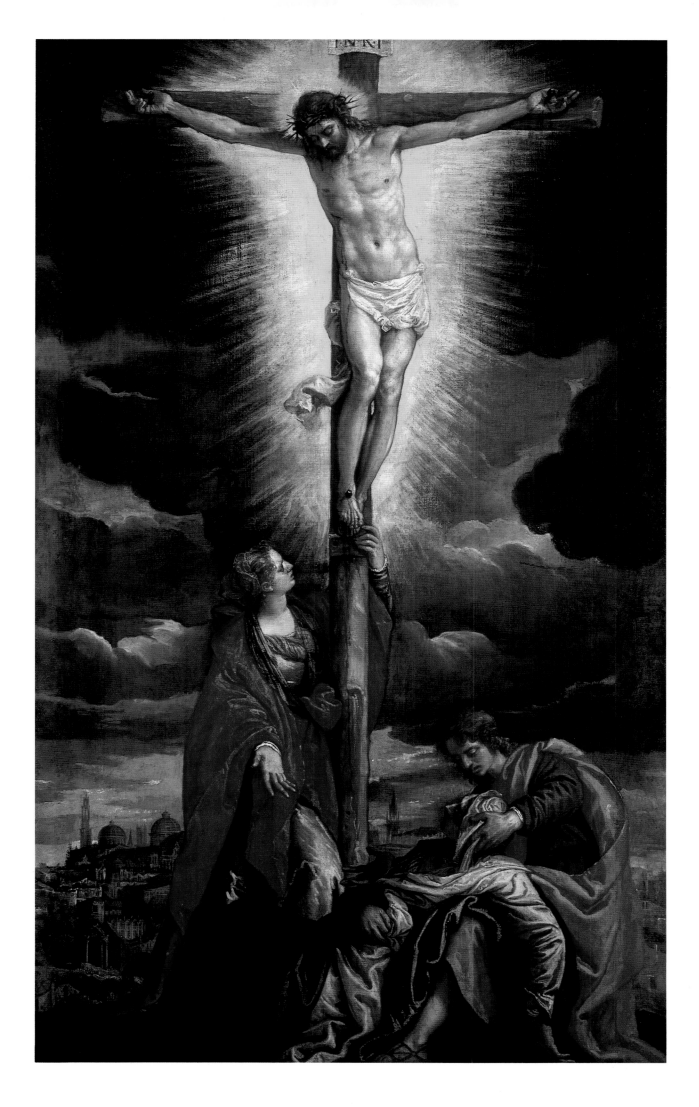

second decade of the sixteenth century than with the late Mannerist epoch from which this picture dates. The picture's Venetian characteristics are to be found in the handling of color and the depiction of light rather than in the composition. As envisaged by Veronese, the setting of Golgotha closely reflects the text from the Gospel of Saint Mark: "And when the sixth hour had come, there was darkness over the whole land until the ninth hour" (15:33).

Gloomy, oppressive clouds loom over the ethereal city below, sketched in with rapid brushstrokes. Suspended on the cross, the body of the Savior is encircled by a halo that illuminates the Magdalene, who gazes up at him, while John the Evangelist holds the head of the unconscious Virgin Mary in his lap. This transcendental light increases in dramatic intensity as it plays upon the cold, dark red dress of Mary while also revealing, to a lesser degree, the Magdalene's golden brown cloak and John's green tunic and red toga. By making this light piercing the darkness the main protagonist of the picture, Veronese responds in a unique way to the influence of the aged Titian and to that of Jacopo Bassano, noted for his nocturnes. At the same time Veronese also reveals his debt to Tintoretto, who was instrumental in reviving medieval mysticism partly through his inimitable manipulation of light. —V.T.

] 11 [

The Tribute Money

Oil on canvas, 158 × 225 cm
PROVENANCE: Rovigo, Silvestri Collection;[1] London,
Robert Udney Collection;[2] Paris, Edmund Bourke Collection;[3]
Esterházy Collection; acquired 1870, inv. 614

THE PARABLE OF THE TRIBUTE MONEY appears in all the Gospels except that of John: "Render . . . unto Caesar the things which are Caesar's; and unto God the things that are God's" (Matt. 22:21; Mark 12:17; Luke 20: 25). The subject first appears in sixteenth-century art. Titian, who represented the scene solely with Christ and a single Pharisee, seems to have been the first to treat it.[4] Compositions incorporating many figures appear with considerable frequency in the seventeenth century, including the relatively early work by Rubens from 1611–12, now in The Fine Arts Museums of San Francisco.

The Venetians, and Strozzi in particular, seem to have been powerfully attracted to the subject. Strozzi may have known Van Dyck's composition of 1623–24, now in the Palazzo Bianco in Genoa, which is close to Titian's in conception. Strozzi may also have been familiar with Rubens's version through Lucas Vorsterman's reproductive engraving after it.[5] Strozzi's *Tribute Money* shares many features with Rubens's composition, among them the half-length presentation of the several participants. Nonetheless, this half-length format also derives from the sixteenth-century Venetian tradition.[6] The close confrontation between Christ and the Pharisees who crowd around him visually underscores the nature of the intellectual trap they have fabricated to ensnare him.

Strozzi created two closely related archetypal variants of this subject, replicated repeatedly by the master and his studio. The two prime versions are in Budapest and Munich, from which thirteen known replicas derive.[7] Only minor compositional differences distinguish the two groups. The only substantial variant is the figure of the page at the far left. Whereas the paintings in Budapest and Munich are indisputably autograph, most of the replicas are of questionable authenticity. They appear to be copies displaying little of Strozzi's distinctive painting technique.

The harmonious forms, bright colors, and serene atmosphere are imbued with the classical resonance of the Venetian cinquecento, suggesting a date early in the 1630s. By contrast, the Munich version reflects various further influences, resulting in a looser, more painterly style that Strozzi developed in the later 1630s. The page boy at the left in Strozzi's *The Tribute Money* in Budapest looks directly at the viewer, and in attire and characterization derives from antecedents painted by Paolo Veronese. In the Munich version of this subject the page turns his head and is less subtly modeled. This picture reveals

ties with Genoese and Flemish antecedents, filtered through Strozzi's assimilation of Venetian light and color. At the same time it lacks the harmony of the earlier version in Budapest. In technique the rich impastos give way to a looser handling of paint. Because so few dated or documented works by Strozzi exist, the chronology of his oeuvre must remain approximate and somewhat hypothetical.[8]

A distinctive feature of Strozzi's paintings is the eloquent play of hands.[9] By this means the painter introduces dramatic tension into the otherwise calm pathos of the scene.

Strozzi's exuberant colorism may have been partly inspired by Rubens; certain hues and especially the mauve-red tunic of Christ seem Flemish in inspiration. The liberal application of color and impasto well illustrate Strozzi's mature style as it first evolved in Venice.[10] The sophisticated play of light, evincing Strozzi's knowledge of the followers of Caravaggio, gives strong plasticity to the figures while heightening the psychological tension. —I.B.

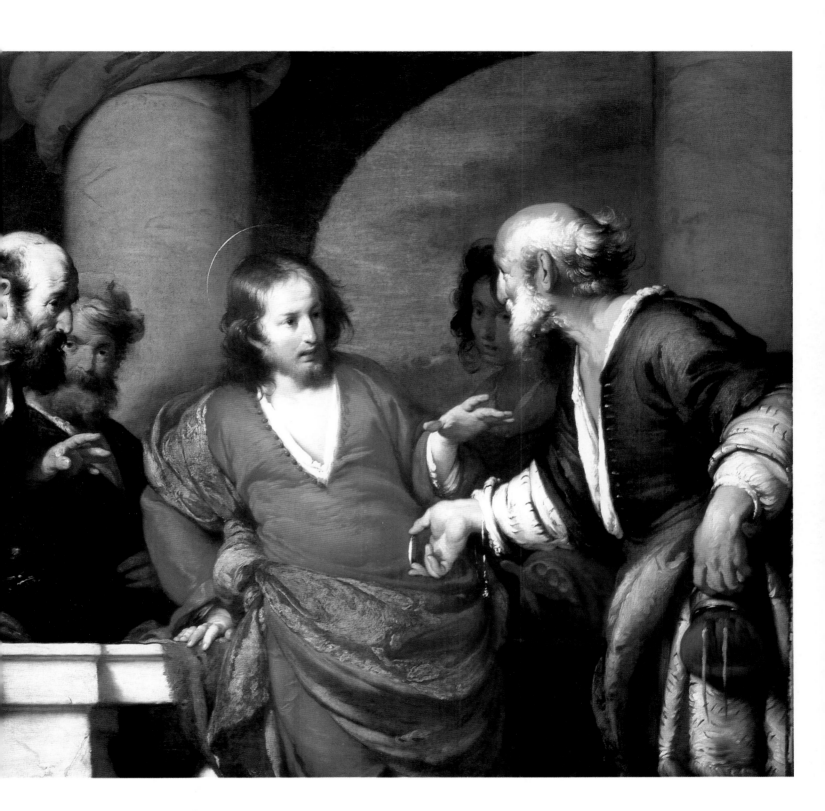

] 12 [

The Annunciation

Oil on canvas, 62.5 × 32 cm
PROVENANCE: János László Pyrker Collection; by whom given
to the Hungarian National Museum, 1836, inv. 612

THIS SPONTANEOUS SKETCH, which defines the composition in its preliminary and elemen-
tal state, serves as the conceptual model for a later, carefully executed work. Whirling dynamism and an
unusually vibrant, yet delicate painterly touch convey the exalted expressive power and immediacy of
this diminutive masterpiece, which possibly dates from the master's last year.[1] The bright, pervading
light is a remarkable premonition of the Venetian settecento.

The Venetian collector N. H. Tommaso Querini, who resided at the Bridge of the Reggio Canal
(al Ponte di Canal Reggio), owned a version of this composition in the eighteenth century,[2] documented
by Pietro Monaco's engraving.[3] Enough compositional discrepancies exist between this engraving and
the sketch in Budapest to indicate that the engraving probably records a larger, finished version of the
composition, as suggested by Pallucchini.[4]

The Annunciation in Budapest is one of the few paintings by Strozzi of such a small scale and is
one of his few *bozzetti.* It is stylistically similar to the sketches *Christ's Entry into Jerusalem* and *Christ
Collapsing under the Cross,* both now in the Palazzo Bianco in Genoa. However, these two paintings
from the master's Genoese period are much earlier in date and are accordingly more detailed and exe-
cuted with a thin application of paint. Seen in this context, the Budapest sketch, in its advanced style
and spontaneity, is unique in Strozzi's oeuvre. In realizing this singular oil sketch, Strozzi indubitably
responded to the example of his Venetian contemporary Domenico Fetti, who generally produced small,
boldly brushed paintings.

Together with Fetti and Liss, both of whom died in Venice, Strozzi was the third foreigner active in
Venice who revitalized Venetian painting during the first half of the seventeenth century. He introduced
foreign ideas such as the sensuous pictorialism of Rubens and the sophisticated elegance of Van Dyck
into Venetian painting. He also emulated the later sixteenth-century Venetian tradition of Paolo Veronese,
lending to it a Baroque gloss full of luminosity and glowing color.

In turn, Strozzi's vigorous painting technique, with its lavish use of impasto and distinctive and
unusual mingling of hues in the flesh tones, was subsequently adopted by several Venetian painters.
For example, the *tenebroso* painters of the mid-seventeenth century—Langetti, Loth, and Zanchi—
admired Strozzi despite the fact that they did not adopt his light and resonant palette. Because of his
widespread appeal, Strozzi uniquely furthered the evolution of Venetian painting from the sixteenth
century to the eighteenth century. —I.B.

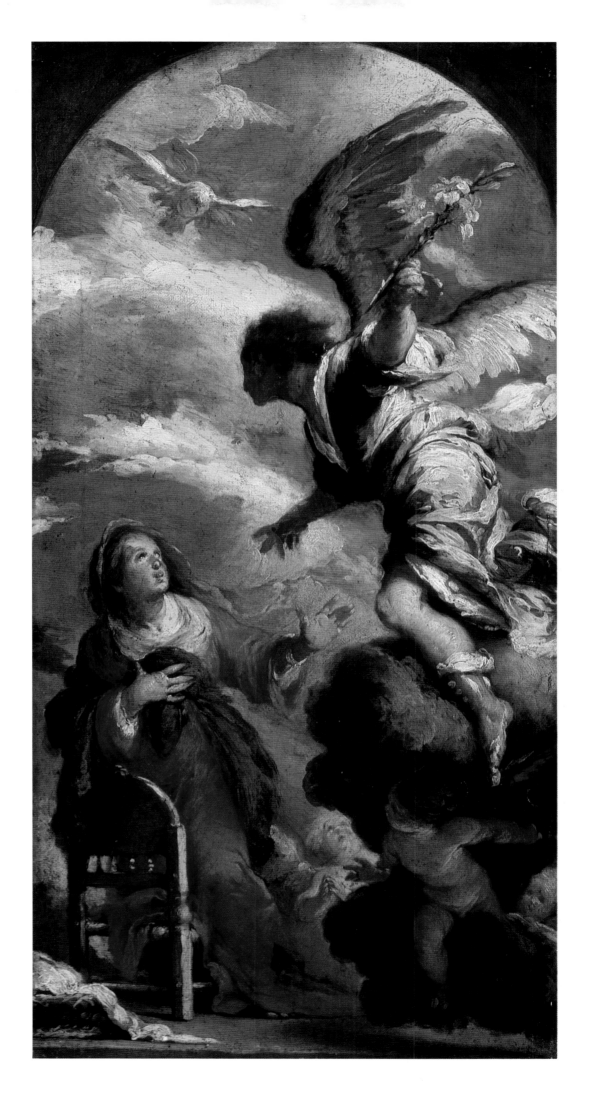

] *13* [

The Annunciation

Oil on canvas, 145 × 120 cm
PROVENANCE: Vienna, Count Sickingen Collection;[1]
Esterházy Collection; acquired,1870, inv. 596

THE EVANGELIST LUKE describes the Annunciation: "the angel Gabriel was sent from God . . . to a virgin [whose] name was Mary. And the angel said . . . blessed art thou among women . . . thou shalt conceive in thy womb . . . a son, and shall call his name JESUS" (1:26–31). The subject was further embellished by descriptions from the Apocrypha.[2]

The first representations of the mystical event of the Annunciation date back to the second and third centuries, to the beginnings of Early Christian art in the catacombs.[3] Later, this scene from the life of the Virgin was presented as a fundamental precept of Christianity. It attained widespread popularity and featured prominently in medieval fresco cycles.[4] During the fourteenth and fifteenth centuries a new pictorial representation of the Annunciation evolved; it placed the event indoors and stressed its mystical nature. This interpretation, which was based on neither Luke's Gospel nor the Apocrypha, emphasized the prediction of the incarnation of Christ by the angel Gabriel, the herald of Divine Wisdom.[5] Initially, this subject became the perfect vehicle for Venetian Mannerism, which shaped the subject through beautiful forms, sensuous illusionism, and supernatural light effects.[6] Renaissance, Mannerist, and Baroque artists alike stressed the transcendental quality of the event and the idealization of the figures and setting. Later sixteenth-century Venetian representations of the Annunciation inspired Bernardo Strozzi to paint the subject in a fully up-to-date Baroque style, in which the figures appear with no reference to a clearly defined setting. His meditative figures express Divine Grace.

Three versions of *The Annunciation* by Bernardo Strozzi are in the collection of the Museum of Fine Arts in Budapest. This example, whose flowing forms and glowing colors are partly inspired by Paolo Veronese, dates a few years later than Strozzi's *Tribute Money* (cat. no. 11). A second version, a fragment containing only the Virgin, appears to be somewhat earlier in date.[7] These two representations of the Annunciation are similar in conception and show Strozzi's tendency to reduce the subject to its basic elements. The background remains undefined: clouds alone set off the figure of Mary. The angel is analogous in pose and physiognomy to the one in Strozzi's *Expulsion of Adam and Eve* in Verona, which probably dates earlier than this *Annunciation.* This exuberant interpretation, with its intense and striking color harmony, shows that Strozzi had fully absorbed the Venetian tradition of color and light. The serene profile of the Virgin, her meditative expression, and her graceful hand gestures convey

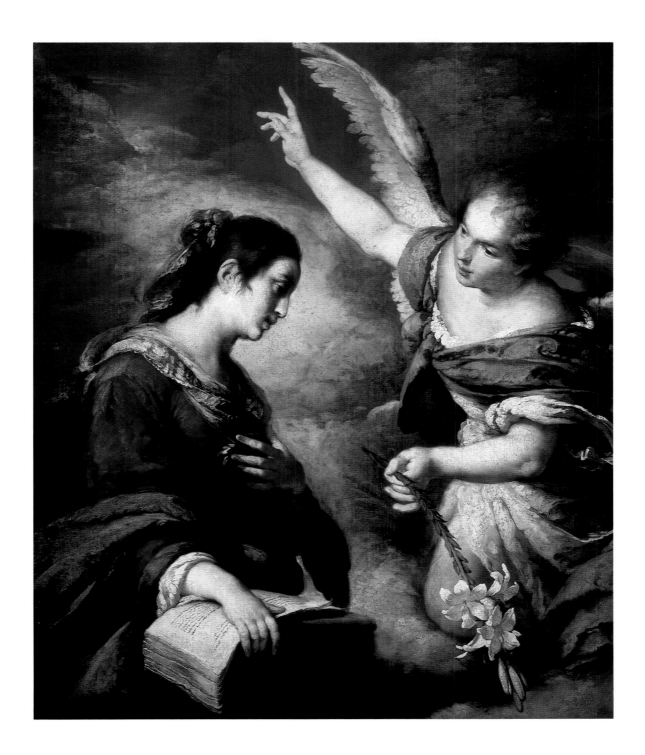

the solemnity of the event. The solid pictorial forms are softened by the almost sultry effect of rich impastos. Although a late work, this *Annunciation* does not seem to date from the very last year of Strozzi's career, as suggested by Pallucchini.[8]

Little is known about Strozzi's evolution as a painter. He had been active for about two decades in Genoa before arriving in Venice in late 1630 or early 1631. Few of his early works are known, and none is documented. In Venice he seems to have quickly found favor as a portraitist and religious painter. The many surviving replicas and copies of his compositions demonstrate Strozzi's enduring popularity.

—I.B.

] *14* [

Christ Healing the Paralytic

Oil on canvas, 95 × 50 cm
PROVENANCE: Esterházy Collection;
acquired, 1870, inv. 654

THIS PREPARATORY SKETCH, like Sebastiano Ricci's *Assumption of the Virgin* (cat. no. 23), served as the design for an altarpiece for the Karlskirche in Vienna. Pellegrini's finished altarpiece, based on this *bozzetto,* is found in the third side chapel on the left in this imperial church. Datable to about 1730, *Christ Healing the Paralytic* was the first altarpiece executed for the Karlskirche but seems to be the last work that Pellegrini produced in Vienna. The *bozzetto* is almost identical with the finished altar piece in design except that it lacks an arched top, thereby omitting the space above the angels.[1]

The subject is taken from the Gospel of Matthew (9:2, 6): "they brought to him a man sick of the palsy, lying on a bed . . . and Jesus said . . . Arise and walk." Pellegrini chose to depict the very moment when the miracle is about to happen. The sick man's expression of devout faith and delight and his forcefully twitching body accentuate Christ's serenity. An amazed and agitated crowd witnesses the scene. The fluid, flickering, and expressive brushwork enhances the miraculous tenor of the subject. The luminous, pervading light becomes the most dominant feature of the painting and heightens the colors with a silvery tone and dissolves form to infuse the subject with poetic delicacy.

Pellegrini was one of the most popular and talented Venetian painters of the first half of the eigh teenth century, yet no comprehensive study of his life and work has yet been written. He was constantly on the move, a typical itinerant painter. At the beginning of his career Pellegrini started traveling with his master, Paolo Pagani, with whom he spent approximately six years in Vienna. Later Pellegrini traveled throughout Europe, spending some five years in England (1708–13) with Marco Ricci and repeatedly making short visits to Austria, France, Germany, and the Low Countries. He always returned to Venice between these trips.

Like Sebastiano Ricci, Pellegrini's origins reveal the influence of earlier masters such as Luca Gior dano, whose later works anticipated the poetic sensibility of the Rococo. Pellegrini soon superseded this late Baroque plasticity to create a style in which pervading light creates poetic pictorial effects.

Pellegrini's reputation principally rested on his allegorical and historical decorative cycles executed in either fresco or oils. Because most of these royal and aristocratic commissions have been destroyed or scattered, his reputation now rests more on his individual biblical and mythological scenes. Had Pelle grini executed major decorative programs in the Veneto, rather than in English country houses, for ex ample, he would have had far more potent influence in his native land,[2] transmitting back to Venice the lessons that he received during his travels.[3]

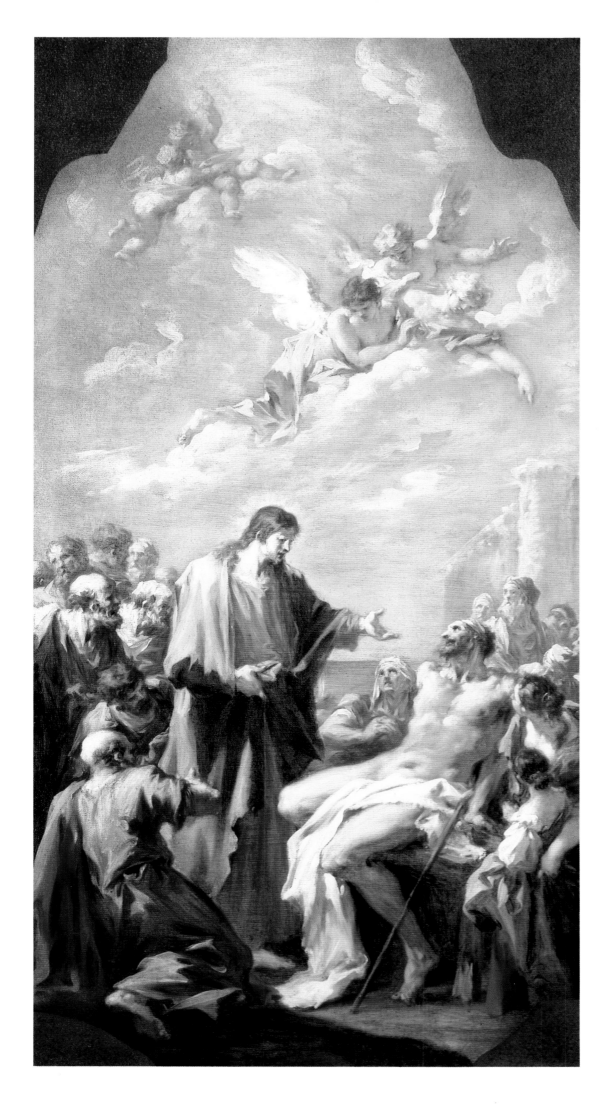

Pellegrini's sketch and finished altarpiece, *Christ Healing the Paralytic,* date about three years earlier than Sebastiano Ricci's *Assumption of the Virgin,* painted for the same church. Ricci apparently never saw Pellegrini's altarpiece. Yet both utilized the S-curve as a compositional device in designing their works. Despite this common feature, the marked differences between the two paintings demonstrate the individual solutions devised by these Venetian artists in fulfilling their respective commissions. When compared to Ricci's dynamic and elaborate composition, Pellegrini's *Christ Healing the Paralytic* is more subdued in approach. Its meditative mood and its grace and lyricism express a strong sentimentality in contrast to the vitality of Ricci's *Assumption.* Pellegrini's picture, although less emphatic in mood, breaks more categorically with the seventeenth-century Venetian precepts of religious painting. He does so by using light effects that brighten the palette to create a poetic colorism, in contrast to the pronounced weightiness and plasticity associated with the earlier style. —I.B.

] 15 [

The Flagellation of Christ

Oil on canvas, 105 × 159 cm
PROVENANCE: János László Pyrker Collection; by whom
given to the Hungarian National Museum, 1836, inv. 685

THE BRIEF AND SCATTERED INFORMATION in eighteenth-century biographies indicates that Nicola Grassi, from Formeaso in the Alpine region of Carnia bordering Austria, was not considered one of the central figures of Venetian artistic life. In fact, until recently he attracted only sporadic interest. However, the exhibition of his works held in Udine in 1961, followed by a monographic exhibition and symposium at Tolmezzo in 1982, have brought Grassi's painting into the limelight.

Zanetti[1] as well as Lanzi[2] mention the master primarily as a portraitist. Lanzi further perceived Grassi as Rosalba Carriera's competitor, yet today his documented oeuvre consists primarily of religious works. Grassi started his career as a pupil of Niccolò Cassana, an artist who had moved from Genoa to Venice and who was responsible for the young artist's initial attraction to those painters such as Piazzetta and Bencovich who revived *tenebrismo*. Under the influence of Pellegrini, Sebastiano Ricci, and Tiepolo, Grassi replaced the expressive chiaroscuro lighting, dark tones, and heavy forms of his early works with high-keyed light, pastel colors, and soft modeling. Grassi was also responsive to Pittoni's Rococo forms, which he emulated in a somewhat less refined manner. Nonetheless, the graceful sophisticated figures recall those of Pittoni.

Initially considered to be by Giambattista Tiepolo,[3] and subsequently by Gianantonio Pellegrini,[4] *The Flagellation of Christ* was correctly attributed to Nicola Grassi by Fiocco,[5] whose opinion was confirmed by Pigler,[6] Garas,[7] and Rizzi.[8] The evident psychological power of the subject is enhanced by the artist's strong interest in anatomy. Grassi composed the scene in a friezelike manner, focusing on the seven characters represented half-length, who all but screen out the background. The torturers gathered in a semicircle around the broken figure of Christ gesture emphatically in a dramatic confrontation, further underscored by strong light effects.

Having earlier accepted Grassi's authorship, in 1982 Garas queried the attribution mainly on the basis of the static composition and the rounded proportions of the robust figures, which she considered alien to the master's taste.[9] To further support her contention, Garas also cited the lack of soft modeling and the unusual coloring of *The Flagellation of Christ*. As a possible alternative Garas proposed the obscure artist Silvestro Manaigo as the possible author of the picture in Budapest. Manaigo is known only through two pictures and two drawings. As a point of comparison Garas cited his *Abraham and Melchisedech,* which has come down to us only through a reproductive engraving. The face of the

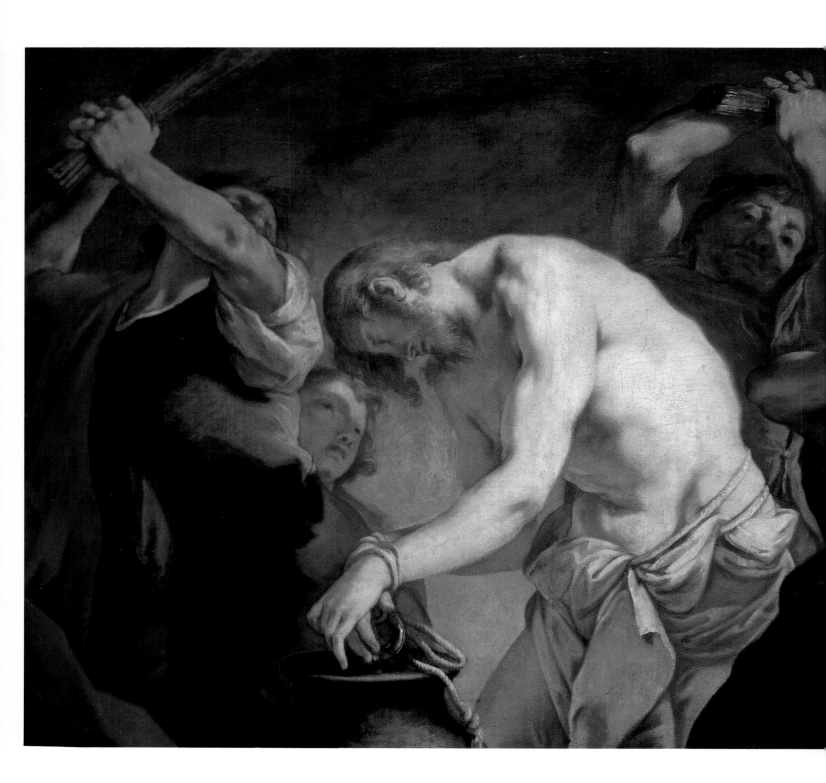

bearded old man is demonstrably close to that of Melchisedech but shows an equally strong correspondence with Grassi's *Saint Francis of Paola*, in the cathedral in Veglia. Moreover, it is undeniable that the partially nude man seen from the back and the two figures preparing to strike Christ are not typical Grassi inventions. Nonetheless we can still find a parallel to the figure on the right in Grassi's drawing of figure studies.[10] The pose of Christ recurs in the same sheet with minor variations. *The Flagellation of Christ* in Budapest is most closely related to Grassi's *Mocking of Job* in the Scheufelen Collection in Stuttgart and *Rebecca at the Well* in the Church of San Francesco della Vigna in Venice. Our painting has not yet been satisfactorily dated: Pigler puts it between 1730–40,[11] while Rizzi[12] and Garas more tentatively consider it an early work.[13]

—Zs.D.

] *16* [

The Nativity

Oil on canvas, 38.5 × 46.5 cm
PROVENANCE: Acquired from István Gerendás
in Budapest, 1952, inv. 52.209

GIOVANNI BATTISTA PITTONI began his career in the workshop of his uncle, Francesco Pittoni, a follower of Luca Giordano. His earliest works were painted jointly with his uncle. Pittoni later enriched his art with elements taken from the painting of Sebastiano Ricci, Antonio Balestra, and Federico Bencovich. By the 1720s he had formed his lyrical and spontaneous manner, which Zanetti appreciated in the following remark: "He was a master of an original style, full of picturesque traits, graceful and pleasing. . . . His paintings were adorned with much charm and an abundance of beautiful images."[1]

In addition to his refined color, the grace of his figures and the fragility of his pious Madonnas make Pittoni one of the most typical representatives of Rococo taste in Venice. Unlike his fellow Venetian painters, such as Pellegrini, the two Riccis, and Amigoni, for example, Pittoni never left his native land, yet he played a significant role in propagating Venetian settecento painting in northern Europe. His altarpieces reached Bad Mergentheim, Schönbrunn, and Diessen, and many Austrian, Bohemian, and German masters, such as Anton Kern and Franz Unterberger, visited his industrious workshop. These altarpieces, as well as Pittoni's multifigured historical scenes, entered the collections of private clients across northern Italy and Central Europe in the form of *bozzetti,* replicas, and copies, assuring his international reputation. This small *Nativity* was evidently made for such a purpose.

Pittoni elaborated on the theme of the Nativity several times. In his analysis of Pittoni's representation of the Nativity, Max Goering classified them into three typological groups.[2] In 1954 Ivan Fenyő first published the version in Budapest in an important article contributing to Pittoni research. Fenyő placed the picture within the second group, which is centered on the altarpiece in the National Gallery in London.[3] In fact, the charming devotional image in Budapest is a reduced autograph replica of the London picture. A similar replica is in a private collection in Great Britain, and another version, in upright format, is in the Accademia dei Concordi in Rovigo.[4]

By the omission of the upper zone and the creation of a tighter composition with half-length figures, Pittoni's image becomes more intimate and lyrical. In his poetic depiction of this simple subject, Mary gazes in delight at her child while Joseph nods off beside the manger. Filtered by grayish brown clouds,

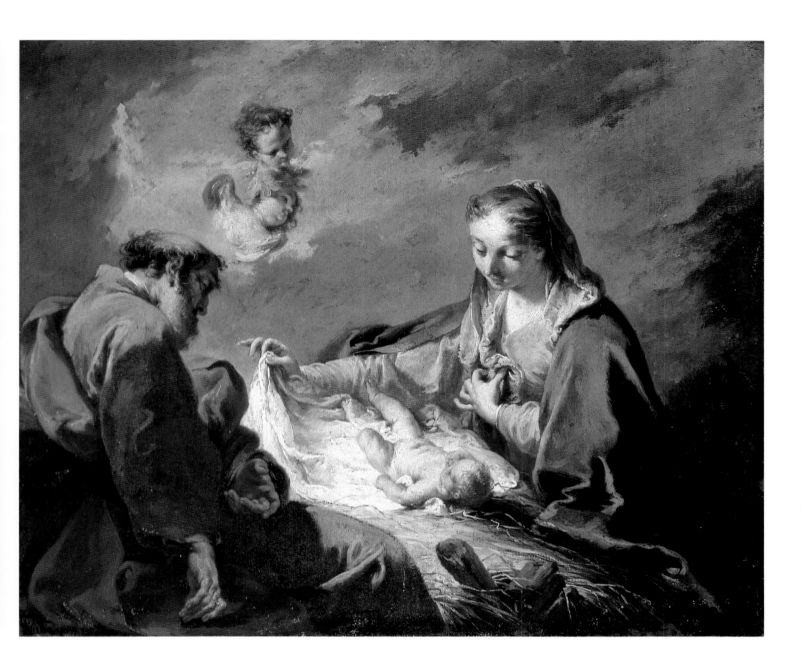

the warm radiating light unifies the composition. It saturates the forms and plays subtly around Mary's mouth, creating the sense of an enigmatic smile. The supernatural brilliant light emanating from the Christ Child illuminates the linen scarf beneath him and deflects onto the wisps of straw. Pittoni subtly contrasts closely related values such as the dark and grayish blues, ochers, and modulated pale reds and enlivens the dull blue of Joseph's cloak with pink. Both Ivan Fenyő and F. Zava Boccazzi, writer of a monograph on Pittoni, date the painting to 1735–38, a few years after the London altarpiece.[5]

—Zs.D.

] *17* [

The Adoration of the Magi

Oil on canvas, 94 × 110 cm
PROVENANCE: Acquired in Budapest, 1978, inv. 78.13

GASPARE DIZIANI is one of the more obscure masters of Venetian settecento painting. Lacking a defined artistic personality, he emulated the styles of practically all his contemporaries, and when harking back to the great cinquecento prototypes, Diziani's response tended to be filtered through the eyes of those same painters. Although few documented paintings by him survive, much documentation charts his activity as an artist.

After a period of formative training in Belluno, Diziani entered the studio of Sebastiano Ricci in Venice. Ricci's influence was a determining factor for the rest of Diziani's life. Because Ricci was in England between 1712 and 1716, Diziani must have come into contact with him either between 1709/10 and 1712 or during the years 1716–17. By 1718 Diziani was in Munich and Dresden (1717–20).[1] While in Dresden, the capital of Saxony, he worked for Augustus the Strong, mostly executing decorations for festive occasions and the theater. None of this work survives. Diziani was back in Venice by 1720, when he entered the painters' guild. He seems never to have left the city and its environs from this time on.

Until recently the earliest securely documented surviving painting by Diziani was *The Ecstasy of Saint Francis* in the Church of San Rocco in Belluno, dated 1727, painted when the artist was thirty-eight.[2] In its composition and modeling of the figures, this picture demonstrates Sebastiano Ricci's pervasive influence. Considerably earlier drawings survive from 1713 and 1718, including *The Adoration of the Magi* from the latter year, now in the Museo Civico in Udine.[3] This drawing seems to be a preparatory design for a large altarpiece and may plausibly be considered the sketch for the lost altarpiece for the Hofkirche in Dresden.[4]

In 1963 Garas first identified *The Adoration of the Magi* as a work by Diziani[5] and recognized its connection with the drawing in Udine. This painting somewhat alters and reduces the composition of the drawing, focusing on the figure group. In all probability it is the *bozzetto* for Diziani's Dresden altarpiece of 1718, making it his earliest known painting. Both the drawing in Udine and the picture in Budapest show Ricci's profound influence.[6] Diziani's painting is, however, a more gentle and less dynamic rendering, lacking Ricci's energetic figures or strong plasticity. The composition, with figures seen slightly from below, may derive from Paolo Veronese's *Mystic Marriage of Saint Catherine,* in the Accademia in Venice. A more immediate source of inspiration may have been Ricci's *Holy Family with*

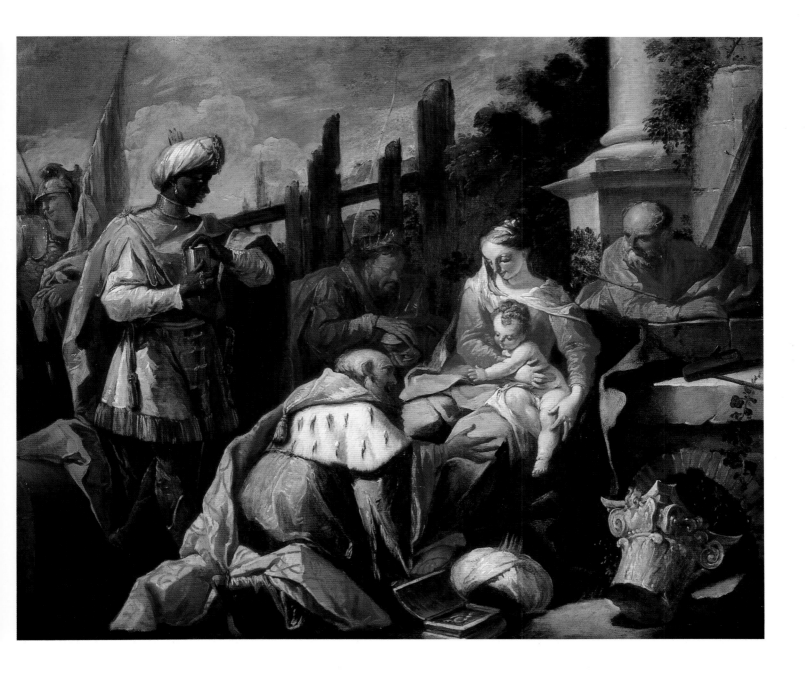

Saint Ignatius of Loyola,[7] executed about 1704–8, when Diziani was possibly active in Ricci's studio. Elements common to Ricci's compositions—such as the Virgin's twisting figure and head bent in lost profile and the motif of the column and its base—may well have directly inspired Diziani.

An eclectic painter, Diziani widely utilized the ideas and styles of his Venetian contemporaries yet never slavishly copied the compositional inventions of those artists. A recently identified variant of *The Adoration of the Magi* from Diziani's later period, now in the Rijksmuseum in Amsterdam, portrays the same composition in reverse.[8] —I.B.

] *18* [

The Rest on the Flight into Egypt

Oil on canvas, 47.7 × 65 cm
PROVENANCE: Münsterschwarzach, Germany,
Church of the Benedictine Order; Munich, private collection;[1]
presented to the museum by József K. Beer, 1932, inv. 6536

"THE LORD APPEARETH to Joseph in a dream, saying, Arise, and . . . flee into Egypt . . . he took the young child and his mother by night, and departed" (Matt. 2:13–14). Saint Matthew's account of the flight of the Holy Family, to protect the infant Christ from the wrath of Herod, was subject to fanciful, descriptive elaboration in the Apocrypha of the actual journey to Egypt.[2] Based on this source two visual interpretations of the episode evolved: the Flight into Egypt and the Rest on the Flight into Egypt. Both subjects were popular in the Baroque period[3] and enabled artists to represent the ever-changing relationship between man and nature, infusing the latter with strong emotional and spiritual overtones either as a protective foil to the Holy Family or as a threatening wilderness.

This painting is identical in composition, in reverse, to Domenico's etching dated 1750. This print is number thirteen in the series *Pictorial Thoughts on the Flight into Egypt,*[4] executed between 1750 and 1753 and dedicated to Carl Philipp von Greiffenklau, Prince Bishop of Würzburg, the leading patron of Giambattista Tiepolo and his sons at the time.[5] As Giambattista Tiepolo and his son, Domenico, only arrived in Würzburg on December 12, 1750, Domenico must have started the etched series, *The Rest on the Flight into Egypt,* before his departure from Venice, as the first plate bears the date 1750.[6]

Domenico's concept of the flight as an unfolding narrative sequence is unique. The twenty-four etchings of the series provide the most comprehensive treatment of the subject in European art. He explored a full range of representational possibilities from the departure of the Holy Family from Bethlehem to their arrival at a city gate in Egypt, possibly alluding to the city of Hermopolis.[7] Only three of the images specifically represent the Holy Family resting.[8] In treating this subject and responding to the challenge of placing figures in a landscape setting, Domenico displays his compositional inventiveness while maintaining the sense of poignant religious significance of each moment in the unfolding drama.[9]

In creating his many scenes illustrating the Flight into Egypt Domenico did not follow his father slavishly, yet sufficient elements of Giambattista's style are still evident to indicate that Domenico did not break away completely from his father's manner to develop his own, individual style. Giambattista's influence may be observed in certain borrowed details, including the gestures of specific figures. In the

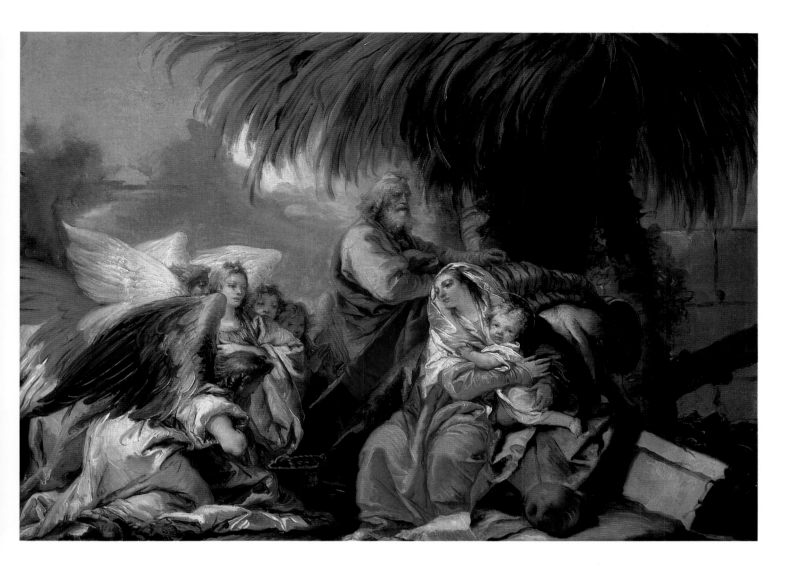

case of the painting in Budapest the figures of the Virgin and Child and the general setting recall Giambattista's *Adoration of the Magi*.[10] Conversely, most of Giambattista's painted representations of the Flight postdate Domenico's series;[11] thus he may have turned to his son's prints for inspiration.

The composition of the etching reverses that of the painting in Budapest and probably dates later than the picture.[12] The pictorial space in the painting is more compressed than in the print. Despite the heavy application of paint, the somewhat chalky surface quality, lively coloration, and pronounced silvery light in this picture manifest Domenico's striving to establish a distinctive style. He infuses this work with a personal and poetic mood. The resulting painting is one of Domenico's most successful early compositions, a work probably intended for private meditation. —I.B.

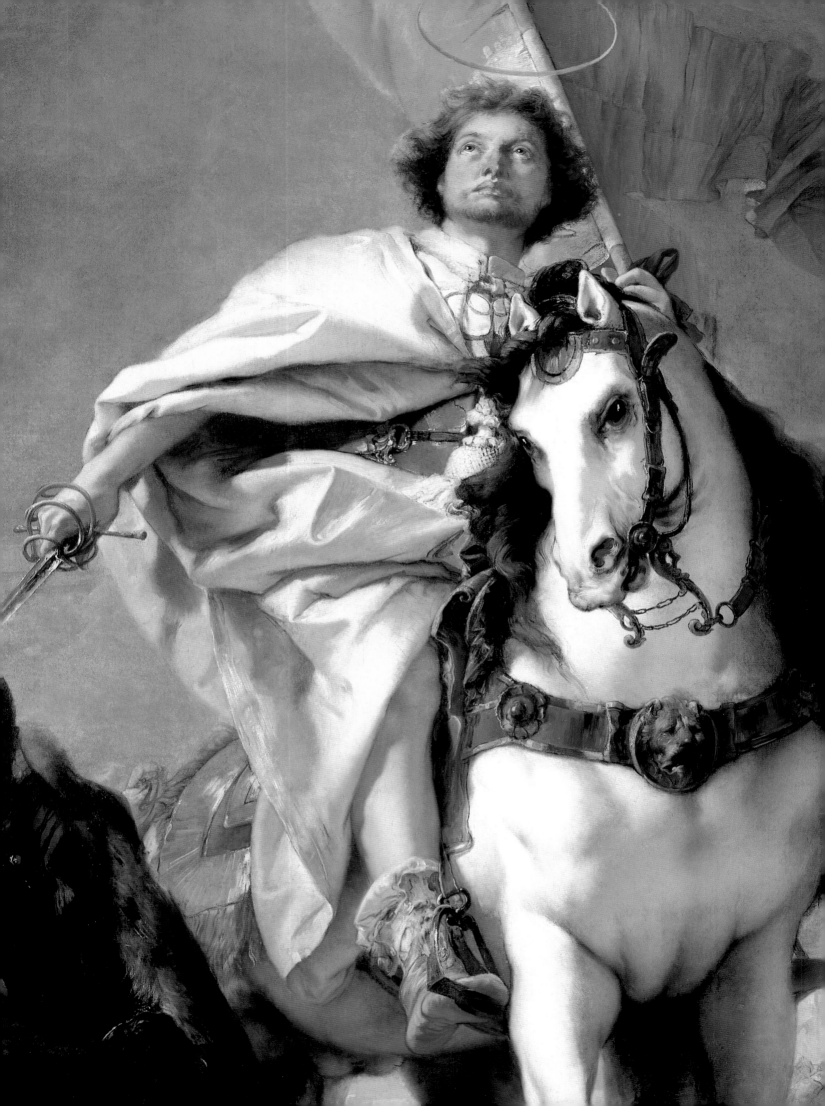

THE VIRGIN

AND

SAINTS

] *19* [

The Holy Family with a Female Saint

Oil on poplar panel, 65 × 94 cm
SIGNED ON BANDEROLE: *VIZENZO C.P.*
PROVENANCE: János László Pyrker Collection; by whom given
to the Hungarian National Museum, 1836, inv. 78

VINCENZO CATENA is one of the better-documented sixteenth-century Venetian painters. He was a man of considerable means, as indicated by his two wills of 1515 and 1525[1] and was known to certain of the leading Venetian humanists, including Marcantonio Michiel and Cardinal Pietro Bembo, thus indicating that the artist moved in elevated social circles. Further documentation also links him to two of the leading younger painters in Venice: Giorgione and Sebastiano del Piombo.[2]

Catena was deeply influenced by Giovanni Bellini, but his early paintings also betray the influence of Cima da Conegliano and Bartolommeo Vivarini, the latter of whom, Robertson postulates, may have been Catena's first instructor.[3]

The Holy Family with a Female Saint clearly indicates Catena's working methods early in his career. The artist conflates two of Giovanni Bellini's innovations—the placement of the Virgin and Child before a panoramic landscape and the *sacra conversazione,* with figures represented in three-quarter length before a continuous landscape backdrop. Catena's figures of the Virgin and Child derive from Bellini's *Madonna of the Meadow* of about 1500 in the National Gallery, London, although he modifies the position of the Virgin's hands, no longer held in prayer but supporting the Infant Christ on her lap. More generally, Catena's composition relates to Bellini's *Madonna with the Baptist and a Female Saint* now in the Accademia in Venice, which Robertson dates to about 1504.[4] On the basis of its close connection to Bellini's *Madonna of the Meadow,* Robertson dates Catena's *Holy Family with a Female Saint* to shortly after 1505.[5]

The translucent light and a strong linearity, evident in the sharp contours of the figures and their draperies, indicate Catena's close study of Cima da Conegliano's paintings. In modifying Bellini's Madonna, Catena seems to have adapted the position of the Virgin's hands and the detail of the awakened Christ Child from Cima's well-known *Madonna and Child* of about 1485–86 in the Philadelphia Museum of Art.[6] Cima also produced many representations of the *sacra conversazione* theme with figures projected in three-quarter length before hilly landscapes below cloudy skies.[7]

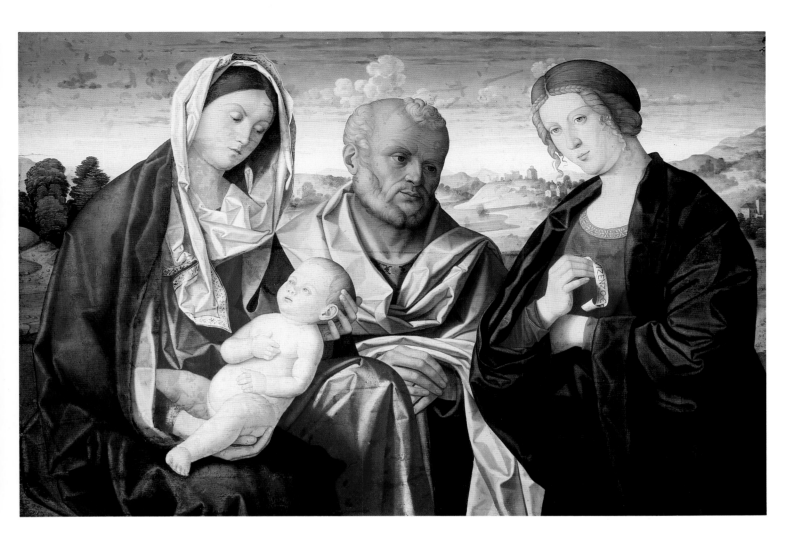

Despite his debt to Bellini and Cima, Catena displays considerable originality in the Budapest *Holy Family with a Female Saint.* Instead of representing the Virgin and Child at the center, flanked on either side by accompanying saints, Catena represents the Holy Family with Joseph at the center, deferentially standing behind the Virgin. Unlike Bellini's painting in the Accademia, which still retains a ledge across the foreground, Catena omits this pictorial framing device.[8]

The still unidentifiable female saint at the right is notable for her elegant coiffure and for her novel gesture holding the banderole which bears the artist's signature. Her braided hair and the wiry locks that frame her face recur with progressively greater refinement in Catena's slightly later *sacra conversazione* representations in Dresden, Glasgow, and Liverpool, and in a second important picture in Budapest.[9] These indicate Catena's determination to remain up-to-date vis-à-vis the idealized blond-haired female figures of Titian, Sebastiano del Piombo (cat. no. 43), and Palma Vecchio. —G.K.

] *20* [

Saint Roch Cured by the Angel

Oil on canvas, 227 × 151 cm
PROVENANCE: Commissioned for the San Gaudioso Chapel in the
Church of Sant'Alessandro, Brescia; Brescia, Avogadro Collection,
by 1785; Brescia, Fenaroli Collection; purchased from the
Venetian dealer Luigi Resimini, 1895, inv. 1253

SAINT SEBASTIAN AND SAINT ROCH were the two intercessors to whom the pious could pray when seeking divine protection from the plague. According to legend, Roch, a native of the French city of Montpellier during the fourteenth century, contracted the deadly disease in Piacenza on his return from a pilgrimage to Rome. He withdrew to a forest where, miraculously, he was healed by an angel. His loyal dog accompanied him and brought him food. This is the subject of Moretto's late altarpiece,[1] painted about 1545. The saint sits under a tree, his wound tended by an angel with an ointment jar and a surgeon's knife in his hand. To the left the dog appears holding a loaf of bread in its mouth. Certain of the buildings in the background refer to Rome and are immediately recognizable: the Pyramid of Cestius, the columns of the Forum, the Torre delle Milizie, and the massive barrel vaults of the imperial baths.

In this scene, dramatic tension is restrained and emotional expression is reserved. Roch seems to be asleep rather than suffering, and the mystical moment of healing unfolds in a subdued atmosphere bordering on serenity. In its timelessness, the scene makes no attempt to represent a mystical, supernatural event. Rather, the faith that Moretto da Brescia expresses in his religious paintings is simultaneously honest, genuinely devout, and down-to-earth. His quiet prose is best revealed when compared with Titian's noble pathos, the highly wrought emotionalism of Lotto (who actually befriended Moretto in Bergamo), Romanino's full-blooded narrative art, or, recalling the next generation, Tintoretto's exuberance and Veronese's magnificent theatricality.

The silky, silvery sheen of the palette is one hallmark of Moretto's refined, meditative art. Another typical feature is his depiction of material details with extraordinary verisimilitude. Despite their formal compositional role, these arresting and readily recognizable artifacts become a composite image of sixteenth-century life. The satchel lying in the grass with its untied string, the saint's garments including the *calzone* rolled down to expose the wound, the pilgrim's staff with the hat suspended from it, and the neatly knotted white kerchief are all rendered realistically. The objectivity, lucid spatial definition, balanced palette, and naturalism in this painting manifest Moretto da Brescia's local Lombard heritage. Throughout his career, the Venetian impulses that he received either directly from Titian or indirectly

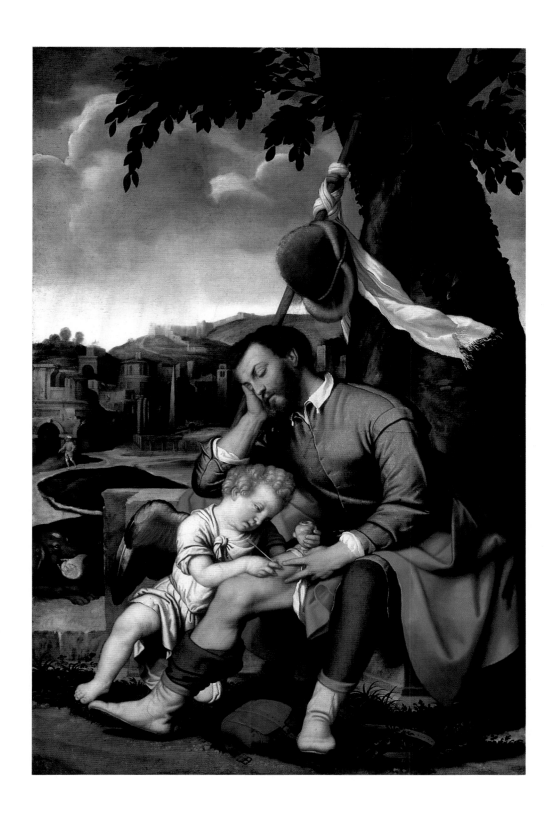

from Romanino never fully dislodged the quattrocento Lombard tradition, yet Moretto's classicizing manner and his striving for monumentality indicate the degree to which he embraced progressive ideas.

A painting of the same subject in the Museo Civico in Crema, made shortly before 1500 by Vincenzo Civerchio,[2] probably inspired Moretto's *Saint Roch Cured by the Angel*.[3] —V.T.

] 2 1 [

Sleeping Girl

Oil on canvas, 67.5 × 74 cm
PROVENANCE: Esterházy Collection; acquired, 1870, inv. 609

THIS PAINTING has been cut along all four sides,[1] making it difficult to determine its actual subject because symbolic attributes may have been eliminated. Although in its current state *Sleeping Girl* appears to be a pure genre subject, originally this picture almost certainly represented a religious theme—Mary Magdalene.

As a subject for pictorial representation the Magdalene became very popular after the Council of Trent, depicted either as an elegantly dressed, voluptuous young woman or, following her conversion to Christianity, as a penitent, living in the desert. Mary Magdalene became one of the most popular images of the seventeenth century.[2] She is often displayed with her ointment jar or as a devoted and humble follower of Christ, washing his feet. She is also frequently represented in ecstasy or in repentance.[3] Only rarely was she depicted asleep, as is the case in Caravaggio's small painting in the Doria Pamphili Gallery in Rome. Likewise, the conspicuous kerchief rarely features prominently in depictions of the Magdalene.[4] In allegorical representations of meditation or melancholy, the female personification, strongly reminiscent of the Magdalene, appears in a painting by Fetti of about 1618,[5] and in Giovanni Battista Castiglione's well-known etching of about 1645–46.[6] Not coincidentally, the posture of these figures is closely associated with sleep.

In the painting in Budapest Fetti represents the Magdalene in the process of being converted.[7] Having wept, she fell asleep; her pink nose and eyelids are characteristic signs of weeping. The smile on her face indicates her conversion to Christianity.

In the Esterházy Collection this work was ascribed to Paolo Veronese.[8] Mündler reattributed it to Fetti in 1869.[9] In 1943 Longhi questioned this attribution and, instead, proposed Sigismondo Coccapanni as the painting's author.[10] Coccapanni's indisputable oeuvre has subsequently been reduced to a mere handful of paintings,[11] leaving the attribution of *Sleeping Girl* uncertain. In any case this powerfully realistic and sublime painting is demonstrably closer to the followers of Caravaggio than to Coccapanni's dramatic sensuality.

Despite these attempts to reattribute it to other masters,[12] the attribution of *Sleeping Girl* to Fetti warrants serious consideration. Comparison of *Sleeping Girl* to Fetti's *David* in the Accademia in Venice, a work datable to about 1617–19,[13] shows an analogous treatment of meticulously elaborate details in the clothing and David's plumed cap. The richly applied paint in both pictures and the pink hue and

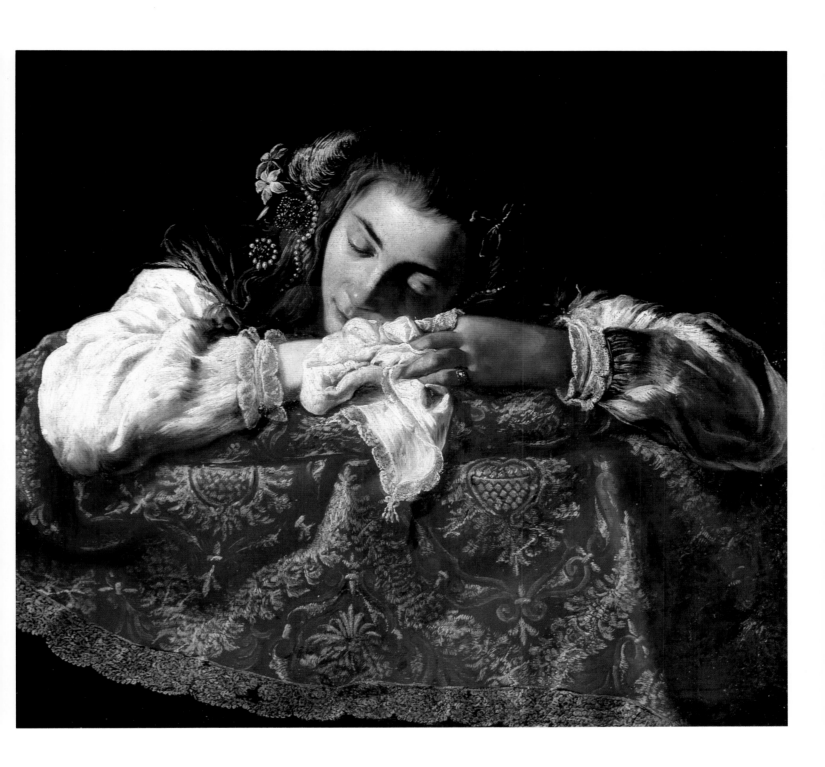

sentimental expression of the faces are comparable. Both works display the influence of Caravaggio in the way the artist sets the figures off prominently against a dark background. During the latter half of the nineteenth century the *David* was ascribed to a follower of Caravaggio.[14] Later it was ascribed to Johann Liss, until Fiocco, correctly, in our opinion, assigned it to Fetti in 1929. Fiocco also considered *Sleeping Girl* to be Fetti's masterpiece.[15]

It is known from old inventories and more recent auction catalogue references that Fetti represented the Magdalene frequently. His earliest surviving representation of the Magdalene, datable to his early Roman period before 1613, is now in the Fondazione Roberto Longhi in Florence.[16] Ironically, this picture shares certain affinities with the recognizable style of Coccapanni.

A *Magdalene* from Fetti's more mature period, from about 1620, is in the Doria Pamphili Gallery in Rome.[17] It derives principally from a prototype by Correggio, most conspicuously in the artist's use of the motif of the right hand supporting the head. Its fluid yet subtle painterly treatment and the refined representation of deep but transparent shadows display Fetti's knowledge of Rubens.

Sleeping Girl in Budapest should be dated between these two *Magdalene*s in Florence and Rome. Its Roman reminiscences are strong in terms of the modeling of the figure and in the detailed treatment of the patterned brocade. A date of around 1615, early during Fetti's sojourn in Mantua, seems reasonable. —I.B.

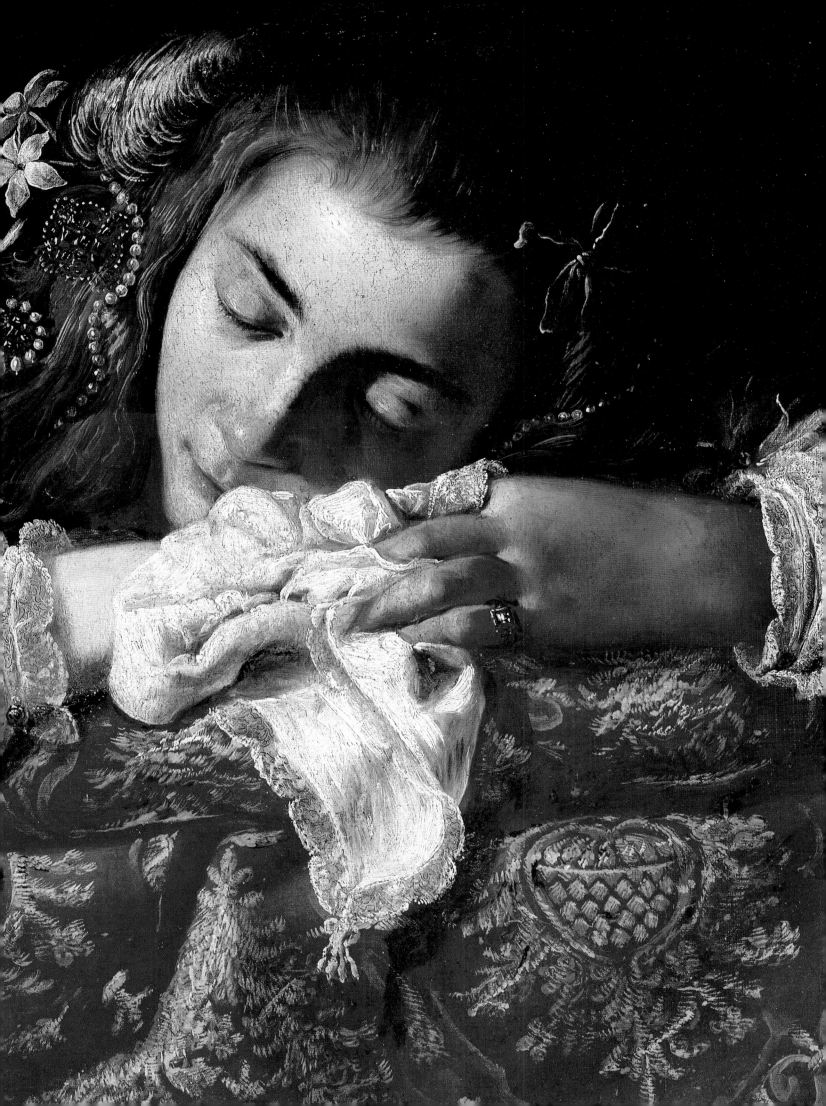

] 2 2 [

Faith, Hope, and Charity

Oil on canvas, 176 × 145.5 cm
PROVENANCE: Purchased at the 49th auction of the BÁV
[state-run auction house], Budapest, 1979, inv. 79.4

KLÁRA GARAS, responsible for discovering Lazzarini's works in Hungary, first identified the artist and patron of this painting, as well as its date.[1] The composition is probably identical with Lazzarini's *Allegory of Faith, Hope, and Charity* painted in 1694 for Procurator Diedo, a painting mentioned by Vincenzo da Canal, the artist's biographer.

Enthroned among clouds, the female figures personifying the three theological virtues, with their traditional attributes, are close to the descriptions as provided by Ripa.[2] Faith can be identified by her white garment and the cross and Hope by her green dress, upward gaze, and the anchor in her lap, whereas Charity is recognizable by her red robe and the three children surrounding her. The dignified, robust figures filling most of the picture field, the heavy, sculptural draperies, and the delicate palette, undisturbed by strong effects of light and shadow, result in a monumental decorative composition. Lazzarini's typical, oval, youthful female facial types, recalling Pietro Liberi's heroines, represent a formal, idealized standard of beauty. Like his antecedents Carpioni and Liberi, Lazzarini also drew inspiration from Padovanino and Venetian cinquecento painters. By contrast, the precise, finished draftsmanship, articulated composition, and the smooth, polished paint surface endow Lazzarini's works with an almost anti-Venetian character. It is no accident that Maratta was one of Lazzarini's most enthusiastic admirers and that Lanzi spoke of his works as if their creator had been trained in Rome or Bologna.[3]

Although providing a counterpart to the prevailing Venetian Baroque *tenebroso* style, Lazzarini's classicizing mode failed to take hold in Venice. None of his distinguished pupils, including G. B. Tiepolo, G. Diziani, and G. Camerata, chose to perpetuate this classicizing tendency.

Though Lazzarini was not trained in Bologna, his art was very close to that of Cignani and especially to that of Franceschini. In their facial types and poses, the putti in Lazzarini's paintings recall those by Franceschini. In fact, Lazzarini may well have been inspired to paint the subject of the allegory of Charity by his Emilian colleague. Vincenzo da Canal, as early as 1752,[4] mentions numerous versions of Lazzarini's *Charity,* both as an independent composition and as a component in larger allegories.[5]

This painting dates from Lazzarini's mature period, when he was at the peak of his career and fulfilling his most significant commissions. It is closely related to these commissions in several respects. The characterization of the figures and the motif of the suckling infant in the allegory of Charity links the

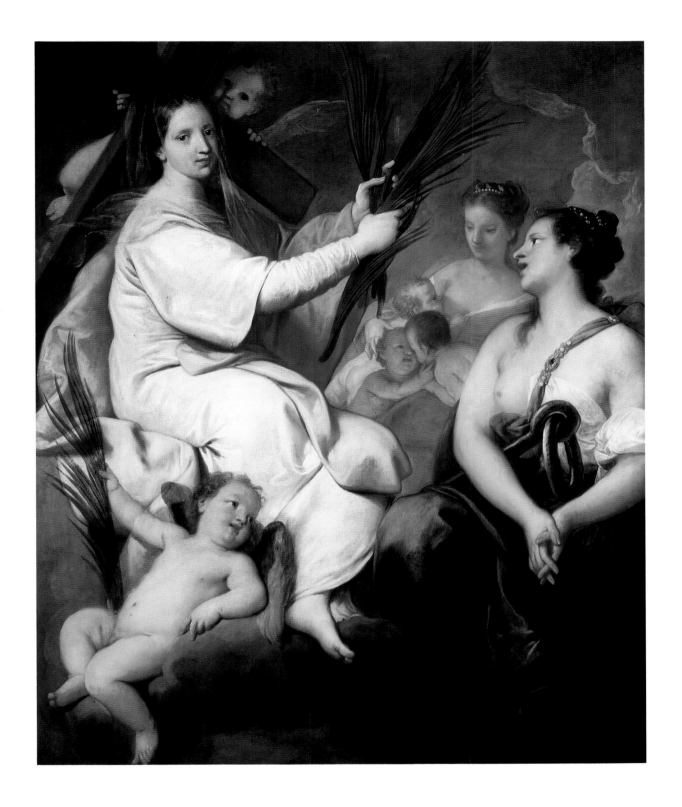

Budapest picture to the gigantic composition *San Lorenzo Giustiani Distributing Alms* in the Church of San Pietro in Castello, made in 1691. Our painting dates from 1694, the year when Lazzarini painted the allegorical series on the triumphal arch erected in honor of the warrior doge, Francesco Morosini, in the Sala dello Scrutinio of the Palazzo Ducale. As noted by Garas,[6] the seated female personification of Religion is virtually interchangeable with the figure of Faith in the Budapest painting. —Zs.D.

] 2 3 [

The Assumption of the Virgin

Oil on canvas, 95 × 51.5 cm
PROVENANCE: Esterházy Collection; acquired, 1870, inv. 642

THIS SMALL *BOZZETTO* is Ricci's preparatory sketch for the altarpiece commissioned by the Holy Roman Emperor, Charles VI, for the Karlskirche in Vienna.[1] The finished painting is located in the second side chapel on the left and was Ricci's last important enterprise of 1733–34 in Vienna.[2] Ricci's work was already known firsthand in Vienna, where he decorated the Blue Staircase (originally the Mirror Room) in Schönbrunn Palace in 1701–2 for Charles's father, Emperor Leopold I.[3]

Gregory of Tours (died 593/94) provided the primary source for representations of the Assumption of the Virgin. Gregory drew on apocryphal sources such as those ascribed to the Apostle John or the Pseudo-Melito.[4] Despite the lack of biblical references, the Feast of the Assumption became one of the most sacred events in the calendar of the Roman Catholic church. Its celebration, held annually on August 15, can be traced back to the seventh century.

The Budapest painting is the artist's initial idea for this commission.[5] Its freshness and dynamism were immediately extolled and, in the words of Ricci's contemporary and admirer, L. Pascoli, "gained the satisfaction not only of His Majesty, but of the whole nobility, and all the professors and connoisseurs."[6] Its success is further illustrated by numerous variants of which the ones in the National Gallery of Prague, Munich, Aschaffenburg, and Lvov are the most notable.[7] It also had great influence on Hungarian painting; several eighteenth-century copies of the composition exist in provincial churches scattered throughout western Hungary.

Ricci's *Assumption of the Virgin* is composed along a three-dimensional S-curve, divided into three planes. This presentation elaborates on Ricci's earlier treatment of the subject in Clusone, Bergamo.[8] The awkwardness of the earlier work (consisting of two sections with a gap between them) is supplanted by the more elaborate yet balanced composition of the Budapest painting.

The extreme torsion of the figures is brilliantly resolved by the elegant choreography of Ricci's design. The pictorial vitality, the spirited painting technique, and the extraordinary freshness of the color scheme display Ricci's energy in shaping his initial idea. Numerous pentimenti, visible to the naked eye, and the rapid brushwork, showing the influence of Magnasco, further demonstrate Ricci's intense creativity. His facility and sense of immediacy characterize the brilliance of painting preliminary sketches on canvas, a practice that the greatest eighteenth-century Venetian masters perfected to an astonishing degree.

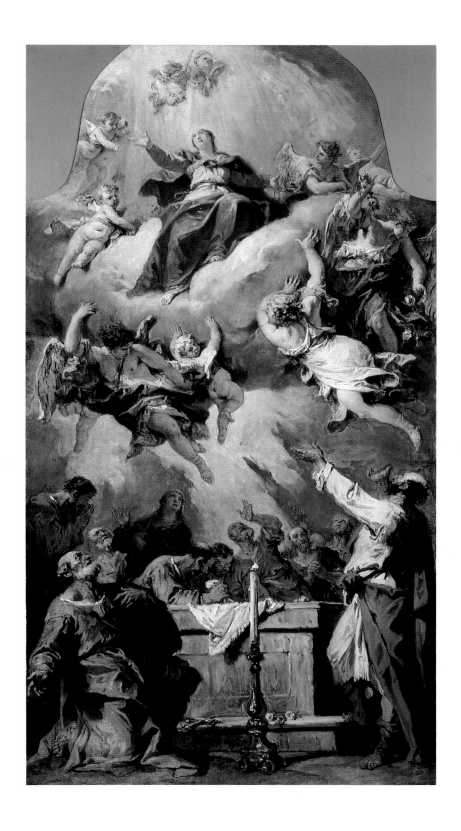

Differences between the sketch and the finished painting exist. For example, the sketch contains fewer putti. More important, Ricci's reliance on the participation of assistants in executing the finished altarpiece resulted in a less spirited and less colorful work, which is rather disappointing in its overall effect.

—I.B.

] *24* [

Saint Elizabeth of Hungary Distributing Alms

Oil on canvas, 72 × 42.5 cm
PROVENANCE: Pécs, Hungary, private collection;
from which acquired, 1927, inv. 6155

SAINT ELIZABETH OF HUNGARY (1207–1231) was the daughter of Andrew II, king of Hungary. At age fourteen she married Louis IV, landgrave of Thuringia. In Germany she devoted herself to works of charity in accordance with her sense of religious piety. According to legend, one day when she descended from her royal residence, the Wartburg, to distribute bread, she was stopped by her husband, who had forbidden her to give to the poor. When Louis demanded to see the contents of her basket, he saw in it nothing but a mass of red roses. Later, after her husband's death, Elizabeth chose to live in seclusion at Marburg. Under the direction of her confessor, Conrad of Marburg, she did penance and ministered to the sick. Elizabeth was canonized by Pope Gregory IX in 1235, only four years after her death. The cult of Saint Elizabeth of Hungary was very popular in Central Europe during the Middle Ages and later, especially during the Baroque period. Pittoni represents Saint Elizabeth of Hungary giving bread to the poor rather than displaying her basket of roses, thereby stressing how she personifies Charity, one of the three theological virtues.

This *bozzetto* was the preparatory sketch for a much larger altarpiece Pittoni executed for the Schlosskirche at Bad Mergenthau in Württenberg, Germany.[1] Recently discovered documents confirm the date of execution of this altarpiece to 1734.[2] Although Pittoni's style did not evolve substantially throughout his career, this indisputable documentation helps to date certain of the artist's other paintings. Despite the fact that he did not have access to this documentary evidence, Pigler, as early as 1931, dated Pittoni's sketch in Budapest to 1734,[3] based on its stylistic affinity to similar religious paintings executed by Pellegrini and Sebastiano Ricci for the Karlskirche in Vienna (cat. nos. 14 and 23). Pigler, not knowing the ultimate destination of this commission, further suggested that the finished altarpiece based on this *bozzetto* may originally have been destined for this new, important, imperially funded church, resulting from Charles VI's vow to erect a splendid ecclesiastic monument to San Carlo Borromeo. Such a commission would not have been unreasonable, because, at this time, Pittoni was fulfilling a commission from the Viennese court to produce two compositions for the chapel of Schönbrunn Palace.[4]

Although Pigler's hypothesis proved erroneous, the fact that Venetian painters received commissions for altarpieces in the Karlskirche seems to have triggered a nationalistic rivalry in securing further decorative commissions for the church. As the project evolved, a chauvinistic spirit seems to have won

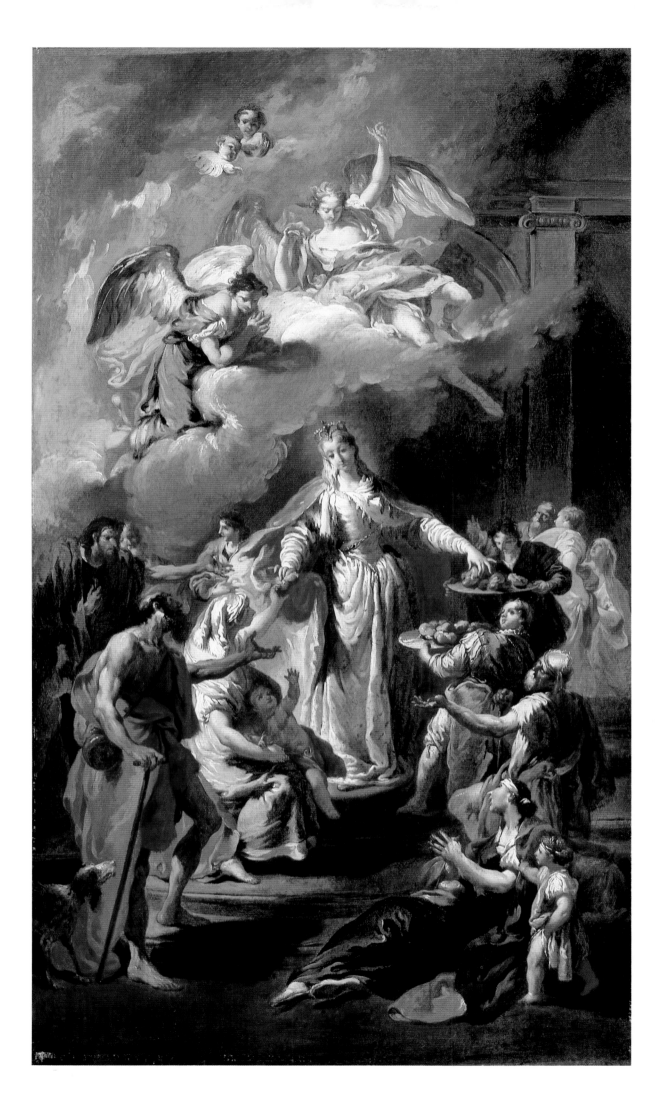

out, because the last four commissions were assigned to the Austrian painters Daniel Gran, Martino Altomonte, and Jacob van Schuppen.

In his altarpiece of the same subject, *Saint Elizabeth of Hungary Distributing Alms,* Daniel Gran followed Pittoni's composition closely.[5] Gran obviously knew Pittoni's composition; his variant dates from 1736–37, a few years after Pittoni delivered his painting to Germany.

Pittoni's *Saint Elizabeth of Hungary Distributing Alms* displays two opposing trends in eighteenth-century Venetian art. His graceful figures recall the work of Sebastiano Ricci, whereas the pronounced chiaroscuro effects display his knowledge of Piazzetta. Because of its subject, this small sketch was very popular, and more than a dozen copies and replicas are known. Of these the one in the Barockmuseum in Salzburg is of sufficiently high quality to suggest that it might be an autograph variant by Pittoni.[6] —I.B.

] 25 [

Saint James the Great Conquering the Moors

Oil on canvas, 317 × 163 cm
SIGNED ON THE SWORD: *G. TIEPOLO F.*
PROVENANCE: Commissioned in 1749 by Ambassador Ricardo Wall for the chapel of
the Spanish embassy in London[1] but never installed; Spanish Royal Collection (?), by 1751;[2]
probably purchased in Madrid by Edmund Bourke (1801–11);[3] London, William Buchanan sale,
June 1, 1816, lot 49 (presumed property of Bourke);[4] London, European Museum sale, March 1819,
lot 590 (property of Bourke);[5] acquired by Prince Paul Esterházy from Bourke's widow in Paris, 1821;
Esterházy inventory of December 5, 1821, no. 1082;[6] acquired, 1870, inv. 649

ACCORDING TO LEGEND, Saint James the Great appeared at the Battle of Clavijo in 844 to help the Spanish in their first victorious battle against the Moorish invaders of the Iberian peninsula. This event was recognized as the starting point of the *Reconquista,* the recapturing of Spain for Christianity. Fittingly, because of his intervention, Saint James the Great became the patron saint of Spain.

The subject of this painting was determined by its destination: the altar of the chapel of the Spanish embassy in London, i.e. in the capital of a rival empire of "heretic" religion. Because the painting represented the patron saint of Spain, it made indirect reference to the deep-seated political and mercantile rivalry between Spain and England and to the fact that England had abandoned Roman Catholicism to embrace Protestantism. Tiepolo did not choose the more usual rendering of Saint James as a pilgrim, a subject already popular in Spain and Italy in the seventeenth century,[7] but represented him more appropriately as a fearless Christian warrior (*miles christianus*), mounted on horseback.[8] Both the monumentality and the dynamism of this painting suggest the glory of the Roman Catholic church, which was integral to the historical legend as well as to Spain's sense of destiny, in maintaining and spreading the true faith. The last great representative of the Venetian settecento, Giambattista Tiepolo spent his last years in Madrid working on Spanish royal commissions. However, *Saint James the Great Conquering the Moors* was painted in Venice much earlier, before Tiepolo's departure for Würzburg in 1750.

The monumental handling and the pastel colors give this painting a frescolike quality, and it is one of Tiepolo's most beautiful and spellbinding works. Although Saint James assumes a superhuman presence, Tiepolo's portrayal is not overly dramatic. Indeed, this heroic figure is conceived in a classical manner, mounted on horseback like an ancient hero: statuesque, dignified and detached from the battle.[9] The idealized features of the saint's upturned face convey a devout expression, underscored by the nobility of the white thoroughbred steed. *Saint James the Great Conquering the Moors* dates to what has been termed Giambattista's "classical period,"[10] a critical time of transition in which the radiating magnificence and splendor of his images are blended with realism and religious piety.[11]

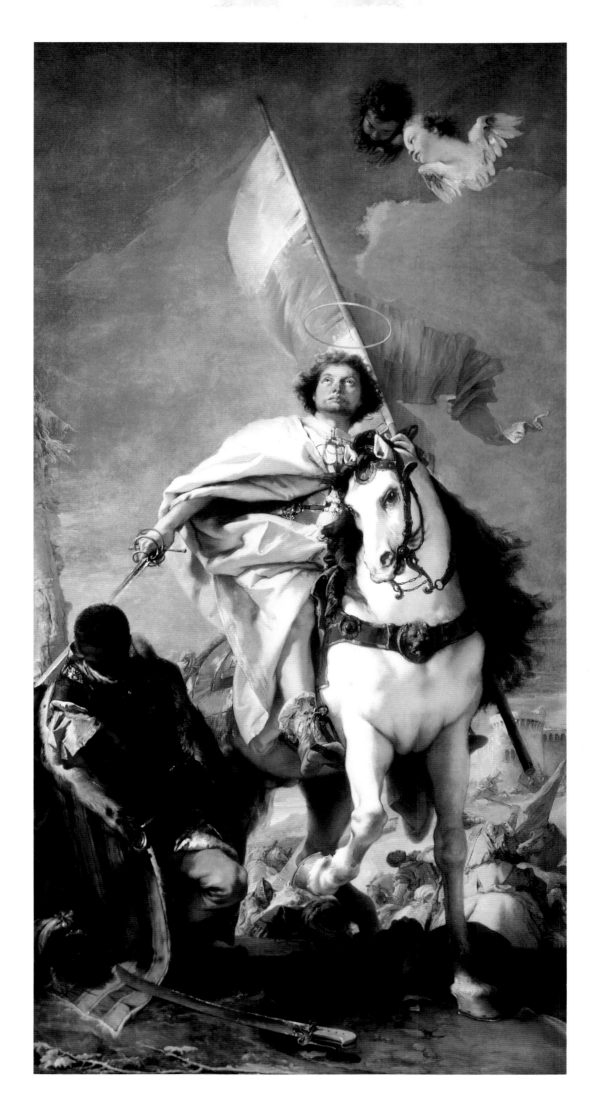

Upon receiving Tiepolo's painting, the commissioner, Richard Wall, and the chaplains of the Spanish embassy in London feared that the horse might cause a scandal.[12] They believed that the horse would fascinate the viewer and thus distract from the intended function of the altarpiece as a focus for prayer and meditation. Right from the beginning the ambassador considered withdrawing the commission, using the somewhat lame excuse that it would be more appropriate to seek a Spanish painter.[13] Wishing to be rid of Tiepolo's altarpiece and capitalizing on the excuse that others praised it, Wall proposed that the painting be presented to the Spanish king.[14] This course of action seems to have been implemented.[15]

The Museum of Fine Arts in Budapest also owns a chalk drawing of the saint's head[16] attributed either to Giambattista[17] or to his son, Domenico.[18] Considering how much the expression of the face in the drawing differs from that found in the print by Domenico,[19] we have come to believe that the drawing is a preparatory study by Giambattista for the saint's head. Like the painting, the drawing also anticipates later stylistic developments and has a decorative richness fused with rational objectivity—qualities most readily associated with Giambattista Tiepolo's works produced in Würzburg.

During World War II this canvas was rolled up and taken with the rest of the collection to Germany. Along with several other paintings, however, it only reached the Hungarian border [Szentgotthárd], where it was found, lying in the snow, in February 1945. The damage it suffered at this time was properly repaired only in 1988 with the aid of the Hungarian National Art Foundation in New York.[20] —I.B.

] *26* [

The Virgin Immaculata with Six Saints

Oil on canvas, 72.8 × 56 cm
PROVENANCE: János László Pyrker Collection; by whom given
to the Hungarian National Museum, 1836, inv. 651

THE VIRGIN IMMACULATA WITH SIX SAINTS is an eighteenth-century variation of a typically Venetian theme which first evolved in the quattrocento, the *sacra conversazione,* where an assembly of saints is in holy conversation, presided over by the Madonna.

Whereas the Christ Child appears with the Virgin in most *sacra conversazione* subjects, in Tiepolo's painting he is absent. Instead, the Virgin Mary appears as the *Immaculata,* her purity symbolized by her white gown. And whereas during the seventeenth century this subject as depicted by Guido Reni in Italy or Murillo in Spain represents the Virgin triumphant, Tiepolo's Virgin is deeply meditative. This spirit of meditation is reflected in every face and gesture and is reinforced by *vanitas* symbols such as the skulls, the cross (in this case the subject of meditation), and the decaying, ancient building.

Saints Francis and Peter, two of the most celebrated Franciscan saints, are represented in this image, implying that the subject may be Franciscan in derivation since the cult of the Immaculate Conception was strongly promoted by the Franciscan order.[1]

The composition departs radically from quattrocento prototypes that represent the subject either in half-length format or within a strict bilaterally symmetrical architectural setting. Tiepolo's painting also breaks from the tradition of Paolo Veronese, who placed his religious subjects of this type before monumental architectural backdrops. The tradition initiated by Veronese was perpetuated well into the eighteenth century by painters such as Sebastiano Ricci and others.

In his innovative format Tiepolo employs elements from the world of theater to shape his Baroque vision of a miraculous apparition, far removed from prosaic, daily reality. The open composition retains a hint of the Venetian Renaissance pictorial device that offers a glimpse into the distance to one side of the figures, while architectural components resembling stage props screen the other. The gracefully gesturing figures are elaborately arranged along a central serpentine line, which also serves to connect the heavenly and earthly realms. This scheme, as well as the graceful style, suggests that this is a typical example of *barochetto,* the Italian-Venetian equivalent of the French Rococo.[2] This style is characterized by rich fabrics and elaborate drapery patterns, with windblown capes that flutter gracefully, not subjected to violent agitation.

The Virgin Immaculata with Six Saints displays an extraordinarily measured chromatic and compositional equilibrium, as well as a decorative elegance underscored by the sensuousness of the painterly

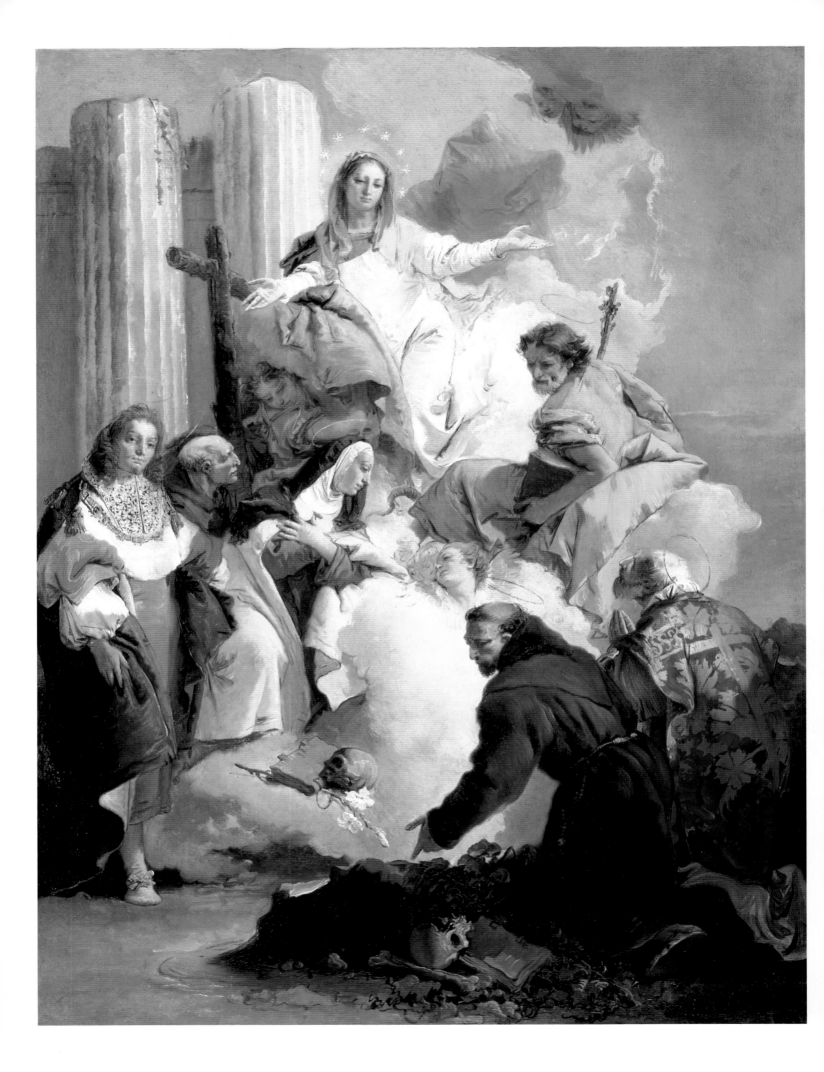

presentation.[3] Despite its small dimensions, this painting is not a sketch but a monumental composition radiating magnificence and splendor. The complex delineation of space doubtlessly reflects the influence of Mengozzi-Colonna, an architectural painter with whom Tiepolo often collaborated.

Various dates have been proposed for the painting.[4] Catherine Whistler's dating of the execution to 1748–50,[5] contemporaneous with *Saint James the Great Conquering the Moors,* seems the most acceptable.

The popularity of this subject in Spain, and the inclusion of two Spanish saints, Peter and Theresa, may indicate that this diminutive devotional picture was intended for a Spanish patron or institution. One plausible candidate could have been the duke of Montealegre, the Spanish ambassador to Venice.[6] Conversely, Garas has suggested that a religious brotherhood could have commissioned the picture.[7] The prominence of Saint Louis led Whistler to conjecture that the commissioner might have been Alvise Cornaro, since the name Louis, rendered in Venetian dialect, is Alvise.[8] However, until firm documentation is discovered, the commissioner of this painting remains a mystery.[9] —I.B.

Madonna of the Rosary with Saint Catherine of Siena and Saint Dominic

Oil on canvas, 126 × 86 cm
PROVENANCE: Budapest, private collection; acquired, 1965, inv. 65.3

THE YEAR OF THE GREAT GUARDI EXHIBITION in Venice, 1965, also witnessed a sensational Guardi discovery in Budapest, when the Museum of Fine Arts purchased this *gonfalone* (processional banner), which features the same composition on both sides. Owing to its original function, the work came to the museum in rather worn condition. Iván Fenyő published it as a joint product of the two Guardis, attributing the recto to Giovanni (right) and the verso to Francesco (page 140).[1] Probably commissioned by a Dominican confraternity of the rosary, the painting depicts the infant Christ descending with his mother on a throne of clouds and offering his blessing, while the Madonna passes a rosary to Saint Catherine of Siena. Saint Dominic watches the celestial scene in adoration.

Between 1730 and 1745 Gianantonio Guardi made numerous copies of antique (i.e., cinquecento) and contemporary painters' works on commission for Marshal Matthias von Schulenburg, but in many other instances he was fond of reformulating the inventions of other artists. The prototype of the composition in Budapest was recognized by George Knox in a drawing by Giovanni Battista Tiepolo, the *Madonna of the Rosary* from the Orloff Album.[2] The composition is indeed very close to Tiepolo's sheet but, as Alice Binion notes,[3] the Madonna and the Child appearing in the Guardis' processional banner are not so obviously inspired by Tiepolo. In formulating the central part Gianantonio probably adapted an existing model, as he did in his other Madonna compositions.

Much of the subtlety of the paint facture on the recto has been lost through abrasion, but it still displays varied and energetic brushwork. The coloring, dominated by yellows, blues, greenish browns, and white, is particularly arresting in the sketchily defined landscape; the spontaneity of the lively brushwork makes the tones seem to flicker. Although similarly executed landscape backdrops appear in many other works of the master, the best proof of Gianantonio's authorship is the Madonna's lovely, narrow face, which recurs most notably in Guardi's altarpiece in Belvedere di Aquileia. In the secondary application of the cartoon on the verso, which is credited to Francesco, his own imprint is clearly distinguishable in the more muted coloring, the looser, thinner painting technique, and in the wider, less graceful head of the Madonna, which finds its closest analogy in Francesco's signed *Tecchio Madonna* in Milan.

No debate exists among the Guardi scholars defining the two brothers' joint authorship of this processional banner, a document of fundamental importance for distinguishing between the two hands. Disagreement exists about its dating, however. Fenyő puts it at around 1735,[4] during the short period

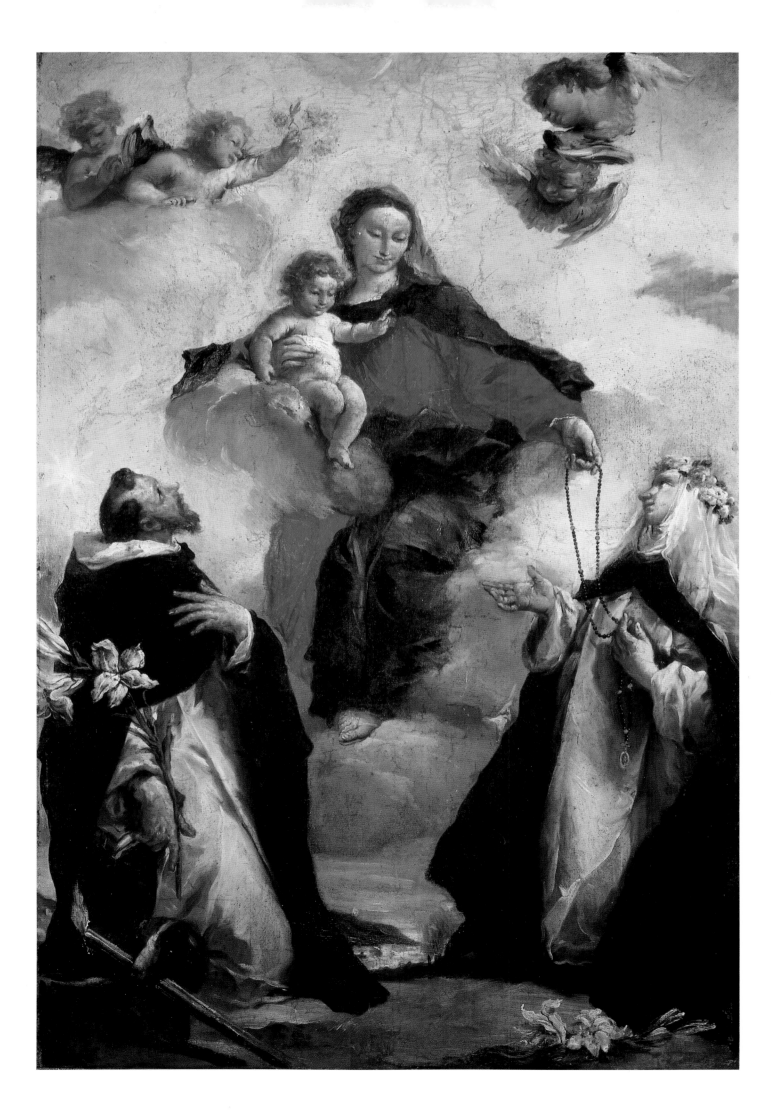

when, following his apprentice years in his elder brother's *bottega,* Francesco began to display his own style in paintings done in collaboration with his master. Mahon accepts Fenyő's proposal,[5] but Morassi, whose monograph on the Guardis remains the standard reference, argues for the years between 1745 and 1750,[6] thereby dating the processional banner in Budapest close to Gianantonio's masterpieces, the altarpiece in Belvedere (after 1746) and the Tobias scenes painted on the organ shutters in the Church of San Angelo Raffaele in Venice (1749–50).

These major late works by Gianantonio Guardi are characterized by almost splintered brushwork dissolving through the dazzling refraction of color. Their style seems far removed from the more structured and monumental imagery and the more disciplined brushstrokes found in the processional banner in Budapest. On balance, the earlier dating for this work as initially proposed by Fenyő seems preferable. —Zs.D.

] *28* [

The Ecstasy of Saint Theresa

Oil on canvas, 72 × 56 cm
PROVENANCE: Purchased at the 28th auction of the BÁV
[state-run auction house], Budapest, 1972, inv. 72.6

ALTHOUGH THE BUDAPEST COLLECTION contains numerous Venetian settecento works by masters of the two generations succeeding Sebastiano Ricci, the artist most richly represented is Francesco Fontebasso. The Museum of Fine Arts possesses a complete ensemble of paintings that originally decorated a room in the Palazzo Bernardi in Venice. This suite consists of two monumental history paintings, four tondos depicting mythological subjects, and a ceiling painting. It offers splendid witness to the master's grandiose, spectacular style inherited from Tiepolo. By contrast, *The Virgin Appearing to Saint Jerome* and *The Ecstasy of Saint Theresa,* included in this exhibition, display Fontebasso's skills on a more intimate scale.

The subject of the painting is perhaps the most frequently depicted episode from the life of Saint Theresa of Avila, a sixteenth-century Spanish Carmelite nun canonized in 1622. In her autobiography, Saint Theresa describes her vision in which an angel appeared before her and pierced her heart repeatedly with his flaming arrow to infuse her with Divine Grace and to imbue her with the love of God. Infused with mysticism and spiritualism, this expression of *amor dei* was extremely popular in the Venetian settecento: almost every painter from Sebastiano Ricci, Diziani, and Piazzetta to Giambattista Tiepolo elaborated on it. Klára Garas posits that the prototype of Fontebasso's composition may have been Sebastiano Ricci's altarpiece in the Church of San Girolamo degli Scalzi in Vicenza, which dates to about 1727.[1] In this writer's opinion, however, Fontebasso's painting is linked more closely to one of Ricci's preparatory drawings now at Windsor Castle for his altarpiece in Vicenza.

Most sources, including an inscription on one of Fontebasso's drawings, mention Ricci as Fontebasso's master.[2] Until his trip to Rome in 1728, Fontebasso worked in Ricci's studio and had ample opportunity to study Ricci's preparatory designs for the Vicenza commission. Ricci's altarpiece is conceived in a tumultuous, Baroque manner containing vigorous figures that almost break out of the picture field. By contrast, Ricci's drawing and Fontebasso's painting are reduced to three figures. Consequently, the compositions are more compact and self-contained, and the poses of the figures are less theatrical. Although filtered by grayish pink clouds, the light still casts deep shadows on the tiled floor and in the deep folds of the garments. The kneeling figure of Saint Theresa, so typically characterized by the *crudezza* (crudeness) denounced by Fontebasso's critics Pasta,[3] Lanzi,[4] and Moschini,[5] is balanced by a

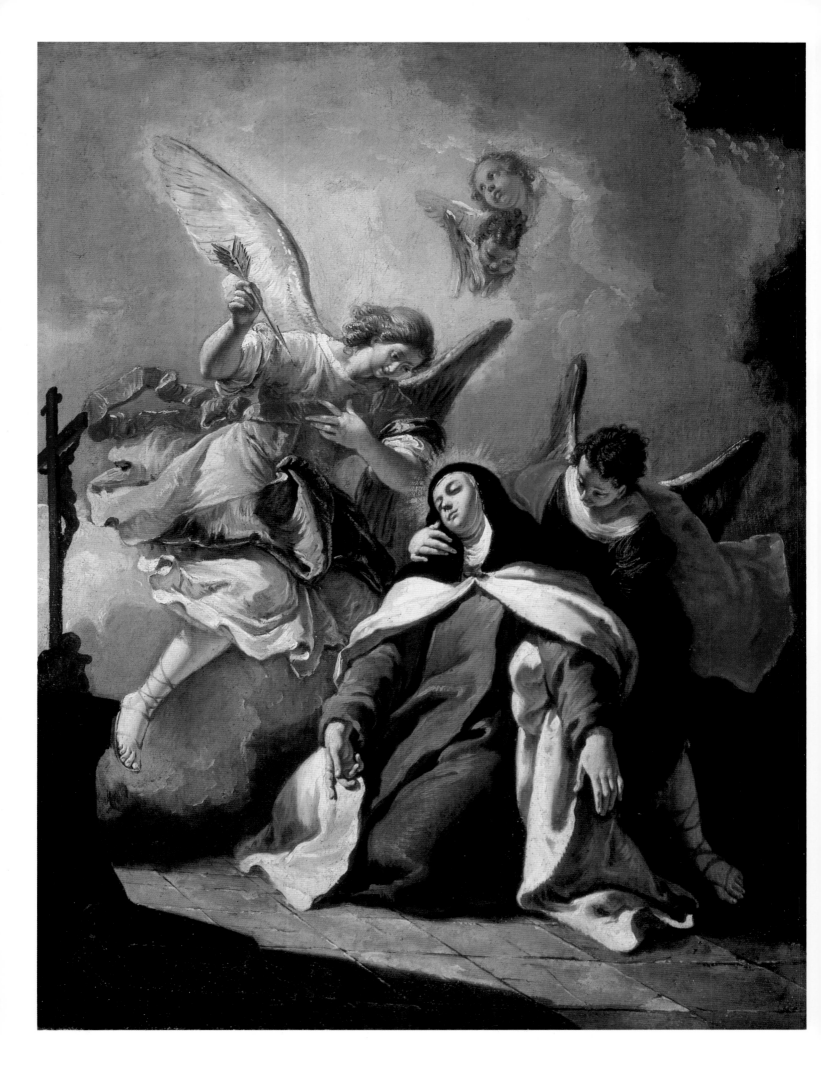

certain Rococo lightness and refined, almost affected charm of the angel about to stab her with the arrow. The figure of the angel enveloped by artfully fluttering draperies recurs without significant change in one of Fontebasso's drawings of the Annunciation in the Courtauld Institute of Art in London (gift of Robert Witt). Fontebasso applies his bright colors with fast, lively brushstrokes. His distinctive coloristic vein derives from his two guiding stars: Sebastiano Ricci and Giambattista Tiepolo.

Basing her judgment on its somewhat cumbersome forms, Marina Magrini, in her Fontebasso monograph,[6] places *The Ecstasy of Saint Theresa* at the close of the master's mature period but does not provide a more precise date for this work.　　—Zs.D.

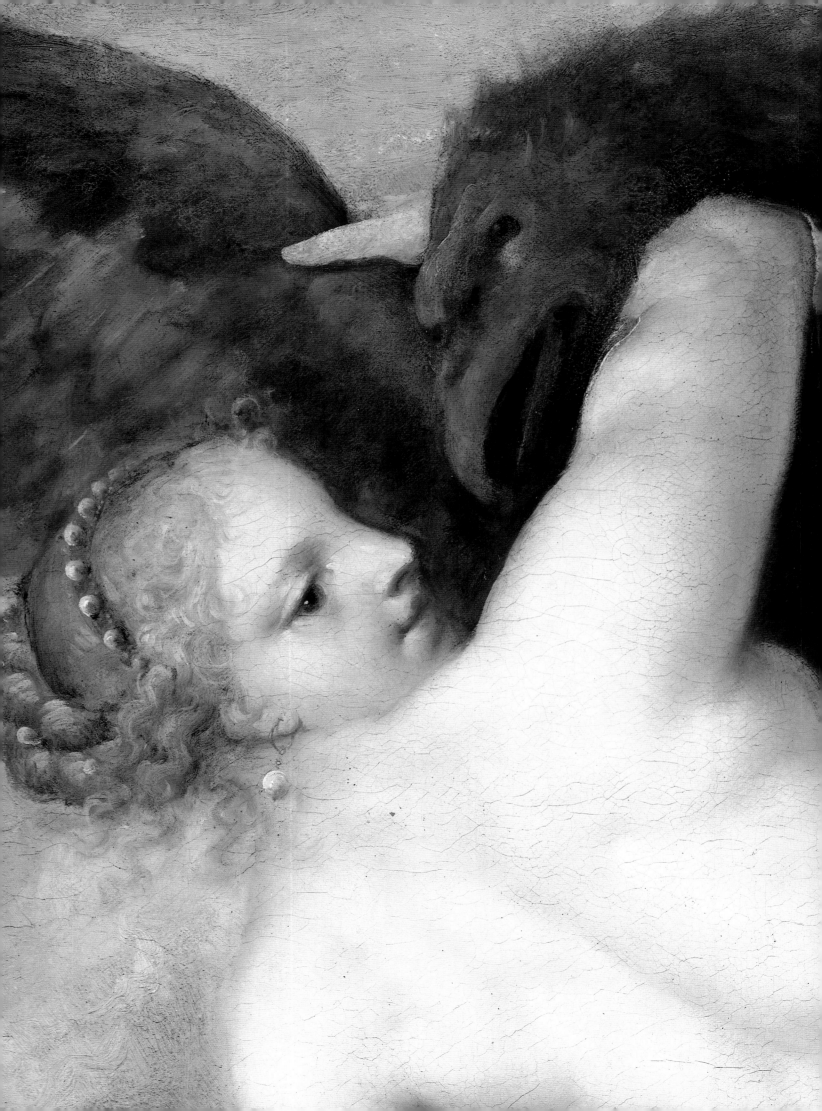

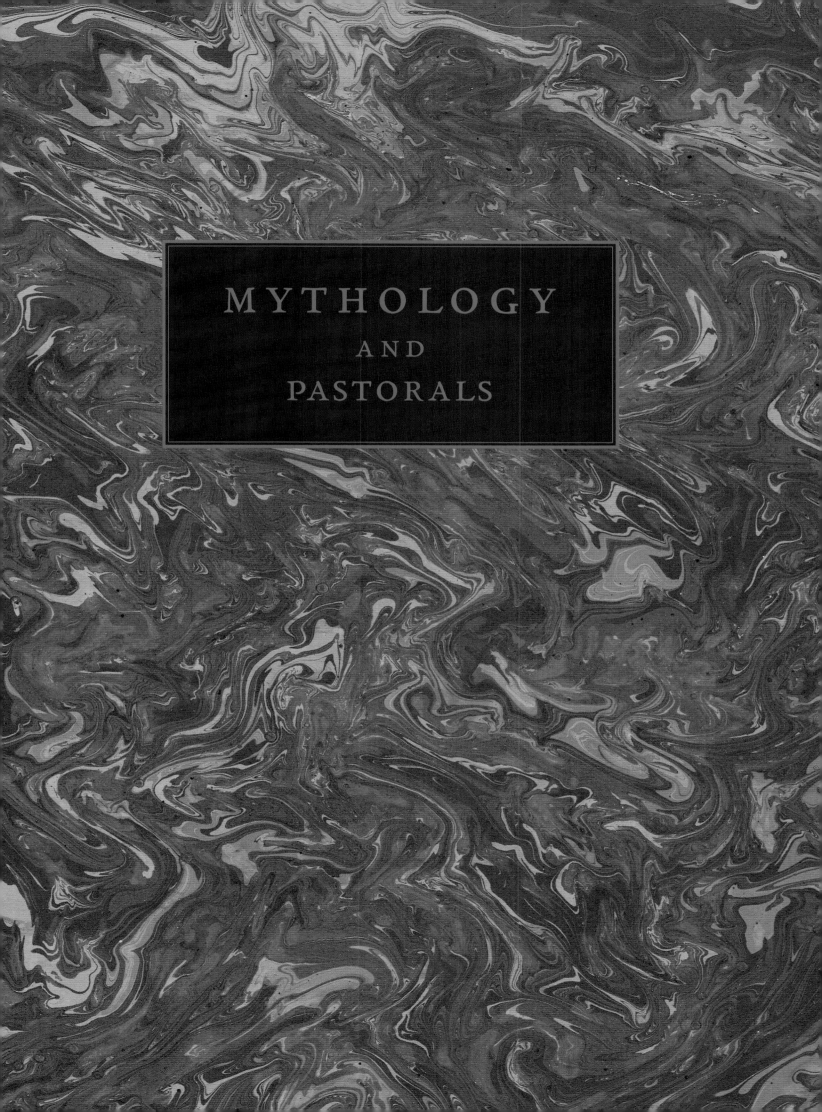

MYTHOLOGY

AND

PASTORALS

] *29* [

The Sleeping Apollo with the Muses and Fame Departing from Parnassus

Oil on canvas, 44.5 × 74 cm
PROVENANCE: Brussels and Vienna, Archduke Leopold Wilhelm Collection (cited in
the 1659 inventory [no. 255] as anonymous and prior to having been cut down drastically along
the right side); imperial Habsburg Collection; transferred to Pozsony Castle (now Bratislava), 1770;
transferred to the residence of the President of the Chamber in Buda; transferred to the
National Museum of Hungary, 1848; transferred to the National Picture Gallery,
the precursor of the Museum of Fine Arts, 1875, inv. 947

FORMERLY REGARDED as the work of an unknown Netherlandish painter, this picture was identified by Andor Pigler, the recently deceased former director of the Museum of Fine Arts in Budapest, as a documented but long-lost work by Lorenzo Lotto.[1]

Specified with the unmistakable description of its unique theme, the painting is cited no fewer than eight times in Lotto's account book, the *Libro di spese diverse*.[2] The entries made between 1549 and 1553 record the artist's failed attempts to sell this work. One entry, for instance, reveals that several paintings, including the *Sleeping Apollo*, found no buyers at an art lottery held at the Loggia dei Mercanti in Ancona in August 1550. A receipt, dated June 26, 1552, in Loreto, the painter's last abode in his peripatetic career, testifies that the picture was returned permanently to its creator on that very day.[3]

At some point toward the end of the seventeenth century, the canvas was cut down. Originally its composition included another large tree and a landscape section with the remaining five Muses on the right-hand side. The painting is reproduced in its present reduced state in the *Prodromus*, the catalogue of the imperial collection in Vienna published by Stampart and Prenner in 1735, which is illustrated with reproductive engravings.[4]

There is no known literary source for this subject. Apollo, leader of the Muses, falls asleep in the shade of laurel trees on Parnassus with his lute in his hand. The Muses scatter in undignified disarray across the hill, while Fama, the god of fame, carrying a trumpet, flees from the disorder in the sacred grove. The clothes and attributes hurriedly discarded by the Muses—a celestial globe, books, and musical instruments—form a gleaming still life in the light filtered by the trees.

Opinions concerning the dating of the picture differ considerably,[5] and even greater uncertainty exists as to whether the subject should be interpreted as a capricious mythological idyll or as a parody. Millard Meiss thinks that Lotto may be referring to the unhappy state of the arts during the Middle Ages.[6] Meiss's other suggestion is that Lotto may have used this ironic invention to satirize his altogether

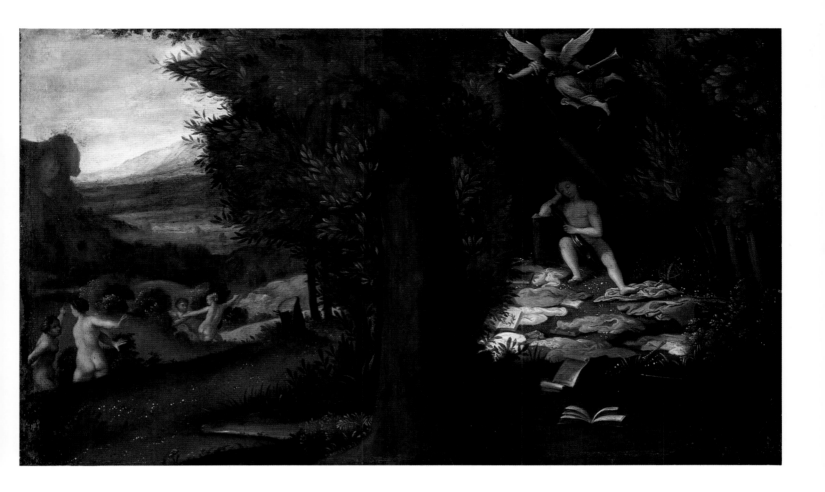

too parsimonious patron. According to Mariani Canova's interpretation, the picture warns against the pursuit of the liberal arts without the governance of rational thought, as personified in Greek mythology by Apollo.[7] Gentili relates the loss of Apollonian harmony to the decline of the power of Venice, finding in the painting the reverse of those celebrated representations of Parnassus by Mantegna and Raphael that flatter earthly rulers.[8] The picture's documented fate—Lotto's repeated failure to sell it—is clear indication that it was made not for a client but to satisfy his own inner compulsion. —V.T.

] *30* [

Sleeping Shepherd

Oil on canvas, 99.5 × 137.5 cm
PROVENANCE: Esterházy Collection; acquired, 1870, inv. 119

FOLLOWING HIS MOST MANNERIST PHASE during the 1550s, Jacopo Bassano produced a progressively increasing number of bucolic genre scenes, introducing a new category into Italian painting. Besides representing allegories of the four seasons and the twelve months, he preferred Old and New Testament subjects that enabled him to include elements of everyday village life, animals, and landscape. *The Parable of the Sower* in the Thyssen Collection in Madrid and *Abraham Setting out for Canaan* at Hampton Court Palace are two notable early examples of Bassano's Old and New Testament genre pieces.[1]

The Venetian forerunners of this imagery are Giorgione's bucolic idylls inspired by ancient and contemporary pastoral poetry. The demand for such subjects stemmed from city dwellers' longing for the purity of nature and the simplicity of a rural-pastoral way of life. Whereas Giorgione's idylls evoke the inaccessible dream world of mythology, Bassano's genre subjects are earthy, plausible, and were readily accessible to the contemporary viewer. The pastorals of Giorgione and his circle were inspired by Virgil's *Eclogues,* while Bassano's genre pieces were inspired by Virgil's *Georgics.*[2]

The dependence of painting of this period on literary sources and rhetorical aims virtually precluded the depiction of genre subjects unless based on a universally recognized text or embodying readily apprehended allegorical associations. However, *Sleeping Shepherd* is one of those rare exceptions to the rule where, at least to date, research has failed to identify the biblical, mythological, or allegorical source upon which the subject is based. Rearick,[3] referring to the calendar illustration in the *Grimani Breviary* by Simon Benning and others, thinks that Bassano's *Sleeping Shepherd* may represent the month of August and thus illustrate the zodiacal sign Leo; however, this hypothesis is debatable. Vittoria Romani[4] thought it wise to retain the title *Sleeping Shepherd* in the catalogue accompanying the Bassano exhibition of 1992–93.

The sleeping young man, lying back against a tree, is not necessarily the dominant actor of the picture. That role can be assigned equally to the heavily loaded white horse, the little boy driving the cattle and sheep toward the watering trough, or the two dogs. The sensitive characterization of the animals is surely based on careful studies after nature, yet the artist's somewhat summary attention to details may be explained by the painter's Titianesque method. He records the overall optical impression rather than focusing on precise detail. The composition in its overall pictorial organization becomes monumental and ceremonial in effect.[5]

148

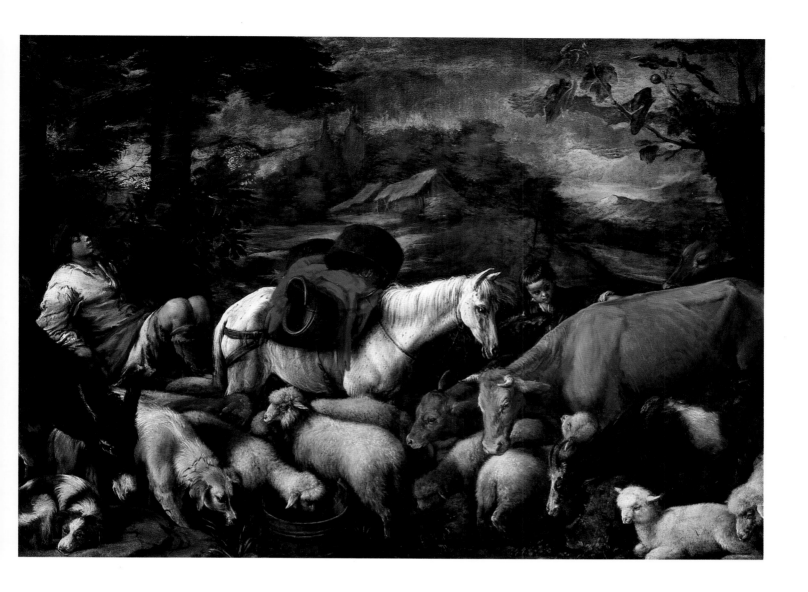

In the 1812 inventory of the Esterházy Collection, the painting was attributed to Jacopo, the head of the Bassano family. Not even Venturi[6] questioned Jacopo's authorship. Later, however, Arslan[7] and then Berenson,[8] followed by Pigler,[9] reattributed the painting to Jacopo's youngest son, Gerolamo. This deeply entrenched error of attribution was not corrected for many years. The proper attribution of *Sleeping Shepherd,* and its recognition as a significant work in Jacopo Bassano's oeuvre made around 1568, is due to Alessandro Ballarin, whose distinguished contribution to cinquecento studies is due in large measure to his study of Bassano.[10] —V.T.

] 3 1 [

Hercules Expelling the Faun from Omphale's Bed

Oil on canvas, 112 × 106 cm
PROVENANCE: Vienna, Kunsthistorisches Museum; transferred through
bilateral agreement to the Museum of Fine Arts, 1932, inv. 6706

THE STORY ON WHICH THIS PAINTING IS BASED, containing both comic and erotic elements, is drawn from Ovid's *Fasti* (2:331–358). As a prank, Hercules and Omphale switched clothes and retired to their bedchamber for the night. While they were asleep, the goat-legged faun stole into the bedroom and, deceived by the female garments, slipped into bed beside Hercules, who ejected the intruder with a mighty kick. In response to the startled cries of Omphale, servants rushed in and everybody present had a good laugh at the forest dweller's expense.

According to Carlo Ridolfi in 1648,[1] Tintoretto painted this subject at least twice: once for Emperor Rudolph II, en suite with three other mythological compositions; and once for the Venetian jurist Nicolò Crasso. Earlier authorities remained divided as to whether the painting in Budapest was that painted for Crasso or for Rudolph II.[2] In her study of 1967, Klára Garas[3] firmly endorsed the notion that the painting in Budapest was the one commissioned by Emperor Rudolph II. In her reconstruction of its provenance, she concluded that this *Hercules Expelling the Faun from Omphale's Bed* was one of the paintings left by Rudolph II to his younger brother, Archduke Albert, who took it from Prague to Brussels in 1616. The picture was then purchased by the duke of Buckingham before 1628 and subsequently acquired by Archduke Leopold Wilhelm at the Buckingham auction held in Antwerp in 1649. Thus, in hardly more than three decades, the picture returned to Prague. In 1738 this painting by Tintoretto was already in Vienna,[4] from where it finally came to Hungary.

Several major pictures found their way to the Kunsthistorisches Museum in Vienna by this circuitous route, yet doubts remain concerning the provenance of the Hercules scene. The description of the subject in early inventories is often too summary to guarantee that the painting described is indisputably the one now in Budapest.[5]

Garas concedes that a proper reconstruction of the series of four pictures acquired by Rudolph from Tintoretto is just as difficult, and Ballarin concurs with her.[6] Although his description of the series contains iconographical errors, *The Origin of the Milky Way* which Ridolfi described is uncontestably the painting now at the National Gallery in London. However, the picture in London clearly does not correspond in size or date with *Hercules Expelling the Faun from Omphale's Bed* in Budapest, indicating that these two paintings could not have been part of the same decorative ensemble.[7]

The problem is complicated by a drawing attributed to Joseph Heintz, which copies the composition.[8] It diverges in a number of minor ways from the painting in Budapest and may indicate that another variant of the subject once existed. Heintz worked in the court of Rudolph II and most likely would have reproduced the Tintoretto painting made for the emperor, probably now lost.[9] Based on this evidence, it seems appropriate to reconsider the hypothesis put forth by Engerth[10] and Thode,[11] who maintain that the surviving version of Hercules should be identified with the picture once in the Crasso Collection. Ridolfi's description of it clearly corresponds with the picture.[12] The fact that Ridolfi speaks of a "picciol tela," that is, a small canvas, does not contradict this hypothesis.

This late nocturne may be dated to about 1585.[13] The flickering torch light illuminates the figures who emerge from the darkness, seemingly drawn to each other as if held in balance by a mysterious magnetic field. —V.T.

] *3 2* [

Iris in the Realm of Hypnos

Oil on canvas, 137 × 148 cm
PROVENANCE: Esterházy Collection; acquired, 1870, inv. 599

THE SUCCESS OF CARPIONI'S PICTURES depicting classical themes was already noted by his eighteenth-century biographers. For example, Orlandi states: "He applied himself to imaginary inventions like dreams, sacrificial scenes, bacchanals, triumphal processions, and dancing putti, with the most beautiful *capricci* ever invented by a painter."[1]

The actual subject of this depiction of Iris in the kingdom of Hypnos, the god of sleep, was first identified by Andor Pigler.[2] The painting in Budapest is one of Carpioni's most original mythological *capricci.* Its popularity is amply demonstrated by the nearly two dozen surviving versions, including examples in the Accademia and the Museo Correr in Venice, the Palazzo Venezia in Rome, and the Kunsthistorisches Museum in Vienna.[3] These autograph versions, existing in different sizes and formats, were probably intended to decorate bedchambers. Of these, the version in Vienna, dated 1656, may be regarded as the earliest.

Carpioni depicted the theme of Iris in the Realm of Hypnos with extreme inventiveness, employing different motifs and varying the casts of characters in each of them. The literary source for the subject is the myth of Ceyx and Alcyone in Ovid's *Metamorphoses,* but the Casa del Sonno (or House of Sleep) is described by Virgil in the *Aeneid,* Statius in the *Thebaid,* Ariosto in *Orlando Furioso,* and Cartari[4] in *Le imagini degli dei degli antichi,* among others. Carpioni represents the episode in which Juno's messenger, the thousand-colored Iris, arrives, descending on a rainbow into the realm of permanent darkness and silence to ask Hypnos for a comforting dream for Alcyone, who is grieving for the late King Ceyx, who died at sea. Sprawled over his bed-throne surrounded by his subjects, Hypnos suddenly awakens from his stupor and with his left hand beckons Morpheus, the god of dreams, who is the other winged deity present. Morpheus, who is capable of transforming his appearance, assumes the form of Ceyx to execute Juno's orders. The composition includes many figures caught up in their own vain dreams, lying amid the actors of the scene—old men resembling Greek philosophers and ugly old women, youths, and turtle-riding children. All watch the events curiously, assuming expressions either of disapproval or fear.

The first known representation of this subject is probably Baldassare Peruzzi's painting in the Villa Farnesina in Rome. Later, Iris in the Realm of Hypnos became a popular theme among the leading Italian Mannerists including Naldini, Primaticcio, Zuccaro, and Zucchi, who relied on the writings of

Annibale Caro and Vasari to define and elaborate iconographical details of the subject. Carpioni preserved certain traditional symbols, including the owl referring to darkness and death and the poppy representing lethargy and consolation induced by sleep. This is why Hypnos is wearing a crown of poppies. Carpioni, however, did not strive for the same iconographic precision demonstrated by his predecessors. The magical grottolike setting has been eliminated, and it is furthermore difficult to identify Icelos and Phantasos, or the personifications of the attributes of sleep, or the river Lethe.

Dated by Pilo to the 1660s,[5] this painting represents Carpioni's mature style. The sharply defined shadows in the cold light, the precise, assured draftsmanship, the marked contours of the figures, and the lustrous colors all elevate the picture to the first rank within this master's uneven oeuvre. Although Carpioni's style developed under the influence of Poussin and the Bolognese academic tradition, the artist replaced the heroic Roman style with a more protean conception in which distorted and bizarre elements bordering on caricature accord well. The influence of Carpioni's putative master, Padovanino, can also be recognized in the positioning of the figures, especially the two robust, recumbent ones in the foreground functioning as repoussoirs. —Zs.D.

] *33* [

Bacchus Discovering Ariadne on Naxos

Oil on canvas, 66.5 × 85 cm
PROVENANCE: Vienna, F. Manzurani Collection;
Esterházy Collection; acquired, 1870, inv. 622

ONE OF THE MOST POPULAR mythological subjects represented in the sixteenth to eighteenth centuries was Bacchus's encounter with the daughter of King Minos of Crete, the lovely princess Ariadne abandoned by the unfaithful Theseus. Owing to the numerous classical literary sources, Philostratus,[1] Ovid,[2] and others,[3] there were a number of differing iconographic interpretations of this event, which took place on the island of Naxos. The most popular episodes of this story involve the god catching sight of the sleeping Ariadne; comforting Ariadne lamenting her fate; raising her crown into the heavens where it becomes a constellation, the Corona Borealis; and the triumphant nuptial procession of the couple. Based on the description of Catullus[4] and other sources, painters such as Carpioni often represented Bacchus's entourage with many extra participants, who complemented the festive scene.

It was probably Ovid's *Ars amandi* that served as Carpioni's primary source in depicting the unexpected initial meeting, resulting in "love at first sight." Bacchus, the god of wine, approaches Ariadne with a thyrsus in his hand and a wreath of vine leaves and flowers on his head. His hesitant demeanor reflects both his surprise and awakened desire. "And the god said: Look, I am present, with a love that shall be more faithful. Fear nothing, O maiden of Gnossos, for Bacchus's wife you shall be. I give you the gift of heaven, a star to be seen in the heaven, and often you'll guide the ships, when they're lost, O crown of Crete. He spoke; and then from his chariot (that his tigers might not claw her) he leaped."[5] The intimate contact between the two main characters contrasts with the wild and frenzied *thyasos,* that is, the train of satyrs, sileni, and maenads. "[T]he cymbals clashed along the shore; and drums, beaten with frantic hands. . . . And see, now come the Bacchantes, behind them their wild hair streaming; and see, the throng of the Satyrs, nimbly preceding the god."[6] By depicting many different musical instruments accompanying the uninhibited rhythmic ritualistic dance, Carpioni translates the cacophony and frenzy of this troupe into the language of painting.

Szigethi posits that Titian's paintings of the same themes[7] made for Alfonso d'Este were the initial prototypes for Carpioni's *Bacchus and Ariadne,* as well as for its companion piece, the *Bacchanale.*[8] Carpioni may have known Titian's masterpieces, either through copies by Padovanino or even firsthand, if we subscribe to the hypothesis that he did indeed journey to Rome.

Poussin and his circle were another source of inspiration for Carpioni. After an initial Caravaggesque phase, Carpioni's mature style became established only after he settled in Vicenza in 1638. By this date Carpioni's art displays the influence exerted by Poussin and, in a broader sense, academicism, whether Roman, Bolognese, or Venetian. This would explain Carpioni's purified forms, careful and precise manner of painting, and his choice of colors that conform to this classicizing tradition.

In contrast to his idealized concept of beauty, Carpioni sometimes intentionally includes ugly and grotesque elements into his style, a feature that links him to Pietro della Vecchia, among his Venetian contemporaries. By this process Carpioni seemingly transforms the heroic figures of Poussin into antiheroes and replaces the grandeur of that master's style with one more conducive to genre. The introverted, enigmatic, and seemingly bitter character of the master's figures may, at the same time, reflect his own melancholic temperament mentioned by Orlandi.[9]

Carpioni is known to have represented the theme of Bacchus and Ariadne on several other occasions, including one surviving painting in the Lingner Collection in Dresden. Sebastiano Ricci paraphrased Carpioni's picture now in the Sonino Collection in Venice in his own most beautiful depiction of Bacchus and Ariadne, now in the National Gallery in London[10]—splendid proof of the popularity of Carpioni's compositions even into the following century.　　　　　　　　　　　　　—Zs.D.

JOHANN KARL LOTH

MUNICH 1632–1698 VENICE

] *34* [

Ceres

Oil on canvas, 132 × 97.5 cm
PROVENANCE: Esterházy Collection;[1] auctioned, 1867;[2]
purchased from a Budapest collection, 1993, inv. 93.9

SUMMER IS PERSONIFIED BY THE MONUMENTAL, nude figure of Ceres in profile. She is identified by the ears of corn she wears with her pearls, as well as by the putto holding a barely visible sheaf of wheat.

Since the fourteenth century it was not unusual to represent abstract allegories, such as the liberal arts or the virtues and vices, as female personifications. During the Renaissance and especially during the Baroque period, the four seasons, the four times of day, the four humors, and the four elements, as well as Hope, Peace, Prosperity, Transience, Time, and Truth, were represented through genre or mythological scenes, or by allegorical figures.[3] In his *Iconologia* published in 1603, Ripa recorded prototypes existing "since antiquity" but added his own inventions, which inspired subsequent allegorical renderings.[4] Here Ceres, the goddess of fertility (of agriculture and corn) seems to represent Summer, one of the four seasons, rather than Earth, one of the four elements.[5] This canvas probably belonged to a series, although its companion paintings are now untraceable.[6]

The German painter Johann Karl Loth was first active in Vienna, then in Florence, Milan, and Verona, before settling in Venice in 1687, although he visited Venice much earlier in his career. Subsequent to Langetti, and together with Zanchi, Loth belonged to the group of Venetian painters who practiced Caravaggio's *tenebroso* style. Later Loth's style shifted to the Venetian tradition of colorful, virtuoso modeling.

Loth's almost life-size, robust figure of Ceres is striking in its lack of idealization. The artist eschews a sensuous, erotic approach to female beauty. Whereas the lighting reveals a trace of *tenebrismo*, the device of showing the subject from the back, here in half-length, is a truly Venetian characteristic, deriving from the oft-repeated motif that occurs in the work of Jacopo Bassano. Yet the articulation of the muscular back is typical of Loth himself.

The seventeenth-century Venetian tradition remains obscured by the glorious heritage of the cinquecento and the dazzling reincarnation of Venetian colorism during the eighteenth century as defined by the Tiepolos. Because of its idiosyncratic and sometimes disturbing stylistic features, seventeenth-century Venetian painting was completely neglected by scholars for a long time. It remained, nonetheless, an essential element within the development of later Venetian painting, because Venice was also

158

receptive to Roman and Bolognese influences in perpetuating and reviving its own tradition. Loth, for example, was influenced by the art of Veronese and Tintoretto as transmitted by the example of Padovanino. Loth was also responsive to the innovations of Caravaggio and, in his turn, had significant impact on eighteenth-century artists like Piazzetta and Pellegrini.

This intriguing picture, filling a gap in the sequence of Venetian seventeenth-century painting, was recently discovered and acquired by the Museum of Fine Arts in Budapest.[7] —I.B.

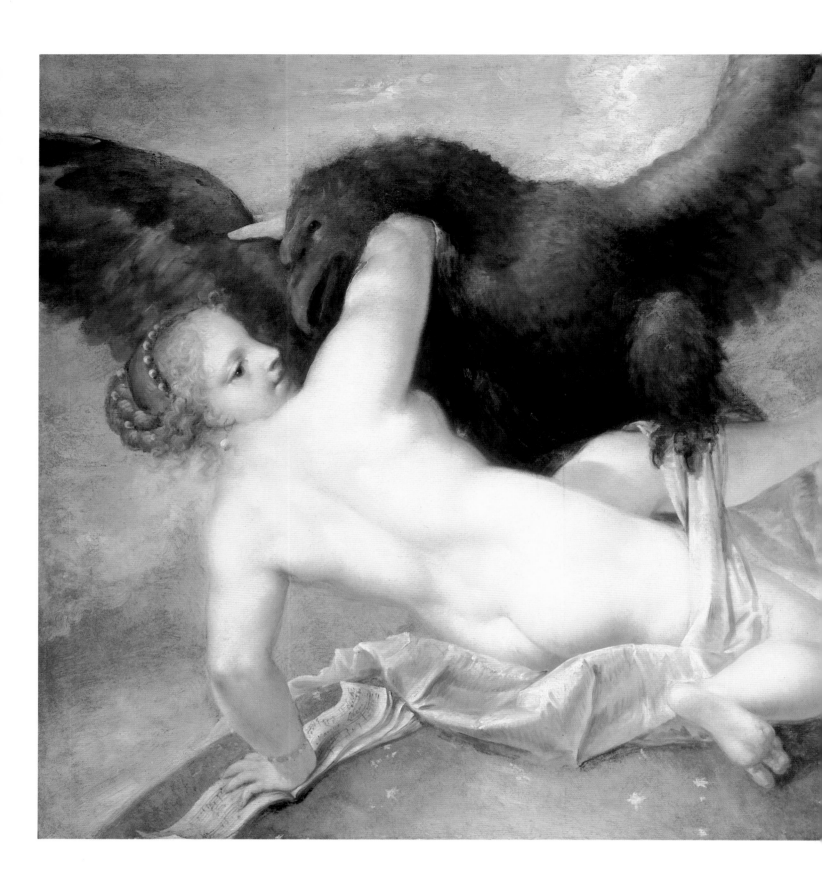

] *35* [

Jupiter and Asteria

Oil on canvas, 118 × 153 cm
SIGNED LOWER LEFT, ON THE MUSICAL SCORES: *Marcus Liberi*
PROVENANCE: Esterházy Collection; acquired, 1870, inv. 616

THE HEROINE of this mythological scene was first thought to be Hebe, then for a long time Mnemosyne. Only recently has she been identified as Asteria, goddess of the stars, the only woman pursued by Jupiter in the guise of an eagle.[1] The daughter of the titan Coeus and of his consort Phoebe, Asteria appears with her attributes: the star-studded blue celestial globe and the book of musical scores referring to the music of the spheres, which originates from the revolution of the planets. For this picture Liberi chose to represent the moment when Jupiter, in his attempt to ravish Asteria, carried her off into the skies. During her abduction the goddess underwent several metamorphoses in her efforts to escape from Jupiter's embracing talons, first changing herself into a quail and then into a stone. Finally she fell into the Aegean Sea, creating the island of Delos.

The story derives from a long literary tradition. In the weaving contest between Arachne and Pallas Athena described by Ovid in his *Metamorphoses,* Arachne, the "Maeon Girl," embroiders the image of Asteria as one of Jupiter's lovers. Asteria's story is narrated by Hyginus in his *Fabulae* and by Boccaccio in *La geneologia degli dei de gentili.* Asteria is also featured in Cartari's handbook on mythology, *Le imagini degli dei degli antichi.*[2] Nevertheless, the myth was rarely chosen as a subject by painters, owing perhaps to the far greater popularity of the two stories of similar characters, those of Leda and Ganymede. The myth of Asteria was never represented as an independent tale but was always included in the stories of the *Loves of Jupiter* (Amori di Giove). A celebrated example within a series was Perino del Vaga's fresco in the Stanza delle Metamorfosi of the Palazzo Doria in Genoa.

Marco Liberi's style is so close to that of his father, Pietro Liberi, that attempts to distinguish between their works on the basis of quality usually result in attributing the less successful paintings to the son. However, the picture in Budapest, the only signed work by Marco Liberi, is equal in quality to Pietro Liberi's most beautiful mythological compositions. Looking at the soft contours of the forms or the gently modeled head, we feel that Zanetti's harsh criticism is hardly justified: "The forms do not have the grandeur his father displays. The faces are almost caricatures of his most excellent master's beautiful heads."[3]

In his composition Marco subtly exploits the pictorial and sensual opportunities provided by the subject. Specifically, the artist contrasts the voluptuous recumbent nude female figure with the velvety plumage of the eagle hovering above her. The pose of Asteria leaning backwards somewhat precariously can be traced to similar figures in his father's work, and even further to Mannerist prototypes such as Tintoretto's *Three Graces* in the Anticollegio of the Palazzo Ducale in Venice, and to Palma Giovane's *Prometheus* in a private collection in Venice. The horizontal format and the *di sotto in su* perspective projecting upwards suggest that this painting may originally have been a *sopraporta,* that is, an overdoor. Its character, the scale of the figures, and the subject matter closely link *Jupiter and Asteria* to two works by Pietro Liberi, *The Three Graces* and *A Mythological Scene,* now at Hampton Court. Moreover, its measurements are identical to theirs, suggesting that the three paintings might once have hung together as the decor of a formal room within a Venetian palace. —Zs.D.

] 36 [

Danaë and the Shower of Gold

Oil on canvas, 149 × 158.5 cm
PROVENANCE: Vienna, auction P. Galvagni, 1869; Vienna, Ödön Zichy
Collection; Jenő Zichy Collection; by whom bequeathed to the city of Budapest, 1906;
transferred to the museum from the Municipal Gallery, 1953, inv. 53.482

IN CONTRAST TO THE RARELY DEPICTED STORY of the unconsummated affair between Jupiter and Asteria, the ravishing of Danaë was one of the most popular mythological subjects during the Renaissance and Baroque periods and one that enabled artists to paint the beauty of the female nude. According to the myth, Acrisius, king of Argos, locked his daughter Danaë up in a bronze tower, hoping to prevent her from bearing a grandchild who, it was predicted, would inadvertently cause his death. However, Jupiter, in the guise of a shower of gold, found his way to her and consummated his passion for the princess. Their union produced a son, Perseus, who fulfilled the prophecy by accidentally killing his grandfather with a discus.

In Bellucci's representation Danaë is reclining on a splendid antique couch, feigning surprise but acquiescing as she looks upwards, while little putti assisting Jupiter's seduction of Danaë somersault down from above to pour gold coins into her lap. The subject immediately recalls Titian's *Danaë,* which survives in several autograph versions as well as in the form of reproductive engravings. The ugly servant woman, a foil to the beautiful princess, adds further irony to the erotic content as she greedily tries to catch the falling gold coins in her apron. This motif can also be traced back directly to Titian's invention. By his skillful employment of chiaroscuro, Bellucci underscores the scene's underlying sensuality. The forms are firmly modeled, yet the light, the source of which is Jupiter himself, gently embraces Danaë's body and gradually dissolves into soft, caressing shadows. This is what Zanetti may have had in mind when he noted: "Bellucci introduced great masses of shadows . . . but so soft, uncertain, and sometimes opportunely pronounced that they give much force to his paintings."[1] In addition to the tight composition, the impact of the painting is enhanced by Bellucci's elegant palette: gold, white, and fiery red harmonize decoratively on the brocaded bedspread, the silk kerchief, and the servant's dress.

Attributed earlier to Padovanino, then by Fiocco to Bellucci,[2] this painting is one of Bellucci's most successful mythological scenes in which a female nude dominates the composition. His characteristic demure female, whose pose and gestures are affected, is closely related to Liberi's and Lazzarini's typical heroines.[3]

163

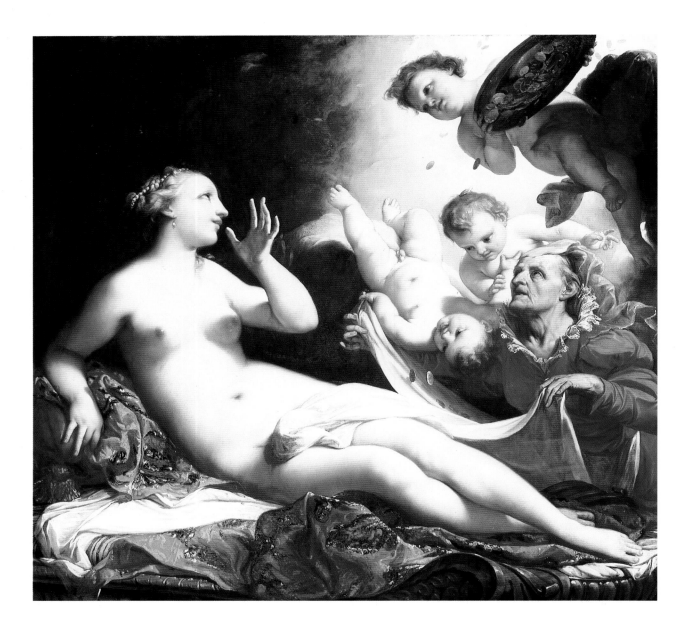

In about 1710 Bellucci again depicted the story of Danaë and the shower of gold in a much larger, upright painting, in which the composition is reversed. This version, painted for Elector Johann Wilhelm of the Palatinate in Düsseldorf, is now in the Alte Pinakothek in Munich. Klára Garas, supported by Kultzen,[4] considers the Budapest painting to be the earlier of the two versions, dating it to the early part of the decade, immediately before Bellucci settled in Vienna.

These mature works, characterized by boldly contoured figures and expressive use of light and shadow, are on the one hand still related to Venetian *tenebrosi* such as Antonio Zanchi and to painters of the Emilian seicento. On the other hand, they already exhibit the sophisticated and fastidious Baroque refinement termed *barocchetto,* which paved the way for the Rococo. Bellucci's decorative, ceremonial style was further developed in his later and most notable works painted not in Italy, but for patrons in Vienna, Düsseldorf, Bensberg, and London.

—Zs.D.

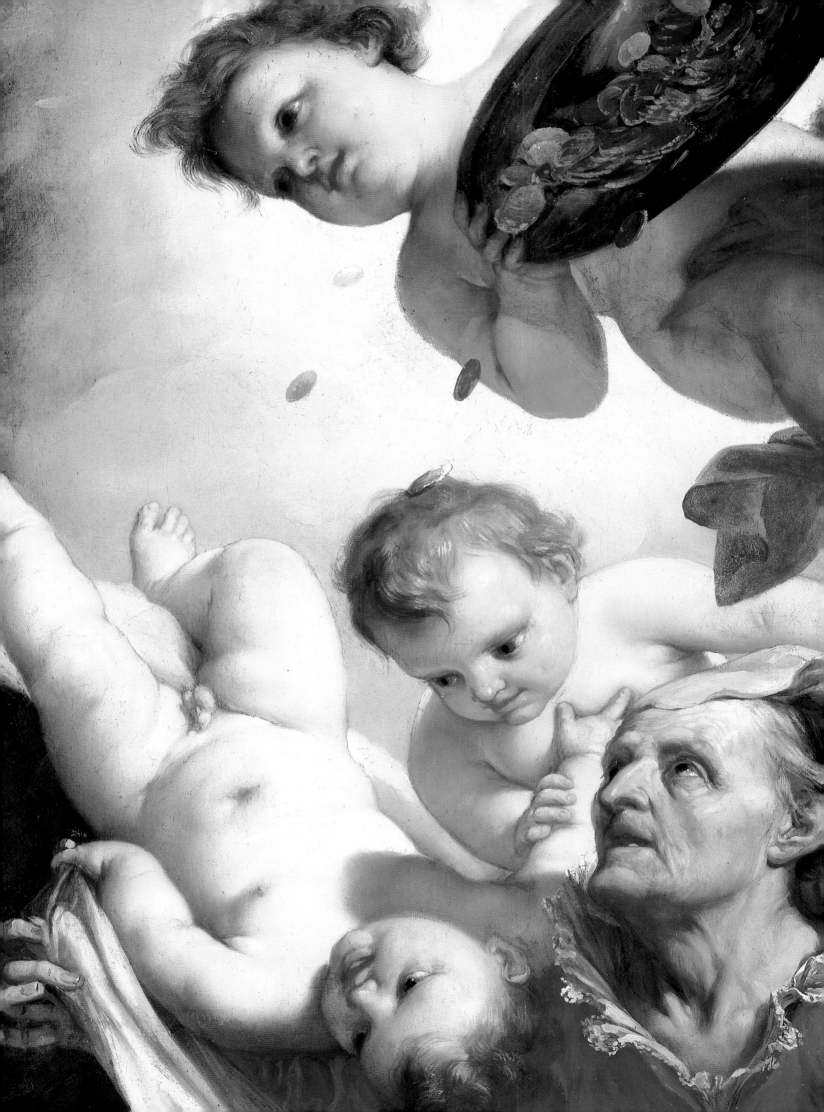

] 37 [

Venus and a Satyr

Oil on canvas, 100.7 × 125.3 cm
PROVENANCE: Venice, Maffeo Pinelli Collection, 1785; Esterházy Collection,
1820–67; transferred from the general government art storage depot
to the museum, 1958, inv. 58.43

ANDOR PIGLER published this painting in 1962 and identi‐
fied it with the following item from the inventory of the artist's
estate, made at the time of his death: "Una Venere con satiro che la
guarda."[1] Subsequent monographs on Ricci cite three more com‐
positions featuring Venus and a satyr that fit the inventory descrip‐
tion equally well—the paintings in the Staatsgalerie in Stuttgart,
the Alessi Collection in Trieste,[2] and a picture auctioned at Chris‐
tie's, London, in 1974 (June 28, lot 32).[3] Thus we cannot be certain
that the picture in Budapest is indeed the one that Ricci kept in his
possession until his death. Therefore, its indisputable provenance
can be traced back only to the collection of Maffeo Pinelli.

A decorative curtain and foliage provide an elegant backdrop
for this idyllic mythological scene, which is presented in a simple yet
bold composition and painted with effortless skill. The bearded old
satyr, half kneeling, is cautiously observing the ravishingly beau‐
tiful, recumbent nude sleeping Venus, while plump little Cupid,
hardly taller than his bow and quiver, is slumbering beside his
mother, with his feet tucked under him. The sensuous, indeed vo‐
luptuous posture of Venus is further enhanced by Ricci's resonant
palette. In contrast to the white sheet and slate gray curtain setting
off Venus's luminous flesh tones, the coloristic intensity of the crim‐
son bed cover is erotically suggestive. The warm color is softly re‐
peated in the ribbon loosened from her hair, which gently winds
around her breast, and in Cupid's weapons. The gentle, soft con‐
tours and the vigorous brushstrokes also add to the pictorial quali‐
ties of the painting.

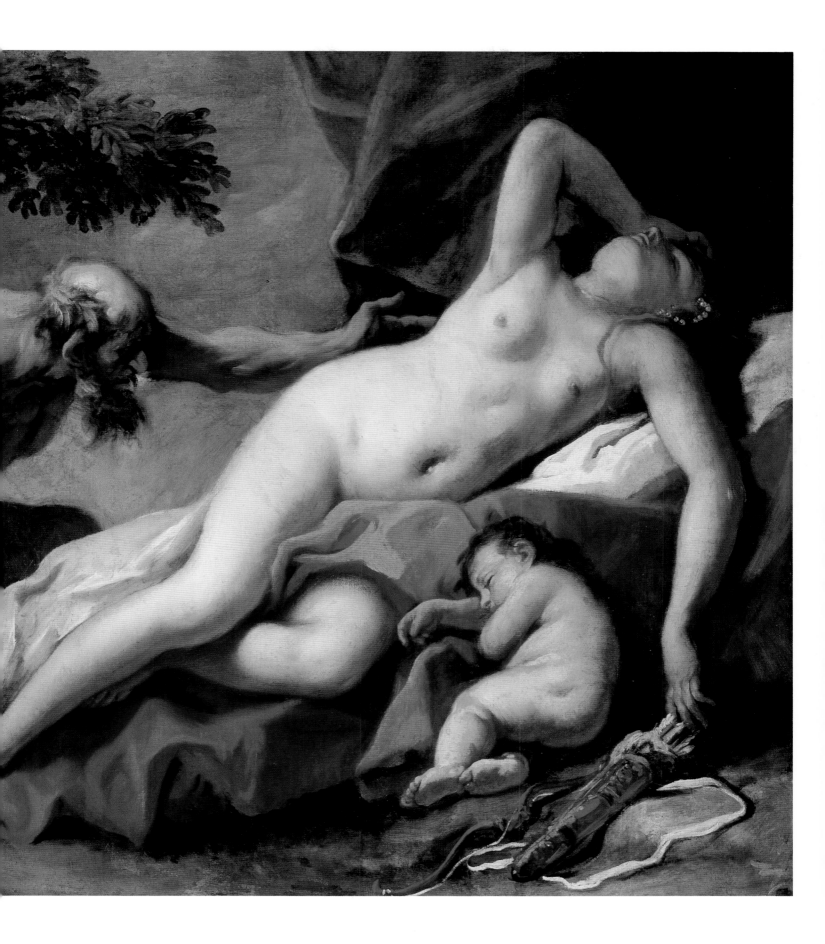

Ricci's composition of the sleeping Venus and the satyr represents a popular subject with a long tradition. Similar images juxtapose dreaming and wakefulness, the soft female nude and the hard muscular male body, feminine sophistication and masculine brute strength. Important antecedents to Ricci's work that stress these polarities include the ancient Roman relief in the Villa Ludovisi in Rome, Titian's *Pardo Venus* in the Louvre, and an engraving by Annibale Carracci, to cite three notable examples. Even the languid gesture of Venus's right arm recurs in several of Ricci's compositions, such as his *Bacchus and Ariadne* in a private collection in Milan, and recalls well-known ancient, Renaissance, and Baroque prototypes. The archetype for this motif is probably a Roman sculpture, *The Sleeping Ariadne* from the second century A.D., in the Vatican Museums, but Ricci could also have referred to Titian's use of this distinctive hand gesture in his *Andreans* in the Prado, Madrid, and in his *Pardo Venus.*

Disagreement exists about the date and style of the painting. Pigler dates it to the years around 1730,[4] whereas Klára Garas prefers 1716–20, the period following Ricci's stay in England.[5] Jeffrey Daniels, the noted Ricci specialist, accepts Garas's dates and emphasizes Tintoretto's influence in the scale of the figures. Daniels considers Ricci's *Satyr Family*[6] as being particularly close in style to the picture in Budapest. *Venus and a Satyr* is also stylistically and compositionally closely related to works painted in England. The sleeping pose repeats almost verbatim that of Endymion in Ricci's painting *Diana and Endymion,* at Chiswick House in London.

—Zs.D.

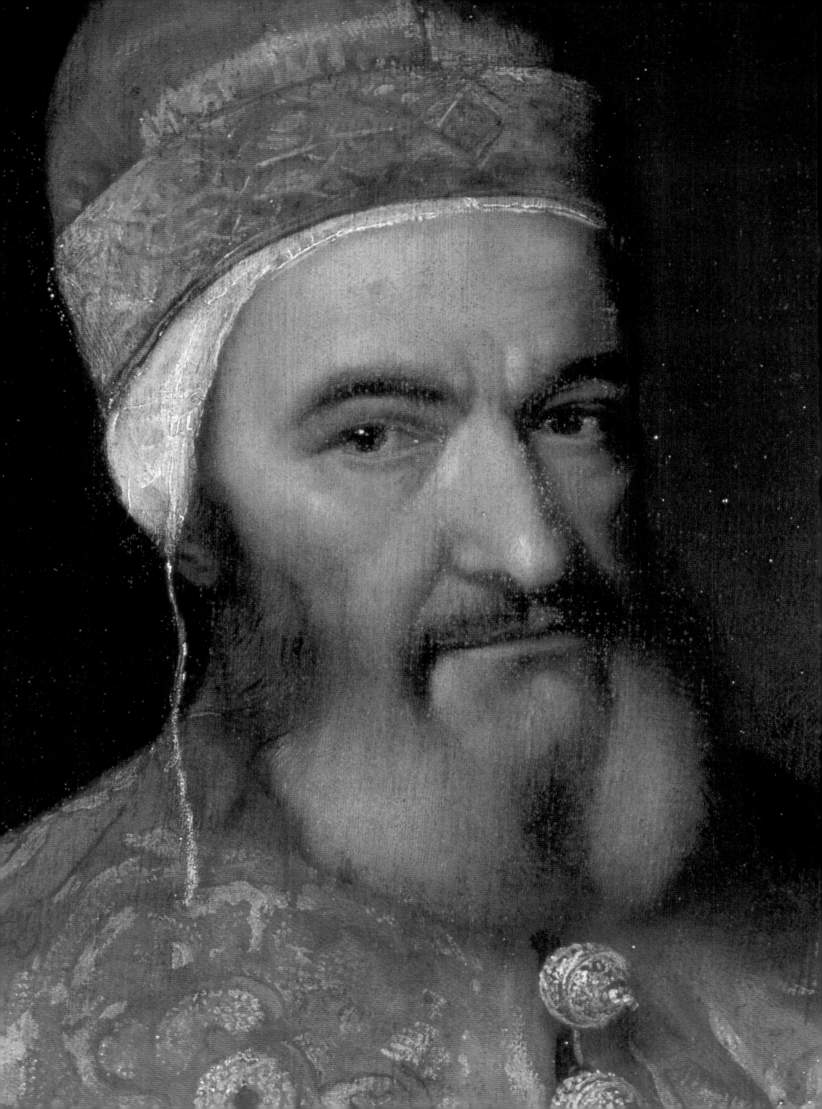

PORTRAITS

AND

GENRE

] *3 8* [

Caterina Cornaro, Queen of Cyprus

Oil on poplar panel, 63 × 49 cm
INSCRIBED AT UPPER LEFT: *CORNELIAE GENVS NOMEN FERO /*
VIRGINIS QUAM SYNA SEPELIT / VENETVS FILIAM ME VOCAT SE⁄ / NATVS
CYPRVSQ SERVIT NOVEM / REGNOR SEDES QUANTA SIM / VIDES SED BELLINI
MANVS / GENTILIS MAIOR QUAE ME TAM / BREVI EXPRESSIT TABELLA[1]
PROVENANCE: János László Pyrker Collection; by whom given
to the Hungarian National Museum, 1836, inv. 101

THOUGH THE CORNELIUS LINEAGE mentioned in the inscription was a fabrication, Caterina Cornaro was born in 1454 to a respectable family with venerable roots. Her whole life was determined by rulers of Venice who chose her to be a political tool of the Republic. The Venetian Senate adopted Caterina as its daughter solely to marry her to King James Lusignan II of Cyprus, the island state so vital to Venetian trade in the eastern Mediterranean. Eight months after their wedding, James II died, and, in subsequent years, his widow's position became increasingly precarious. Both Ferdinand of Naples and the Sultan of Egypt were poised to capture Cyprus. Finally the *Serenissima* sent Giorgio Cornaro to persuade his sister to abdicate in favor of Venice. Thus, in 1489, the queen of Cyprus re⁄ turned to her native city, where her noble gesture to the Republic was honored by a festive reception. She was also granted the property of Asolo near Treviso, where she retired and maintained a splendid court, surrounding herself with poets and humanists.

 Gentile Bellini's *Caterina Cornaro* is one of the earliest known female portraits in Venetian paint⁄ ing;[2] it must have been made close to the turn of the century. We also see Caterina with the same looks, age, and dress next to the master's signature in Bellini's large *Miracle of the Relic of the True Cross,* now in the Accademia in Venice.[3]

Gentile Bellini's high social standing and artistic reputation is compellingly indicated by the last three lines of the Latin inscription on this portrait. The artist was knighted by Emperor Frederick III. The *Serenissima* commissioned Bellini to paint the portraits of all the doges in office for a princely fee and also sent him to Constantinople in 1479 at Sultan Muhammad II's invitation.

Bernard Berenson made reference to this portrait in his letter to Mary Castelloe, written from Budapest on October 28, 1890, following his visit to the National Picture Gallery of the Hungarian Academy of Sciences. In his inimitable, witty manner, Berenson, upon seeing *Caterina Cornaro, Queen of Cypress* for the first time, described Bellini's ability as a portraitist as follows: "I must tell you at any rate about the greatest thing all in all that there is in this gallery. It is Gentile Bellini's portrait of Caterina Cornaro. . . . As a painting, as portraiture nothing could be better. Gentile here shows him⁄

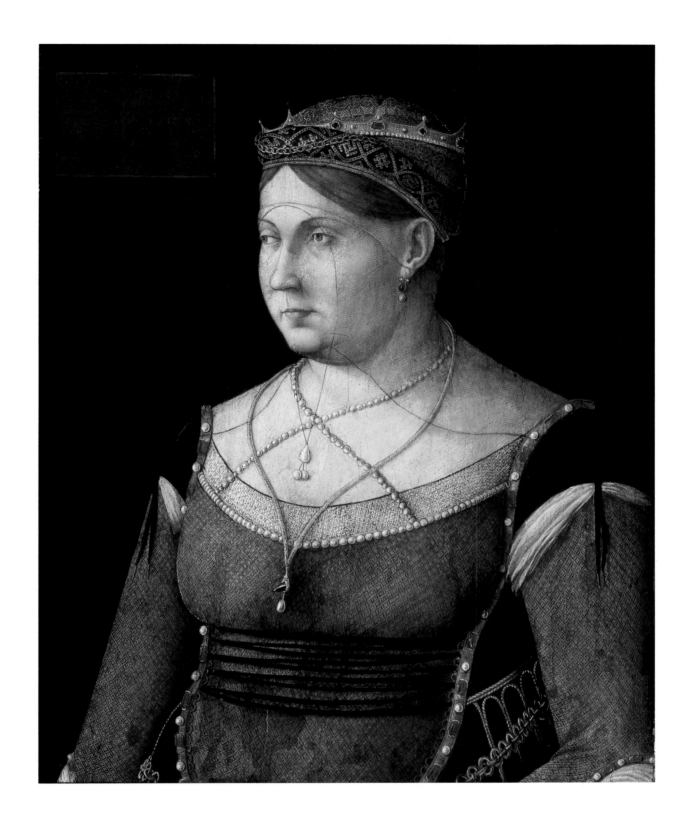

self the greatest portrait painter up to this day."[4] By contrast, John Pope-Hennessy's acerbic evaluation of the artist was perhaps triggered by Bellini's dry and objective descriptive manner: "revealing in its deadly evenness of emphasis the mind of a cartographer."[5] The sitter's regal garments, the empty and purely symbolic remnants of her former glory, are matched by her expression of sad resignation, which lends poignancy to this royal likeness.

—V.T.

] *39* [

Portrait of a Man

Oil on poplar panel, 51.5 × 42.7 cm
PROVENANCE: Bought at the auction of the Somzée Collection, Brussels,
May 24–June 11, 1904, lot 334, inv. 2538

THIS PORTRAIT COMMANDS OUR ATTENTION and piques our curiosity: we want to know more about the sitter's personality. Since his facial expression is inscrutable, our attention is drawn to extraneous details, with particular emphasis on the decorative elements. The fur coat is noteworthy for its simplicity, unusual in Bartolommeo's oeuvre. The painter's hand is more immediately recognizable in the representation of the tight-fitting gold-embroidered cap, complemented by the red velvet hat set askew on the head and embellished with a medal. This sort of elegant adornment is similar to Moretto da Brescia's full-length *Portrait of a Man* in London, which bears the date 1526, and thus provides a point of reference for dating the Budapest painting. The intense facial expression, illuminated in a Leonardesque manner, is set off by the rolled-up green curtain. So much does this unusual backdrop resemble those of Bartolommeo's *Portrait of Bernardino Lesmo* (Milan, Ambrosiana) and *Portrait of Ludovico Martinengo* (London, National Gallery) that it functions almost as the signature that must once have been legible on the *cartellino* at the left, before the unfortunate abrasion of the picture's surface.[1]

In a study written in 1895 shortly after Bartolommeo Veneto had been rediscovered in an exhibition held in the New Gallery in London, Berenson[2] first identified this artist as the author of the *Portrait of a Man* in Budapest. This painter represents a rare case even among lesser-known masters of the Italian cinquecento because no contemporary biographical account of him survives. As a result, later chroniclers and critics did not mention him. Bartolommeo Veneto's oeuvre has been reconstructed solely on the basis of attributions by scholars within the last century.

Gilbert[3] explains the centuries-long silence by stressing that Bartolommeo Veneto painted his panels exclusively for private individuals, failing to cultivate a wider public reputation by decorating churches, monasteries, or secular buildings. In his signature that appears on his earliest work, a *Madonna and Child* made in 1502, he declared himself a son of both Venice and Cremona.[4] In this image, together with another *Madonna and Child,* of 1505 in the Accademia Carrara in Bergamo, and the *Circumcision* dated 1506 in the Louvre in Paris, Bartolommeo demonstrates that his artistic production links him to the numerous followers of Giovanni Bellini. Other features suggest that he may have begun his career in the workshop of Gentile Bellini.[5]

Bartolommeo's portraits, painted mostly in Milan in the second and third decades of the sixteenth century, already indicate a complex style, making it extremely difficult to place him in the broader evolu-

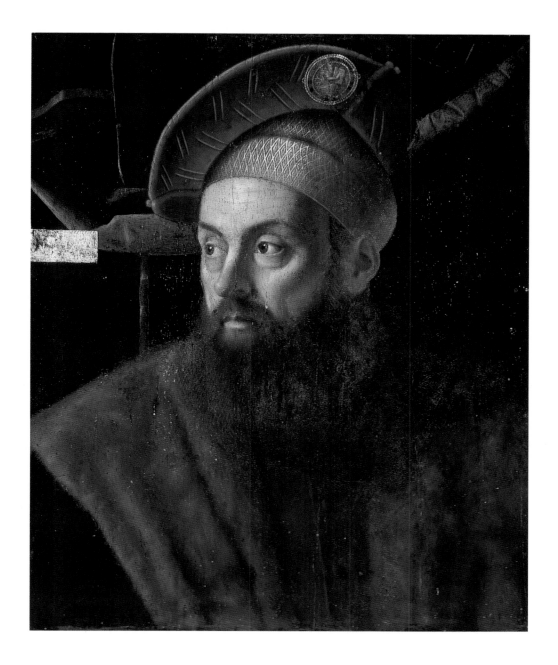

tion of Italian art. Researchers analyzing his stylistic origins have detected in his portraits the influence of more than a dozen masters. Certainly his portraits and pseudo-portraits[6] display many crosscurrents affecting north Italian painting, including the late quattrocento in Venice, Leonardo's Lombard followers, and ideas percolating into Italy from north of the Alps. Bartolommeo's portraits are markedly individual, ranging from the playful to the splendidly decorative, whereas some even attain a somewhat caustic expression. Did Bartolommeo find himself out of the mainstream of Venetian painting because of his assimilation of so many sources of inspiration, as Gilbert maintains?[7] If he did so, he strayed no further from it than did Amico Aspertini of Bologna, Mazzolino of Ferrara, or, to raise our sights, Lorenzo Lotto. These artists, working at the periphery of the leading cultural centers of Italy, developed unusual personal styles. Their art, along with that of Bartolommeo Veneto, shares a certain idiosyncratic character which cannot be justifiably categorized by such broad stylistic definitions as archaizing, classicizing, or Mannerist.

—V.T.

] 40 [

Portrait of a Youth ("Antonio Broccardo")

Oil on canvas, 75.5 × 54 cm
FRAGMENTARY INSCRIPTION ON THE
BALUSTRADE: *ANTONIUS BROKARDUS MAR.*
PROVENANCE: János László Pyrker Collection; by whom given
to the Hungarian National Museum, 1836, inv. 94

THIS PICTURE, UNIVERSALLY RECOGNIZED for its high quality, has spawned many opinions and hypotheses pertaining to its attribution, date, and iconography, whereas actual evidence securely documenting it as a work by Giorgione is minimal.[1] No fundamental breakthrough has been achieved since 1880, when the painting was first published.[2] Many aspects remain to be conclusively established, such as whether it was painted by Giorgione or one of his followers, its date, the identity of the sitter, and the meaning of the emblems on the balustrade.

For all the authorities in favor of Giorgione's authorship, an equally large number reject it. As a plausible working premise, we may assume that the Budapest portrait corresponds stylistically to the *"Giustiniani" Portrait* in Berlin, the *Laura* and the *Boy with Arrow* in Vienna, the *Self-Portrait* in Braunschweig, and the *Old Woman* inscribed *Col tempo* in Venice. Scholars are in full agreement that the portrait in Budapest radiates an enchanting atmosphere and makes a decisive break with quattrocento portrait conventions, demonstrating in essence what Pope-Hennessy[3] calls the romantic stream of the Venetian Renaissance.

Turning his head aside, the long-haired youth with soft features gazes melancholically into the distance.[4] To convey the sincerity of his emotions, he raises his hand to his chest. Despite the damage caused by time and earlier injudicious restorations, the sensitive modeling of the face and hand, caught in soft raking light from the left, is still evident. The introverted expression of longing was quite unknown in portraiture before Giorgione. The Neoplatonic cult of beauty, poetry in the tradition of Petrarch, bucolic literature and the revival of interest in myths of the Golden Age pervasive in the Veneto at this time are all reflected in this contemplative expression.[5] The pronounced emotional tenor expressed by the sitter, and his hairstyle, which corresponds to the one in the Berlin portrait, would place the Budapest youth in the first decade of the cinquecento.[6]

Although a later addition, the fragmentary inscription on the balustrade refers to the poet Antonio Broccardo and not to a namesake.[7] Broccardo died prematurely in 1531. Although we do not know the date of his birth, he would have been no more than a child around 1510.

Of the emblems replete with allegorical content on the balustrade, the inscription on the right-hand side has been effaced completely. The triple female head enclosed in a wreath might represent Hecate, the

ancient Greek goddess of the underworld, magic, and wisdom. In this connection, certain scholars have proposed that the youth was possibly a member of a secret hermetic society. In this case the hat, a distinguishing sign of liberated slaves, could possibly refer to the sitter as an initiate.[8] One theory interprets the letter V, which also occurs in other portraits by Giorgione and his circle, as the initial letter of the word *vivus,* indicating that the portrait was made from life.[9] —V.T.

] *4 I* [

Portrait of a Youth

Oil on limewood panel, 38.7 × 29 cm
PROVENANCE: Venice, Bartolomeo della Nave Collection, until 1636;
Basil Feilding Collection, earl of Denbigh and later duke of Hamilton, 1638–49;
Brussels and Vienna, Archduke Leopold Wilhelm Collection; bequeathed to the Austrian
Habsburg emperor; transferred to Hungary with the collection of Archduke Joseph,
Palatine of Hungary; auctioned after his death in 1847; Baron Richard
Hammerstein Collection; by whom given
to the museum, 1907, inv. 3460

THIS *PORTRAIT OF A YOUTH,* together with its companion piece, *Portrait of a Young Woman,*[1] was still cited as by Giorgione in the English listing of Bartolomeo della Nave's collection compiled around 1637 at the time it was auctioned: "No. 48 A Roman Consul armd crownd with bays as triumphing pal 1½." Its pendant was described as "No. 49 The Wife of the said Consul crownd with Vines of the bigness idem." It was first attributed to Palma Vecchio in the Vienna inventory of Leopold Wilhelm's collection in 1659. This pair of portraits appears in David Teniers's picture now in the Alte Pinakothek in Munich, showing the gallery of Archduke Leopold Wilhelm in Brussels.[2]

The 1637 description of Palma Vecchio's *Portrait of a Youth,* alluding to a classicizing, idealized portrait with a reference to antiquity, is essentially correct. The slightly turned head, the musing glance, the breastplate with the red sash knotted at the shoulder, as well as the young woman's emotional hand gesture, her loose hair, bared left shoulder, and the idyllic landscape background unifying both pictures, create a classical sense of harmony. The two portraits were traditionally called *The Betrothed Couple:* the ivy and grape leaves belong to the standard repertory of love symbols.[3] As is the case with so many contemporary Venetian portraits containing references to poetry and the antique, it remains impossible to determine if these subjects depict actual sitters as idealized likenesses.[4]

Despite the Giorgionesque expression of the sitters, these portraits also derive from Giovanni Bellini's style to such a degree that Frimmel believed them to have been painted either by the old Bellini or the young Palma.[5] Detlev von Hadeln,[6] however, no longer doubted the attribution to Palma, basing his opinion on the enamellike coloring and the gently rounded forms. An interesting problem illuminating the Bellini connection surfaced when x-ray examinations revealed the existence of two overpainted studies of male heads that are closely related to the portraits painted by Bellini around 1500.[7] Ballarin convincingly draws attention to the fact that Palma Vecchio, having arrived in Venice from the *terraferma,* probably found it easier to emulate the aged Bellini's gradually evolving style than to try to assimilate the radical innovations of Giorgione, Titian, and Sebastiano del Piombo.[8] According to Ballarin, the paintings by Giovanni Bellini that are closest in style to *The Betrothed Couple* are *The Child Bacchus* and

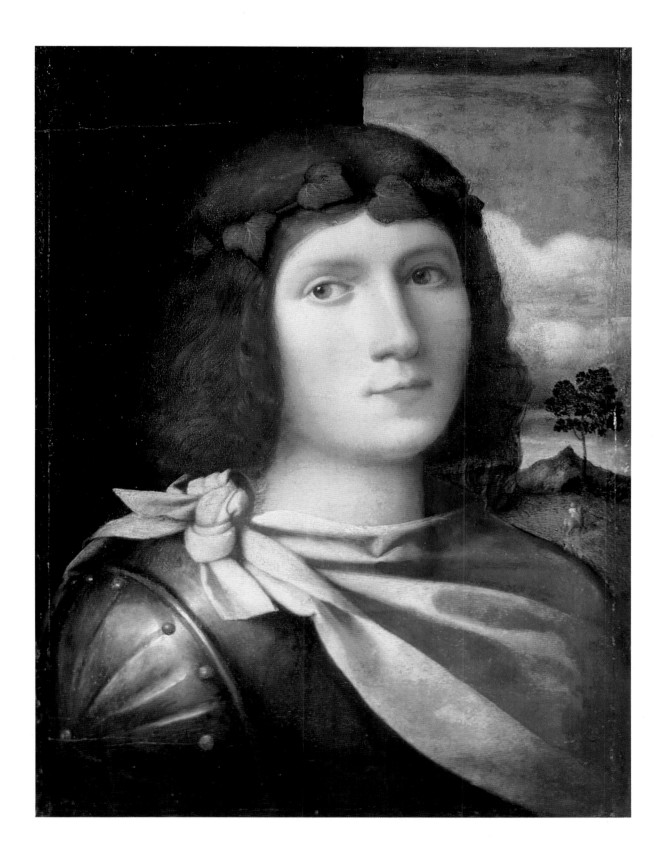

The Feast of the Gods, both in the National Gallery of Art in Washington, D.C., and the *Woman Combing Her Hair* in Vienna. These are all late works datable after 1500. As possible sources of influence, these help determine the dating of the Budapest portraits, suggesting a date shortly after 1510,[9] which is more likely than 1505–8 as proposed by Gombosi and Garas.[10] —V.T.

] 4 2 [

Portrait of a Man

Oil on poplar panel, 83.5 × 71.5 cm
PROVENANCE: Brescia, Fenaroli Collection; purchased from
the Venetian dealer Luigi Resimini, 1895, inv. 1254

LIGHT FROM A WINDOW TO THE LEFT serves to emphasize the expression of the man who turns away from the viewer. His contemplative gaze recalls the influence of Giorgione, which is also evident in Romanino's earliest surviving dated work, *The Lamentation* of 1510, now in the Accademia in Venice. Romanino's palette was inspired by the Venetian school: the patterned gold embroidery embedded in the black of the heavy, wide-sleeved garment glows before the dark green curtain. Romanino depicts this unknown nobleman in a gallant manner, convincingly rendering space and movement. Although not statuesque, the figure seems corporeal, demonstrating the master's ability to emulate Titian's painterly innovations with understanding and finesse.

Romanino's authorship is universally accepted, even though scholars remain uncertain about the dating of the *Portrait of a Man* in Budapest. It is difficult to place this portrait chronologically because no dated portraits by this master survive. Comparison with Romanino's other works in different media and genres can prove deceptive since in portraiture the client's taste is a major factor determining its style. The majority of critics date *Portrait of a Man* to between 1516 and 1519 or even specifically to 1519, either slightly prior to or contemporary with Romanino's frescoes in the cathedral at Cremona.[1] Advocating the latter view, Ferrari[2] cites as a parallel a secondary figure in the fresco *Christ before Caiphas*. Despite Ferrari's hypothesis, we consider the dating suggested by Suida[3] and Pigler[4] to the 1520s to be more convincing. Ballarin refines and supports this dating on stylistic grounds.[5] He convincingly distinguishes between the plebeian, caricaturelike, anticlassical tastes of the Cremona frescoes and the more refined characterization of the Budapest portrait. It fits more easily into the period of Romanino's career following his return from Cremona, when he began collaborating with the young Moretto da Brescia on the decorations of the Cappella del Sacramento in the Church of San Giovanni Evangelista in his native town of Brescia.

A second version of this portrait, in the Accademia Carrara in Bergamo, was long considered to be autograph.[6] However, when the two versions were exhibited side by side in the Romanino exhibition in 1965, the superior quality of the painting in Budapest became apparent. The Bergamo painting is evidently by a sixteenth-century copyist. Close comparison confirms that the minor differences in the facial features only betray the inabilities of the copyist to replicate the original. Therefore, the contention of Boselli[7] and Pigler,[8] that the pictures in Bergamo and Budapest represent different sitters, is no longer tenable.
 —V.T.

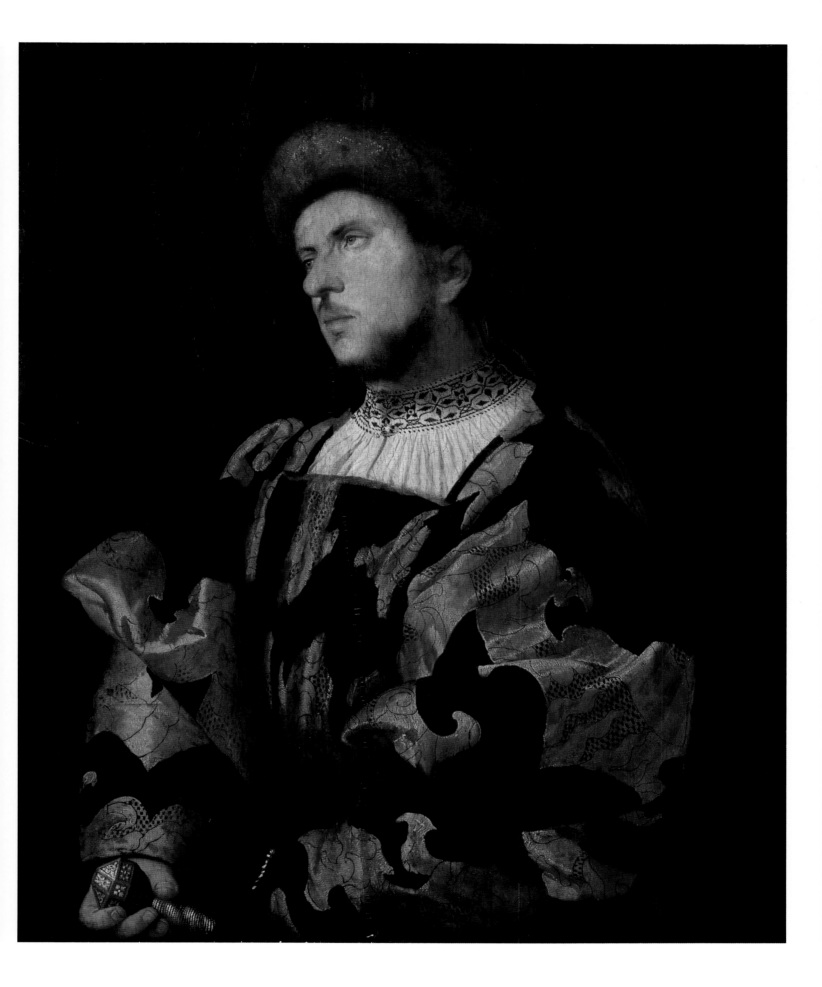

] *43* [

Portrait of a Young Woman

Oil on poplar panel, 52.5 × 42.8 cm
PROVENANCE: Vienna, auction (H. O. Miethke), February 15–16, 1869;
Vienna, Dr. R. Hussian Collection; Budapest, György Ráth Museum;
transferred to the museum, 1949, inv. 51.2879

INVITED TO ROME BY AGOSTINO CHIGI, banker to the Vatican, Sebastiano Luciani left his native town of Venice in 1511, leaving behind him the decisive period of his artistic development, which occurred during the first ten years of the cinquecento. This crucial decade of Venetian painting still holds countless secrets despite sustained research. The aged Giovanni Bellini was still producing masterpieces such as his *San Zaccaria Altarpiece* and the *Madonna of the Meadow.* Carpaccio continued to paint his splendid cycles of legends of lives of the saints for the Scuole, and Albrecht Dürer crossed the Alps for a second extended period in Venice. Practically overnight Giorgione introduced seminal innovations, simultaneously initiating a new relationship between artist and patron. While Giorgione was decorating the Fondaco dei Tedeschi, Titian, a lad of hardly twenty years, worked at his side.

This decade is admirably represented in this exhibition: Catena's *Holy Family with a Female Saint* (cat. no. 19), Palma Vecchio's *Portrait of a Youth* (cat. no. 41),[1] Giorgione's *Portrait of a Youth* (cat. no. 40), and, last but not least, this *Portrait of a Young Woman,* whose relationship to Giorgione's Budapest painting in terms of its composition and mood is self-evident. Its subtle tonal modulation and exquisite coloring are also very Giorgionesque, resembling Giorgione's *Portrait of a Man* in Berlin or his *Laura* in Vienna. At the same time, this picture reveals certain stylistic characteristics that would ally Sebastiano del Piombo with the Central Italian Renaissance art of Raphael and Michelangelo. For example, the lucid composition and the geometrically simplified plastic modeling underscore the importance of design over color. On this basis, Frimmel, somewhat hesitantly, attributed *Portrait of a Young Woman* to Sebastiano del Piombo.[2] György Gombosi, the outstanding Hungarian specialist in north Italian cinquecento art, endorsed Frimmel's attribution with total conviction.[3]

Today scholars unanimously regard *Portrait of a Young Woman* as one of Sebastiano's earliest works,[4] placing it even earlier than the two other half-length female figures from his Venetian period, the *Salome* in London and *The Wise Virgin* in Washington, both from about 1510. It also precedes the two multifigured compositions made in that decade, *The Judgment of Solomon* at Kingston Lacey and the *San Giovanni Cristostomo Altarpiece.*

Gombosi[5] and Hirst[6] consider Sebastiano's so-called *Fornarina* in the Uffizi Gallery to be a Roman, classicizing version of the picture in Budapest, thus anchoring our painting firmly in the master's oeuvre.

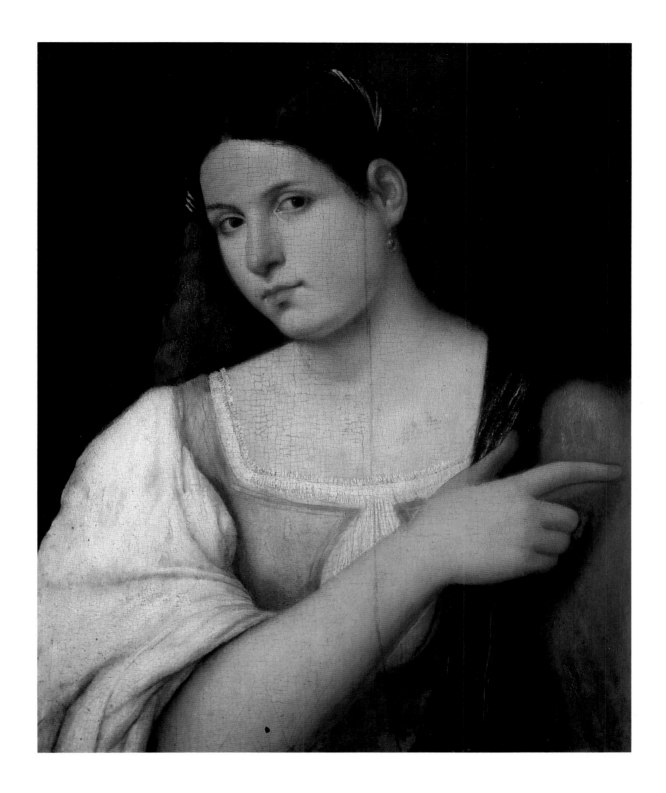

Hirst convincingly argues that *Portrait of a Young Woman* may have been painted from a live model, yet it should not be interpreted primarily as a portrait but as a genre subject in the guise of an idealized likeness, in which the young woman's glance and pointing gesture may convey an erotic meaning.[7]

The Museum of Fine Arts also possesses two later paintings by this celebrated master: *Portrait of a Youth*,[8] painted in Rome around 1515; and *Christ Carrying the Cross*,[9] painted on slate between 1535 and 1540 for the Patriarch of Aquilea, which anticipates the austere art of the Counter-Reformation.

—V.T.

] 44 [

Portrait of a Woman

Oil on poplar panel, 90 × 75 cm
PROVENANCE: Esterházy Collection; acquired, 1870, inv. 91

ALTHOUGH BERNARDINO LICINIO is not an artist of the first rank, this exhibition includes paintings by lesser talents working in the shadow of the greatest painters in order to provide a balanced appraisal of the period. Artists like Licinio provided pictures of a type that until the early sixteenth century were reserved only for the elite. To meet the demands of a larger but less wealthy clientele, they produced both conventional and novel subjects for wider consumption. By propagating these images, the numerous artists of second rank helped shape the visual culture of Venice and the Veneto.

Licinio was born in Venice to a family from Bergamo. His art initially emulated that of Giovanni Bellini, and subsequently that of Giorgione, Palma Vecchio, and Titian.[1] Licinio then processed their styles into an easily recognizable manner. The bulk of his output consists of religious paintings, individual portraits, and a modest number of group portraits. A second *Portrait of a Woman,* also in Budapest, bears the Roman numerals MDXXII on a stone pedestal at the left,[2] making it the first dated work of the artist.

Sources mention Licinio as active as a painter in Venice as early as 1511 and again in 1515. This painting, which belongs to a class of idealized women's portraits of the *Bella* type, was probably painted around 1515. This dating is also supported by the motif of the stepped-stone parapet and the modeling of the thick blond hair. Vertova convincingly contends that the hairnet, fashionable in the second decade of the sixteenth century, was inadvertently removed from this picture during an early injudicious cleaning.[3] Moreover, when compared with the female likeness of 1522, the pose of *Portrait of a Woman,* with its partially turned head and its dreamy expression, recalls Giorgione, implying a somewhat earlier dating. The woman's emphatic gesture, with her left hand pressed against her bosom, and the inclusion of a book in her right hand, possibly Petrarch's *Sonnets,* further manifest the influence of Giorgione's subject matter, in which beauty and love are eulogized.[4]

As is inevitable with minor masters, the lofty poetic content of the works that inspired them is reduced to a cliché. Despite the pleasing contrast of the loose-sleeved red dress, made prettier by the short green mantle set against the fair skin and blond hair, the head and hands are disproportionately small for the sitter's wide shoulders. The shape of the body is schematic and fails to convey a palpable sense of life, while the rigid, angular folds of the dress also betray the brush of a painter who lacked the sensibility necessary to achieve truly subtle modeling of form through color. —V.T.

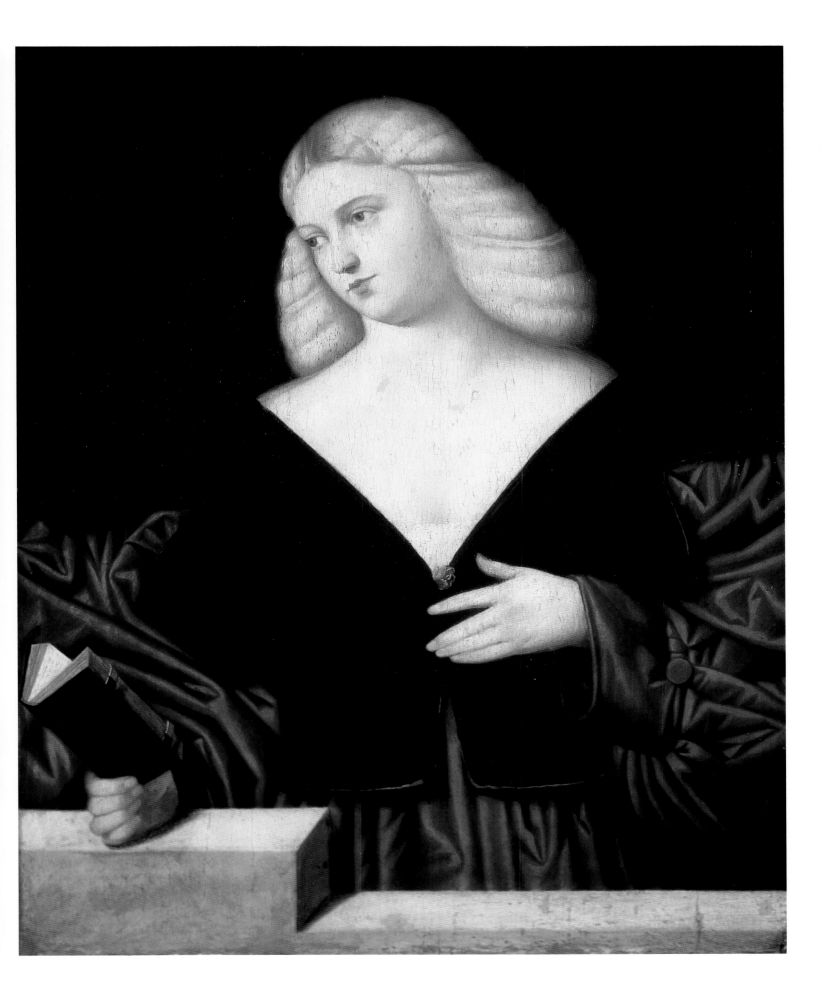

] 45 [

Portrait of Doge Marcantonio Trevisani

Oil on canvas, 100 × 86.5 cm
PROVENANCE: Bologna, Zampieri Collection (?); Vienna, Count Sámuel Festetits
Collection, until 1859; Vienna, auction Dr. F. Sterne (H. O. Miethke), Jan. 12ff., 1886,
lot 840; Pozsony (Bratislava), Count János Pálffy Collection; by whom
bequeathed to the museum, 1912, inv. 4223

AS OFFICIAL PAINTER of the Venetian Republic from 1516, Titian was obligated to produce likenesses of the doges in office for the series of portraits in the large council hall of the Palazzo Ducale. In 1577, a year after the artist's death, this entire series perished in the great fire that consumed the Sala del Maggior Consiglio. The surviving authentic doge portraits by Titian, which include *Andrea Gritti* at the National Gallery of Art in Washington, D.C., *Niccolò Marcello* at the Vatican Gallery, *Marc-antonio Trevisani* in Budapest, and *Francesco Venier* in the Thyssen-Bornemisza Collection now in Madrid, are thus either replicas or variants of the portraits intended for the council hall.

One of the characteristics of Titian's portraiture is his avoidance of compositional repetition. The portrait in Budapest was formerly thought to be a copy of the destroyed painting by Titian. However, Klára Garas convincingly contends that the *Portrait of Marcantonio Trevisani* in the Accademia in Venice, in which the sitter wears an ermine cloak, although painted long after Trevisani's death and currently attributed to Jacopo Palma Giovane, can be more justifiably considered to be a copy of the destroyed picture by Titian.[1] Scholarly opinion remains divided as to whether the *Portrait of Doge Marcantonio Trevisani* in Budapest is a work from Titian's hand or a product from his workshop.[2]

In November 1553 Pietro Aretino, Titian's influential friend, much feared by many, wrote two sonnets praising Doge Trevisani's portrait, probably the one destroyed in the fire.[3] Yet Aretino's description of the image as almost able "to speak, think, and breathe" does not help to identify the picture. This phrase, which derives from ancient *topoi* and recurs often in contemporary criticism, serves to remind the late-twentieth-century viewer, raised on art theories denying the traditional principles of naturalism, that the pictorial illusion of reality powerfully affected sixteenth-century viewers with quasi-magical force.

Titian used innovative methods to create a compelling sense of realism, a quality fully recognized by contemporary apologists of Venetian painting. He experimented with novel painterly devices, thereby continuing and refining practices initiated by Giovanni Bellini and Giorgione. At the same time, Titian distanced himself from the more traditional and well-established close-up descriptive likenesses found, for example, in Gentile Bellini's oeuvre, including his *Portrait of Caterina Cornaro* (cat. no. 38). By imitating the qualities of surfaces and materials, Titian strove toward a greater optical verisimilitude.

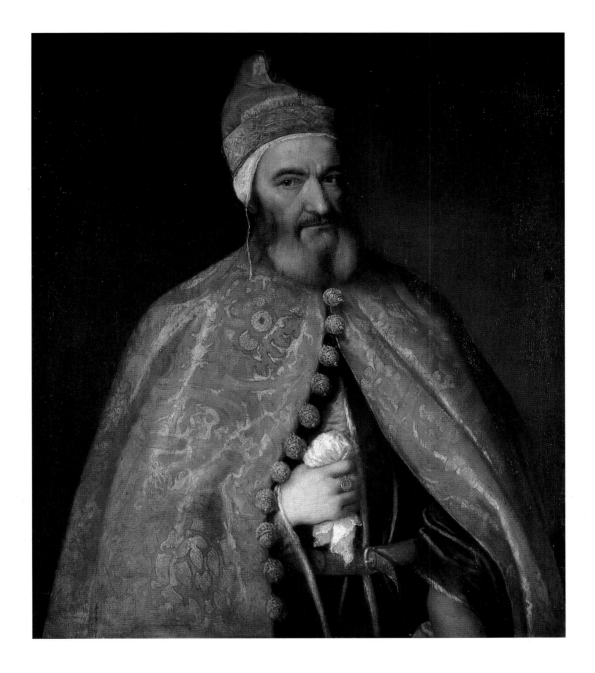

As a result, we can sense the tactile value of the sickly, pale face, the tired gaze, the soft beard, in contrast to the sumptuous fabrics absorbing the light, including the *corno,* the distinctively shaped headgear worn by the doge. The neutral background harmonizes with the dominant shades of the sitter's clothing, a device also used in Titian's early masterpiece of about 1510, the so-called *Portrait of Ariosto,* in the National Gallery in London.

 The portrait of the elderly patrician Venetian doge reveals another of Titian's hallmarks—the ability to convey simultaneously social status and human fallibility. Marcantonio Trevisani's power as doge was more symbolic than actual; he occupied that eminent position in the Venetian Republic three days short of one year. During this period no outstanding political event took place. Trevisani accepted the post reluctantly at age seventy-eight, after considerable pressure from his peers, and died during Mass in the chapel of the Palazzo Ducale on May 31, 1554.[4] —V.T.

187

] 46 [

Portrait of a Cardinal

Oil on canvas, 57.5 × 45.5 cm
PROVENANCE: London, auction Lucien Bonaparte, 1816; London, auction
duke of Lucca, 1840–41; Esterházy Collection; acquired, 1870, inv. 108

ALTHOUGH THE ATTRIBUTION of this arresting portrait to Jacopo Bassano may be open to dispute, scholars unanimously praise its exceptionally high quality and bold characterization.[1] Zampetti focuses on its pictorial and chromatic brilliance,[2] whereas Boschetto emphasizes its powerful sense of mental concentration.[3] Its artistic brilliance matched with its strong portrayal of personality indicate that this *Portrait of a Cardinal* can only be by one of a handful of the greatest Venetian masters of the cinquecento, yet none of the proposed attributions to Titian, Bassano, and Savoldo has proven fully convincing.[4]

Rodolfo Pallucchini's hypothesis that the portrait is a fragment from a considerably larger painting was confirmed when the picture was conserved eight years ago.[5] When the overpaint was removed, the position of the sitter's right arm was revealed, indicating that the original portrait represented a three-quarter or full-length seated figure, subsequently cut down and transformed into a portrait bust.

Returning to the issue of attribution, the least convincing proposal is that to Savoldo. Conversely, the most plausible attribution is to Jacopo Bassano, yet ironically his surviving portraits, especially his only signed example in the Memphis Brooks Museum of Art, Memphis, Tennessee, offer inadequate stylistic analogies. However, certain figures in his religious paintings, such as the Saint Jerome in the *Saint Anne Altarpiece* of 1541 in the Museo Civico in Bassano or God the Father in the *Holy Trinity Altarpiece* of 1547 in Angarano, are extremely similar in their physiognomy and characterization to this *Portrait of a Cardinal.*

Klára Garas's study of 1970 is the most detailed discussion concerning the attribution of the painting and the identification of the sitter.[6] She argues that the earlier nineteenth-century identification of the picture as Titian's *Portrait of Cardinal Pietro Bembo* was not without justification. Garas accepts the painting in Budapest as the portrait that Titian painted of Bembo shortly before Bembo's death and which Ridolfi described in Torquato Bembo's house in Padua.[7] Titian executed this likeness during his stay in Rome in 1545–46. In identifying the sitter as Bembo, Garas uses as her main supporting evidence a mosaic, now in the Museo Nazionale in Florence, made by the Zuccati brothers after a drawing by Titian. The facial features in this mosaic are similar to those in *Portrait of a Cardinal* in Budapest. Unfortunately, a mosaic portrait is a singularly inappropriate medium for comparison because of the schematic representation necessitated by its technique. Titian's indisputable *Portrait of Cardinal Pietro Bembo,* surviving in two versions,[8] represents a more gaunt figure with leaner features and a thinner

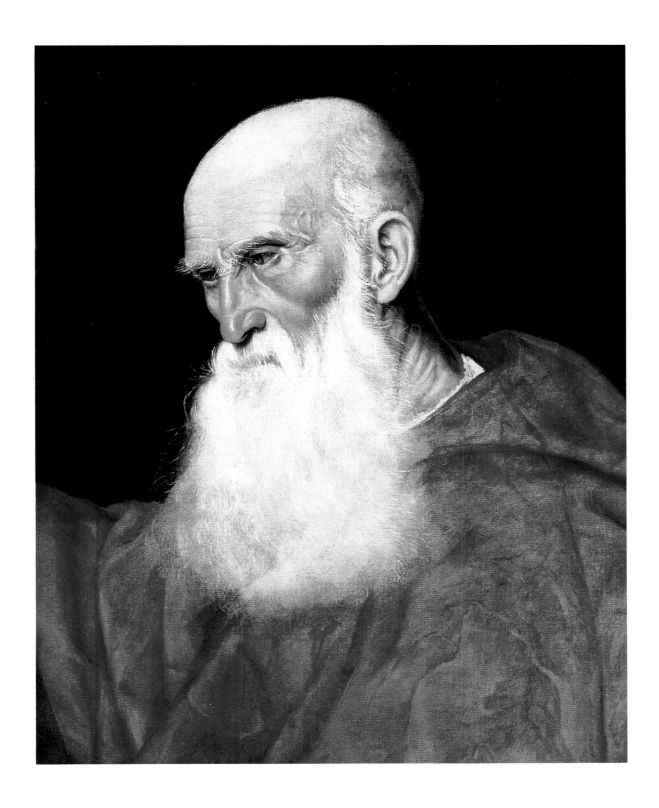

bridge of the nose. It is also difficult to accept Garas's supposition based on stylistic grounds: the striking naturalism of the Budapest portrait is inconsistent with Titian's more painterly portraits from the mid-1540s, such as his celebrated *Pietro Aretino* in the Palazzo Pitti in Florence or *Pope Paul III Farnese with His Nephews* in Naples. Conversely, Titian's rhetorical eloquence differs from the penetrating characterization projected by the *Portrait of a Cardinal* in Budapest, which conveys a poetic sense of resignation which testifies to the inherent dignity of the aged sitter. —V.T.

] 47 [

Portrait of Jacopo Contarini (?)

Oil on canvas, 105 × 83.5 cm
SIGNED BOTTOM RIGHT: *Jo: Bap: Moronus. p. MDLXXV;* INSCRIPTION
ADDED UPPER RIGHT: *JACOBUS CONTARENO Pottestas PADve Aetatis . . . G. B. . . .*
PROVENANCE: Vienna, Count Sámuel Festetits Collection; Vienna, Pietro di Galvagni Collection;
Vienna, Friedrich Jakob Gsell Collection; Vienna, Count Edmund Zichy Collection; by
descent to Jenő Zichy; by whom bequeathed to the city of Budapest, 1906; trans-
ferred to the museum from the Municipal Gallery, 1953, inv. 53.501

MORONI WAS ACTIVE in and around Bergamo. His oeuvre is clearly divided into two com-
ponents—religious subjects and portraiture. Working under the influence of his teacher, Moretto da
Brescia, Moroni's dryly conceived religious subjects conform to the conventions laid down by the Coun-
cil of Trent and are far removed from the pictorial magnificence of Paolo Veronese.

As a portraitist Moroni was a genius on a par with Titian, Lotto, and Moretto. A specialist in this
capacity, Moroni attained greatness because portraiture deeply inspired him. His inventiveness does not
merely find expression in the variety of compositions ranging from portrait busts to life-size, full-length
likenesses. He enriches his repertory through subtle compositional means—by varying the garments and
including attributes either symbolic in nature or denoting the sitter's high political or social station.
Ultimately, Moroni's brilliance as a portraitist is best gauged by his ability to capture a genuine psycho-
logical bond between sitter and viewer. In certain instances the sitters stand aloof before us, while others,
like *The Tailor* in London, are captured with such immediate candor that they seem about to speak.

With few exceptions, Moroni's portraits, whether introverted or extroverted, convey a seriousness
verging on the austere. He depicts his sitters with objectivity and keen insight. Paralleling Bronzino's
icily aristocratic models, the souls in most of Moroni's portraits seem to remain hidden, and none convey
the challenging, animated candor of Veronese's finest portraits. Moroni's style shows no association with
Giorgione's lyricism or Titian's apotheosis of the individual. His reserved sitters perfectly manifest Gom-
bosi's characterization of one of the essential components of Mannerism: its intellectual skepticism.[1]

The robust sitter in this portrait leans against a stone plinth and gazes toward us. His bearded face
seems conventional, revealing no inner intellectual tension or emotion. Unlike the dramatic illumina-
tion characterizing the *Portrait of Antonio Navagero, Podesta of Bergamo,* now in the Brera in Milan,
the light in the Budapest likeness is evenly diffused throughout. Moroni's colors are more subdued than
those employed by Titian or Veronese in their portraits. This coloristic intensity is muted by the soft
light ranging across his subjects and more fully absorbed by them. In the *Portrait of Jacopo Contarini*
Moroni creates a discreet, yet harmonic coloristic balance between the sitter's delicately colored salmon

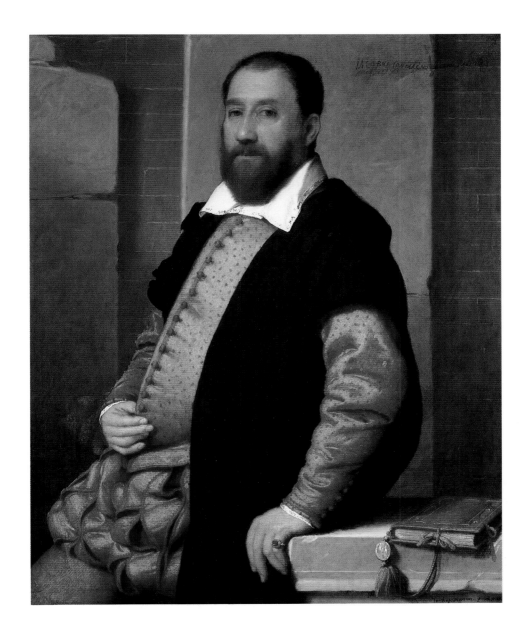

and brownish purple garment and the unexpected flashing white collar, poised against the subdued tones of the architectural backdrop.

In composition and setting this painting is most closely related to the *Portrait of Gerolamo Vertova*, now in a private collection in Bergamo. In both works the artist creates a shallow stage before a backdrop composed of brick walls and stone pilasters. The crumbling architecture may convey a sense of the transitory nature of life with the passing of time, thus symbolizing earthly vanity.[2]

In contrast to the many inscriptions found on Moroni's portraits, the one on the picture in Budapest is a subsequent addition and cannot help identify the sitter. In 1575, when the picture was made, the podesta of Padua was Jacopo Foscarini; no patrician named Jacopo Contarini ever held that office.[3] If the inscription is at least partially accurate, the possibility arises that the sitter, albeit not his putative title, is correctly identified. Based on this hypothesis, Mina Gregori[4] and Klára Garas[5] believe that our painting is, in all likelihood, the work described in the inventory of Paolo Contarini's house in Venice as cited in his will of September 29, 1680: "un Ritrato con Nobile in habito rosso, Moron." —V.T.

] 4 8 [

Portrait of a Man

Oil on canvas, 120 × 102 cm
PROVENANCE: Pozsony (Bratislava), Count János Pálffy Collection;
by whom bequeathed to the museum, 1912, inv. 4288

DEPICTED THREE-QUARTER LENGTH, the dashing young man in this portrait nonchalantly places his right hand on a table. With his left arm akimbo, he draws back the ermine trim of his cloak and gazes directly at the viewer. The sitter's aristocratic demeanor exudes casual elegance, an example later emulated with such success by Anthony van Dyck and Thomas Gainsborough. In Veronese's *Portrait of a Man,* however, this extroverted, self-assured pose also expresses the artist's own self-confidence and his seemingly effortless handling of the medium and subject.

Despite Veronese's distinctive and inimitable characterization as a portraitist, repeated art-historical examination of his origins and sources indicates that his early portrait likenesses betray the influence of Brescian prototypes, in particular those of Moretto da Brescia and Romanino.[1] Our portrait dates somewhat later, by which time Veronese had superseded these influences. Ballarin and Rearick date it to about 1555,[2] whereas others associate it closely with the fresco decorations of the Villa Barbaro at Maser, from the early 1560s.[3]

The ruins dominating the background vista, set before a sky streaked with clouds, project in condensed form the essence of Veronese's notion of aestheticism. Although Italian artists of the sixteenth century admired Roman antiquity, Veronese's imaginary building in ruins documents neither the artist's interest in architecture nor his nostalgia for the former splendor of ancient Rome. Rather, it is an imaginary motif employed solely to enhance the picturesque effect of this magnificent portrait. It functions as a component of the setting as do the two trees in full leaf, the wall covered by ivy, or the curtain that has been pulled aside. Subsequently, such motifs serve as standard props or foils for aristocratic likenesses in the Baroque period, when their presence has become purely conventional.

This *Portrait of a Man* in its own way illustrates Veronese's attitude toward artistic license, which culminated in his testimony of July 18, 1573, in his defense before the Inquisition, which accused him of profaning the Last Supper. Veronese said, "We painters have the same right to freedom as do poets and fools."[4] The trial ended in Veronese's favor; the church court resolved the conflict by simply allowing him to retitle the composition *Feast in the House of Levi,* painted for the refectory of the Dominican abbey in Venice and now in the Accademia. Of all the Italian painters of the cinquecento, Veronese advocated pure painting freed to a marked degree from theological, philosophical, or even psychological underpinnings. To an unprecedented degree he celebrated the process of painting itself regardless of the

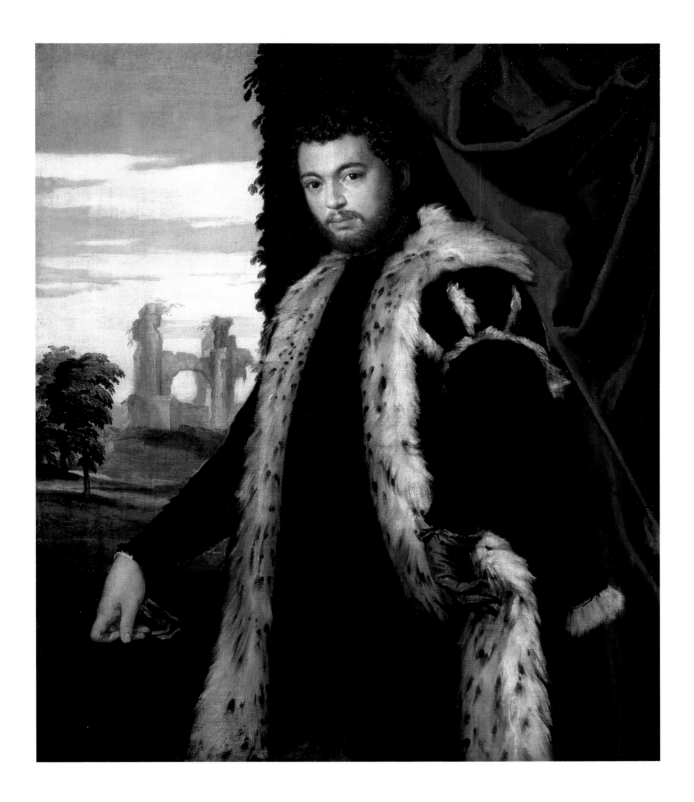

subject represented. His virtuosity was paramount, and he effortlessly harmonized beauty of color, form, and outline, fused with eloquent formal gestures and magnificent garments and settings. He weaves these elements together to embody and glorify the realm of sight. The sunlit, festive atmosphere demonstrates Veronese's belief in the prerogatives of the painter, as indicated by his statement before the Inquisition. Our *Portrait of a Man* displays the same sense of visual pleasure, formal elegance, and assurance so characteristic of Veronese, the most hedonistic Venetian painter of his age. —v.t.

] 49 [

Portrait of a Dominican Friar

Oil on canvas, 43.5 × 32 cm
PROVENANCE: Probably Mantua, Gonzaga Collection, 1627;[1] duke of Hamilton
Collection, before 1643;[2] Brussels and Vienna, Archduke Leopold Wilhelm Collection; by whom
bequeathed to the Austrian Habsburg imperial collection;[3] transferred to Pozsony Palace (Bratislava), by
1781;[4] transferred to the castle in Buda, 1784;[5] transferred from the apartments of the President of
the Chamber to the Hungarian National Museum, 1848;[6] transferred to the National
Picture Gallery, the precursor of the Museum of Fine Arts, 1875, inv. 580

FETTI, A NATIVE OF ROME, began his artistic training under Cigoli at the beginning of the seventeenth century but was also strongly influenced by the followers of Caravaggio. From 1613 to 1622 Fetti was court painter to Federico Gonzaga in Mantua. There he had access to the famous collection of Venetian and Flemish pictures, which deeply impressed him and helped shape his style. Fetti seems to have spent only the last eight months of his life working in Venice, but still had great impact there. His small, lyrical paintings, which express his compassion for humanity, contrasted markedly with the grandiose manner of Tintoretto or the mysterious, dark canvases of Palma Giovane.

In early Habsburg inventories this *Portrait of a Dominican Friar* was correctly ascribed to Fetti, but this fact was later forgotten. From the eighteenth century onward this picture was attributed to Van Dyck[7] or to one of his followers. It was Pigler who first reconfirmed the correct attribution in 1967,[8] and Garas provided further documentary support in 1967 and 1968.[9]

Safarik accepts the attribution to Fetti,[10] but in his analysis overstresses the importance of the small and schematic reproductive image that appears in *Prodromus,* the catalogue of the imperial collection in Vienna, published in 1735 by Stampart and Prenner.[11] Based on it he asserts that *Portrait of a Dominican Friar* is in poor condition. The engraving shows more curly hair and more shadow on the face, admittedly on a minute scale. Safarik concludes that these features disappeared as a result of overcleaning. He maintains that the somewhat plebeian face of the print became more idealized in the picture through retouching and overpainting and that Fetti's hand can only be perceived in isolated passages. Whereas Safarik assumes that the reproductive image in *Prodromus* faithfully records Fetti's picture, we contend that this image should be interpreted quite differently. Rather, it is a sketchily defined, generalized approximation never aspiring to be a graphically accurate recapitulation of Fetti's intimate and simple composition. Apart from minor losses, this *Portrait of a Dominican Friar* is actually in good to excellent condition.[12] Although this work has been cut down considerably, it fully illustrates Fetti's lively, painterly manner and, in its delicate yet assured touch, recalls Fetti's late style. Certain realistic details like the delineation of the habit as well as the fluid brushwork relate it to Flemish prototypes, yet its chromatic richness and luminous colorism are fully Venetian in conception.

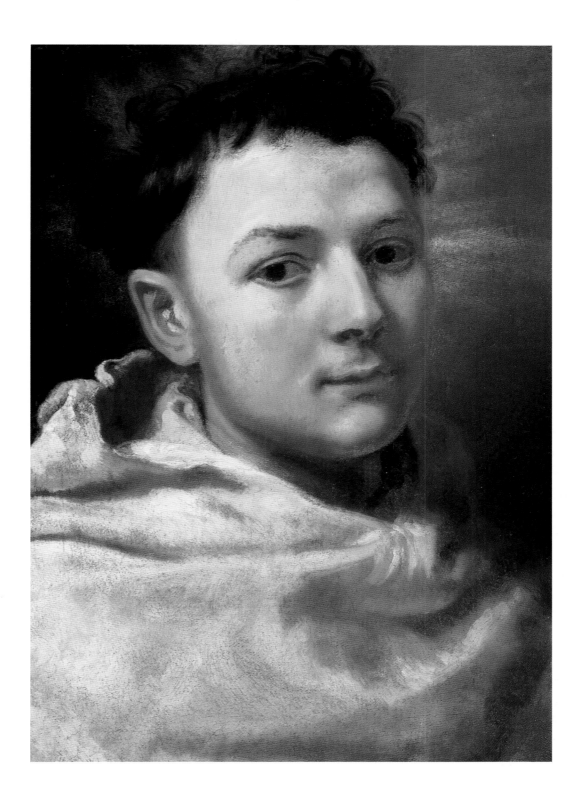

The question remains whether Fetti portrayed a real Dominican monk. The lack of attributes obscures the issue. In earlier museum catalogues the sitter was identified as Saint Aloysius Gonzaga, patron of Mantua and member of its ruling family. This appealing hypothesis cannot withstand comparison with indisputably documented likenesses of Saint Aloysius,[13] who was canonized only in 1726. The presence of the halo in Fetti's painting would have to allude to another, earlier, saint. In character this likeness may have been similar to the alleged *Portrait of Federico Gonzaga* of about 1620,[14] but because it is so seriously cropped, offers few points of comparison in terms of detail. —I.B.

] 50 [

Girl with Distaff

Oil on canvas, 48 × 39.2 cm
PROVENANCE: Esterházy Collection; acquired, 1870, inv. 643

GENRE SUBJECTS, AN IMPORTANT CATEGORY of Venetian settecento painting, are almost completely absent from the collection of old masters in Budapest. The only genre painting that can be included in this exhibition, on the basis of its Venetian flavor, is this touchingly lovely cabinet piece, *Girl with Distaff*. Its appeal lies in the simplicity and natural rendering of its subject. The charming young lass, taking a break from her work and propping her head on her hand, faces the viewer coquettishly with the candor of her tender age. The essence of the painting is hidden in the subtle and even enigmatic details of the face depicted close-up. The girl's glance is animated by the light sparkling in her green eyes, which also underscores the profile of her nose while defining her saucy half-smile.

Despite its portraitlike character, *Girl with Distaff* represents a social type (*popolana*) rather than an actual person. Character heads (*teste di carattere*) constitute a special category within genre painting in which attractive, interesting, and at times exotic physiognomies are portrayed. Such character studies were very popular in eighteenth-century Italy and were widespread in France (where they were called *têtes d'expression*) as well. Artists from Bologna (G. M. Crespi, G. Gandolfi), from Lombardy (Ceruti, Cipper), or Venice (Piazzetta, Nogari, Maggiotto) propagated this genre—a circumstance contributing to the uncertain authorship of the Budapest painting, which still remains to be decisively determined.

While in the Esterházy Collection the painting was still ascribed to Murillo.[1] Later, Mündler linked it to the Veronese artist Pietro Rotari, who worked outside Italy in Dresden and St. Petersburg,[2] and whose most successful subjects were his enchanting bust-length depictions of coy young girls. The attribution to Rotari, which remained in force for over a century,[3] was first queried by M. Natale, followed by M. Gregori, both of whom attribute the painting to Ceruti, one of the most original Lombard masters of naturalism.[4]

Born in Milan but working in the tradition of the Brescia-Bergamo artists exemplified by Carlo Ceresa, Ceruti was also known as a painter of still lifes as well as portraits, yet he is most celebrated for his monumental genre pictures executed with graphic realism. He depicted his protagonists—the homeless orphans, beggars, disease-ridden old people, and deformed cripples of eighteenth-century society—without the slightest attempt at idealization. These are represented with pitiless objectivity, devoid of sentimentalism or humor that would mitigate their rough and primitive strength.

196

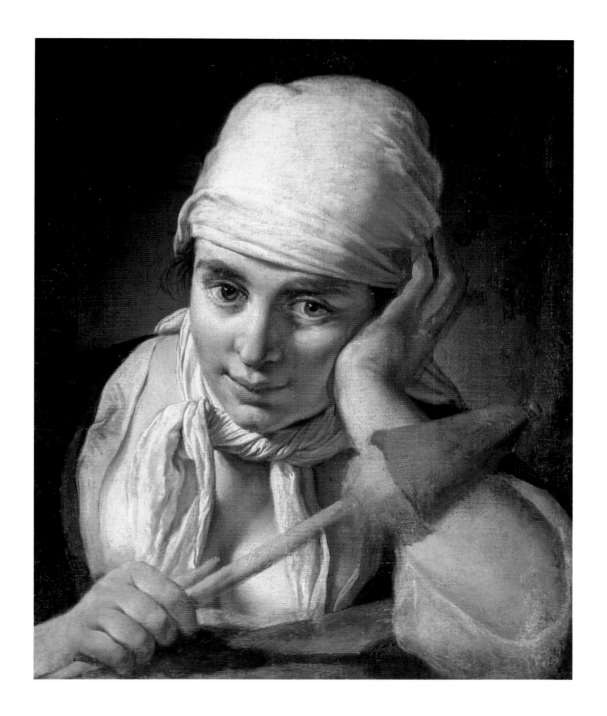

Ceruti's sojourn in Venice and Padua (1734–39) or, more precisely, his association with Venetian painting due mainly to his patron, Marshal Matthias von Schulenburg, provided a turning point in his artistic development. He was captivated by Pietro Longhi's interior paintings,[5] yet it was probably Piazzetta who inspired Ceruti to make his delightful half-length genre figures,[6] which, according to Gregori,[7] include the *Girl with Distaff* in Budapest. These paintings are cheerful in mood, idealized in character, and portrayed in precise compositions with lively coloring. F. Moro has recently proposed Paolo Borroni as the possible author of the Budapest picture.[8] Borroni, a painter from Voghera rediscovered only a quarter of a century ago, closely imitated Ceruti's inventions in a somewhat dry manner.

—Zs.D.

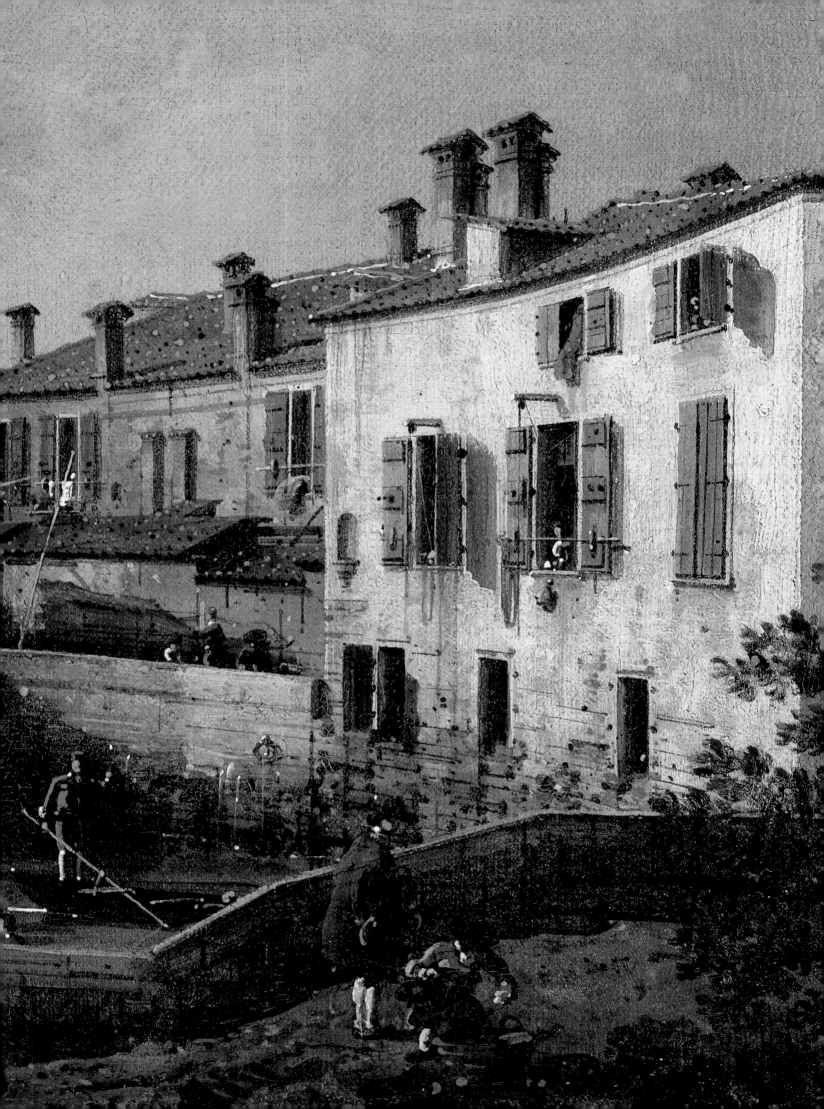

VENICE

AND

LANDSCAPE

] *5 1* [

Allegory of Venice

Oil on canvas, 140 × 140 cm (octagonal)
PROVENANCE: János László Pyrker Collection; by whom
given to the Hungarian National Museum, 1836, inv. 105

CARLO RIDOLFI AND SUBSEQUENT CHRONICLERS describing Venice and its art treasures mention this octagonal composition as the one painted by Veronese to decorate the ceiling of the reception room at the Magistrato delle Legne, the government office responsible for the supply of fuel wood.[1] These seventeenth- and eighteenth-century descriptions are corroborated by the exact engraved copy by Andrea Zucchi published in 1720 in *Lovisa: Il gran teatro delle pitture e prospettive,*[2] which further confirms the original destination of the allegory. With one notable, yet overlooked, exception, the literature on this picture perpetuates the erroneous view that this office was located in the Palazzo Ducale. To date, Juergen Schulz is the only authority to demonstrate that the office indisputably had its headquarters in the grain storehouse building, demolished in 1807, close to the doges' palace but not a part of it.[3]

Under a curtained canopy, guarded by the lion of Saint Mark, the female figure embodying the *Serenissima* sits enthroned on her globe. Her casually dignified pose, her bejeweled, shining garment, the heavy drapery embroidered with gold, as well as her all-encompassing gaze and the scepter in her left hand are attributes of her sovereignty. In 1575–77 Veronese painted the same subject as part of the ceiling decoration of the Sala del Collegio in the Palazzo Ducale. This scene, representing the personification of Venice flanked by Justice and Peace, contains a similarly enthroned central figure. The Budapest version likely dates shortly thereafter.

Hercules,[4] personification of heroic virtue, faces us with a rhetorical gesture, while Neptune, his back to the viewer, is identified by his trident and his loincloth of sedge. Neptune maintains a gymnastic Mannerist pose while paying homage to Queen Venice. In his left hand he holds a shell filled with pearls, the treasure of the seas. An even bigger shell is held by a putto accompanying him. The wealth gained from maritime commerce is also indicated in a more pragmatic way by the chest half-covering the child.

On the basis of its relatively small size and certain weaknesses in execution, Schulz regards this picture as a copy.[5] However other scholars believe that the picture acquired by Pyrker is Veronese's origi- nal composition mentioned in the sources and recorded in the engraving. The painting's abraded surface makes it difficult if not impossible to establish whether the pictorially weak areas, quite unworthy of Paolo Caliari, should be attributed to its current damaged condition[6] or to workshop intervention. Fur-

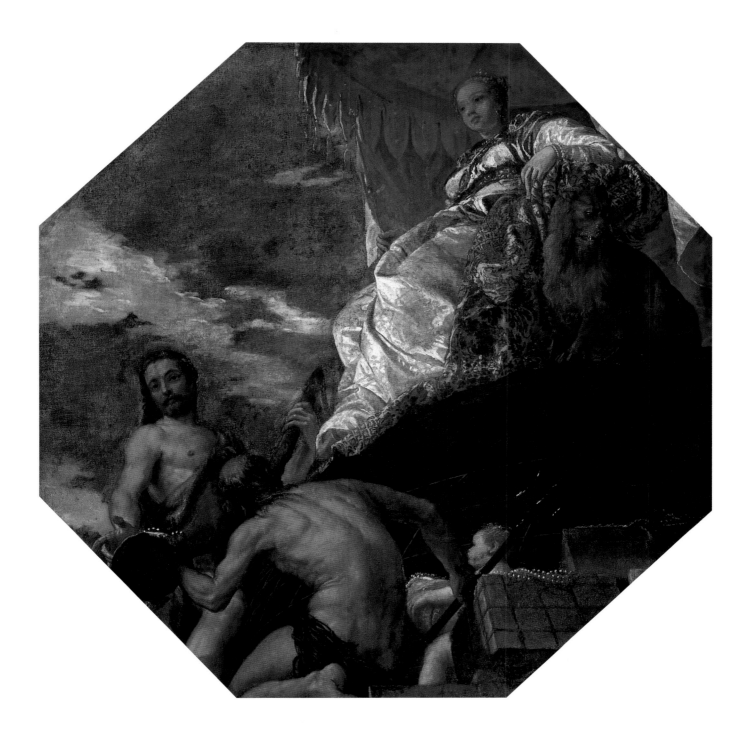

thermore, the smaller format, compared with Veronese's allegories in the Palazzo Ducale, can simply be explained by the scale of the particular hall for which it was intended.

A vast gulf separates Veronese's political allegories from the fresco decorations eulogizing the Medici dynasty produced by Vasari and his assistants in the Palazzo Vecchio in Florence, the official residence of Cosimo I, grandduke of Tuscany.[7] Governed by his instinctively antidogmatic attitude, Veronese, through his compositional inventiveness and spontaneous pictorial ideas, expressed his frivolous love of pomp, thereby providing a counterbalance to the official seriousness and ceremonial solemnity normally required by such civic commissions.　　　　　　　　　　　　—V.T.

] *52* [

Landscape with Fishermen and Shepherds

Oil on canvas, 103 × 96 cm
PROVENANCE: Hungarian Ministry of the Interior;
transferred to the museum, 1957, inv. 57.17

THE FOCAL POINT OF THIS DRAMATIC LANDSCAPE *capriccio* is the huge water-side grotto overgrown with ivy and populated by fishermen, shepherds, and their comrades. This evocative locale is enhanced by a picturesque castle ruin and a waterfall. The rays of the setting sun partially enter the cave and highlight the fluttering drapery of the figures. They also illuminate the cliff tops and play on the sparkling water breaking on the rocks. Lilac-pink clouds enrich the coloration of a landscape that can almost be regarded as proto-Romantic.

Andor Pigler catalogued this painting as an anonymous, eighteenth-century north Italian work made under Alessandro Magnasco's influence.[1] After its restoration in 1990 and the appearance of an earlier unknown version, and taking into account the verbal opinion expressed by Mauro Natale,[2] Dobos attributed this painting to Sebastiano Ricci, placing it within the stylistic period when he was deeply influenced by Magnasco.[3] In fact, during the course of his career, Ricci came into close contact with Magnasco several times. They probably met in Milan between 1695 and 1698, then worked together at the Medici court in Florence from 1706 until 1707. Magnasco's biographer, Soprani, mentions Ricci as a pupil and emphasizes that Magnasco taught him how to convey graceful movement.[4]

Ricci acknowledged his debt to Magnasco in a number of paintings,[5] which recall Magnasco's eccentric world not only in their choice of subject but also in the gesticulating, withdrawn figures in hunched postures. However, the Venetian element in these works is evident in Ricci's fiery coloring and fluid brushwork, ranging from thick impasto to refined, thinly applied glazes. The painting in Budapest belongs in this category together with its possible pendant, the *Imaginary Landscape* formerly in the Contini-Bonacossi Collection in Florence.[6] It is closely connected to the Budapest painting in mood, similarity of landscape elements, and figure types and is virtually identical in its measurements. Geiger considered the Contini-Bonacossi *Imaginary Landscape* a joint work of Magnasco and Tavella,[7] whereas Pospisil considered it to be solely by Tavella.[8] Conversely, as early as 1930 Delogu considered it to be a joint product of Sebastiano and Marco Ricci.[9]

The question arises as to whether Sebastiano Ricci, regularly a collaborator with other painters, allowed his nephew Marco to paint the Budapest landscape or perhaps chose Giovanni Antonio Peruzzi, whom sources mention as a colleague.[10] However, a comparison with landscape details in Sebastiano Ricci's other paintings reveals the same nervous, broadly applied brushwork in stripes of glowing color

in the foreground and adjacent rocks. This brushwork betrays the same hand responsible for the land-scape details in the preliminary studies for the frescoed pendentives in the Church of San Bernardino dei Morti in Milan and the guardian angel fresco in the Church of Santa Maria del Carmine in Pavia, both ascribed with certainty to Sebastiano Ricci. The same brushwork also appears in the background of *Bacchus and Ariadne* in the National Gallery in London. Therefore, it seems conclusive that the Buda-pest landscape is Sebastiano Ricci's work, inspired by his direct contact with Alessandro Magnasco during the years Ricci spent in Florence or Milan. —Zs.D.

] 53 [

The Locks at Dolo

(Le Porte del Dolo)

Oil on canvas, 30.5 × 44.5 cm
SIGNED ON THE BACK: *Io Zuea Antonio Canal deto il Canaleto, feci*
PROVENANCE: Budapest, private collection; purchased,
1978, inv. 78.14

THE INNOVATIVE SUBJECT of this painting was inspired
by the mainland around Venice (*terraferma*), which Canaletto in-
troduced in his series of engravings from 1744, entitled *Vedute altre
prese dai luoghi altre ideate*. In these the artist recorded the environs
of the Brenta River near Venice and incorporated typical details of
Padua, Marghera, Mestre, and Dolo, the sites frequented by Vene-
tians during the increasingly popular excursions termed *villeggia-
ture*. Dozens of drawings and paintings are related to the series. The
engraving (bearing the inscription *Le Porte di Dolo*), the prelimi-
nary drawing for which is in the Asscher Collection in London,
displays a close relationship to the painting in Budapest.[1]

Unlike Canaletto's larger panoramas, the picture in Buda-
pest has a relatively narrow focus, showing the sunken oval basin
containing the closed locks at Dolo, behind which gondolas ap-
pear, hardly ruffling the still water. At the left, a house, containing a
butcher's shop with a sign board and outdoor shrine, blocks the
view. The foreground is enlivened by staffage including a lacemaker
and a fruit vendor and a group of people at the foot of the bridge.[2]

This intimate and nostalgic painting is unusual in Canaletto's
oeuvre and is characterized by the emphatic use of chiaroscuro,
subdued coloring, and distinctively calligraphic brushwork. At the
right, deep shadow cast by the lock gate falls across houses bathed in
strong light. In contrast to the sunlit side, the foreground is almost
completely in shade, in conformity to the notation "per l'ombra
questo,"[3] which appears on the handrail of the bridge in the pre-
liminary drawing. By means of contrasting light and shadow, the
house roofs and foliage become a patchwork of dark and light color.

Canaletto merely delineates the hands and faces of the figures with the tip of his brush. The marionette-like figures are animated by this deft application of small dots and thin lines of paint.

Stylistically this painting belongs to a group formerly ascribed to Bernardo Bellotto.[4] They were isolated by W. G. Constable, who correctly attributed them to Canaletto. Until its restoration in 1990, the painting in Budapest was also attributed to Bellotto.[5] Yet stylistic discrepancies, subsequently supported by the discovery of the signature on the back, confirmed Canaletto's indisputable authorship of this picture.[6] The group classified by Constable comprises, among others, the well-known pair *The Porta Portello* and *The Brenta Canal* in the National Gallery of Art in Washington, the *View from the Brenta* now in a private collection in London, *Torre di Marghera,* formerly in a private collection in Berlin, and *Mestre* and *At Dolo,* formerly in the Norbury Collection, Malvern, which were auctioned in London in 1986.[7] Since the picture in Budapest is linked to the paintings formerly in Berlin and Malvern not only in subject and style but also in its measurements, we can safely hypothesize that all four were originally part of a series that may have included other works as well.[8] —Zs.D.

] 54 [

The Piazzetta dei Leoncini in Venice

Oil on canvas, 55.5 × 83.5 cm
PROVENANCE: Esterházy Collection; acquired, 1870, inv. 628

UNTIL THE BEGINNING of the present century this painting was classified under the collective name of Canaletto. Finally, in 1912, Fogolari recognized it as Marieschi's work.[1]

The Venetian *veduta* painters of the seicento and settecento recorded virtually every facet of the Piazza San Marco and its surroundings from every possible angle. One exception is the Campo San Basso, concealed at the foot of the northern flank of the Basilica of San Marco. Michele Marieschi was the first to discover the picturesque and scenographic possibilities of this architectural ensemble and added it to the repertory of Venetian townscape painting. In this daring composition Marieschi assumes an elevated vantage point and creates a wide prospect that expands the perceived space of this small square. It came to be called the Piazzetta dei Leoncini after two red marble lions were set up next to its wellhead in 1722. The pillared facade and belfry of the Church of San Basso stand out in the row of buildings to the right, among houses with roof gardens, balconies, and sign boards. This church was built after the fire of 1676 according to Baldassare Longhena's design. Beyond it are the Torre dell'Orologio and the Procuratie Vecchie, boldly foreshortened. The view is blocked by a row of buildings at the western end of the piazza, including Sansovino's vanished masterpiece, the Church of San Gimignano, demolished during the Napoleonic era. The left-hand side of the square is composed of the facade of the basilica with the campanile just visible behind. The church's lacy gables, pinnacles, and arcades, supported by clustered columns and the Porta dei Fiori, although barely articulated, are architecturally accurate.

Marieschi recorded the same view of the Campo Basso in one of his engravings, in the twenty-one-sheet series published under the title *Magnificentiores selectioresque urbis venetiarum prospectus*, in 1742. However, the print contains different staffage and includes certain minor changes in architectural detail. Although depicted from the same viewpoint, the engraving includes the top of one of the domes of the Basilica of San Marco. Basing his opinion on the types of figures and on the looser grouping of the *macchiette*, or stock figure types, Dario Succi considers the picture in Budapest later than the one in Munich, dating it to around 1735–36.[2] Despite our general lack of biographical knowledge about Marieschi and his whereabouts during these years, it is known that during the mid-1730s Marieschi, on his return to Venice after his putative trip to Germany, painted twelve *vedute* for Marshal Matthias von Schulenburg. Though the influence of Canaletto is still evident, in Marieschi's pictures from this time

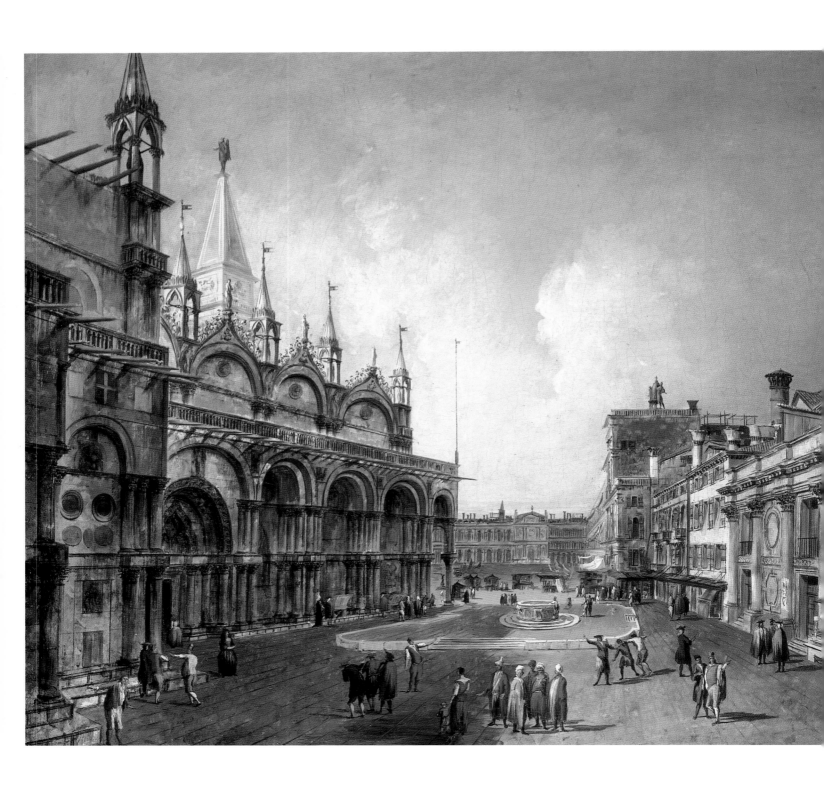

we can discern the characteristics that would become his trade-mark: the slightly dry and graphic representation of architectural details set off by thin brown lines, the yellowish gray patchlike de-lineation of walls, and his sparkling, kaleidoscopic coloring.

Marieschi also worked as a stage designer. In this *veduta* and analogous compositions, he placed buildings one behind the other like stage flats, rather than projecting them according to the laws of scientific perspective. As if on a stage defined by those buildings, the theater of everyday life in Venice plays itself out in the sticklike figures painted in vivid flecks of color resembling those that appear in the paintings of Marco Ricci and Gaspare Diziani. —Zs.D.

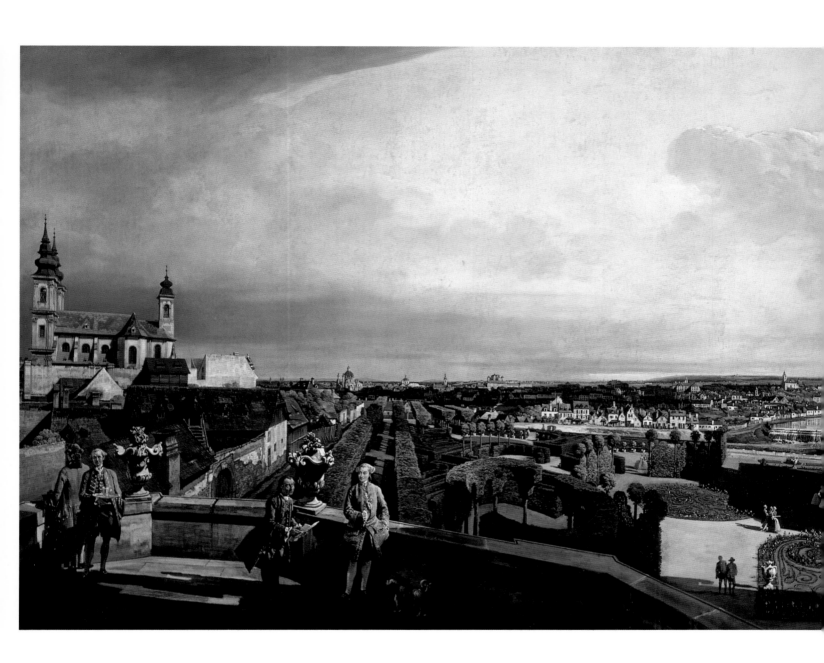

] 55 [

The Kaunitz-Esterházy Palace and Gardens in Vienna

Oil on canvas, 134 × 237 cm
PROVENANCE: Possibly commissioned by Prince Wenzel
Anton Kaunitz-Rietberg, Vienna, 1759;[1] transferred to Austerlitz,
by 1838;[2] Budapest, Count Géza Andrássy Collection, by ca. 1905;[3]
Budapest, Countess Andrássy-Kaunitz Collection, 1930;[4]
transferred to the museum from the Export Board for
Heavy Industry, 1952, inv. 52.207

THIS IS A FINE EXAMPLE of *veduta* painting, a specialty uniquely associated with Venice during the eighteenth century. In his architectural views of Venice, Canaletto raised such urban topographical views to unprecedented heights, catering principally to the taste of English tourists.

Canaletto's nephew, Bernardo Bellotto, although active mostly outside Venice, carried on the tradition of Venetian *veduta* painting. After his formative years in Italy working under his uncle, by 1747 Bellotto had left his native city never to return. He received his first great commission to paint various views of Dresden. Subsequently he worked in Vienna, where he produced a series of city scenes which constituted a new stage in his development as a *veduta* painter.[5] These consisted of thirteen large canvases painted for the Empress Maria Theresia in 1759 and 1760, in which Bellotto represented views of the city of Vienna and various imperial palaces in its environs.[6]

While in Vienna Bellotto also seems to have received commissions from the princes Liechtenstein and Kaunitz, two leading patrons of the arts associated with the imperial Habsburg court.[7] Although Bellotto was clearly inspired by Canaletto's compositional format, his palace views are innovative. They combine precise architectural renderings of magnificent palaces with formal landscape motifs and an informal rendering of the surrounding countryside.

Bellotto had already combined these components in his earlier Dresden views. Whereas many of the architectural subjects in his Dresden *vedute* were Rococo in style, Bellotto's Viennese pictures

211

represented Baroque buildings. In *The Kaunitz-Esterházy Palace and Gardens in Vienna* Bellotto depicts an exterior view of the recently built summer palace of Prince Kaunitz with its surrounding formal gardens and, beyond, a glimpse of the southeastern district of the imperial city of Vienna. This combination is without precedent, is essentially non-Italian in character, and stands in contradistinction to the typical Venetian *veduta*. To the left, the Mariahilfer Church and in the distance the Karlskirche and the Belvedere are readily identifiable.

In the foreground Prince Kaunitz appears with his secretary.[8] This portrayal of the owner before a view of his property was an innovation first realized by Bellotto in the Liechtenstein and Kaunitz commissions.

In terms of its balanced composition, *The Kaunitz-Esterházy Palace and Gardens in Vienna* is the most successful painting Bellotto produced in Vienna. The only other comparable picture from the series is *The View of Vienna Seen from the Belvedere,* now in the Kunsthistorisches Museum in Vienna. However, in that composition the Upper Belvedere, the main palace, is not represented. Moreover, because the formal park receives less emphasis and portrait likenesses are omitted altogether, the resultant composition is less harmonious.

The Baroque garden, hitherto seldom represented in Bellotto's work, appears as a distinguishing innovation in the Vienna views and proves to be an element particularly sympathetic to his style. The evolving theatricality of Bellotto's style is enhanced by the pronounced architectural perspective and the rich chiaroscuro. This stylistic shift may derive from late Baroque illusionism and the influence of Piranesi's Roman views.[9]

In his Viennese *vedute* Bellotto applies paint more thickly and with more impasto than in his earlier works. His color scheme is basically cool and the ground tone is a shade of olive green. This palette is characteristic of the whole Viennese series and contributes to the unprecedented, solemn eloquence of *The Kaunitz-Esterházy Palace and Gardens in Vienna.*[10]

This painting is of particular interest for the Museum of Fine Arts in Budapest because the Esterházy Gallery, purchased by the Hungarian government in 1870 to form the foundation of the museum's collections, was exhibited in this Viennese palace between 1815 and 1865, prior to its transfer to Budapest. Furthermore, since the Kaunitz-Esterházy Palace no longer exists, only the Esterházy Park in Vienna indicates where this magnificent edifice once stood.

—I.B.

Notes to Catalogue

Cat. no. 1

1. Pietro Monaco (active in Venice, 1735–1775) engraved this composition in the same direction when it was in the Vidiman Collection in Venice for a title page of 1739 (Wurzbach 3; Steinbart 1940, fig. 52). No documentary evidence confirms that the Budapest version of this subject was the one engraved.

2. Kammerer was the director of the Museum of Fine Arts between 1906 and 1914, during the period when the present building first opened.

3. See Pigler 1974, 1:191–197.

4. Most of our knowledge about Liss stems from Joachim von Sandrart's published account of him in Sandrart 1675, pp. 187–188.

5. Authentic versions of the subject exist in the National Gallery in London (inv. 4597) and in the Kunsthistorisches Museum in Vienna (inv. 1244). Literature generally favors the London version. An enlarged copy from the seventeenth century, with the addition of a landscape on the right, is in the Ca' Rezzonico in Venice, and further copies exist in private collections.

6. Cornelis Galle's reproductive engraving (Hollstein 31) records Rubens's composition.

7. Compare, for example, the dynamic drapery patterns and the foreshortened figure in Ricci's *Moses Defending the Daughters of Jethro* (cat. no. 5).

8. Levey 1959a, pp. 58–59. His dating applies specifically to the version of this subject in London, but I believe that the fully autograph replica in Budapest is close in date.

9. Augsburg/Cleveland 1975, pp. 88–89, cat. no. A20. Levey 1959a.

10. The assertions of Rowlands 1975, p. 835, and Spear 1976, p. 590, that the picture in Budapest is merely a copy are not borne out by examination of the picture since its conservation treatment. Pallucchini 1981, p. 145, maintains his belief in its authenticity.

Cat. no. 2

1. These include *The Allegory of Sculpture and Painting* in the Accademia in Venice and *Venus and the Three Graces* in the Museo Civico in Vicenza.

2. Zanetti 1771, p. 385.

3. Sirén 1914, p. 204.

4. Zanetti 1771, p. 385; for the full citation see my catalogue entry on Marco Liberi's *Jupiter and Asteria* (cat. no. 35). This assertion also applies to such paintings as *Venus and Adonis* in the Schönborn Gallery at Pommersfelden.

5. Garas 1981a, p. 98.

6. In Milan 1993, p. 107, cat. no. 33.

7. Venice, Palazzo del Cancellerie (formerly in the collection of the Pisani family and Alvise Morosini), in the Schönborn Collection in Vienna, and in the Liechtenstein Collection.

8. Published by Garas 1981a.

Cat. no. 3

9. For example in *The Three Graces* in Hampton Court Palace and *Venus Triumphant,* now in a private collection in Rovigo, Italy.

10. Lanzi 1795–96, 3:249, describes this characterization as "i capelli stessi distingue in modo da poter numerargli" (the hairs are so distinctly drawn that they can be counted).

Cat. no. 3

1. Boschini 1660, p. 539: "inzegnio tenebroso e scuro."

2. Stefani Mantovanelli 1990, pp. 43–104.

3. The most notable examples are in Greenville, N.C., Bob Jones University; Isola Bella, Borromeo Collection; Pommersfelden, Schönborn Collection; and Sibiu, Muzeul Brukenthal. See ibid., pp. 66–67, 72, 83–84.

Cat. no. 4

1. Mentioned by Éber 1926, p. 108. While in the Csetényi Collection this painting and its pendant (cat. no. 5) were erroneously considered to be by Giambattista Tiepolo.

2. A mythological ceiling painting, attributed to Marco Liberi, formerly in the Csetényi Collection, was first cited by Éber 1926, p. 108, along with the two Old Testament subjects by Sebastiano Ricci. The current whereabouts of this ceiling painting are unknown. Garas 1992 conjectures that all three paintings once in the Csetényi Collection may have originally constituted a single cycle and that the ceiling painting might also be by Ricci. I should like to thank Dr. Garas for this information.

3. Pigler 1974, 1:96–97 and 151.

4. Now in the Accademia in Venice; see Pallucchini 1952.

5. Certain of these copies have been published, including one in a private collection in Venice, 132 × 200 cm (Daniels 1976, p. 142, cat. no. 492), a second also in Venice, 133 × 200 cm (Daniels 1976, p. 139, cat. no. 475). Also see Pallucchini 1952, pp. 63–68, and Muraro 1973.

6. Pallucchini 1952, p. 80; Garas 1977, p. 13, pl. 5; Daniels 1976, p. 21; and Martini 1964, p. 161, pl. 22.

7. Wessel 1984, pp. 198–199 note 16, provides a good survey of the influences exerted on Ricci during his formative years.

Cat. no. 5

1. Enggass 1982, p. 91.

2. Its most compelling antecedent is Paolo Veronese's *Family of Darius before Alexander* in the National Gallery in London.

3. Pilo 1976, p. 51. On Veronese as a prototype for settecento artists see Garas 1990, pp. 65–71.

4. Now in the Accademia in Venice. This sketchbook was first published by Bassi 1949, p. 123.

5. Watson 1948, p. 290. The best example is Ricci's *Susanna and the Elders* now at Chatsworth (Daniels 1976, p. 2, cat. no. 6), which copies Veronese's original in the Louvre.

6. Watson 1948; Daniels 1976, p. 49, cat. no. 153. Consul Smith's engraver was J. B. Jackson. Veronese's original is now in the Prado. A similar case must have been Ricci's *Bathsheba* in Berlin (Daniels 1976, p. 14, cat. no. 41), which entered the collection of Frederick the Great after 1764 as a Veronese.
7. As cited by Daniels, in *Atti su Ricci* 1976, p. 74.

Cat. no. 6
1. Heinemann 1962 lists over one hundred paintings documented or ascribed to the artist. He cites thirty-two signed works, ten of which bear dates mostly within the period 1510–21.
2. Shapley 1979, p. 29, surmises that Basaiti may even have been Cima's pupil. Basaiti completed two of Vivarini's unfinished altarpieces, including *The Vocation of the Son of Zebediah,* which he signed and dated 1510.
3. Heinemann 1962, no. 171a, fig. 266, as by Basaiti adapted from a composition of Giovanni Bellini.
4. This picture was conserved in 1993 by David Marquis at the Upper Midwest Conservation Association. At some point in the mid-nineteenth century, much of the figure of Christ was overpainted, and his hair was straightened and parted down the center, so that it resembled a wig. In this transformation, many of the rays emanating from Christ's head were painted out or reduced in length. Fortunately the original paint layer was not disturbed during this process of extensive overpainting. As a result, Basaiti's original conception is remarkably well preserved.
5. Panofsky 1927, pp. 261–262.
6. Ibid., p. 264.
7. Belting 1985, pp. 15–17, 41.
8. Robertson 1968, pl. xcvb.

Cat. no. 7
1. The first of these derives from Bassano's master, Bonifazio de' Pitati. The second is dominated by Pordenone and the study of engravings after Raphael. The fourth and last period may be qualified as the master's most Venetian phase, with its night scenes and the increasingly free, sometimes vibrating brushwork.
2. Longhi 1948, p. 52; Ballarin 1967, p. 98; Freedberg 1971, p. 373; Magagnato, in Venice 1981, p. 173; and Pallucchini 1982, no. 19. The most recent analysis of the painting is in the catalogue of the exhibition held at Bassano and later Fort Worth: Rearick, in Fort Worth 1993.
3. Venturi 1929, pp. 1150–1153.
4. These include paintings in the Fitzwilliam Museum in Cambridge, the Christie Collection in Glyndebourne, and the National Gallery in London.

Cat. no. 8
1. Burckhardt 1930, pp. 399–400.
2. Oil on canvas, 146 × 196 cm; see Morassi 1939, p. 29.
3. Oil on canvas, 155.6 × 205.7 cm, inv. 63.58; see Minneapolis 1970, p. 397, cat. no. 211.
4. Oil on canvas, 75 × 100 cm; see Banzato, in Padua 1991, p. 284, cat. no. 236, as a copy after Polidero da Lanciano.
5. Oil on canvas, 104.5 × 136 cm, inv. 1054; see Pigler 1967, p. 737, and Budapest 1991, p. 127. A replica or copy of this composition is in a private collection in Stockholm; information was provided by the owner in a letter dated July 4, 1988, in the museum files.
6. Maxon 1964, pp. 12–16.
7. In the Galleria Nazionale in Rome; the Castle Museum in Prague; the Pinacoteca Arcivescovile in Milan; the Rijksmuseum in Amsterdam; and the Dresden Gallery.

8. Berenson 1936, p. 292. Subsequently Morassi (1939, p. 29) and Panazza (1958, p. 22) endorsed Berenson's view.
9. Pallucchini-Rossi 1982, 1:248, cat. no. A69.
10. Garas 1955, pp. 47–48.
11. Pigler 1967, pp. 81–82.
12. Berenson 1957, p. 42.
13. Humfrey 1990, p. 163, cat. no. 145.
14. Berenson 1897, p. 123.
15. Oral communication, 1984.
16. Banzato, in Padua 1991, p. 284, cat. no. 236.
17. On Polidoro da Lanciano, see Wethey 1976, pp. 190–199.
18. The same head appears in the Minneapolis composition. Maxon 1964, p. 16 note 4, states that this head is quoted from the sculpted portrait of Vitellius, the most famous of the Grimani marbles.

Cat. no. 9
1. These revolutionary pictorial expressions deeply influenced El Greco.
2. Bercken 1942, p. 41.
3. Pallucchini 1950, pp. 81–83, 155; Pallucchini 1969b, pp. 31–33.
4. Pallucchini-Rossi 1982, 1:20, 30, 136, 137, cat. no. 42; for further bibliography, see Pigler 1967, p. 692.

Cat. no. 10
1. "Homer himself, in a long work, may sleep." Translation by Robert Herrick in *Hesperides,* 1648, l. 95.
2. Venturi 1900, p. 236.
3. Piovene-Marini 1968, cat. no. 236.
4. Cited in Pigler 1967, p. 746.
5. Gombosi 1928, pp. 728–729.
6. Venturi 1927, p. 328.
7. Fiocco 1934, p. 128.
8. Berenson 1957, p. 130.
9. Pallucchini 1984, p. 143, discussed the *Crucifixion* in the Church of San Lazzaro dei Mendicanti, Venice, and its relationship to the Budapest painting: "In questa pala c'è una ricerca di effetti luministici, che mi sembra tocchino il momento più alto e conclusivo nella Crocefissione del Szépművészeti Múzeum di Budapest" (In this altarpiece there is an effort to portray luminous effects which, in my opinion, achieves its greatest and most conclusive moment in the Crucifixion in the Museum of Fine Arts in Budapest).

Cat. no. 11
1. The Budapest version of this subject is probably the one mentioned by F. Bartoli in 1793 in the Casa Silvestri in Rovigo. The description "Un grazioso pagetto, in un angolo del quadro, merita per la sua bizzarra veste, e disinvolta fisionomia d'essere con piacere considerato" seems to refer to the page in the Budapest version (A charming little page in a corner of the painting deserves to be admired for his odd garment and disarming expression); see Pallucchini 1981, p. 159.
2. This or one of the variants of the "Budapest type" was engraved by C. H. Hodges in 1787.
3. Bourke had been the Danish ambassador in Naples, Madrid, London, and Paris. The greater part of his collection, consisting principally of Spanish paintings, was purchased by Prince Esterházy in London in 1819 and Paris in 1821. This painting by Strozzi was acquired from Bourke's widow in Paris.
4. Titian painted two versions of the subject, his celebrated painting in Dresden of 1516 and a much later version in the National Gallery in London of 1568; further, see Pigler 1974, 1:336–338; Kirschbaum 1990, 4:571.
5. See Kirschbaum 1990, 4:571.

6. The Venetian half-length format derived from the north, but by the late fifteenth century was fully assimilated into the Venetian pictorial tradition. In later Italian art a half-length composition would have been considered Venetian in derivation; further, see Ringbom 1965.
7. Mortari 1966 cites and reproduces the following replicas, which I have regrouped according to archetype.
A. *The Budapest Group*
1) Budapest, Museum of Fine Arts; 2) Florence, Uffizi; 3) Treviso, Bishopric; 4) Bologna, Galleria Cortinovis; 5) Dortmund, formerly Cremer Collection; 6) Genoa, private collection; 7) Rovigo, Galleria del Seminario; 8) Vienna, formerly Galerie Sanct Lucas; 9) Camigliano (Lucca), Collection of Marchese Torrigiani.
B. *The Munich Group*
1) Munich, Alte Pinakothek; 2) Rovereto, Accademia degli Agiati; 3) Stockholm, National Museum; 4) Stockholm, Bukowski auction, April 3, 1957, lot 203; 5) Mezzocorona, Donati Collection; 6) Venice, Penzo Collection.
8. This is the chronology proposed by Mortari 1966, p. 51, and accepted by Kultzen 1986, pp. 66–67.
9. Strozzi's interest in the rhetorical importance of hands is further demonstrated in his study sheet in the Palazzo Rosso in Genoa; Mortari 1966, figs. 447–448.
10. Mortari 1966, p. 96.

Cat. no. 12
1. Pallucchini 1981, p. 164.
2. Mortari 1966, p. 96.
3. *Raccolta di cento e dodici quadri . . .* (Venice, 1763); cited by Garas 1992 and Matteucci 1955, fig. 169.
4. Pallucchini 1981, p. 164.

Cat. no. 13
1. His sale cites a painting of this description by Strozzi. Prince Esterházy acquired another painting from Count Sickingen, by Daniele Crespi, now also in the Museum of Fine Arts, inv. 539.
2. For example, Pseudo-James 11:1–3; see Hennecke-Schneemelcher 1959, p. 284. For further examples see Kirschbaum 1990, 4:422–423.
3. Künstle 1928, 1:333.
4. Giotto's frescoes in the Arena Chapel in Padua constitute a notable example.
5. Künstle 1928, 1:333–341; Kirschbaum 1990, 4:422–437.
6. For example, this style enabled El Greco to evolve his visionary scenes, spatially complex and often partially enveloped in swirling clouds.
7. Mortari 1966, p. 95, dates this fragment later and considers it an autograph repetition of the completely preserved composition in Budapest.
8. Pallucchini 1981, p. 164. When *The Annunciation* in Budapest is compared with the *Madonna and Child* in the Querini Stampaglia Museum in Venice, which seems to be one of Strozzi's last works, it becomes evident that the Budapest painting must date slightly earlier. A premonition of the novel, straight, horizontal brushwork so evident in the Querini Stampaglia painting is found on Gabriel's chest in the Budapest *Annunciation*.

Cat. no. 14
1. Garas 1992 cites Pellegrini's preparatory pen drawing in the Kunsthalle in Bremen, inv. 55/294, 204 × 195 mm. Many replicas and copies of the original *bozzetto* exist, including examples in the museums in Prague and Vienna and in private collections in Klosterneuburg, Montreal, Munich, and Vienna.
2. Levey 1959b, p. 28.

3. Garas, in her pioneering article of 1962, p. 85, posits that Pellegrini, in his ceiling executed in 1720 for the Banque Royale in Paris, but destroyed two years later, incorporated formal and iconographical elements of the French Rococo into his design. This interpretation runs counter to the general assumption that Pellegrini influenced French painting, as is commonly stated in present-day literature, e.g., Zampetti 1971, 3:55.

Cat. no. 15
1. Zanetti 1771, p. 450.
2. Lanzi 1795–96, 3:222.
3. While in the Pyrker Collection the painting was still considered to be by Tiepolo.
4. It was listed under Pellegrini's name in Térey's 1916 catalogue of the Museum of Fine Arts (pp. 266–267).
5. Fiocco 1929, p. 86.
6. Pigler 1967, p. 284.
7. Garas 1968a, cat. no. 26.
8. In Tolmezzo 1982, p. 46 note 8.
9. Garas 1982, pp. 119–124.
10. London, auction (Sotheby's), March 6, 1973.
11. Pigler 1967, p. 284
12. In Tolmezzo 1982, p. 46 note 8.
13. Garas 1982, pp. 119–124.

Cat. no. 16
1. Zanetti 1771, p. 460: "autore fu d'uno stile originale, pieno di pittoreschi vezzi, di gentilezze e di amenita . . . Vaghezza molta, belle e copiose immagini adornavano le pitture sue."
2. Goering 1934.
3. Fenyő 1954, pp. 279–282. The London painting was formerly in the collection of Lord Willoughby at Grimsthorpe Castle; in 1958 the National Gallery purchased it.
4. Zava Boccazzi 1979, pp. 122, 131, and 157. Lesser-quality versions can only be regarded as workshop products. These include examples in the Mittelrheinisches Museum in Koblenz, in Weimar, a painting formerly in the Gatti-Casazza Collection in Venice, and a work formerly on the art market in Milan. See Zava Boccazzi 1979, nos. 196, 199, 201, 202.
5. Fenyő 1954; Zava Boccazzi 1979, p. 122.

Cat. no. 17
1. Zugni-Tauro 1971, pp. 28–30.
2. The date and the artist's initials, *MDCC / XXVII / G.D. / F.*, were revealed during the conservation of this painting for the settecento exhibition held in Belluno in 1954; see Valcanover, in Belluno 1954, p. 86.
3. It is signed *Da 1718;* see Rizzi 1962, pp. 111–112.
4. In 1718 Diziani is recorded in Dresden, and the *D* inscribed on the drawing may denote that city. Longhi 1762 gives a detailed account of Diziani's activity in Saxony.
5. It was then in a Hungarian private collection.
6. Whereas the drawing was formerly attributed to Nicola Grassi, the painting was ascribed to Sebastiano Ricci. Rizzi 1962 and Garas 1963 established the correct respective attributions of these two works.
7. Formerly London, Gallery Heim, 1975; Daniels 1976, p. 88, fig. 60.
8. Briganti 1990, pp. 186, 194, fig. 259. It had long been considered to be a *bozzetto* by Sebastiano Ricci.

Cat. no. 18
1. The first two items of the provenance are cited by Rizzi, in Passariano 1971, p. 171.

2. In particular those of Thomas, the Pseudo-Matthew, and the Arabic Gospel of the Infancy. However, Domenico Tiepolo may also have drawn on more recent theological writings, or had the advice of a cleric, as only one of his prints illustrating the Flight into Egypt (no. 22; Rizzi 1971, cat. no. 88, *The Falling of the Idol*) appears to derive directly from the Apocrypha; Schwartz 1975, p. 95 note 4.

3. See Voss 1957, who discusses the evolution of the subject in the seventeenth and eighteenth centuries.

4. *Idée pittoresche sopra La Fugga in Egitto di Giesu, Maria e Gioseppe opera inventata ed incisa da me Gio: Domenico Tiepolo in Corte di detta Sua Altessa Reverendissima && Anno 1753* (Würzburg, 1753); Rizzi 1971, pp. 160–213, cat. nos. 67–93. Two paintings, whereabouts unknown, follow the fourth and twelfth etchings of the series; see Mariuz 1971, p. 115. Domenico Tiepolo also produced independent etchings representing scenes from the Flight into Egypt; Rizzi 1971, cat. nos. 57, 65, 66, 94–96.

5. Only three etchings from this suite, plates 13, 19, and 21 (Rizzi 1971, cat. nos. 79, 85, and 87), are dated—1750, 1752, and 1753 respectively.

6. This etching represents the same image as the painting in Budapest. Domenico could have taken both the painting and the copperplates for the etched suite with him to Würzburg; see Russel in Washington 1972, p. 93.

7. Kirschbaum 1990 2:46.

8. Plates 13, 19, 23; Rizzi 1971, cat. nos. 79, 85, 89.

9. As indicated by Schwartz 1975, p. 159. A process of change and evolution governs the compositions. Later prints within the series represent an elaboration of preceding scenes; see Russell in Washington 1972, pp. 93–94.

10. Rizzi 1971, cat. no. 27, which he dates to about 1740.

11. Pallucchini-Piovene 1968, cat. nos. 290–293 (1766–70).

12. Rizzi, in Passariano 1971, p. 171; Russell in Washington 1972, pp. 108–109.

Cat. no. 19

1. Subsequently Catena added various codicils to his wills. His major bequest was to the Scuola dei Pittori and was sufficient to enable this artists' confraternity to acquire land and to erect permanent quarters. If painting was a vocation for Catena, he also appears to have had other substantial sources of income, possibly linked to the import of spices and drugs. For discussion of Catena's will and the disposition of his estate, see Robertson 1954, pp. 5–9.

2. The inscription on the back of Giorgione's *Laura*, in translation, quoted from Robertson 1954, p. 12 note 5: "1506 the first day of June this was done by the hand of master Giorgio of Castelfranco . . . colleague of Master Vincenzo Catena at the instance of M. Giacomo." In 1525 Catena served as a witness at the marriage of Sebastiano del Piombo's sister.

3. Ibid., p. 14.

4. Robertson 1968, p. 115.

5. Robertson 1954, p. 17.

6. Humfrey 1983, pp. 140–141, cat. no. 122, pl. 2, with a listing of ten replicas by Cima and his workshop, indicating the popularity of this composition.

7. Fine examples of this type in Munich and Washington, both datable to the 1490s, contain landscape backdrops with buildings and trees at the crests of the hills that recur in Catena's *Holy Family with a Female Saint*, repr. in Humfrey 1983, cat. nos. 102, 163, pls. 50, 33.

8. In earlier representations of the Virgin and Child accompanied by saints (see Robertson 1954, cat. nos. 1–3) Catena retains the ledge and with only one exception—his picture in Dresden (Robertson 1954,

cat. no. 8)—never employs the ledge in any of his subsequent compositions of this type.

9. Robertson 1954, cat. nos. 8–11, pls. 7–10.

Cat. no. 20

1. For the most complete discussion of the picture's provenance, stylistic connections, and dating see Begni Redona, in Brescia 1988, cat. no. 83, and Begni Redona 1988, pp. 440–443.

2. Guazzoni 1985, p. 172; see Marubbi 1986, p. 90, cat. no. 5. Civerchio's eclectic style derived from Foppa and the Milanese followers of Leonardo.

3. A smaller copy of a detail of the Moretto in Budapest, which was purchased by Károly Pulszky in Venice in 1895, subsequently appeared in the Scarpa auction in Motta di Livenza, also in 1895; see Pigler 1967, p. 465.

Cat. no. 21

1. Works in the imperial Viennese collections, especially portraits, were often radically cropped when they were installed into the wall paneling of the Stallburg Gallery. Such was the case of two Tintoretto portraits as well as Fetti's *Portrait of a Dominican Friar* (cat. no. 49). A Viennese provenance for *Sleeping Girl* prior to 1812 should not be precluded. A strip, about 8 cm wide, was added across the top of *Sleeping Girl,* probably during the nineteenth century.

2. Mâle 1932, pp. 67–69.

3. M. Mosco provides a detailed discussion of the subject in Florence 1986.

4. Although one later example is Ceruti's representation of the subject now in the possession of Credito Bergamasco, Bergamo; reproduced in Florence 1986, p. 204.

5. Now in the Accademia in Venice, oil on canvas, 179 × 140 cm.

6. Reproduced in Florence 1986, p. 272.

7. Although now only a fragment of the painting remains, the posture of the Magdalene suggests that she is kneeling at a prayer stool.

8. The unusual pose of *Sleeping Girl* derives from a lost work by Veronese, known from the print by J. Moyreau; Pigler 1967, p. 224.

9. In preparation for the purchase of the Esterházy Collection, Otto Mündler, an advisor to the Louvre, provided estimates of the entire collection. At the same time he made many new and perceptive attributions, all of which are cited by Pigler 1967. Also see Mündler 1909.

10. Longhi 1943, p. 56 note 77.

11. Szigethi, in Milan 1993, p. 86, and Contini 1990.

12. The most recent monograph on Fetti, that by Safarik 1990, ascribes *Sleeping Girl* to Coccapanni, p. 301, cat. no. A14.

13. Inv. 669, oil on canvas, 175 × 128 cm; Safarik 1990, p. 48, cat. no. 9.

14. As cited in catalogues of the Accademia from 1852 to 1894.

15. Fiocco 1929, pp. 16, 87.

16. Safarik 1990, p. 224, cat. no. 98. This is an immature work that manifests inconsistencies in draftsmanship. It also demonstrates Fetti's as yet unresolved attempt to assimilate outside influences and forge them into his own style.

17. Ibid., p. 226, cat. no. 99.

Cat. no. 22

1. Garas 1981a, p. 95.

2. Ripa 1680, pp. 88–89; 106–107; 242–243.

3. Lanzi 1795–96, 3:205.

4. Canal 1752.

5. Examples exist in Venice in the Museo Correr and the Galleria dell'Accademia; Estergom, Christian Museum, etc. In all likelihood the three infants in the painting in the Accademia in Venice were

inspired by one of Franceschini's representations of the same subject now in the Kunsthistorisches Museum in Vienna.

6. Garas 1981a.

Cat. no. 23

1. The Karlskirche, designed by Johann Bernhard Fischer von Erlach, was begun in 1715 and completed under the supervision of the architect's son, Joseph Emmanuel, in 1737. This church was dedicated to San Carlo Borromeo to fulfil a vow taken by the emperor during the plague of 1713. The Karlskirche appears in the distance in Bellotto's view of the Kaunitz Palace and Gardens (cat. no. 55).

2. Similar pictures in the Museum of Fine Arts, Budapest, by Martino Altomonte (1731, inv. 436), Daniel Gran (1736–37, inv. 439), and Giovanni Antonio Pellegrini (ca. 1730, inv. 654; cat. no. 14) are preparatory sketches for altarpieces in the same Viennese church. In fact, bozzetti for four of the six altarpieces in the Karlskirche are in the Museum of Fine Arts in Budapest.

3. Garas, in Atti su Ricci 1976, pp. 105–109.

4. Kirschbaum 1990, 2:275–283.

5. Safarik 1964, p. 112, and Kiel 1969, p. 495, express great enthusiasm for the spirited energy of the bozzetto in Budapest.

6. Pascoli 1736, p. 385: "incontrò la piena soddisfazione non pure de S.M.C. e C. ma di tutta la nobiltà, di tutti i professori ed intendenti."

7. The version in Prague, 103 × 63 cm, is the closest of all the bozzetti to the finished altarpiece. That in Aschaffenburg, 145 × 84.5 cm, may possibly be by Fontebasso, whereas the small painting in Lvov, 53.5 × 29.5 cm, appears to be a later reduction of the composition. These and other variants are discussed by Waźbiński 1971, pp. 102–103.

8. The bozzetto for this work is now in the Museum of Fine Arts, Springfield, Massachusetts.

Cat. no. 24

1. Oil on canvas, 425 × 230 cm; Zava Boccazzi 1979, pp. 111–112, cat. no. 4.

2. The documents fail to mention the name of the artist, but this omission is inconsequential because the picture is signed; Bonn-Brühl 1961, pp. 195–196, cat. no. 191; Zava Boccazzi 1979, pp. 111–112, cat. no. 4.

3. Pigler 1931, p. 213.

4. The Apotheosis of Saint John Nepomuk and The Education of the Virgin, Zava Boccazzi 1979, pp. 180–181, cat. nos. 244 and 245.

5. Gran's bozzetto for this commission is also in the Museum of Fine Arts, Budapest, inv. 439.

6. Zava Boccazzi 1979, pp. 158–159, cat. no. 177. She also lists the many copies of the Budapest composition. A recently published pen drawing seems to be the artist's initial preparatory idea for the composition. Its basic arrangement is similar but involves fewer figures than the bozzetto in Budapest. It is now in a private collection in Germany and is published by H. G. Golinski, in Bonn 1989, p. 345, cat. no. 108. I should like to thank Zsuzsanna Dobos for bringing this information to my attention.

Cat. no. 25

1. Pérez Sánchez 1977, p. 75. The painting arrived in London by August 1750.

2. The painting arrived in Madrid via Bilbao, in May 1751; Urrea 1988, p. 221.

3. Bourke (1761–1821) was Danish ambassador to Spain between 1801 and 1811 and to England between 1814 and 1819.

4. This was a sale by private contract and not an auction. Buchanan, a Scotsman, had his premises at 60 Pall Mall. The sole surviving copy of this sale catalogue is now at the Barber Institute of the University

of Birmingham. I am much obliged to B. B. Fredericksen (letter of November 13, 1990) and the Getty Provenance Index for bringing this reference to my attention.

5. The European Museum, owned by John Wilson in London, exhibited pictures from private owners and arranged to sell them by private contract. A photocopy of this sale catalogue is in the Getty Center Library; the original belongs to Mr. Richard Lloyd of Saffron Walden, England, a descendant of John Wilson. I am grateful to Patricia Teter of the Getty Provenance Index for this information.

6. Meller 1915, pp. 199–250, published the 1820 and subsequent inventories of the Esterházy Collection.

7. Pigler 1974, 1:438–439.

8. Saint George, the patron saint of England, was the obvious iconographical prototype for this theme. Carreño, in his Saint James in Budapest, derived inspiration from Rubens's Saint George in the Prado in Madrid; Pérez Sánchez, in Madrid 1986, p. 33.

9. Although contemporary with the Palazzo Labia frescoes (1747–50), this painting is more closely related to the frescoes in Würzburg and to the Saint Roch of Noventa Vicentina as suggested by Levey 1986, p. 169.

10. Rizzi, in Passariano 1971, p. 71, terms the decade 1741–50 "La Stagione Classica."

11. This religious spirituality, combined with a style emphasizing hard contours, will become typical of Tiepolo's later work. Because of its associations with Spain many scholars came to believe that Saint James the Great Conquering the Moors should be dated much later: Morassi 1962, p. 7 (1767–70); Pallucchini-Piovene 1968, cat. no. 241 (1757–58); Garas 1977, no. 15 (1757–58).

12. As described in a letter of September 6, 1750: "los capellanes, que temen que la figura del caballo no cause escándalo"; quoted by Pérez Sánchez 1977, p. 75. The painting's measurements were also wrong, so the altarpiece was never installed in its intended spot.

13. Eventually this came to pass. Preciado de la Vega painted its replacement depicting Saint James as a pilgrim; Pérez Sánchez 1977, p. 76.

14. Pérez Sánchez 1977, p. 76: "sea digno de presentarle al Rey." In Venice Tiepolo's painting found warm praise (Doge Grimani had seen it), but in London people were already divided in their judgment; see, e.g., Wall's letter of December 3, 1750.

15. Urrea 1988, p. 221, yet this painting does not seem to be recorded in royal inventories.

16. White and sanguine chalk on blue paper, 322 × 353 mm, inv. 1929-2164.

17. Knox 1980, p. 223, cat. no. M116.

18. The attribution to Domenico is more generally accepted: Chicago 1985, p. 76, cat. no. 30 (entry by Andrea Czére); Czére 1990, cat. no. 59.

19. Rizzi 1971, pp. 290–291, cat. no. 132. Previously it was assumed that Giandomenico made his etching in Madrid (Garas 1977, cat. no. 15; Pérez Sánchez 1977, p. 77) whereas Whistler (1993, p. 389) dates this print to 1750, before the painting was dispatched to London. This earlier dating seems to be supported by the print's influence in Venice. See, for example, G. Gandolfi's painting Saint Martin (Budapest, Museum of Fine Arts, inv. 10060). See Czobor 1953, pp. 175–180.

20. This picture is in an elaborate, period Venetian gilt frame.

Cat. no. 26

1. I am grateful to Catherine Whistler who suggested the Franciscan subject in a letter of April 3, 1993.

2. Barochetto evolved out of the high Baroque and was a determining factor on the Appenine peninsula between 1720 and 1770; see Enggass 1970, pp. 81–86.

3. Passariano 1971, p. 71.

4. Morassi 1962, p. 7 (1750–60); Passariano 1971, no. 64 (1755–56); Garas 1977, cat. no. 14 (1737–40).

5. The figure of Saint Louis relates to a drawing in Munich (Knox 1980, cat. no. M207), cited by Garas (1977, cat. no. 14), and a painting now in York. Whistler suggests that both these pictures are from about 1746 and provide a point of departure for Tiepolo's painting in Budapest. Whistler addresses the potential significance of this comparative material in her letter to me of April 3, 1993, and in her article from 1993, p. 391.

6. This dignitary was in a position to intervene to secure the commission for *Saint James the Great Conquering the Moors*.

7. Garas 1977, cat. no. 14.

8. Whistler, in her letter of April 3, 1993, stressed that this is pure hypothesis, lacking documentary support.

9. Along with six other Italian paintings including that by Domenico Tiepolo in this exhibition, this picture was stolen on November 5, 1983. Miraculously, all were recovered on January 25, 1984, although in damaged condition. *The Virgin Immaculata with Six Saints* had been cut from its stretcher and folded down the middle, thus requiring major conservation work.

Cat. no. 27

1. Fenyő 1968. This processional banner is not the sole example from the Guardi workshop. The banner in the Galleria Nazionale d'Arte in Trieste depicting a bishop saint on both sides is also considered to be a joint work, while the *gonfalone* showing the Birth of the Virgin and the personification of Faith in the Episcopal Seminary in Vittorio Veneto is regarded as Francesco's independent creation.

2. Knox 1968. The altarpieces in Vigo d'Anaunia, Belvedere di Aquileia, and Cerete Basso, closely analogous to the Budapest *Madonna of the Rosary*, are also derived from works by Solimena, Sebastiano Ricci, and Veronese, respectively.

3. Binion 1968, p. 519.

4. Fenyő 1968.

5. Mahon 1968.

6. Morassi 1984, pp. 74–76, pp. 314–315 note 43. Further references addressing the importance of processional banners by the Guardi brothers include Bonelli 1990 and Morassi 1966–69.

Cat. no. 28

1. Garas 1973, p. 67.

2. The inscription on the drawing *The Washing of the Feet* (Milan, Castello Sforzesco) reads: "Francesco Fontebasso veneto scolaro del Ricci fece."

3. Pasta 1775, p. 139.

4. Lanzi 1795–96, 3:214.

5. Moschini 1815, 1:443.

6. Magrini 1988, p. 131 note 29.

Cat. no. 29

1. Pigler 1953–54; followed by the immediate reaction of Zampetti 1953a. For further literature see Pigler 1967, pp. 395–396. Pigler's distinguished career serving the museum and the wider world of art history spanned seven decades. His critical catalogue of the old-master paintings in the collection of the Museum of Fine Arts (published in 1937, 1954, and 1967) and his indispensable handbook of iconography, *Barockthemen* (published in 1956 and 1974), command widespread respect.

2. Lotto 1969, pp. 18, 19, 68, 69, 100, 128, 162, 345.

3. Venice 1953, p. 192.

4. Garas 1967a, pp. 43–52, 66; Garas 1968b, pp. 188, 196, 218.

5. Pigler 1953–54, pp. 165–168, and Mariani Canova 1975, cat. no. 248, date the painting to the second half of the 1540s, whereas Nicco Fasola 1954, pp. 104–105, dates it to around 1517, and Bianconi 1955, p. 61, and Berenson 1956, pp. 130, 462, date it about 1530.

6. Meiss 1976, p. 223.

7. Mariani Canova 1975, cat. no. 248.

8. Gentili 1973, pp. 79–80: "Siamo in ogni caso—quale che possa essere l'esatta datazione—ben al di là dell'apogeo politico-culturale di Venezia, già da anni costretta alla cautela all'interno, alla rinuncia all'esterno, ad un generale ripiegamento sopra se stessa: in tale situazione si spiega questo completo ribaltamento del mito apollineo in forma pessimistica, nel riconoscimento che l'armonia della cultura e della civiltà di classe che la sottende e la egemonizza—può essere, prima o poi turbata dal 'disordine'" (No matter what the precise date may be, clearly it occurred after the political and cultural apex of Venice, a city that for years had been obliged to exercise internal caution and to renounce external influences, resulting in a general withdrawal into itself. In such circumstances the complete transformation of the Apollonian myth into a pessimistic mode is understandable, since it was realized that the harmony of the culture and class structure that sustained and dominated the city could, sooner or later, be thrown into disorder). Aurenhammer, in Vienna 1987, p. 236, cat. no. 1, repeats Gentili's interpretation in its essentials.

Cat. no. 30

1. Other biblical events were the perfect vehicle for this approach: episodes such as the Annunciation to the Shepherds were produced in Bassano's workshop in several versions, the best of which is now in the National Gallery of Art in Washington, D.C.

2. On Venetian bucolic painting in general, see Rosand, in Washington 1988, pp. 20–82.

3. Rearick, in Fort Worth 1993, pp. 126–127.

4. Romani, in Fort Worth 1993, pp. 369–371, cat. no. 45.

5. Ibid.

6. Venturi 1900, p. 236.

7. Arslan 1931, p. 303; Arslan 1960, 1:287.

8. Berenson 1957, fig. 1220.

9. Pigler 1967, p. 46.

10. Ballarin, in Turin 1990, p. 144.

Cat. no. 31

1. Ridolfi 1648, pp. 50, 55.

2. See Pigler 1967, pp. 694–695.

3. Garas 1967b.

4. Mechel 1783, p. 4, cat. no. 5.

5. Only with strong reservations can the picture now in Budapest be securely identified with "ein Satiro bei enem Weib" in the 1615 inventory of the imperial bequest; "A Fiction of Divers Women and a Satyr" in the Buckingham inventory of 1635; "A piece of fancy containing naked figures and a satyr" in the 1648 Buckingham auction catalogue; or "Ein fabel mit vielen Figuren" in the 1685 inventory of Prague Castle. Quoted by Garas 1967b, pp. 29–35.

6. Ballarin 1968, p. 254.

7. Though admitting its problematic nature, de' Vecchi (1970, pp. 125–126), Pallucchini-Rossi (1982, p. 228, cat. no. 447), and others alike accept the identification with Rudolph II's painting.

8. Gerszi 1990, pp. 29–32, with the attribution to Joseph Heintz.

9. Again admitting the contradictions involved in the reconstruction of the series of pictures, Gerszi considers Heintz's drawing to be a copy of the *bozzetto* owned by Crasso rather than of the painting taken to the imperial court.

10. Engerth 1884, p. 329, cat. no. 464.

11. Thode 1901, p. 47.

12. Ridolfi 1648 , p. 55: "Il Signor Niccolò Crasso, Iureconsulto chiarissimo ha in picciol tela Hercole, che furiosamente rigetta Sileno entrato incautamente allo scuro nel di lui letto, credendosi di goder Iole, la quale destatasi al rumore con una sua Fante fanno amendue mostra de corpi loro delicatissimi, ove accorsa un altra Fante con una lucerna che dà lume all'historia" (The distinguished jurist, Signor Niccolò Crasso, owns a small canvas of Hercules shown in the act of furiously ejecting from his bed Silenus, who had imprudently entered it in the dark in the hope of enjoying Iole's [Omphale's] favors. Awakened by the noise, she and a maidservant exhibit their exquisite bodies, while another maidservant rushes in with a lamp that illuminates the scene).

13. There is no evidence to support Garas's suggestion (1967b, p. 32 note 9) that Crasso's version was a sketch.

Cat. no. 32

1. Orlandi 1753, p. 311: "S'applico ad invenzioni ideali come sogni, sacrifici, baccanali, trionfi e balli de puttini con i piu belli capricci che mai abbia inventato altro pittore."

2. Pigler 1929, p. 258; Pigler 1939, pp. 234–235.

3. Pigler 1974, 2:241–242, who lists nineteen variants.

4. Ovid, *Metamorphoses*, book 11, ll. 589–632; Virgil, *Aeneid*, book 6, ll. 278–285, 893–901; Statius, *Thibaid*, book 10; Ariosto, *Orlando Furioso*, canto 14; Cartari 1556, pp. 142–144.

5. Pilo 1962, p. 89.

Cat. no. 33

1. *Imagines*, book 1, l. 15.

2. *Metamorphoses*, book 8, ll. 175ff.; *Ars amandi* (The Art of Love), book 1, ll. 525ff.; *Fasti*, book 3, ll. 459ff.

3. Further sources include Homer, *Odyssey*, book 11, ll. 321ff.; Nonnos, *Dionysiaca*, 47, ll. 265ff.

4. *Carmina*, 64.

5. Ovid, *The Art of Love*, book 1, ll. 555ff., with the omission of certain lines.

6. Ibid., ll. 538ff., with the omission of certain lines.

7. In Milan 1993, p. 72, cat. nos. 9 and 10.

8. Also at the Museum of Fine Arts, Budapest, inv. 633.

9. Orlandi 1753, p. 311.

10. Published by Martini 1964, fig. 53.

Cat. no. 34

1. 1820 Esterházy inventory, no. 394 (as by Daniel Seghers). This bizarre misattribution to Seghers must have derived from a confusion with D. Seiter (1649–1705), a pupil and follower of Loth.

2. *Ceres* was not part of the main body of the Esterházy Collection acquired by the Hungarian government in 1870 but belonged to the collection kept in Pottendorf (Austria), consisting of some 270 paintings considered at the time to be less significant works. It is not known where the 1867 auction took place, as no contemporary record survives, but since these paintings keep turning up on the Hungarian market the most probable site was Budapest. (Oral communication by Klára Garas.) On the Esterházy collections see Meller 1915.

3. Pigler 1974, 2:14, 51–52, 58–60, 144, 172, 242, 491.

4. Ripa 1603. This book went through several editions well into the eighteenth century.

5. Davidson Reid 1993, pp. 337–342.

6. Ewald 1965, for example, mentions a *Ceres* and a *Drunken Silenus* (cat. nos. 385 and 459, both pl. 63), cited as companion paintings when hung in the Hagedorn Collection in Dresden in the eighteenth century. The *Ceres* in Budapest may have had as companions Venus, Bacchus, and Vulcan, or, if we think only in terms of female personifications, Flora, Pomona, and Vesta. Contemporary comparative material would include F. Albani's ceiling fresco in the Palazzo Verospi in Rome or O. Mosto's garden statues in Salzburg; see Pigler 1974, 2:513–514.

Manfredi, a painter in the circle of Caravaggio that so clearly influenced Loth, depicted the Four Seasons as half-length figures (Dayton, Ohio, Dayton Art Institute; repr. in Moir 1967, 2: pl. 44).

7. The discovery was made in 1994 by Andrea Czére, Chief Curator of Prints and Drawings; see Czére 1994.

Cat. no. 35

1. Dobos, in Milan 1991, pp. 22–23, cat. no. 3.

2. Ovid, *Metamorphoses*, book 6, ll. 103–114; Boccaccio 1581, book 4, p. 66; Cartari 1556, p. 77.

3. Zanetti 1771, p. 385: "Le forme non hanno la grandiosità del padre. Le fisionomie sono quasi caricature delle belle teste dell'insigne maestro."

Cat. no. 36

1. Zanetti 1771, p. 413: "[Bellucci] introdusse . . . gran masse di ombreggiamenti . . . ma cosi tenere, incerte e talora opportunamente caricate che diede forza molta a'dipinti."

2. Gombosi 1932, p. 330, first cites Fiocco's attribution of *Danaë* to Bellucci.

3. This idealized female type recurs in Bellucci's *Mars and Venus* formerly in the Steffanoni Collection in Bergamo, his *Danaë at Sea* in the Alte Pinakothek in Munich, and in his *Faith Saving Love* in the Musée des Beaux-Arts in Bordeaux.

4. Garas 1968a, cat. no. 2; Kultzen-Reuss 1991, pp. 33–34.

Cat. no. 37

1. "A venus with a satyr who is gazing at her"; Pigler 1962; Zampetti 1959–60.

2. Pigler 1962 mentions this painting but defining it as a *vanitas* allegory, does not identify it with the picture cited in the inventory.

3. Daniels 1976, p. 60, cat. no. 184, fig. 70.

4. Pigler 1962.

5. Garas 1968a, cat. no. 3.

6. Formerly at the Heim Gallery in London; Daniels 1976, p. 62, cat. no. 190.

Cat. no. 38

1. "I am of the Cornelius clan, bearing the name of the virgin buried on Mount Sinai. The Senate of Venice call me their daughter, and Cyprus, seat of nine kingdoms, serves me. You can see how honorable I am. But even greater honor is due to Gentile Bellini who painted me in such a small picture."

2. For further literature on this painting see Pigler 1967, pp. 51–52; Garas 1981b, cat. no. 2; Collins 1982, pp. 201–208; Meyer zur Capellen 1985, pp. 68–69, 126–127; and Budapest 1991, p. 7.

3. This picture was part of the series painted for the Scuola Grande di San Giovanni Evangelista in Venice.

4. For the full quotation, see Berenson-Kiel 1974, p. 226.

5. Pope-Hennessy 1963, pp. 50–51.

Cat. no. 39

1. For the bibliography of this painting, see Pigler 1967, p. 41; for the most recent critical description of the painting, see Garas 1981b, cat. no. 13.

2. Berenson 1895, p. 35; the only monograph written about the painter (A. Venturi, "Bartolommeo Veneto," *Archivio Storico dell'Arte* [1899]: 432–462) does not mention the Budapest painting.

3. Gilbert 1973, p. 3. Gilbert provides an in-depth analysis of Bartolommeo Veneto's work, putting special emphasis on Gentile Bellini's influence on the artist.

4. For this and the following works cited, see Rama 1988, pp. 637–638 and bibliography.

5. Gilbert 1973, p. 5.

6. These include the famous *Courtesan* in Frankfurt, the *Salome* in Dresden, the *Woman Playing a Lute* in the Brera in Milan and in the Isabella Stewart Gardner Museum in Boston.

7. Gilbert 1973, p. 6.

Cat. no. 40

1. For bibliography, see Pigler 1967, pp. 264–266; Budapest 1991, p. 49. See also Brown, in Venice 1992, cat. no. 68. For a general discussion of all problems concerning the picture and full bibliography, see Ballarin, in Paris 1993, pp. 324–329, cat. no. 25.

2. Lermolieff 1880, p. 191.

3. Pope-Hennessy 1963, pp. 132, 135, 136.

4. X-ray examination revealed that the eyes originally looked upward. The present appearance results from pentimenti; see Kákay Szabó 1954, p. 87.

5. Pope-Hennessy 1963, pp. 132, 135, 136; Ballarin 1983, p. 511.

6. The earliest date for the painting, ca. 1503, is provided by Ballarin, in Paris 1993, p. 328. As a means of supporting his iconographic hypothesis, Auner (1958, p. 167) suggests a date of about 1530, thereby simply discarding the visual evidence of style and fashion history. Auner interprets an epigram in the *Anthologia graeca* to mean that Broccardo, having successfully concluded a trip in 1530 or 1531, dedicated his hat to Hecate, the guardian of roads. He thought that the date MDXXX or MDXXXI had originally appeared on the worn-off tablet.

7. For the two other Broccardos cited in sources, see Richter 1937, p. 211.

8. Hartlaub 1925, pp. 66–71.

9. De Grummond 1975, pp. 346, 352.

Cat. no. 41

1. Inv. 939, oil on limewood panel, 38.8 × 28.5 cm. Together with several other pictures from the imperial collection in Vienna, the *Portrait of a Young Woman* first came to Pozsony in 1770 and then to the residence of the President of the Chamber in Buda. By 1848 it was in the National Museum. Thus the two pictures, originally belonging together, came at different times via different routes to Hungary and, finally, to the Museum of Fine Arts.

2. A miniature copy of Teniers's painting is found in Storffer's splendid painted inventory from 1733 (Vienna, Kunsthistorisches Museum), and an engraved copy of the same picture appears in the *Prodromus* published in 1735 by Stampart and Prenner. For the provenance, inventory data, and bibliography see Pigler 1967, pp. 526–527.

3. Noé 1960, p. 22.

4. Rylands 1988, p. 110.

5. Frimmel 1908b, pp. 200–202.

6. Hadeln 1911.

7. Garas 1964, p. 57.

8. Ballarin 1968, pp. 250–251. Only later did their innovations increasingly affect Palma.

9. Scholars arguing for this date cite the *Portrait of a Man,* dated 1510, in the Borghese Gallery in Rome, a work attributed to Palma

that still lacks the Giorgionesque influence manifest in the Budapest portraits: Suida 1934–35, p. 93; Ballarin 1968, pp. 250–251; Mariacher 1968, p. 49; Mariacher 1975, p. 207; Rylands 1988, pp. 126, 195.

10. Gombosi 1937, p. 17; Garas 1981b, cat. no. 9.

Cat. no. 42

1. Lermolieff 1893, p. 115; Nicodemi 1925, p. 76; Gilbert 1959, p. 263; Ferrari 1961, cat. no. 37; Brescia 1965, cat. no. 21; Boselli 1965, p. 205; Garas 1981b, cat. no. 17; Frangi 1986, p. 175.

2. Ferrari 1961, cat. no. 37.

3. Suida 1934, p. 551.

4. Pigler 1967, p. 584.

5. Ballarin, in Paris 1993, cat. no. 70.

6. Inv. 963, oil on canvas, 81 × 71 cm.

7. Brescia 1965, cat. no. 63; Boselli 1965, p. 205; Pigler 1967, p. 584; Garas 1981b, cat. no. 17; Rossi 1988, p. 269.

8. Boselli 1965, p. 205.

9. Pigler 1967, p. 584.

Cat. no. 43

1. Scholars remain divided in their opinion on Palma Vecchio's picture, yet even if it dates after 1510 rather than before, the styles of Giorgione and the aged Bellini, the two most influential Venetian artists of the first decade, merge in the portrait with rare clarity.

2. Frimmel 1892, p. 258.

3. Gombosi 1925–26.

4. Berenson (1957, p. 96), followed by Freedberg (1971, p. 478 note 44), rejected the attribution to Piombo and ascribed the portrait to Licinio. To accept this premise, we would have to conclude that the gifted teenager Licinio had lost his talent upon reaching adulthood, because none of his indisputable pictures remotely attains the quality of this picture. Other authorities who endorse Sebastiano del Piombo's authorship include Pigler 1967, pp. 547–548; Lucco 1980, cat. no. 4; and Garas 1981b, cat. no. 10.

5. Gombosi 1925–26, p. 64.

6. Hirst 1981, p. 95.

7. Ibid., p. 94.

8. Ibid., pp. 96, 101–102; Garas 1981b, cat. nos. 11 and 12.

9. Hirst 1981, pp. 125, 133–136; Tátrai 1983, cat. no. 19.

Cat. no. 44

1. The Museum of Fine Arts in Budapest has in its collection a half-length *Madonna and Child with Two Saints* by Licinio clearly inspired by Bellini and hence a work dating from his youth; inv. 4439, oil on poplar panel, 58 × 74 cm; Pigler 1967, p. 382; Vertova 1975, p. 414, cat. no. 23.

2. Inv. 51.802, oil on poplar panel, 83.5 × 71.5 cm; Pigler 1967, pp. 382–383; Vertova 1975, p. 414, cat. no. 21; Garas 1981b, cat. no. 35.

3. Vertova 1975, p. 414, cat. no. 22. Vertova was the first scholar to propose dating this painting between 1510 and 1515.

4. By the same token, Licinio's *Portrait of a Woman* recalls Titian's celebrated painting *Flora,* now in the Uffizi, ca. 1515, which may have influenced Licinio in creating this idealized female likeness.

Cat. no. 45

1. Garas 1981b, cat. nos. 24 and 25.

2. Those accepting this work as by Titian include Crowe-Cavalcaselle 1877, 2:551; Gombosi 1926, pp. 282, 284; Hadeln 1930, pp. 492, 571, 584; Suida 1933, pp. 72, 73, 168, pl. CCIIa; Berenson 1957, p. 184; Pallucchini 1969a, pp. 136, 299; Garas

1981b, cat. nos. 24 and 25; Azzi Visentini, in Bern 1991, cat. no. 119. Scholars who consider this a workshop product include Tietze 1936, p. 133; Ballarin 1968, p. 254; Valcanover 1969, cat. no. 363; Wethey 1971, pp. 183–184.

3. Aretino 1957–60, 2:433.

4. Azzi Visentini, in Bern 1991, cat. no. 119.

Cat. no. 46

1. Wethey 1971, p. 154.

2. Zampetti, in Venice 1957, cat. no. 3.

3. Boschetto 1963, cat. no. 9.

4. For the most recent summary of opinions concerning this picture see Begni Redona, in Milan-Frankfurt 1990, p. 198.

5. According to Pallucchini 1957, p. 116, who argues in favor of Bassano's authorship, the painting is not a portrait and "evidentemente è un frammento di un quadro più grande" (evidently is a fragment of a larger painting).

6. Garas 1970, pp. 62–67, and Garas 1981b, cat. nos. 26 and 27.

7. Ridolfi 1648, 1:192.

8. The earlier and better preserved version is in the National Gallery of Art in Washington, D.C., whereas a later and poorly preserved variant is in the Capodimonte in Naples; Wethey 1971, cat. nos. 82 and 83.

Cat. no. 47

1. Gombosi 1943, p. 67.

2. Gregori 1979, p. 239. Gregori supports her dating of the portrait in Bergamo to about 1560, comparing it to two dated works that, in our opinion, have little in common with it or the portrait in Budapest.

3. Pigler 1967, pp. 467–468.

4. Gregori, in Bergamo 1979, p. 247, cat. no. 81.

5. Garas 1981b, cat. no. 34.

Cat. no. 48

1. See Pigler 1967, p. 747; Budapest 1991, p. 129; Pignatti-Pedrocco 1991, p. 154.

2. Ballarin 1968, p. 254; Rearick, in Venice 1988, p. 95.

3. Piovene-Marini 1968, cat. no. 144; Pignatti 1976, pp. 77–78, cat. no. 107; Garas 1981b, cat. no. 43; Pallucchini 1984, p. 71; Pignatti-Pedrocco 1991, p. 154.

4. "Nui pittori si pigliamo licenzia che si pigliano i poeti e i matti"; from the minutes of the trial quoted by Piovene-Marini 1968, pp. 84–85.

Cat. no. 49

1. Garas 1968b, p. 206, cat. no. 73.

2. Described as "The head of a friar in white" and lacking an attribution; Garas 1967a, p. 73.

3. Cited in the inventories of 1649 and 1659 (cat. nos. 171 and 73 respectively) of Leopold Wilhelm's collection as by Fetti and with measurements including the frame of about 58 × 46 cm; Garas 1967a, pp. 73, 79; Garas 1968b, pp. 186, 206, fig. 257.

4. In 1781 a second shipment of paintings to the palace did not include this picture. Although no documentary evidence indicates specifically when the first shipment of paintings arrived in Pozsony, it probably occurred no more than one or two years earlier than the second; Garas 1969, pp. 92–93.

5. Garas 1969, pp. 94–95.

6. In the wake of the revolution and war of independence seventy-eight paintings were confiscated by the independent Hungarian government and turned over to the Hungarian National Museum, where the pictures remained even after the defeat of this government.

7. Larsen 1980, cat. no. A16, continues to maintain the attribution to Van Dyck, dating the canvas to about 1614 and not excluding the possibility that it is a self-portrait, analogous to Van Dyck's *Self-Portrait* in the Akademie der bildenden Künste in Vienna.

8. Pigler 1967, p. 223.

9. See notes 1 and 2 above.

10. Safarik 1990, pp. 297–298, cat. no. 134.

11. This is plate 11 in Stampaert-Prenner 1735.

12. A photograph of this painting after cleaning and before inpainting was published in Milan 1993, p. 82, which indicates the few, incidental surface losses.

13. For example, the two paintings by G. Seghers and A. Milani in the Kunsthistorisches Museum in Vienna (inv. 2624 and 1624 respectively).

14. Safarik 1990, p. 288, cat. no. 130.

Cat. no. 50

1. Item no. 1150 in the 1831 inventory of the Esterházy Collection.

2. As listed in Mündler's inventory of 1869, see Pigler 1967, p. 591.

3. Pigler 1967, pp. 591–592; Garas 1968a, cat. no. 46.

4. Natale, oral communication in 1984, and Gregori, oral communication in 1987.

5. An obvious inspiration is Longhi's *Card Players,* Raleigh, North Carolina Museum of Art.

6. These pieces include *Bust of a Young Woman* (Mora, Zornsmuseet), *Girl with Kitten* and *Boy with Puppy* (both London, private collection).

7. Gregori, in Brescia 1987, p. 44.

8. Moro, oral communication in 1990.

Cat. no. 51

1. Ridolfi 1648, p. 314: "nel palco del Magistrato delle legne dipinse Venetia, Nettuno innanzi con Tritoni, che la tributano di marini doni" (in the reception hall of the magistracy of firewood he painted Venice, with Neptune and Triton before her, offering her gifts of the sea). For later references and literature see Pignatti 1976, p. 140; Budapest 1991, p. 129; Bern 1991, cat. no. 116.

2. See Ticozzi 1975, pp. 27–28.

3. Schulz 1968, p. 139.

4. According to Pigler 1967, p. 746, because Hercules is positioned next to Neptune, god of the sea, he personifies the land. It is more likely, however, that he symbolizes heroic virtue, a quality that made Venice great. Ridolfi takes a similar stance in his discussion of another painting, formerly in the Palazzo Ducale (Magistrato delle Biade) and now in the Accademia. In identifying the subject of the picture as Hercules and Ceres Paying Homage to Venice, Ridolfi also associates the attribute of heroic virtue with Hercules. See Piovene-Marini 1968, cat. no. 182.

5. Schulz 1968, p. 139.

6. Based on Schulz's archival research we know that by 1762 a committee of painters had determined that the picture's condition was poor; ibid.

7. Tuscany drifted politically increasingly farther away from Venice, which remained a republic despite its crises and declining commerce. Through the use of erudite didacticism, shameless bombastic flattery, and personal cultism dressed up as mock science, Vasari and his academic circle made the genre of political allegory into something that is difficult for the modern viewer to understand and appreciate.

Cat. no. 52

1. Pigler 1967, p. 507.

2. Natale, oral communication in 1990.

3. Dobos, in Milan 1991, pp. 32–35, cat. no. 8.

4. Soprani 1768, p. 159: "i graziosi movimenti delle figure."

5. For example, two versions of *Temptations of Monks* in the Musée Départemental des Vosges in Épinal, a *Landscape with Monks* in the National Gallery of Scotland in Edinburgh, the *Landscape with Washerwomen* in the Museo Civico in Trieste, and a *Landscape* in the Museo Civico in Udine.

6. Another version of the painting of this subject is in the Koch Collection in Düsseldorf.

7. Geiger 1949, pp. 84–85, 87.

8. Pospisil 1945, p. lv.

9. Delogu 1930, pp. 94, 96.

10. Their joint work includes *The Temptation of Saint Anthony* in the Porro Collection in Milan; published by Arslan 1959, pp. 304–305.

Cat. no. 53

1. Constable 1962, 1:131–138; 2: cat. nos. 356, 497, 595. Two further painted versions of this subject are known: one is in the Ca' Rezzonico in Venice and the other, formerly in the Beurdeley Collection, was auctioned in Paris in 1920. Neither, however, is authentic.

2. In the engraving of the same subject, Canaletto left the view and the architecture almost unchanged, modifying isolated details here and there. Near the gondoliers, for instance, a transport vessel known as a *burchiello,* which carried passengers between Venice and Padua, is just putting in, and the figures include an elegant lady walking arm in arm with her beau.

3. "this area in shadow."

4. A considerable number of paintings and drawings representing Brenta subjects are attributed to Bellotto. On the basis of his uncle's engraving, Bellotto also elaborated on the theme of the Porte del Dolo, for example in his painting in Dresden, transforming it into an imaginary view with Palladian buildings.

5. See Dresden 1963–64, cat. no. 1; Kozakiewicz 1972, 2:458, cat. no. Z294.

6. See Dobos, in Milan 1991, pp. 58–59, cat. no. 18.

7. Ibid.

8. *San Giacomo di Rialto* (Budapest, private collection), once considered to be its pendant (see Kozakiewicz 1972, 2:450, 453, cat. no. Z268), could not have been its companion because it is different in size, style, and theme.

Cat. no. 54

1. Fogolari 1912, p. 56. Two variant paintings of nearly identical size are also generally regarded as autograph: one is in a private collection in Paris, and the other, together with its pendant representing the Grand Canal at the Ca' Pesaro, is in the Alte Pinakothek in Munich. Toledano 1988, pp. 72–73, V.6.1–V.6.4.

2. In Gorizia 1989, p. 120 note 24.

Cat. no. 55

1. Regrettably no documentation for this commission survives, but at the time of the prince's death in 1794 it was still in the Kaunitz family's possession.

2. While still in the possession of the Kaunitz family and not that of the Andrássy, as erroneously cited by Kozakiewicz 1972a, p. 211.

3. Frimmel 1908b: "Seit etwa drei Jahren von Austerlitz weg nach Budapest zu Seiner exzellenz Herrn Grafen Géza Andrássy gewandert ist" (about three years ago this painting was transferred from Austerlitz to Budapest to His Excellency, Count Géza Andrássy).

4. Vienna 1930, p. 14.

5. Because Bellotto's Viennese *vedute* were not readily accessible, his potential influence on Viennese topographical painting was minimal. See Vienna 1965, pp. 59–60.

6. The imperial series of Viennese subjects were placed in the palaces they depicted. They were only first listed together in the catalogue of the Kunsthistorisches Museum in 1882 and were first exhibited as a group there in 1890. This fact confirms that they were never intended to make up a single, unified, late Baroque scheme of interior decoration as proposed by Heinz, in Essen 1966, p. 6. No documentary evidence survives for this commission or for the intended placement of these imperially commissioned Viennese views.

7. Both were great collectors. Moreover, Prince Kaunitz also founded the Wiener Manufaktur- und Graveurschule (Viennese School for Crafts and Engraving) in 1758. The Museum of Fine Arts owns important paintings once in the possession of the imperial chancellor, Prince Kaunitz. These came to the museum via the Esterházys.

8. First proposed by Frimmel 1908b, p. 202. This supposition is reinforced by J. Schmuzer's engraved portrait of Prince Kaunitz after the painting by L. Tocqué; repr. *Gazette des Beaux-Arts* 106 (July 1958): 85. The Budapest Museum recently acquired a portrait of the prince (Inv. no. 93.10, oil on copper, 27 × 20.5 cm) with younger but similar features.

9. Kozakiewicz 1972, 1:117.

10. Kozakiewicz 1972, 1:118.

Catalogue References

Short references are keyed to the notes to the catalogue.

Aretino 1957–60
Aretino, P. *Lettere sull'arte de Pietro Aretino.* Ed. by E. Camasasca and F. Pertile. Milan, 1957–60.

Arslan 1931
Arslan, W. *I Bassano.* Bologna, 1931.

Arslan 1959
Arslan, E. "Contributo a Sebastiano Ricci e ad Antonio Francesco Peruzzi." In *Studies in the History of Art Dedicated to W. E. Suida on His Eightieth Birthday.* London, 1959.

Arslan 1960
Arslan, E. *I Bassano.* 2 vols. Milan, 1960.

Atti su Ricci 1976
Atti del Congresso Internazionale di studi su Sebastiano Ricci e il suo tempo. Udine, 1976.

Auner 1958
Auner, M. "Randbemerkungen zu zwei Bildern Giorgiones und zum Broccardo-Porträt in Budapest." *Jahrbuch der Kunsthistorischen Sammlungen in Wien* 54 (1958): 151–172.

Ballarin 1967
Ballarin, A. "Jacopo Bassano e lo studio di Raffaello e dei Salviati." *Arte Veneta* 21 (1967): 77–101.

Ballarin 1968
Ballarin, A. "Pittura veneziana nei musei di Budapest, Dresda, Praga e Varsavia." *Arte Veneta* 22 (1968): 237–255.

Ballarin 1979
Ballarin, A. "Una nuova prospettiva su Giorgione: La ritrattistica degli anni 1500–1503." In *Giorgione. Atti del Convegno Internazionale di studio per il 5. centenario della nascita.* Castelfranco Veneto–Venice, 1979.

Ballarin 1983
Ballarin, A. "Giorgione e la Compagnia degli Amici: Il 'Doppio ritratto' Ludovisi." In *Storia dell'Arte Italiana dal medioevo al quattrocento.* Turin, 1983.

Bartoli 1793
Bartoli, F. *La Pittura, scultura ed architettura della città di Rovigo.* Venice, 1793.

Bartsch
Bartsch, A. *Le peintre-graveur.* 21 vols. Vienna, 1803–21.

Bassi 1949
Bassi, E. "Due quadri di Sebastiano Ricci dimenticate." *Arte Veneta* 3 (1949): 121–123.

Begni Redona 1988
Begni Redona, P. V. *Alessandro Bonvicino, Il Moretto da Brescia.* Brescia, 1988.

Belting 1985
Belting, H. *Giovanni Bellini: Pietà Ikone und Bilderzählung in der Venezianischen Malerei.* Frankfurt-am-Main, 1985.

Bercken 1942
Bercken, E. v. d. *Die Gemälde des Jacopo Tintoretto.* Munich, 1942.

Berenson 1895
Berenson, B. *Venetian Painting Chiefly before Titian at the Exhibition of Venetian Art.* The New Gallery. London, 1895.

Berenson 1897
Berenson, B. *The Venetian Painters of the Renaissance.* New York–London, 1897.

Berenson 1936
Berenson, B. *Pitture italiane del Rinascimento.* Milan, 1936.

Berenson 1956
Berenson, B. *Lorenzo Lotto.* London, 1956.

Berenson 1957
Berenson, B. *Italian Pictures of the Renaissance: Venetian School.* London, 1957.

Berenson-Kiel 1974
Kiel, H. *Looking at Pictures with Bernard Berenson: Selected and with an Introduction by Hanna Kiel.* New York, 1974.

Bianconi 1955
Bianconi, P. *Tutta la pittura di Lorenzo Lotto.* Milan, 1955.

Binion 1968
Binion, A. "Tiepolo-Guardi: New Points of Contact." *Burlington Magazine* 110 (1968): 519.

Boccaccio 1581
Boccaccio. *La geneologia degli dei de gentili.* Venice, 1581.

Bonelli 1990
Bonelli, M. *Restauri e ritrovamenti.* Udine, 1990.

Boschetto 1963
Boschetto, A. *Giovanni Gerolamo Savoldo.* Milan, 1963.

Boschini 1660
Boschini, M. *La carta del navegar pitoresco.* Venice, 1660.

Boselli 1965
Boselli, C. "La mostra del Romanino." *Arte Veneta* 19 (1965): 201–210.

Briganti 1990
Briganti, G. *La pittura in Italia: Il settecento*. Milan, 1990.

Budapest 1991
Museum of Fine Arts, Budapest. Old Masters' Gallery. A Summary Catalogue of Italian, French, Spanish, and Greek Paintings. Ed. by V. Tátrai. London-Budapest, 1991.

Burckhardt 1930
Burckhardt, J. *Beiträge zur Kunstgeschichte von Italien*. Berlin-Leipzig, 1930.

Camesasca 1974
Camesasca, E. *L'opera completa del Bellotto*. Milan, 1974.

Canal 1752
Canal, V. da. *Vita di Gregorio Lazzarini*. 1752. Ed. by G. A. Moschini. Venice, 1809.

Cartari 1556
V. Cartari. *Le imagini colla sposizione degli dei antichi*. Venice, 1556. Ed. by V. Chartarii as *Imagines deorum*. Frankfurt, 1687.

Collins 1982
Collins, H. F. "Time, Space and Gentile Bellini's *The Miracle of the Cross* at the Ponte San Lorenzo." *Gazette des Beaux-Arts* 100 (December 1982): 201–208.

Constable 1962
Constable, W. G. *Canaletto: Giovanni Antonio Canal, 1697–1768*. 2 vols. Oxford, 1962.

Contini 1990
Contini, R. "Sulle spartizioni del Coccapanni: Alessandro Rosi e Luciano Borzone." *Paradigma* 9 (1990): 141–168.

Crowe-Cavalcaselle 1877
Crowe, J. A., and G. B. Cavalcaselle. *Tizian: Leben und Werke*. Leipzig, 1877.

Czére 1990
Czére, A. *Italienische Barockzeichnungen*. Budapest, 1990.

Czére 1994
Czére, A. "Egy újabban felbukkant kép az Esterházy gyűjteményből" (A Recently Discovered Painting from the Esterházy Collection). *Művészettörténeti Értesítő* 1–2 (1994): 41–44.

Czobor 1953
Czobor, Á. "Un tableau récemment acquis de Gaetano Gandolfi au Musée Hongrois des Beaux-Arts." *Acta Historiae Artium Academiae Scientiarum Hungaricae* 1 (1953): 175–180.

Daniels 1976
Daniels, J. *Sebastiano Ricci*. Hove, 1976.

Davidson Reid 1993
Davidson Reid, J. *The Oxford Guide to Classical Mythology in the Arts, 1300–1900*. 2 vols. New York-Oxford, 1993.

de Grummond 1975
de Grummond, N. Th. "VV and Related Inscriptions in Giorgione, Titian, and Dürer." *Art Bulletin* 57 (1975): 346–356.

de' Vecchi 1970
de' Vecchi, P. *L'opera completa del Tintoretto*. Milan, 1970.

Delogu 1930
Delogu, G. *I pittori minori del settecento*. Venice, 1930.

Éber 1926
Éber, L. *Művészeti Lexikon*. Budapest, 1926.

Engerth 1884
Engerth, E. R. v. *Kunsthistorische Sammlungen des Allerhöchsten Kaiserhauses: Gemälde. Beschreibendes Verzeichnis*. Vol. 1. Vienna, 1884.

Enggass 1970
Enggass, R. "Tiepolo and the Concept of the Barochetto." In *Atti del Congresso Internazionale di Studi sul Tiepolo, Udine, 1970*. Milan, n.d.

Enggass 1982
Enggass, R. "Visual Counterpoint in Venetian Settecento Painting." *Art Bulletin* 64 (1982): 89–97.

Ewald 1965
Ewald, G. *Johann Carl Loth, 1632–1698*. Amsterdam, 1965.

Fenyő 1954
Fenyő, I. "Zur Kunst Giovanni Battista Pittonis." *Acta Historiae Artium Academiae Scientiarum Hungaricae* 1 (1954): 279–300.

Fenyő 1968
Fenyő, I. "An Unknown Processional Banner by the Guardi Brothers." *Burlington Magazine* 110 (1968): 65–69.

Ferrari 1961
Ferrari, M. L. *Il Romanino*. Milan, 1961.

Fiocco 1929
Fiocco, G. *Die venezianische Malerei des siebzehntes und achzehntes Jahrhunderts*. Florence-Munich, 1929.

Fiocco 1934
Fiocco, G. *Paolo Veronese*. Rome, 1934.

Fogolari 1912
Fogolari, G. "Ricordi della pittura veneziana del Vecchio Campanile di San Marco." *Rassegna d'Arte* 12 (1912): 49–61.

Frangi 1986
Frangi, F. "G. Romanino: Ritratto maschile." In *Pittura del cinquecento a Brescia*. Milan, 1986.

Freedberg 1971
Freedberg, S. J. *Painting in Italy, 1500 to 1600*. The Pelican History of Art. Harmondsworth, 1971.

Frimmel 1892
Frimmel, Th. v. *Kleine Galeriestudien*. Vol. 1. Bamberg, 1892.

Frimmel 1908a
Frimmel, Th. v. "Wiedergefundene Bilder aus berühmten alten Sammlungen." *Blätter für Gemäldekunde* 4 (1908): 199–201.

Frimmel 1908b
Frimmel, Th. v. "Ein Canaletto aus der fürstlich Kaunitzschen Galerie." *Blätter für Gemäldekunde* 4 (1908): 202–204.

Garas 1955
Garas, K. "Deux tableaux de Rocco Marconi en Hongrie." *Bulletin du Musée Hongrois des Beaux-Arts* 7 (1955): 42–49.

Garas 1962
Garas, K. "La plafond de la Banque Royal de G. A. Pellegrini." *Bulletin du Musée Hongrois des Beaux-Arts* 21 (1962): 75–93.

Garas 1963
Garas, K. "Quelques oeuvres inconnues de Gaspare Diziani à Budapest." *Bulletin du Musée Hongrois des Beaux-Arts* 23 (1963): 79–96.

Garas 1964
Garas, K. "Giorgione et Giorgionisme au XVIIe siècle." *Bulletin du Musée Hongrois des Beaux-Arts* 25 (1964): 51–80.

Garas 1967a
Garas, K. "Die Entstehung der Galerie des Erzherzogs Leopold Wilhelm." *Jahrbuch der Kunsthistorischen Sammlungen in Wien* 63 (1967): 39–80.

Garas 1967b
Garas, K. "Le tableau du Tintoret du Musée de Budapest et le cycle peint pour l'empereur Rodolphe II." *Bulletin du Musée Hongrois des Beaux-Arts* 30 (1967): 29–48.

Garas 1968a
Garas, K. *La peinture vénitienne du XVIIIe siècle.* Budapest, 1968.

Garas 1968b
Garas, K. "Das Schicksal der Sammlung des Erzherzogs Leopold Wilhelm." *Jahrbuch der Kunsthistorischen Sammlungen in Wien* 64 (1968): 181–278.

Garas 1969
Garas, K. "La collection des tableaux du Château Royal de Buda au XVIIIe siècle." *Bulletin du Musée Hongrois des Beaux-Arts* 32–33 (1969): 91–121.

Garas 1970
Garas, K. "Die Bildnisse Pietro Bembos in Budapest." *Acta Historiae Artium* 16 (1970): 57–67.

Garas 1973
Garas, K., et al. "Nouvelles acquisitions, 1967–1972." *Bulletin du Musée Hongrois des Beaux-Arts* 41 (1973): 67.

Garas 1977
Garas, K. *Eighteenth-Century Venetian Painting.* 3d rev. ed. Budapest, 1977.

Garas 1981a
Garas, K. "Opere di Gregorio Lazzarini, Marco Liberi e Pasquale Rossi a Budapest." *Arte Veneta* 35 (1981): 95–101.

Garas 1981b
Garas, K. *Italian Renaissance Portraits.* 3d rev. ed. Budapest, 1981.

Garas 1982
Garas, K. "Rapporti dei pittori tedeschi ed austriaci col Grassi e con la pittura veneziana dell'epoca." In *Nicola Grassi e il Rococo europeo. Atti del Congresso Internazionale di Studi.* Udine, 1982.

Garas 1990
Garas, K. "Paolo Veronese—copie, falsi ed imitazioni nel settecento." In *Studi Centro Tedesco di Studi veneziani,* no. 8. Sigmaringen, 1990.

Garas 1992
Garas, K. "Catalogue of the Seventeenth- and Eighteenth-Century Venetian Paintings in the Budapest Museum of Fine Arts." Manuscript, 1992.

Geiger 1949
Geiger, B. *Magnasco.* Bergamo, 1949.

Gentili 1973
Gentili, A. "Problemi del simbolismo armonico nella cultura postelisabettiana." In *Il simbolismo del tempo. Studi di filosofia dell'arte.* Rome-Padua, 1973.

Gerszi 1990
Gerszi, T. "Nouvelles attributions aux maîtres de la cour de Rodolphe II." *Bulletin du Musée Hongrois des Beaux-Arts* 73 (1990): 21–38.

Gilbert 1959
Gilbert, C. "Portraits by and near Romanino." *Arte Lombarda* 4 (1959): 261–267.

Gilbert 1973
Gilbert, C. "Bartolommeo Veneto and His Portrait of a Lady." *The National Gallery of Canada Bulletin* 22 (1973): 2–16.

Goering 1934
Goering, M. "Zur Kritik und Datierung der Werke des Giovanni Battista Pittoni." *Mitteilungen des Kunsthistorischen Institutes in Florenz* 4 (January 1934): 201–248.

Gombosi 1925–26
Gombosi, Gy. "Un ritratto giovanile di Sebastiano del Piombo." *Dedalo* 6 (1925–26): 57–66.

Gombosi 1926
Gombosi, Gy. "A Szépművészeti Múzeum Tizian-arcképei." *Magyar Művészet* 2 (1926): 272–284.

Gombosi 1928
Gombosi, Gy. "Veronese (1528–1588)." *Magyar Művészet* 4 (1928): 721–728.

Gombosi 1932
Gombosi, Gy. "Dipinti italiani nei Musei Ráth e Zichy di Budapest." *Rivista d'Arte* 14 (1932): 321–330.

Gombosi 1937
Gombosi, Gy. *Palma Vecchio.* Klassiker der Kunst. Vol. 38. Stuttgart-Leipzig, 1937.

Gombosi 1943
Gombosi, Gy. *Moretto da Brescia.* Basel, 1943.

Gregori 1979
Gregori, M. "Giovanni Battista Moroni." In *I pittori bergamaschi dal XIII al XIX secolo.* Vol. 3. *Il cinquecento.* Bergamo, 1979.

Guazzoni 1985
Guazzoni, V. "Contenuto ed espressione devozionale nella pittura del Moretto." In *I musei bresciani: Storia ed uso didattico.* Brescia, 1985.

Hadeln 1911
Hadeln, D. v. "Über einige Frühwerke des Palma Vecchio." *Monatshefte für Kunstwissenschaft* 4 (1911): 224–226.

Hadeln 1930
Hadeln, D. v. "Dogenbildnisse von Tizian." *Pantheon* 6 (1930): 489–494.

Hartlaub 1925
Hartlaub, G. F. *Giorgiones Geheimnis.* Munich, 1925.

Heinemann 1962
Heinemann, F. *Bellini e i Belliniani.* Venice, 1962.

Hennecke-Schneemelcher 1959
Hennecke, E., and W. Schneemelcher. *Neutestamentliche Apokryphen.* Vol. 1. *Evangelien.* 3d ed. Tübingen, 1959.

Hirst 1981
Hirst, M. *Sebastiano del Piombo*. Oxford, 1981.

Hollstein
Hollstein, F. W. H. *Dutch and Flemish Etchings, Engravings, and Woodcuts, 1450–1700*. Amsterdam, 1949–.

Humfrey 1983
Humfrey, P. *Cima da Conegliano*. Cambridge, 1983.

Humfrey 1990
Humfrey, P. *La pittura veneta del Rinascimento a Brera*. Florence, 1990.

Kákay Szabó 1954
Kákay Szabó, L. "Département de restauration." *Bulletin du Musée Hongrois des Beaux-Arts* 5 (1954): 86–88.

Kiel 1969
Kiel, H. "Dal Ricci al Tiepolo." *Pantheon* 27 (1969): 494–497.

Kirschbaum 1990
Lexikon der christlichen Ikonographie. Ed. by E. Kirschbaum. 8 vols. 2d ed. Rome-Freiburg-Basel-Vienna, 1990.

Knox 1968
Knox, G. "Tiepolo-Guardi: A New Point of Contact." *Burlington Magazine* 110 (1968): 278.

Knox 1980
Knox, G. *Giambattista and Domenico Tiepolo: A Study and Catalogue Raisonné of the Chalk Drawings*. Oxford, 1980.

Kozakiewicz 1972
Kozakiewicz, S. *Bernardo Bellotto*. 2 vols. London, 1972.

Kultzen 1986
Kultzen, R. *Venezianische Gemälde des 17. Jahrhunderts. Bayerische Staatsgemäldesammlungen*. Munich, 1986.

Kultzen-Reuss 1991
Kultzen, R., and M. Reuss. *Venezianische Gemälde des 18. Jahrhunderts. Bayerische Staatsgemäldesammlungen*. Munich, 1991.

Künstle 1928
Künstle, K. *Ikonographie der Kristlichen Kunst*. Freiburg im Breisgau, 1928.

Lanzi 1795–96
Lanzi, L. *Storia pittorica della Italia*. 3 vols. Bassano, 1795–96.

Larsen 1980
Larsen, E. *L'opera completa di Van Dyck*. 2 vols. Milan, 1980.

Lermolieff 1880
Lermolieff, I. *Die Werke italienischer Meister in den Galerien von München, Dresden und Berlin*. Leipzig, 1880.

Lermolieff 1893
Lermolieff, I. *Kunstkritische Studien über italienische Malerei. Die Galerie zu Berlin*. Leipzig, 1893.

Levey 1959a
Levey, M. *The German School. The National Gallery*. London, 1959.

Levey 1959b
Levey, M. *Painting in Eighteenth-Century Venice*. London, 1959.

Levey 1986
Levey, M. *G. B. Tiepolo: His Life and Art*. New Haven and London, 1986.

Longhi 1762
Longhi, A. *Compendio delle vite dei pittori veneziani*. Venice, 1762.

Longhi 1943
Longhi, R. "Ultimi studi sul Caravaggio e la sua cerchia." *Proporzioni* 1 (1943).

Longhi 1948
Longhi, R. "Calepino veneziano." *Arte Veneta* 2 (1948): 41–55.

Lotto 1969
Lotto, L. *Libro di spese diverse*. Ed. P. Zampetti. Venice-Rome, 1969.

Lucco 1980
Lucco, M. *L'opera completa di Sebastiano del Piombo*. Milan, 1980.

Magrini 1988
Magrini, M. *Francesco Fontebasso*. Vicenza, 1988.

Mahon 1968
Mahon, D. "The Guardi Banner at Budapest." *Burlington Magazine* 110 (1968): 219–220.

Mâle 1932
Mâle, E. *L'art religieux après le Concile de Trente*. Paris, 1932.

Mariacher 1968
Mariacher, G. *Palma il Vecchio*. Milan, 1968.

Mariacher 1975
Mariacher, G. "Palma Vecchio: Le opere." In *I pittori bergamaschi dal XIII al XIX secolo*. Vol. 1. *Il cinquecento*. Bergamo, 1975.

Mariani Canova 1975
Mariani Canova, G. *L'opera completa del Lotto*. Milan, 1975.

Mariuz 1971
Mariuz, A. *Giovanni Domenico Tiepolo*. Venice, 1971.

Martini 1964
Martini, E. *La pittura veneziana del settecento*. Venice, 1964.

Marubbi 1986
Marubbi, M. *Vincenzo Civerchio: Contributo alla cultura figurativa cremasca nel primo cinquecento*. Milan, 1986.

Matteucci 1955
Matteucci, A. M. "L'attività veneziana di Bernardo Strozzi." *Arte Veneta* 9 (1955): 138–154.

Maxon 1964
Maxon, J. "A Possible Tintoretto." *The Minneapolis Institute of Arts Bulletin* 53 (1964): 12–16.

Mechel 1783
Mechel, Ch. v. *Verzeichnis der Gemälde der Kaiserlich Königlichen Bilder Gallerie in Wien*. Vienna, 1783.

Meiss 1976
Meiss, M. "Sleep in Venice: Ancient Myths and Renaissance Proclivities." In *The Painter's Choice*. London-New York, 1976.

Meller 1915
Meller, S. *Az Esterházy Képtár Története* (History of the Esterházy Collection). Budapest, 1915.

Meyer zur Capellen 1985
Meyer zur Capellen, J. *Gentile Bellini*. Wiesbaden-Stuttgart, 1985.

Minneapolis 1970
Catalogue of European Paintings in the Minneapolis Institute of Arts. Minneapolis, 1970.

Moir 1967
Moir, A. *The Italian Followers of Caravaggio*. Cambridge, Mass.,
1967.

Morassi 1939
Morassi, A. *Catalogo delle cose d'arte e di antichità d'Italia*. Vol. 11.
Brescia-Rome, 1939.

Morassi 1962
Morassi, A. *A Complete Catalogue of the Paintings of G. B. Tiepolo*.
London, 1962.

Morassi 1966–69
Morassi, A. "Altre novità e precisazioni su Antonio e Francesco
Guardi." *Atti dell'Accademia di Udine, 1966–69* 7 (1970): 9–10.

Morassi 1984
Morassi, A. *Guardi: I dipinti*. 2d ed. 2 vols. Venice, 1984.

Mortari 1966
Mortari, L. *Bernardo Strozzi*. Rome, 1966.

Moschini 1815
Moschini, G. A. *Guida per la città di Venezia*. Venice, 1815.

Mündler 1909
Mündler, O. "Schätzungliste von Otto Mündler über die Bestände der
Esterházy-Galerie." *Az Országos Magyar Szépművészeti Múzeum
Állagai* 1 (1909): 3–40.

Muraro 1973
Muraro, M. "Fortuna di un tema mistico-erotico: Betsabea al bagno."
Antichità Viva 12, no. 2 (1973): 26–28.

Nicco Fasola 1954
Nicco Fasola, G. "Per Lorenzo Lotto." *Commentari* 5 (1954):
103–115.

Nicodemi 1925
Nicodemi, G. *Gerolamo Romanino*. Brescia, 1925.

Noé 1960
Noé, H. A. "Messer Giacomo en zyn 'Laura.'" *Nederlands
Kunsthistorisch Jaarboek* 11 (1960): 1–35.

Orlandi 1753
Orlandi, P. A. *Abecedario pittorico*. Venice, 1753.

Pallucchini 1950
Pallucchini, R. *La giovinezza del Tintoretto*. Milan, 1950.

Pallucchini 1952
Pallucchini, R. "Studi ricceschi: I, Contributo a Sebastiano."
Arte Veneta 6 (1952): 63–68.

Pallucchini 1957
Pallucchini, R. "Commento alla mostra di Jacopo Bassano."
Arte Veneta 11 (1957): 97–118.

Pallucchini 1969a
Pallucchini, R. *Tiziano*. Florence, 1969.

Pallucchini 1969b
Pallucchini, R. "Inediti di Jacopo Tintoretto." *Arte Veneta* 24 (1969):
31–53.

Pallucchini 1981
Pallucchini, R. *La pittura veneziana del seicento*. Venice, 1981.

Pallucchini 1982
Palucchini, R. *Bassano*. Collana d'arte Paola Malipiero, no. 13.
Bologna, 1982.

Pallucchini 1984
Pallucchini, R. *Veronese*. Milan, 1984.

Pallucchini-Piovene 1968
Pallucchini, A., and G. Piovene. *L'opera completa di Giambattista
Tiepolo*. Milan, 1968.

Pallucchini-Rossi 1982
Pallucchini, R., and P. Rossi. *Tintoretto: Le opere sacre e profane*.
2 vols. Milan, 1982.

Panazza 1958
Panazza, G. *I Civici Musei e la Pinacoteca di Brescia*. Bergamo, 1958.

Panofsky 1927
Panofsky, E. "Imago Pietatis: Ein Beitrag zur Typengeschichte des
'Schmerzensmanns' und der 'Maria Mediatrix.'" In *Festschrift für
Max J. Friedländer zum 60. Geburtstag*, pp. 261–308. Leipzig, 1927.

Pascoli 1736
Pascoli, L. *Vite de' pittori, scultori ed architetti moderni*. Vol. 2. Rome,
1736.

Pasta 1775
Pasta, A. *Le pitture notabili di Bergamo che sono esposte alla vista del
pubblico*. Bergamo, 1775.

Pérez Sánchez 1977
Pérez Sánchez, A. E. "Nueva documentación para un Tiepolo
problemático." *Archivo Español de Arte* 50, no. 17 (1977): 75–80.

Pigler 1929
Pigler, A. "A barokk tárgyválasztás és formanyelv" (Baroque Choice
of Subjects and Language of Forms). *Magyar Művészet* 5 (1929):
253–264.

Pigler 1931
Pigler, A. "G. A. Pittoni Szent Erzsébet vázlata" (Pittoni's Sketch
of Saint Elizabeth). *Az Országos Magyar Szépművészeti Múzeum
Évkönyvei* 6 (1931): 207–213.

Pigler 1939
Pigler, A. "The Importance of Iconographical Exactitude." *Art Bulle-
tin* 21 (1939): 228–237.

Pigler 1953–54
Pigler, A. "A New Picture by Lorenzo Lotto: The Sleeping Apollo."
Acta Historiae Artium 1 (1953–54): 165–168.

Pigler 1962
Pigler, A. "Un tableau provenant de la succession de Sebastiano
Ricci." *Bulletin du Musée Hongrois des Beaux-Arts* 20 (1962): 71–73.

Pigler 1967
Pigler, A. *Katalog der Galerie Alter Meister*. Budapest, 1967.

Pigler 1974
Pigler, A. *Barockthemen*. 3 vols. Budapest, 1974.

Pignatti 1976
Pignatti, T. *Veronese*. Venice, 1976.

Pignatti-Pedrocco 1991
Pignatti, T., and F. Pedrocco. *Veronese: Catalogo completo*. Florence,
1991.

Pilo 1962
Pilo, G. M. *Carpioni*. Venice, 1962.

Pilo 1976
Pilo, G. M. *Sebastiano Ricci e la pittura veneziana del settecento.* Pordenone, 1976.

Piovene-Marini 1968
Piovene, G., and R. Marini. *L'opera completa del Veronese.* Milan, 1968.

Pope-Hennessy 1963
Pope-Hennessy, J. *The Portrait in the Renaissance.* New York–Washington, 1963.

Pospisil 1945
Pospisil, M. *Magnasco.* Florence, 1945.

Rama 1988
Rama, E. "Bartolomeo Veneto." In *La pittura in Italia.* Vol. 2. *Il cinquecento.* Milan, 1988.

Richter 1937
Richter, G. M. *Giorgio da Castelfranco.* Chicago, 1937.

Ridolfi 1648
Ridolfi, C. *Le meraviglie dell'arte.* Venice, 1648. Ed. by D. v. Hadeln. Berlin, 1914.

Ringbom 1965
Ringbom, S. *Icon to Narrative: The Rise of the Dramatic Close-Up in Fifteenth-Century Devotional Painting.* Abo, 1965.

Ripa 1603
Ripa, C. *Iconologia, overo descrittione di diverse imagini cavate dall'antichità e di propria inventione trovate e dichiarate de Cesare Ripa . . . di nuovo revista e dal medisimo ampliata di 400 e più imagini.* Rome, 1603.

Ripa 1680
Ripa, C. *Della più che novissima iconologia (ampliata dal Gio. Zavatino Castellini).* Padua, 1680.

Rizzi 1962
Rizzi, A. "Opere inedite di Gaspare Diziani nel Friuli." *Acropoli* (1962): 111–112.

Rizzi 1971
Rizzi, A. *The Etchings of the Tiepolos: Complete Edition.* London, 1971.

Robertson 1954
Robertson, G. *Vincenzo Catena.* Edinburgh, 1954.

Robertson 1968
Robertson, G. *Giovanni Bellini.* Oxford, 1968.

Rossi 1988
Rossi, F. *Accademia Carrara 1. Catalogo dei dipinti sec. XV–XVI.* Bergamo, 1988.

Rowlands 1975
Rowlands, J. "Johann Liss at Augsburg." *Burlington Magazine* 118 (1975): 832–836.

Rylands 1988
Rylands, Ph. *Palma il Vecchio: L'opera completa.* Milan, 1988.

Safarik 1964
Safarik, E. A. "Il settecento veneziano nelle collezioni Cecoslovacche." *Arte Veneta* 2 (1964): 110–118.

Safarik 1990
Safarik, E. A. *Fetti.* Milan, 1990.

Sandrart 1675
Sandrart, J. von. *Teutsche Academie der Bau-, Bild- und Malereykünste.* Nuremberg, 1675. Ed. by R. A. Peltzer. Munich, 1925.

Schulz 1968
Schulz, J. *Venetian Painted Ceilings of the Renaissance.* Berkeley–Los Angeles, 1968.

Schwartz 1975
Schwartz, S. "The Iconography of the Rest on the Flight into Egypt." Ph.D. diss., New York University, 1975.

Shapley 1979
Shapley, F. R. *Catalogue of the Italian Paintings. National Gallery of Art.* Vol. 1. Washington, D.C., 1979.

Sirén 1914
Sirén, O. *Nicodemus Tessin d. J. Studieresor, 1687–1688.* Stockholm, 1914.

Soprani 1768
Soprani, R. *Delle vite de' pittori, scultori ed architetti genovesi.* Genoa, 1769.

Spear 1976
Spear, R. E. "Johann Liss Reconsidered." *Art Bulletin* 58 (1976): 582–593.

Stampaert-Prenner 1735
Stampaert, F., and A. Prenner. *Prodromus oder Vor Licht des eröffneten Schau- und Wunder-Prachtes aller deren an dem Kaisl Hof . . . sich befindlichen Kunst-Schätzen und Kostbarkeiten . . .* Vienna, 1735. Published in *Jahrbuch der Kunsthistorischen Sammlungen der Allerhöchsten Kaiserhauses* 7 (1888).

Stefani Mantovanelli 1990
Stefani Mantovanelli, M. "Giovanni Battista Langetti: Profilo dell'artista e catalogo ragionato delle sue opere." *Saggi e Memorie di Storia dell'Arte* 17 (1990): 41–105.

Steinbart 1940
Steinbart, K. *Johan Liss, der Maler aus Holstein.* Berlin, 1940.

Suida 1933
Suida, W. *Tizian.* Zurich-Leipzig, 1933.

Suida 1934
Suida, W. In *Thieme-Becker Lexikon,* s.v., "Romanino, Girolamo."

Suida 1934–35
Suida, W. "Studien zu Palma." *Belvedere* 12 (1934–35): 85–101.

Tátrai 1983
Tátrai, V. *Cinquecento Paintings of Central Italy.* Budapest, 1983.

Térey 1916
Térey, G. v. *Die Gemäldegalerie des Museums für Bildende Künste in Budapest. Vollständiger beschreibender Katalog mit Abbildungen aller Gemälde, I. Byzantinische, Italienische, Spanische, Portugiesische und Französische Meister.* Berlin, 1916.

Thode 1901
Thode, H. *Tintoretto.* Bielefeld-Leipzig, 1901.

Ticozzi 1975
Ticozzi, P. "Le incisioni da opere del Veronese nel Museo Correr." *Bolletino dei Musei Civici Veneziani* 20 (1975): 6–89.

Tietze 1936
Tietze, H. *Tizian: Leben und Werk.* Vienna, 1936.

Toledano 1988
Toledano, R. *Michele Marieschi: L'opera completa.* Milan, 1988.

Urrea 1988
Urrea, Jesús. "Una famiglia di pittori veneziani in Spagna: I Tiepolo." In *Venezia e la Spagna.* Milan, 1988.

Valcanover 1969
Valcanover, F. *L'opera completa di Tiziano.* Milan, 1969.

Venturi 1900
Venturi, A. "I quadri di scuola italiana nella Galleria Nazionale di Budapest." *L'Arte* 3 (1900): 185–240.

Venturi 1927
Venturi, A. *Studi dal vero.* Milan, 1927.

Venturi 1929
Venturi, A. *Storia dell'arte italiana.* IX. 4. Milan, 1929.

Vertova 1975
Vertova, L. "Bernardino Licinio." In *I pittori bergamaschi dal XIII al XIX secolo.* Vol. 1. *Il cinquecento.* Bergamo, 1975.

Voss 1957
Voss, H. "Die Flucht nach Aegypten." *Saggi e Memorie di Storia dell'Arte* 1 (1957): 27–61.

Watson 1948
Watson, F. J. B. "Sebastiano Ricci as a Pasticheur." *Burlington Magazine* 90 (1948): 290.

Waźbiński 1971
Waźbiński, Z. "*Mariae Himmelfahrt* von Sebastiano Ricci für die Karlskirche in Wien." *Wiener Jahrbuch für Kunstgeschichte* 24 (1971): 101–106.

Wessel 1984
Wessel, T. *Sebastiano Ricci und die Rokokomalerei.* Ph.D. diss. Freiburg, 1984.

Wethey 1971
Wethey, H. E. *The Paintings of Titian.* Vol. 2. *The Portraits.* London, 1971.

Wethey 1976
Wethey, H. E. "Polidoro Lanzani: Problems of Titianesque Attributions." *Pantheon* 34 (1976): 190–199.

Whistler 1993
Whistler, C. "Aspects of Domenico Tiepolo's Early Career." *Kunstchronik* 46 (August 1993): 385–398.

Wurzbach
von Wurzbach, A. *Niederländisches Künstler Lexikon.* 3 vols. Vienna, 1906–11. Reprint. Amsterdam, 1974.

Zampetti 1953
Zampetti, P. "Un Lotto scoperto a Budapest." *Arte Veneta* 7 (1953): 167–168.

Zampetti 1959–60
Zampetti, P. "Il testamento di Sebastiano Ricci." *Arte Veneta* 14 (1959–60): 229–231.

Zampetti 1971
Zampetti, P. *A Dictionary of Venetian Painters.* 4 vols. Leigh-on-Sea, 1971.

Zanetti 1771
Zanetti, A. M. *Della pittura veneziana e della opere pubbliche de' veneziani maestri.* Venice, 1771.

Zava Boccazzi 1979
Zava Boccazzi, F. *Pittoni: L'opera completa.* Venice, 1979.

Zugni-Tauro 1971
Zugni-Tauro, A. P. *Gaspare Diziani.* Venice, 1971.

EXHIBITION CATALOGUES

Augsburg-Cleveland 1975–76
Johann Liss. Augsburg, Rathaus, and The Cleveland Museum of Art, 1975–76.

Belluno 1954
Mostra di pitture del settecento nel Bellunese. Belluno, Palazzo dei Vescovi, 1954. Catalogue by F. Valcanover.

Bergamo 1979
Giovanni Battista Moroni. Bergamo, Palazzo della Regione, 1979. Catalogue by F. Rossi and M. Gregori.

Bern 1991
Zeichen der Freiheit: Das Bild der Republik in der Kunst des 16. bis 20. Jahrhundert. Bern, 1991. Catalogue ed. by D. Gamboni and G. Germann.

Bonn 1989
Himmel, Ruhm und Herrlichkeit. Italienische Künstler am rheinischen Höfen des Barock. Bonn, Rheinisches Landesmuseum. Cologne, 1989. Catalogue by H. Schmidt et al.

Bonn-Brühl 1961
Kurfürst Clemens August. Schloss Augustusburg zu Brühl. Cologne, 1961.

Brescia 1965
Mostra di Girolamo Romanino. Brescia, Duomo Vecchio, Chiesa di S. Antonio di Breno, Pinacoteca Tosio Martinengo, 1965. Organized and catalogue by G. Panazza.

Brescia 1987
Giacomo Ceruti, Il Pitocchetto. Brescia, Monastery of San Giulia, 1987. Catalogue by B. Passamani, Mina Gregori et al.

Brescia 1988
Alessandro Bonvicino, Il Moretto. Brescia, Monastery of S. Giulia, 1988. Catalogue by P. V. Begni Redona et al.

Chicago 1985
Leonardo to Van Gogh: Master Drawings from Budapest. The Art Institute of Chicago, 1985.

Dresden 1963–64
Bernardo Bellotto genannt Canaletto in Dresden und Warschau. Dresden, Staatliche Kunstsammlungen, 1963–64. Catalogue by S. Kozakiewicz et al.

Essen 1966
Bellotto genannt Canaletto. Essen, 1966. Catalogue by G. B. Heinz.

Florence 1986
La Maddalena tra sacro e profano. Florence, Palazzo Pitti. Milan, 1986. Catalogue by M. Mosco.

Fort Worth 1993
Jacopo Bassano. Fort Worth, Kimbell Art Museum, 1993. Catalogue ed. by B. L. Brown and P. Marini.

Gorizia 1989
Marieschi tra Canaletto e Guardi. Gorizia, Castle of Gorizia, 1989. Catalogue by D. Succi et al.

Lugano 1985
Capolavori da musei ungheresi. Lugano, Villa Favorita. Milan, 1985.

Madrid 1986
Carreño, Rizi, Herrera. Madrid, Museo del Prado, 1986. Catalogue by A. E. Pérez Sánchez.

Milan 1991
Itinerario Veneto: Dipinti e disegni del '600 e '700 veneziano del Museo di Belle Arti di Budapest. Milan, Finart Casa d'Arte, 1991. Catalogue by Zs. Dobos, A. Czére, and K. Garas.

Milan 1993
L'Europa della pittura nel XVII secolo: 80 capolavori dai musei ungheresi. Milan, Palazzo della Permanente, 1993. Catalogue by A. Szigethi and É. Nyerges.

Milan-Frankfurt 1990
Giovanni Gerolamo Savoldo und die Renaissance zwischen Lombardei und Venetien. Von Foppa und Giorgione bis Caravaggio. Frankfurt, Schirn Kunsthalle, 1990. Catalogue by S. E. Schifferer et al.

Padua 1991
Da Bellini a Tintoretto: Dipinti dei Musei Civici di Padova dalla meta del quattrocento ai primi del seicento. Padua, Musei Civici. Milan, 1991. Catalogue by A. Ballarin and D. Banzato.

Paris 1993
Le siècle de Titien: L'âge d'or de la peinture à Venise. Paris, Grand Palais. Paris, 1993.

Passariano 1971
Mostra del Tiepolo: Dipinti. Passariano (Udine), Villa Manin. Milan, 1971. Catalogue by A. Rizzi.

Tolmezzo 1982
Nicola Grassi. Tolmezzo, Palazzo Frisacco, 1982. Catalogue by A. Rizzi.

Turin 1990
Da Biduino ad Algardi: Pittura e scultura a confronto. Turin, 1990. Catalogue ed. by G. Romano.

Venice 1953
Mostra di Lorenzo Lotto. Venice, Palazzo Ducale, 1953. Catalogue by P. Zampetti.

Venice 1957
Jacopo Bassano. Venice, Palazzo Ducale, 1957.

Venice 1969
Dal Ricci al Tiepolo. Venice, Palazzo Ducale, 1969.

Venice 1981
Da Tiziano a El Greco: Per la storia del Manierismo a Venezia, 1540–1590. Venice, Palazzo Ducale. Milan, 1981.

Venice 1988
Paolo Veronese: Disegni e dipinti. Venice, Fondazione Giorgio Cini, 1988. Catalogue by W. R. Rearick.

Venice 1992
Leonardo e Venezia. Venice, Palazzo Grassi. Milan, 1992. Catalogue by D. A. Brown.

Vienna 1930
Maria-Theresia-Ausstellung. Vienna, Schönbrunn, 1930.

Vienna 1965
Bernardo Bellotto genannt Canaletto. Vienna, Oberes Belvedere, 1965. Catalogue by S. Kozakiewicz et al.

Vienna 1986
Prinz Eugen und das Barocke Österreich. Vienna, Schlosshof and Niederösterreichisches Landesmuseum, 1986.

Vienna 1987
Zauber der Medusa: Europäische Manierismen. Vienna, Künstlerhaus, 1987. Catalogue by W. Hoffman.

Washington 1972
Rare Etchings by Giovanni Battista and Giovanni Domenico Tiepolo. Washington, National Gallery of Art, 1972. Catalogue by D. Russell.

Washington 1988
Places of Delight: The Pastoral Landscape. Washington, The Phillips Collection and National Gallery of Art, 1988.

Index of Artists